PRAISE FOR
A History of Delusions

'A varied and thought-provoking journey.'

The Times

'An utterly engrossing book. It reaches through layers of mania and the distance of centuries to connect you completely to its subjects, such that you miss them when they're gone.'

Zoe Williams

'Riveting case histories grounded in context and narrated with novelistic verve and impressive authority.'

Julie Kavanagh, author of *The Irish Assassins*

'Fascinating and compassionate.'

Horatio Clare, author of *Heavy Light*

'Meticulously researched… this is a good time to take delusions seriously.'

Daily Express

'A humane and thoughtful account.'

Washington Post

'Absorbing… Shepherd goes beyond formal, detached accounts by physicians, trying instead to get a glimpse of whole human beings whose lives unravelled through trauma into delusional thinking… a humane, attentive exploration of locked-in worlds inhabited by people whose mental certainties could be both comforting and terrifying.'

BBC History Magazine

'A timely reminder that nothing is new, just how we deal with it. Shepherd's evocative descriptions take you from seventeenth-century Oxford to twentieth-century Paris with detail as rich as the stories she uncovers. Thought-provoking as well as deeply informative.'

Annie Gray, author of *Victory in the Kitchen*

ALSO BY VICTORIA SHEPHERD

A History of Delusions

STONY JACK AND THE LOST JEWELS OF CHEAPSIDE

TREASURE AND GHOSTS IN THE LONDON CLAY

VICTORIA SHEPHERD

A Oneworld Book

First published by Oneworld Publications Ltd in 2025

Copyright © Victoria Shepherd, 2025

The moral right of Victoria Shepherd to be identified as the Author of this work has been asserted by her in accordance with the Copyright, Designs, and Patents Act 1988

All rights reserved
Copyright under Berne Convention
A CIP record for this title is available from the British Library

ISBN 978-0-86154-888-0
eISBN 978-0-86154-889-7

Typeset by Tetragon, London
Printed and bound in Great Britain by Clays Ltd, Elcograf S.p.A.

No part of this publication may be reproduced, stored in a retrieval system, or transmitted, in any form or by any means, electronic, mechanical, photocopying, recording or otherwise, or used in any manner for the purpose of training artificial intelligence technologies or systems, without the prior permission of the publishers.

The authorised representative in the EEA is eucomply OÜ, Pärnu mnt 139b–14, 11317 Tallinn, Estonia
(email: hello@eucompliancepartner.com / phone: +33757690241)

Oneworld Publications Ltd
10 Bloomsbury Street
London WC1B 3SR
England

Stay up to date with the latest books, special offers, and exclusive content from Oneworld with our newsletter

Sign up on our website
oneworld-publications.com

Contents

Prologue: The Letter 1

I	The Cellar	5
II	The Jewels Make an Entrance	26
III	The Lawrence Family Guard the Treasure	38
IV	The Jewels Go Out into the World	67
V	A Pawnbroker's Son	88
VI	Insider Trading and the Egyptian Book of the Dead	94
VII	The Hoard on Show in the Glittering Gold Room	108
VIII	The Queen's Private Views	121
IX	Who Will Protect a Man These Days?	145
X	The Treasures Go Back Underground	163
XI	The Show Must Go On	186
XII	The Question of Identity and the Original Owner	207
XIII	The Chance of Escape	225
XIV	A Reckoning	240
XV	Making the Catalogue	253
XVI	The Auction of Rings	260
XVII	The Bank of England	269

xviii	Stage and Screen	279
xix	What We Leave Behind	294
xx	The Postwar Ghost	311
xxi	Looking for the St George Opal Ring	331

Postscript 341
Acknowledgements 347
List of Illustrations 351
Notes 353
Index 375

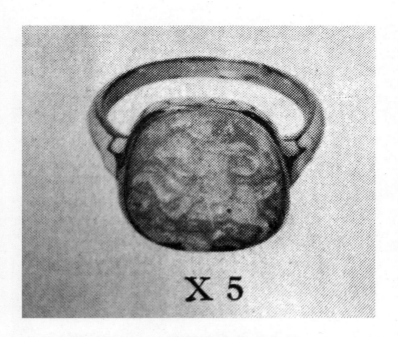

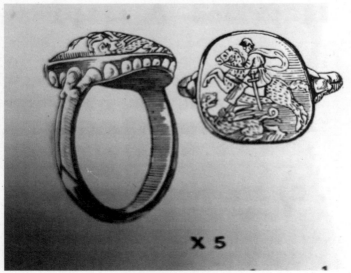

Drawing, and photograph, of acquisition 'X5', a man's gold ring, set with an opal cameo of St George and the Dragon, London Museum catalogue of the Cheapside Hoard, 1928.

File from the archives of the Museum of London:
'The Cheapside Hoard, The Ghost of'

Letter from the archives at the Museum of London: The Cheapside Hoard, The Ghost of A-14: 'A-14000-367.'

A-14000-367

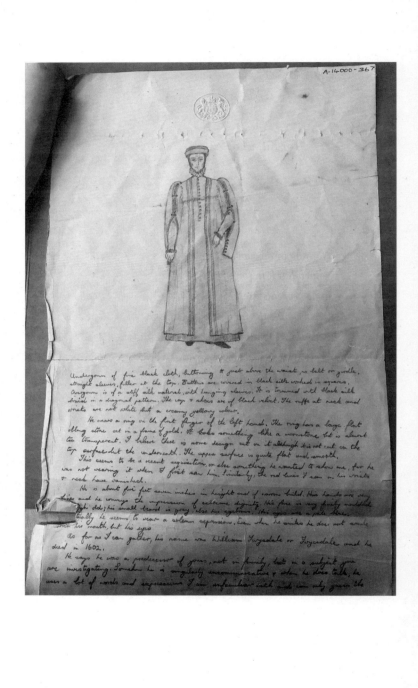

Undergown of fine black cloth, buttoning to just above the waist, no belt or girdle. straight sleeves, fuller at the top. Buttons are covered in black silk worked in squares. Overgown is of a stiff silk material, with hanging sleeves. It is trimmed with black silk braid in a diagonal pattern. The cap & shoes are of black velvet. The ruffs at neck and wrists are not white but a creamy yellowy colour.

He wears a ring on the first finger of the left hand. The ring has a large flat oblong stone set in a frame of gold. It looks something like a moonstone but is almost too transparent. I believe there is some design cut on it although it is not cut on the top surface but the underneath. The upper surface is quite flat and smooth.

This seems to be a recent acquisition, or else something he wanted to show me, for he was not wearing it when I first saw him. Similarly, the red lines I saw on his wrists & neck have vanished.

He is about five feet seven inches in height and of rather build. His hands are very fine and he conveys the impression of extreme dignity. His face is very finely modelled for his age; his small beard is grey, also his eyebrows. His eyes are a pale blue. Usually, he seems to wear a solemn expression, even when he smiles he does not smile with his mouth, but his eyes.

So far as I can gather, his name was William Fysedale or Foysedale and he died in 1602.

He says he was a predecessor of yours, not in family, but in a subject you are investigating. Somehow he is singularly uncommunicative & when he does talk, he uses a lot of words and expressions I am unfamiliar with and can only guess the

For Kit, who loves a treasure hunt

Nothing in the world is hidden forever. The gold which has lain for centuries unsuspected in the ground, reveals itself one day on the surface... Look where we will, the inevitable law of revelation is one of the laws of nature: the lasting preservation of a secret is a miracle the world has never yet seen.

WILKIE COLLINS, *The Woman in White*, 1860

PROLOGUE

The Letter

5 May 1948. Martin Rivington Holmes, a 42-year-old curator at the London Museum, and the man in charge of the world-famous Treasure Trove known as the 'Cheapside Hoard', receives a handwritten letter. He slices it with a letter opener and reads, squinting behind his glasses because the communication is composed in a small, ornate hand. It's from a self-styled 'psychic medium'. They claim to have made contact with the 'ghost' of the original owner of the treasures, an Elizabethan jeweller, who has urgent information to share. Is it a prank? A scam? The 'ghost' jeweller is claiming to be the skilled craftsman who originally fashioned the exquisite treasures now in the Hoard, and he offers a warning. While developing his craft, driven only by scholarly curiosity, he strayed across the pages of ancient learning found inside prohibited manuscripts, and began studying the 'black arts'. Putting theory into practice, he designed and made some exquisite trinkets to bring good luck, placing ancient gemstones into new settings. After that benign success, he was persuaded, by men seeking political advantage, to create other pieces to bring about *bad* luck. These too were a success, regrettably. He buried them in a rush in a Cheapside cellar, mixed with the good ones, on the run from his enemies, with no time to label one from the other. These treasures will

bring harm on their owners. He's been haunting these pieces ever since. Lives are at stake if they fall into the wrong hands.

London is getting its act together after the war and preparing to host the Olympics. It's now time for sleeves-rolled-up pragmatism and professionalism, not fanciful nonsense like this. Martin Holmes the curator should probably throw the letter in the bin, but he can't. The treasures have languished in storage during the war. They are currently being unpacked and many pieces are unaccounted for. His thoughts turn to where the lost pieces might be. Despite himself, he starts to wonder if there are decorative objects at large carrying destructive powers.

That's the thing about ancient treasures. They have obvious material and financial value. The glittering prize. But their hold on us goes far deeper. We invest them with magical qualities, and they brim with otherworldly promise, no matter how rational we consider ourselves to be. They play on the imagination, making rich and poor alike do out-of-character things to get their hands on them.

Treasure. There's a delightful frisson even saying the word, cold on the teeth then the burn, like a slug of rum, summoning images of pirates, maps, caves and locked wooden chests, quests for the legendary gold of 'El Dorado'. It's no surprise Freud and Jung seized on treasure-hunting as a useful metaphor, Freud likening the psychoanalyst to an archaeologist, working on hands and knees, scraping away the layers of the psyche, going back in time to the distant past. Jung talks about the rewards of excavating buried aspects of yourself as claiming 'the treasure hard to attain'. 'Only one who has risked the fight with the dragon and is not overcome by it,' he says, 'wins the hoard.'[1]

Ancient treasures speak to what we lack. For the nostalgic late-Edwardian bourgeoisie, antiquities trailed the seductive perfume of a noble ancestry. Survival alone made them beautiful, representing a mastery over time and an escape from modern-day dysfunction. As cracks appeared in the social order just before the First World War, ancient gems and jewels referenced a grand and distant past, making their purchasers the direct descendants of splendid civilisations and all-powerful empires. Their good breeding and resilience over the centuries compensated a little for the 'premature ageing of modernity'.[2] They sat remote, above the fray, as advanced modern society swirled beneath, serving no practical role whatsoever, but this was key to their appeal. '[O]ur technological civilisation has rejected the wisdom of the old,' observed the philosopher Jean Baudrillard, 'but it bows down before the solidity of old things, whose unique value is sealed and certain.' 'The older the object, the closer it brings us to an earlier age, to divinity, to nature, to primitive knowledge.' The well-to-do hunted antiquities like these through the auction houses, fetishising them for their myths and mystique, keeping them in glass cases.

When the Cheapside treasures were pulled out of the ground during the shaky summer of 1912, they appealed instantly to the crowds. These ancient jewels and gemstones in their Tudor and Stuart settings had the virtue of what Baudrillard called 'minimal function and maximal meaning', making them instantly covetable, answering the bourgeois yearning for an epic origin story.

This mystique had not been lost on previous generations, of course. The Stuart poet philosopher Margaret Cavendish,

Duchess of Newcastle-upon-Tyne, mused on the power of a single piece of jewellery to hold an audience enraptured:

> What several worlds might in an earring be:
> For, millions of those atoms may be in
> The head of one small, little, single pin.
> And if thus small, then ladies may well wear
> A world of worlds, as pendents [sic].[3]

Even in the century of Isaac Newton, an earring could seem magically to contain everything of life, within multiple universes, inside its stone.

CHAPTER I

The Cellar
18 June 1912

Tuesday 18 June 1912 was a warm working day in the square mile of the City. London was in the midst of a building boom not seen since the sweep of redevelopment following the Great Fire in 1666. The dust on Cheapside mingled with the noise of the motorised 'B-type' double-decker omnibuses rattling past, having chased out the last horse-drawn versions the previous year. Electricity cables criss-crossed the street now, but some men still pulled handcarts and there were a few nags negotiating the chuntering vehicles and belching exhausts in the absence of any traffic regulations. Wrought-iron gas streetlamps protruded from the shops, testifying that life would continue in a dim gaseous glow when the sun set.

Cheapside was the main route from St Paul's cathedral to the East End, as it had been for a great many generations, and a hub of commerce, but the buildings had seen better days. Hulking four- and five-storey warehouses and offices of blackened brick lined each side of the street and loomed over it, with shops peddling wares below. Large signs advertised on the facades in carved and gilded letters, signalling an increasingly desperate diversification of products and services and multiple occupancy on every floor: *Blick Typewriters*, *Boots Cash Chemists*, *Percy Truscott*

& Co. Printers, Reliance Ltd Window Cleaning & Plate Glass Insurance, The Emporium Pawnbrokers & Unredeemed Pledges, Wool & Taylor Cash and Credit as Advertised, True Form Boot Company, John Biden Engraver & Printer; there was even room for a *Surgeon Dentist* on Cheapside. The soot-grimed windows on the higher floors displayed a graphic cacophony of temporary hand-painted signs advertising *Offices To Let*. The name Cheapside came originally from the Old English 'chepe', 'cepe' or 'cheop', meaning a marketplace or to barter, rather than low cost, but the hustlers selling goods at high volume for knockdown prices embraced its more modern connotation.

An uneasy atmosphere moved through London that summer. Men in bowler hats on the open-air top decks of the new omnibuses carried the *Titanic* disaster fresh in their minds. Scott's British Antarctic Expedition had just reached the geographic South Pole to find the Norwegians had got there first; Scott died on the return journey. *Hansard* recorded heated questions in Parliament that week over Home Rule in Ireland. Women wearing wide-brimmed hats and pinched expressions chased bargains up and down the thoroughfare, darting between motor vehicles and the horses, outrun by the accelerating cost of the basics. This was London just before the First World War, although of course no one knew the devastating conflict was just around the corner or that the British Empire was nearing its peak, enjoying a last hurrah before a steady decline. Most still knew their place and wore a top hat, a bowler or a flat cap accordingly but, to anyone paying attention, this was a society already in transition.

A defiant economic and architectural confidence whipped round the City, the shouts, crashes and clangs of active

construction in all directions. This Tuesday morning, a team of workmen congregated outside the building at 30–34 Cheapside at the western end of the street, a block down from St Paul's Churchyard. The building sat on the corner plot where Friday Street, one of the narrow medieval feeder alleys, came up from the south side, along the building's eastern edge, to meet the main road. Like its neighbours, this brick building stood four stories high and presented a rambling strip of shop fronts onto Cheapside and, above, a multitude of offices and empty-warehouse square footage for rent. The men assembling in its shadow wore working clothes – thick jackets and high-buttoned waistcoats, collarless shirts and neckerchiefs, trousers held up with braces, flat caps and solid boots – casual labourers or 'navvies' arriving for work.

There were, naturally enough, two corners at the junction between Cheapside and Friday Street, one to the east, one to the west. The building on the eastern corner of the junction, across the road from where the men stood, drew the sightseers, because it still bore a heraldic badge in stone, featuring a picture of a chained swan with a duke's crown around its neck, that had been salvaged after the Great Fire and stuck back on the front of the replacement building. Photographers set up to snap the eastern corner and so it was destined, in years to come, to be mistaken for the site of one of the greatest archaeological discoveries of all time. But it was the building on the western corner, the one that nobody ever thought to photograph, the one always out of frame, that concealed a great secret sixteen feet below the street. It was in front of this corner the men gathered to start work.

This section of Cheapside had been rebuilt many times over the centuries. Once known as Goldsmiths' Row, it had for centuries been a high-end shop window for the City's jewellers selling luxury commodities. There had been a couple of old taverns on the site too, the Wheatsheaf, and the Black Moor's Head. There was little trace of any of that now, the row having burned down during the Fire of London, and these seventeenth- and eighteenth-century buildings were the replacement. Now they too had had their day, and the men were to reconfigure them for modern business premises.

The men received the tools of their trade from the foreman: pickaxes and shovels. This was an extensive excavation job. They had come from work on some of the country's major civic projects. The navvies – 'navigators' or 'navigational engineers' – were employed to build the railways, tunnels, canals, reservoirs and other infrastructure, but had found plenty of work in London in recent years as great swathes of the centre were knocked down and rebuilt: County Hall, the War Office, Kingsway, and Regent's Street. They were typically single men, many, but by no means all, from Ireland, who led hand-to-mouth, itinerant lives. Even the few who brought families with them were constantly on the move, sleeping rough or in doss houses or refuges, trying to stay out of the workhouses. The men could earn better rates than agricultural workers, but were frequently paid in beer rather than cash for their back-breaking efforts; they had a reputation for fighting and, in many cases, a good reason to stay under-the-radar.

Hand-inked architectural drawings by 'T.H. Smith of Basinghall Street' outlined the ambitious plans for the contractor,

showing the front elevation of the building onto 30–34 Cheapside, and the side elevation onto 1–4 Friday Street, colour-coded in pastel pink and blue watercolour, scaled eight feet to an inch.

These plans were the blueprint for transforming the nondescript warehouses and offices into a grand design, in a classic Edwardian style, with tiers of splendid box-bay windows framed by neoclassical columns and pediments, stacked floor over floor, separated by layers of decorative stone friezes, and a spine of curved bays at the corner, rising like a turret to a dome at the top. Stone letters across the second floor were to announce the new name of the building: WAKEFIELD HOUSE. The plans also accommodated a National and Provincial Bank premises on the ground floor, with large plate-glass windows and white-glazed-brick trim.

Historically, the building had belonged to the Worshipful Company of Goldsmiths, the professional association of the jewellers who once occupied the area, but Leopold Rosenthal, acting for the City of London, had ordered that the building be gutted and remodelled to accommodate the business operations of Sir Charles Cheers Wakefield, and his patented 'Castrol' vehicle lubricants. Wakefield's empire had expanded rapidly in tandem with the revolution in motorised automobiles and aeroplanes now leaving the old world behind in its exhaust. His secret sauce to help the Fast Set go faster was to add a dash of castor oil, making the lubricant the perfect consistency for new high-performance motors and making him wildly rich. Wakefield was rising to be the most important man in the City of London, holding every honour and position at one point or another, including Sheriff, and would soon be Lord Mayor. As well as

being a high-ranking Freemason and educational philanthropist, he had helped the Guildhall, the City's administrative heart, to build its own gallery. No expense was to be spared.

The men who arrived for work on 18 June 1912 were not formally contracted, so there is no way to know how many there were of them or their names. The building firm Trollope & Colls ran similar-scale developments of the day, however, including the department store Debenhams & Co., and the Royal Insurance Company, built on nearby Lombard Street in 1912, and the surviving account books and ledgers tally those recruited by sub-contractors as 'Excavator', 'Laborer' and 'General Laborer', for 'Digging and carting away for amount of contract', totting up cost of the manpower along with any materials needed at the end of the week for each section. These men worked alongside large numbers of other tradesmen, including bricklayers, masons, carpenters, slaters, joiners, plasterers, founders, smiths, hot water and gas and electric light fitters, plumbers, zincworkers, painters and glazers.[1]

The architect's drawings featured cut-away sections of the internal workings of the building, showing the old walls and floor levels and locations of the new ones. One cut-away showed the design for the deepest level of the refit, the basement floor, which was to be lowered several feet across the entire site, as well as the location of the new footings, and the pits for the lift shafts. This drawing also pointed out the location of an 'original vault' located three steps down from the current floor level. There was no 'X marks the spot' on the plan, but there should have been.

A small army of men would be needed over several weeks to dig out the basement floor to the required new deeper level.

The men here this Tuesday were one of a relay of teams put to work on the complex task and each of them would be expected to excavate several tonnes of London clay per day.

The detail assigned to dig out the deepest level of Wakefield House, perhaps five or six men, took their picks, shovels and barrows and entered the building, descending to the basement and then the three additional stairs to the 'old vault', a brick-lined cellar at the rear of the building, hidden behind Cheapside, backing on to a little enclosed yard known as Fountain Court.

These men found a hot and airless space to set up in and could work only by the low light of paraffin oil lamps. This cellar belonged to the old tavern, the Black Moor's Head, but no one in London remembered that name. They took their picks to the floor, a chalk surface, unusual given London was built on clay, imported to line the cellar floor at some point. They cut the tools into it. The vault hadn't been touched for a very long time. On the first day of an excavation job they usually had to work through the rubbish dating back to when the Georges had been on the throne, getting it under their fingernails, but today they were starting work at a lower level.

The new City constructions springing up in the building boom were higher and heavier and required deeper foundations than ever before, penetrating the clay right down to the Roman level for the first time. Some of the men had come from construction sites putting up blocks of lofty new 'Mansion flats' in place of houses, meeting demand for *pieds-à-terre* in desirable parts of town for types who would previously have turned their noses up at a flat. They were high density but luxe, usually with a lift. E.M. Forster's novel *Howards End*, written just a couple of years

earlier, articulated widespread anxiety about the encroaching buildings and gave the side-eye to the idea of these edifices as 'progress'. The protagonists were the intellectual Schlegel sisters, due to lose their townhouse at '6 Wickham Place' when the lease expired. It was to be pulled down and replaced by one of these blocks of Mansion flats, described in the novel as 'expensive, with cavernous entrance halls, full of concierges and palms… as humanity piled itself higher and higher on the precious soil of London'. The first wave of development was already casting a shadow into the Schlegels' elegant drawing room. 'Wickham Place' was a fictional address but was presumably meant to be Marylebone, where Forster grew up, his childhood home demolished to make way for Marylebone station.

The men down in the old vault had no stake in the property market but many will have worked under Marylebone and had practice breaking through virgin Stuart and Tudor layers, and beyond, to make holes deep enough for the lift pits with their iron counterweights, finding each stratum undisturbed for centuries.

They hacked on down into the familiar stiff blue-grey London clay beneath, the perfect firm support for the new footings of the City, soon perspiring heavily, their heavy boots scratching. Dust and sweat stung their eyes and noses and caught in their mouths as they chopped the chalk-and-clay mixture and shovelled it onto barrows to be pushed up temporary wooden ramps to the street. They were hardened to long days of work in the semi-dark, only occasionally catching the white of an eye, or exchanging a brief word or joke. With a daily quota to meet they did not let up on the blinding, dehydrating effort. Once

out, they would apply themselves just as diligently to downing beer in superhuman quantities to make up the fluids.

On the clock, they necessarily measured history by the barrowful but kept half an eye out for items of any value.

The digs were by hand, each portion of earth sifted, so finds could be easily spotted, and carefully removed, the land still innocent of mechanised diggers that would smash efficiently, indiscriminately through everything in their way, with the spoil, including any valuables, destined for a quiet life dumped in the marshes at Erith.

As it expands, wet clay will envelop whatever is left in it, and then shrinks as it dries, vacuum packing all in heavy, oxygenless ground. Sometimes one of the men would come across a piece of crockery packed into a void within an old rubbish pile or a well, or an occasional jug, hundreds of years old, startlingly intact, as if irritably tossed out yesterday for the hairline crack that rendered it useless to a cook. Each layer revealed the previous fashion in roof tiles, or the preferred stones for roads, or pot decorations, and a distinctive smell, mustier as you got deeper down and closer to the water table, and the rubbish dumps got older. On the way down, the men would pocket anything that might be worth a second look.

They continued stabbing their shovels and picks into the floor, loading up the barrows. There were many to fill and a long way down to go before knocking off.

Then, at an unspecified hour, one of the workmen cut his pick into ground with an unusual consistency. With its next bite, the metal point hit something hard. This jarring surprise demanded attention, and then a moment's pause to check. It was

the same shudder felt by the field worker, with a new motorised plough in Mildenhall, who, digging down twelve inches to sow beets, heard the wooden peg safety-catch holding the plough to the tractor snap.[2]

The low paraffin lamp-light made it difficult to see what the pick had struck. The workman in question managed to identify splinters of wood as the byproduct of his effort. He hacked away at more of the floor, turning up more splinters. On inspection, the wood appeared to be the rotten timber of an old box.

Lifting what was left of the box, solid objects, a mixture of shapes, mostly small in size – what appears to be jewellery – comes tumbling out. Many other pieces are loose inside the soil filling the box and threaten to fall out through its decayed sides. The men working either side of him notice his rhythm break and his demeanour change, and offer assistance (or perhaps unwanted attention). Another man will remember the container as a bucket rather than a box, containing what he initially thinks is a collection of beads.[3] They chop more and more treasures free of the chalky clay.

It's a confused scene, hands and the objects they hold caked in the same clay, with some bright corners sticking out, and stray loops of gold chains separated from the remains of the container; flashes of metal and colour in the cloying dirt, the men gasping up the last of the fetid air with quickened breaths: not much to go around. No one is in charge of the drama unfolding under the street. As the men try to understand what they have unearthed, it is impossible to have a clear sense who has what, and what might still be on, or even in, the floor. More lumps of clay and splinters of wood fall away from more treasures as they remove them.

The box or bucket – another of the witnesses will claim it was fitted with trays – contains about 150 pieces of jewellery (others will put higher figures on it: 250, 340, right up to the breathless estimate of nearly 500 pieces). These men will remain anonymous, but they are key players – one of them is the *finder*, tied forever to a rare archaeological marker in time, a historical waypoint, linking the past to the future.

Here, in the bowels of the City, is treasure, hidden undisturbed for almost 300 years. Like the Anglo-Saxon burial ship found at Sutton Hoo in Suffolk, or the contents of Tutankhamun's tomb, the 'Cheapside Hoard' will take its place as the most significant find of its kind in the twentieth century. The treasure will be feted as the greatest collection of Tudor and Stuart gems and jewels ever uncovered and an icon of a golden age of archaeology.

The men scrabble for a hexagonal pocket watch with a faceted fold-down lid and lift it out of its cellar-floor burial, still hiding its true green brilliance behind a thick coating of clay and dust. They also deliver from the earth a pendant in the form of a luxuriant 'bunch of grapes', the ripe purple of the amethysts matted by the grey dirt. Trapped inside a clod is a perfume bottle – pomander – on a gold chain, its few exposed corners encrusted with brightly coloured gems, as though a little girl has excitedly gummed them on for a costume party. And a curvaceous salamander, streaked with clay but set with emeralds and diamonds that manage to wink through the dust.

The men have found, and opened, a treasure chest. It's the stuff of boyhood dreams, of bedtime stories and myths, of *King Solomon's Mines*, of *Treasure Island*. Heart-halting possibilities open up to them. They are the pirates in Robert Louis Stevenson's

ripping adventure whose 'eyes burned in their heads…their whole soul…bound up in that fortune, that whole lifetime of extravagance and pleasure, that lay waiting there for each of them.'[4] Or Jim Hawkins, who 'in a far corner, only duskily flickered over by the blaze…beheld great heaps of coins and quadrilaterals built of bars of gold.' They are H. Rider Haggard's adventurer Allan Quatermain, the British-Zulu War veteran and his aristocratic companions, finding Solomon's fabled treasure deep inside a rock somewhere in the unexplored African interior, in a chamber 'not more than ten feet square', with an excitement so intense it made them 'tremble and shake'. '[A] silvery sheen which dazzled us', opening 'a score of wooden boxes' (much like the boxes in the Cheapside cellar), 'the lid rendered rotten by time even in that dry place', filled with 'gold pieces in a shape none of us had seen before, and with what looked like Hebrew characters stamped upon them'. Do they congratulate each other, like Quatermain and his chum?

'We are the richest men in the whole world,' I said, 'Monte Christo was a fool to us.'

'We shall flood the markets with diamonds,' said Good.[5]

What is the treasure worth and what does it mean? The men are faced with a dilemma that will not wait patiently for a decision. Gems and jewels are hard currency, and stones can line an empty pocket and protect you from life's storms. Ancient gemstones are portable wealth: carried on your person, sewn into a jacket lining to smuggle a leverageable asset across a border, traded, pawned, or hidden in a pocket or under floorboards for a rainy day or as an insurance policy, or – in extremis – to buy a life. Jewellery, for people with no access to banks, is the primary

means of moving money through the world and down through generations. The short window to pocket something to sell, or for a mother or sweetheart, will shortly close, and they have to act fast and decide if they can get away with it.

Some of the items the men hold on to are *not* the most obviously valuable. They pick out and dust off palmfuls of unshowy semi-precious gemstones, set into simple rings. Beneath the soil these tiny discs of earthy browns, reds and oranges, like medicinal boiled sweets, are engraved with scenes from classical myth. There are scores of these, loose without any setting. The men prise out other modest pieces, featuring pictures of Christian icons, like a simple finger ring sporting a picture of good old St George. A lot of what they have found is not sparkly or spectacular, but these pieces have been carefully buried too. The modern Edwardian workmen understand the promises made by ten-a-penny gems like these. They offer alternative kinds of insurance, dealing in the currency of superstition.

The excitement of a great treasure 'reveal', whether in history or fiction, is all too often overtaken by feelings of dread, and doubts and fears stir in the minds of the labourers under Cheapside, not least over the very real risk of arrest and imprisonment if they take anything off site without telling their employers. As Quatermain and his men entered King Solomon's treasure chamber, they noticed 'a feeling of sacrilege – breaking the seals that fastened them' and while they were crowing over their splendid fortune their malevolent old guide triggered a mechanism, dropping a stone portcullis across the only exit and trapping them inside, without food or water, to face certain death. She mocks them: 'There are the white stones that ye love,

white men, as many as ye will, take them, run them through your fingers, *eat* of them, he! he!, *drink* of them ha! ha!'

The discovery of the stash in *Treasure Island* is likewise tainted by foreboding. Just as Long John Silver and his fellow buccaneers are about to claim their reward, they hear their dead captain, in a thin, high trembling voice, singing 'Fifteen men on the dead man's chest, yo-ho-ho, and a bottle of rum!' then, faces draining of colour, catch his last words – 'Fetch aft the rum, Darby.' It's a trick by their rivals, exploiting a pirate's fear of vengeful spirits, but they believe they have awakened Captain Flint's ghost and, overcome by panic and dread, begin to pray.[6]

The men under Cheapside will have wanted out of the hot underground vault, for some fresh air if nothing else, but there were hard choices to game out. The record doesn't show how the men decided their next steps, if they hissed and whispered plans together, if they argued, and if so how bitterly, whether it came to threats or blows (and they were famous for bloody vicious brawls, shattered jaws and black eyes) or if someone had decided it was every man for himself and split before the others realised, but, by the end of the day, at least two factions formed, and one took charge of the majority of the find.

The two men carrying the bulk of the treasures hid the pregnant lumps of clay and the loose gems and jewels in any bags and handkerchiefs available to them, slung them over their shoulders, or tucked them inside jackets and, when it was time to knock off, lugged them up the stairs, looking out to avoid the foreman. Successful, they then continued nonchalantly out of the building site, into the dirty midsummer light, the sky laced

with smoke, gas and horseshit, rattled by the motorised buses. They did their best to behave as they would on an ordinary day after many hours grafting: returned their tools for the day, complained of thirst and of the need for beer, pulled on their flat caps and walked slowly away, whistling.

They knew who they would take them to.

These men would be common thieves if they were intercepted carrying what was, ostensibly, stolen property. They would be dragged straight through the courthouse to gaol. The police would not care to know the details about their contact in the trade.

They set off for Wandsworth, an industrial suburb to the south-west of town, nearly seven miles from Cheapside as the crow flies. Seven miles would take too long to walk. The number 22 omnibus could take them from Bank station to Putney Bridge via Piccadilly Circus, skirting Hyde Park, although omnibuses, as a monopoly private company, were not obliged to subsidise workmen's fares as the trams and the underground were. The City and South London Railway offered a route underground from the station at King William Street, just north of London Bridge, all the way to Clapham Common. This option would mean sharing 'padded cells', small carriages necessitated by the depth of the tunnel, but the tickets were cheap and their heavy and precious cargo would be out of the daylight. They must draw as little attention as possible from the crowds that would contain law enforcers on the beat.

One or two of the workmen set off west, towards Great Portland Street, near Oxford Circus, with a small bag of clay-smeared treasures. As these men navigated the cobbled streets of

Covent Garden with their swag secreted under their jackets, they passed the West End theatres, where crowds of late Edwardians were assembling to watch spectacular Shakespearean productions, stories of kingship, church and state, play out with new-fangled electrical special effects. Outside other theatres audiences queued to see their own drawing-room dilemmas under the spotlights. The sun did not set on the empire and, for the well-off, over a decade of peace at home had allowed more time and money for this golden age of theatre. These labourers didn't go to the theatre, they were on their way to make a sale and had to be sure not to give anyone a cause to search them.

Making their way to Great Portland Street with their treasures, the workmen could not avoid signs of a darker, grubbier, bloodier 1912 behind the scenes.[7] An increased police presence evidenced the City's law and order crisis. The West End tailors' premises had reopened for business but it had been a year broken up by unionised strikes and violent protests against cripplingly low wages. These high-end outfitters providing the highest class of work to the well-to-do had won better rates and conditions only once their Jewish counterparts, doing piecework in the Whitechapel sweatshops, had joined the strike, but it had been an acrimonious process. The solidarity from the East Enders had been hard-won, following accusations they were undercutting and undermining the action. The numerous officers on the street corners remained hypervigilant, sensing the peace wouldn't hold. A country rich on the spoils of the colonies was ceding economic supremacy to America and Germany on the world stage. The poor, promised a share of the spoils by the new Liberal government, had grown tired of waiting.

Anxious proprietors guarded Liberty & Co. and the other high-profile West End shops against another threat. On 1 March 150 women had smashed windows simultaneously in a coordinated protest at the government's refusal to include women in the Reform Bill. One of their hammers had been inscribed with the line 'Better broken windows than broken promises'. Firms were working together to counter the ongoing attacks and prevent further loss of trade and damage to their brand-new electric lighting systems. Harrod's Stores, Harvey Nichols & Co. on Knightsbridge, and the shop managers along King's Road were likewise manning the entrances, on high alert.

The two men with the lion's share of the Cheapside treasure reached Clapham Common. They dragged with them bags of heavy contraband, more humped over their shoulder, an operation harder to conceal above ground. As they walked the last mile towards West Hill, they passed the lit-up arched doorways of several new cinemas: there were now twenty-seven screens in Wandsworth alone, offering escape from the City and its tensions. The Biograph was showing *Life on the Oxo Cattle Farms* and a film about the *Titanic*, a benefit for the victims and survivors of the disaster. *With our British King and Queen Through India* was screening at the Globe on Lavender Hill, a documentary on national release presenting the celebrations of the recent Coronation, and the ceremony proclaiming George V and Queen Consort Mary of Teck as the Emperor and Empress of India at the event known as 'the Delhi Durbar'. This last one had proved popular with audiences due to the vivid hues of *Kinemacolor*. In it, the king and queen performed their dominion over the empire, in a visual feast of iconography

to match the all-powerful Tudors, enthroned on a high platform under a canopy, King George V wearing ermine robes and the Imperial Crown of India. Next to him Queen Mary wore the 'Delhi Durbar' tiara, commissioned specially for the event, on top of her tall, furrowed coiffure. The headpiece was mounted with 'the Cambridge Emeralds' – family jewels retrieved from her brother's mistress, Nellie. These ten emerald drops were set in little points around the top of the tiara's dizzying scaffolding, above diamond festoons and more drops of platinum. Underneath the crown, Mary brought a solidness to her expression, a defiantly huffy upper lip that she bequeathed to her granddaughter, Elizabeth II. This was a nation in thrall to the romance and nostalgia of the fabulous theatre of empire. The men venturing through South London that June afternoon had their own treasures stuffed into bags and handkerchiefs, still covered in the matter of the underground City; they pressed on to their destination.

The village of Wandsworth was a landscape dominated by the gasworks. Thanks to high demand, the Wandsworth Gas Company had expanded all along the river frontage on the Wandle. Wandsworth gas was now the cheapest in London, the coal arriving at the wharves where it was heated, releasing gas then stored in large tanks. A national coal strike had just finished, a minimum wage won for the miners, and production restarted. Next to the gasworks, the centuries-old Ram brewery and a vast corn mill were also water-hungry and well positioned on the river. Other 'noxious trades' hazed the air with punchy smells and glass-smudging emissions, producing glue, soap and candles, and they had driven the rich away. The Huguenot

burial ground was the only remaining evidence of the French Protestant refugees who were once in Wandsworth, skilled in hat and dressmaking, working in the textile mills, the last trace of their work a local reputation for great hats.

As it was nearly six in the evening, the two workmen were swept up in thickening commuter crowds trudging back up West Hill. They had traced the route many times or they might have missed the small and crowded window, packed inside a busy run including a greengrocer, a tobacconist, a dyer and a portrait photographer. George Fabian Lawrence's establishment occupied the ground floor of a dreary Victorian building in dirty-cream London stock brick; above it, a two-storey flat, the same arrangement as all the neighbours in the terrace, the casement sash windows stained with factory air. Looking into the display at 7 West Hill, behind the glass, they were faced with what the intrepid newspaper columnist H.V. Morton, called 'the strangest shop in London'.

Dickens would have loved it; an *Old Curiosity Shop*. Inside the top right window sat a sign on a card in a dashing *art-nouveau* font of asymmetric lines, dots and organic swoops, which read: '– Lawrence – Antiquary'. Calling yourself an 'antiquary' was old-fashioned by 1912.

The shop offered a diversion from the day's reality – a spectacle more immersive than any cinema screen. Fixed onto a bracket over the door, by way of a sign, stood an ancient weather-beaten Ka figure from an Egyptian tomb, worn and split by London wind and rain which had taken the paint off years ago. It was from another age altogether. The *Ka* – a hieroglyph of two upraised arms at either end of a flat base, an open 'U'

shape – was the life force, or spiritual double, of a person, and could reside in a statue after death. An Ancient Egyptian would once have placed the figure above a tomb as a guardian to ward off the spirits of evil but now, improbably, it was here, in a dusty and suburban business district of South London, protecting a little shop. Everything it surveyed was positively *nouveau*.

The display blocked a clear view of the inside of the shop. The window was packed full of stock, neatly arranged, with price tags written in longhand, all ridiculously cheap, ranging in age from neolithic flints to Roman pots and Elizabethan shoes found in the clay of London, along with pretty things which girls had worn in their ears when the Stuarts were on the throne. The owner evidently had little commercial sense. He was beckoning the amateur archaeologist, school children or their teachers, his core clientele. Anyone who, for half an hour, wanted to leave 1912 for another century, even another millennium.

The past was for sale here. Countless noses had pressed against this glass and steamed up the untidy cross-section of the history of London, and the world. An astounding jumble filled the shoeboxes and glass cabinets: Ancient Egyptian bowls lay next to Tudor pots containing Saxon brooches; a selection of Ancient Egyptian beads and amulets, Queen Anne footwear for all ages, clay lamps, the stony face of a Roman general; an Egyptian mummy eyeballed you from the recess at the back. There were leather sandals that had charged the cobblestones of London when Boudicca was on the warpath, a mummy's shrunken black hand – like a bird's claw. The journalist H.V. Morton, a regular visitor to the shop, recalled it was as if some 'mighty gale of time' had been blowing into the little room in

Wandsworth: 'all sorts of litter; gusts from Nineveh, Babylon, Thebes, the Aegean, Cyprus, Crete, Rome and Byzantium.' When he first clapped eyes on the place, 'it seemed', he said, finding an even more tempestuous analogy, 'a great tidal wave, beginning when Ancient Egypt was in its prime, passing over the ruins of Ancient Greece and Rome and ending in the reign of the third George…washed up into this shop the bits and pieces of centuries.'[8]

There was, as all visitors had to agree, no other shop in London like it.[9]

The men had come to the man they called 'Stony Jack', a what-it-says-on-the-tin moniker for someone who gives good money for any old stone, brick end or scrap of iron. No visitor to 'Stony Jack' went away empty-handed. They trusted him, unlike his rival 'Old Sixpenny' (read: tightwad) at the Guildhall. If a find turned out to be more valuable than he originally thought, Stony Jack would track you down and make up the difference.[10, 11] He would shout you a drink or offer you a few coins even if it wasn't good enough for the museums.

The navvies had brought him things before, but today they had a shock to deliver. They pushed open the shop door, triggering the bell, and stepped into the gothic fog that greeted all visitors, thanks to the proprietor's chronic tobacco habit, looking for the source of the smoke.

CHAPTER II

The Jewels Make an Entrance
6 p.m., 18 June 1912

The only first-hand account we have of the arrival of the jewels at George Fabian Lawrence's premises, apart from Lawrence's own, is that of the most famous (and notorious) journalist and travel writer of his era, H.V. Morton. Morton never let the truth ruin a good story. But even making allowances for baroque levels of poetic licence, his is an account of the event from a person who was close to it, and it went something like this:

'I was with him',[1] writes Morton, when 'the most sensational event took place' one night 'a few years before the war'. Workmen, two navvies, entered George Fabian Lawrence's shop 'with bulging pockets and something wrapped in a spotted handkerchief'.[2]

The source of the cigar smoke, G.F. Lawrence, fifty-one years old, steps forward from behind his shop counter, with the offending stub clamped between his teeth. 'Whenever I hear people say that Dickens overdrew and exaggerated his characters', Morton mused, 'I think of Lawrence. He might have been created by Dickens.'

He's dressed in the proper uniform of a respectable man of his age, sporting a sober blue worsted wool suit with a stiff white collar and a black tie, peering behind steel spectacles with

oiled-down grey hair and a neat moustache. 'Small and square', he has the appearance of a 'genial frog', an ordinariness taken to the point of absurdity. He's the 'essence of dull respectability', a museum man through and through, but pointed cheekbones, an enigmatic smile and 'the pink complexion of an infant' give his face a friendly, elfin humour. Wincing from the powerful, slender cheroot always in the side of his mouth, he is prone to paroxysms of coughing. Morton remembered him as 'victimised by asthma' and addicted to 'those rancid little squibs',[3] which do not help (neither, clearly, does having a tobacconist as a next-door neighbour).[4]

He's been waiting for years with a 'Job-like patience'[5] Morton admired, always with one eye to the door.

He won't have been expecting a visit from one of his workman recruits on a Tuesday. He has been at his desk at the London Museum in Kensington Palace, where he holds a senior position as inspector of excavations. The navvies come on Saturdays as a rule, when they can get their larger discoveries off the building sites and down to Wandsworth without being spotted by the supervisor, like Sherlock Holmes's 'Baker Street Irregulars', the quick-witted street gang employed to gather facts undercover and report back to base. It must be something special for the men to risk it on a weekday.

Lawrence is in acquisitions for the great London museums, buying showstopper pieces to build their world-class collections, and a private dealer in antiquities on the side. He has been a presence on London's building sites for years, networking like a 'latter-day Fagin'[6] with his pockets full of half-crowns, introducing himself to the workmen, hoping to make them his agents

underground and persuade them to bring him their best stuff. Any men interested in a side-hustle have been given rudimentary instruction in what to look out for, taking a few lessons in how to recognise, for example, fancy Roman tableware by its surface: a glossy red clay-slip glaze, impressed with designs. A glossy white tin glaze might be seventeenth or eighteenth-century, and a bright green colour likely medieval. Examples of this 'Samian ware'[7] sit on the counter, Lawrence's painstakingly slow jigsaw puzzles, half-finished and waiting for the workmen to arrive with new pieces. His proudest acquisition of the year so far is a Roman wine jug, found in the mud at Southwark, inscribed with the earliest mention of the name of London: *Londini Ad Fanum Isidis*, presumably a votive offering at the London temple of Isis. He has London's material in his careful hands all day long. It's clear from their demeanour the men have brought something special today and their futures hang in the balance, awaiting his opinion.

The navvies hand over a 'heavy mass of clay', as Morton remembered it, claiming to have found it 'beneath a building in Cheapside'. It resembles an 'iron football', and they say there is 'a lot more of it'.[8]

Lawrence's visitor and our witness, Henry Vollam Morton, is a tall young man with a small black dab of a moustache and a striped tie over the shoulder, and he joins Lawrence to investigate the delivery. This nineteen-year-old newspaper journalist will become Britain's most popular travel writer between the wars. He has a shrewd-yet-amused take on the world; a long face and inquisitive brows raised under his Panama hat, reminiscent of Peter Sellers as Inspector Clouseau. In eleven years he will be at the opening of Tutankhamun's tomb in Egypt, reporting

the great reveal for the *Express* and audaciously bypassing *The Times*'s exclusive rights to claim his scoop.

The handkerchief 'spilt on the floor, many great lumps of caked earth. "We've struck a toyshop, I think, guvnor!"' says one of the navvies as he indicates 'various bright streaks in the earth'.[9] Sticking in the clay are 'gleams of gold'.[10]

According to Morton, he and Lawrence rush upstairs to the bathroom in the family living quarters above the shop, the Lawrence family home of nearly twenty years, and turn the water onto the clay. Out fall pearl earrings and pendants and all kinds of 'crumpled jewellery'. To their astonishment they see 'tangled gold chains of Tudor design, engraved stones of the Stuart era; cameos, carbuncles, rings and amethysts cut in many a delicate shape fall from the moist soil'.[11] 'Imagine how I took that clay and washed it!' Lawrence recalled.[12]

Morton observes Lawrence's delight, rinsing off the treasures one after another, their details emerging, wet facets catching the light of the gas jet releasing their colours, 'his kind lovable face…wreathed in smiles'.[13] He puffs and swells out his cheeks, a habit when concentrating, recognising the quality of the pieces at once. Nothing will ever be the same for him. He has long believed in treasure hidden from the Great Fire of London under the City (every schoolboy knows how Samuel Pepys buried his wine and cheese that fateful day) but Lawrence has never let go of his hunch there was more than just a high-end picnic stashed away down there.

Lawrence and Morton's is an unlikely friendship, but it has lasted. Lawrence's marketing strategy of sending catalogues of his shop's stock to provincial colleges was catnip to

history-obsessed schoolboy Morton, who enjoyed catching a train down to London from the Midlands to spend Saturday afternoons rummaging. Like Lawrence, Morton has recently been promoted, in his case to assistant editor on the *Birmingham Express and Gazette*. He's a cub of boundless appetite and ambition. It's charm with a sell-by date, however, masking something that in time will curdle his reputation. It really is an extraordinary stroke of luck if he indeed is there to see the jewels arrive.

Lawrence's wife, Florence Emily, follows the commotion into the bathroom. A tall woman, a little older at fifty-four, standing proud and unbreakable in her photographic portraits, with her hair swept up in a loose, high bun. She hates being downstairs in the shop – the stock gives her the creeps – but the excitement is now contagious. Their daughter Ethel May, known as 'May', twenty-six and confined to her wheelchair upstairs much of the time, manoeuvres to the bathroom, with or without the help of her parents to push, taking her place at the sink. She joins in with the work, enthusiastically washing the treasure – there's so much of it. No surviving photographs confirm May's appearance, but young women of her age and class at home in 1912 wear their long hair swept half up into a loose bun, as their mothers did, with high-necked blouses and long skirts. (She will own gloves, a wide-brimmed hat and an umbrella for outings, but these items are likely gathering dust on the coat stand as they are rarely needed.)

May soon takes the lead plucking objects from the lucky dip and washing them, assisted by her father. Some of the pieces are in an unfinished condition, many of the gems unset or with the cutting incomplete, pointing to this being the stock-in-trade of

a City jeweller, and not a private collection. There are special mentions for exquisite scent bottles and brooches, a close examination of an emerald pocket watch cut from a single stone in a display of breathtaking technical bravado, a cameo portrait of Elizabeth I, part of a Communion set in crystal and gold with lots of beautifully cut stones, which Lawrence guesses was a vessel from a monastery collection broken up by Henry VIII. Here is a selection of polished brown and yellow 'toadstones', prehistoric fish teeth polished into decorative pieces.

Lawrence is confident now in his first impression that the collection is for the most part sixteenth-century Elizabethan. There's admiration for enamelled gold chains (the 'enamel' made from a paste of ground glass, fired at an extremely high temperature); loose emeralds, pale sapphires, amethysts and diamonds, 'foiled' pendants probably for earrings, with a thin layer of metal foil placed on the back of the stone to catch in the candlelight, allowing the 'inner fires' to burn fiercely, and a variety of rings set with both precious and semi-precious stones, some ancient intaglio (where the image is engraved into the gem) inside a sixteenth- or seventeenth-century setting.

An antiquarian of Lawrence's experience knows to use only water for the washing of the treasures. There have been horror stories of amateurs getting it wrong. When, for example, a blackened signet ring that likely belonged to William Shakespeare was unearthed in a field in Stratford-upon-Avon back in 1819, the discoverer – Mrs Martin, a local labourer's wife – washed it in nitric acid. To the horror of the local historian who bought it, the precious patina had been lost, but the engraved initials 'W.S.' survived the assault. The letters were in reverse as it was a signet

ring for a wax seal, and between the letters was entwined a 'true lover's knot' of four loops, the one at the top in the shape of a heart. Antiquarians in Lawrence's network are still looking for a document belonging to the Bard fixed with a matching wax seal to prove he was indeed the 'W.S.' referred to on this ring and it didn't in fact belong to a 'Walter Symonds' or 'Wallace Smythson'. Here in the Lawrence family sink are any number of rings, bearing various insignias and other clues to the names and faces of their owners.

The washing continues, piece by piece. Within the hour, one of them pulls out another finger ring, splashes it with cold water, turns it in their hands, brushing off the clay, as per the system that's up and running, but finds it an unusual shape compared to others. They wipe the ring's large oblong stone clean, releasing the opalescent surface and revealing an image: it's a cameo (the image carved in relief, proud on the stone) presenting the figure of St George on his horse, leaning to spear a dragon beneath. It's plain compared to the rest of the Hoard, but bold in its simplicity, an icon of good defeating evil. St George has been a talisman of good luck and protection for soldiers riding into battle since the Crusades, when, in order to inspire his troops, Richard the Lionheart invoked 'George', the Christian martyr, whose faith was so strong he had stood up to the Romans. At Harfleur, Henry V bellowed his name – 'God for Harry, England and Saint George' – at the charge. He is the embodiment of Christian chivalry. It's a highly distinctive piece on closer inspection: the gold band is intricately wrought. And there's a simpler pleasure in it: a St George ring for George Fabian Lawrence, a 'Snap!' of names to raise a wry smile.

St George is an old-fashioned figure in 1912, but he's enjoying a bit of a revival. They can all hum phrases from *Merrie England*, a popular musical entertainment that has barely been off the stage since it opened in 1902, full of Tudor-style ballads and duets, a tale of love rivalries between Queen Elizabeth I, her courtiers and assorted maidens. At the denouement, one of Shakespeare's actors stages a production of the legend of St George for Queen Elizabeth and Lord Essex, producing a ghost in the middle of the performance to warn her off her jealous revenge. She spares Raleigh and transfers her affections to Essex.

St George is also appearing in *Where the Rainbow Ends* at the Savoy Theatre, a family show that opened the Christmas past, with music and special effects to rival *Peter Pan*, already so popular it's just spawned a bestselling illustrated storybook. The fantasy adventure follows four children travelling to a magical land where they will be reunited with their parents, who were tragically lost in a shipwreck on their way back from India. The children summon St George out of semi-retirement to protect them from all manner of mythical foes, and he arrives in a stage-firework flash to steward them to their destination, sword aloft, dressed in a tunic and tights, a tabard with its red cross, a chain-mail hood, and medieval-style pointy-toed slippers.[14]

A renewed interest in an Olde England character like St George is certainly not lost on Morton, soon to be famous for his nostalgic travelogues, a romanticised view of the country and its inhabitants narrated from behind the wheel of his two-seater bullnose Morris Minor; a world passing quickly into the rear-view mirror.

The milky opal swims with its own ancient symbolism. To Edwardians, the gem now has a creeping reputation for bringing bad luck, but Lawrence is well versed enough in this corner of scholarship to tell his daughter that, for more than a thousand years, opals had been considered extra special among gems because they contained all the colours in one stone. An opal had been lucky then, associated with prophecy. It could bring money, even make you invisible (which is why it was associated with thieves). Queen Victoria loved them.

Lawrence has seen enough. He makes his way down to where the workmen are still waiting nervously for his verdict on the value of the treasure, and their money.

He first became acquainted with navvies while working at his father's pawnbrokers, serving Victorian London, when it was standard for a workman to have a pawn ticket in his pocket, as often as not bearing a false name. In 1912, still casually employed, the navvies remain outside the remit of any welfare support, despite the Liberal government's latest reforms, like the new National Insurance scheme, Labour Exchanges or old-age pensions, and they struggle to qualify for 'sick club' protection. The Royal Commission on the Poor Laws had hoped to redistribute the wealth built in the previous century, and the previous leader of the Liberal Party, Henry Campbell-Bannerman, imagined a Britain 'less of a pleasure ground for the rich and more of a treasure house for the nation', but, for the time being, connection to a pawnshop is still nothing less than a lifeline for many of these men.

Stony Jack's valuation this evening is of an entirely different order to any arranged over a pawnbroker's counter. He won't

be offering a consolation beer or a half crown for the effort, and it won't be a loan. He shakes on a deal, expressing gratitude beyond measure and buys most of the find from them in ready cash. Morton said he 'remembered well' Lawrence giving the 'astounded' navvies 'something like one hundred each' (equivalent to around £15,000 today) and 'that he was told the men disappeared and were not seen again for months after that'. (There were already rumours that when a construction site in London shut down unexpectedly it was likely because Stony Jack's archaeological apprentices had just been paid. When work restarted after a period of inactivity it was a sure sign the navvies had run out of money again and returned to work.) No one will offer an explanation for how the equivalent of £30,000 in cash could have been waiting in a drawer at the shop. More likely Morton skirted round this detail, and Lawrence arranged to cash a cheque, bankrolled by one of his aristocratic employers (there was a secret account for the London Museum at Child & Co. – 'Child's Bank' – on Fleet Street, for precisely this sort of acquisition, containing a slush fund equivalent to several million pounds).

H.V. Morton doesn't say how long he himself stayed at the shop at 7 West Hill, but his reportage of the event stops when the navvies left the building, apparently with money stuffed in their pockets.

I would like to say we are lucky to have a wordsmith like Morton to clear up what really happened that night in June 1912. But Morton almost certainly wasn't there that evening. He gave himself away by writing numerous profiles of his long-time

mentor G.F. Lawrence over the decades in the press, and in all but one of them he is a curious reporter interviewing Lawrence, 'England's King of Collectors', about the biggest find of his career. Only in 1951, when he offered up a roving reporter's eye on choice historical sites in the capital for his book *In Search of London*, did he put himself at the scene of 'the most sensational event' in Wandsworth in 1912 – by which point Lawrence was dead and unable to correct the record. Morton says in his autobiography that they went upstairs together to wash the jewels in the bathroom. Except there wasn't a bathroom, just a toilet and a sink, quite a squeeze for let's-call-it-200-odd pieces. In another Morton feature article, when he makes no mention of being there himself, Lawrence took the earth into his kitchen and washed it there, which sounds more likely.

Morton couldn't resist it. He wanted to stand in the Hoard's mysterious light, just as he stood in the glow of Tutankhamun's golden tomb, Panama hat at a dashing angle. Lawrence never once mentioned Morton being by his side for the arrival of the Hoard, despite talking about the event countless times to countless journalists (he was an enthusiastic spinner of a good story to the press). Morton stretched the credible limits of serendipity too far for us to believe he was there on the night, but he was close by for decades, and the men certainly knew each other well. Lawrence often chose to speak through Morton, using him as a mouthpiece in his public relations. Both were deliberately vague about when individual pieces arrived and in what order, preferring to spin a fairytale out of the day, and making themselves the 'finders', heroes in the origin story, even though neither had put a pick through any wooden boxes.

Regardless of our unreliable narrators, we can be confident the first hefty batches of the treasures, comprising the largest share of the objects, did arrive at West Hill, and, at some point, all the visitors did depart, leaving just the Lawrence family and the jewels, upstairs in the flat.

CHAPTER III

The Lawrence Family Guard the Treasure

There is no full or official account of what happened over the two weeks after the family closed the door at 7 West Hill, just snippets here and there of events, upstairs or down in the shop, reported in the press, memoirs and handed-down family memories. But the basic choreography we do know.

Lawrence and his wife and daughter laid out the jewels in his study, referred to by his family as his 'den'. Some of the pieces were quite heavy, some quite sharp, others delicate, and it took a while.

The sprawling mountain of cleaned-up treasures sat incongruously in the little den, hundreds of pieces all piled together: ornate perfume bottles, chains, shiny religious vessels knobbly with decoration, a prismatic jumble of gemstones, the intricately cut facets of amethysts, rubies, emeralds, sapphires and diamonds casting all the colours of the rainbow onto the dingy anaglypta wallpaper. This strange spectacle overwhelmed an already confined domestic space, whose walls were lined with dusty books on archaeology, Greek and Roman history and mythology, old shop ledgers and reference tomes. It was common for homes of the period to be cluttered with ornaments and knick-knacks, the shelves of the nation carrying boxes of the

family favourite games Snakes and Ladders and Ludo, but the Lawrences' were stocked with a particularly melancholy bric-a-brac: a collection of ancient Roman lamps and 'bones and stones', as his granddaughter, Gweneth, remembered. The treasures pulled focus, more beguiling than any electrical special effects on the London stage.

Lawrence could refer to the outside world and its goings on from the first-floor window. There was pleasure in knowing that the treasures would spend their first few nights after they were unearthed from their burial of hundreds of years in such a plain part of South London, in an ordinary home, behind soot-stained lace curtains, shaken by the vehicles running up and down West Hill, a stream of bowler hats and flat caps on stooped heads pouring past, oblivious, up and down.

Treasure hunting had been the propulsive plot of Lawrence's life since his mud-larking days as a boy and the moment he pulled his first palaeolithic flint out of the mud at Stoke Newington in 1881, washed it off in the slurried water and held it up to the pale grey London light. Lawrence's hunch about the wonders down under the City had been bang on the money. This was the jackpot.[1]

That first night 'Grandpa nearly went off his head,' his granddaughter later recalled. 'He couldn't sleep.'

Lawrence knew he was legally obliged to declare the find to the coroner, who would decide in his courtroom if these remarkable objects qualified as 'Treasure Trove', making the find automatically the property of the Crown. It would be an offence to keep it secret.

He also would have to make an account of this afternoon's events, get his story straight, and like the navvies he didn't have

much time until the baton was passed. Fortunes and institutional reputations depended on *who* he said found *what*, and *where*. Any statement specifying the place and personae involved would set in train a series of consequences and claims, impossible to reverse engineer.

It was obvious even to a far less trained eye than his that this was a once-in-a-generation find. These objects promised something rare: new revelations about the perennially beguiling Tudors and their world. More than that, they would remind a beleaguered public of the long history and powerful reach and riches of the empire, its commercial dominance and artistic extravagance, offering a well-timed boost to national pride, reminding London that it was still at the centre of the world.

For the same reason, of course, these treasures, as all treasures in history or fairytale, had the power to wreck the peace and happiness of many. Powerful people would have reason to fight for them, and Stony Jack's version of what had just taken place could make criminals of those involved, or sow more insidious seeds of grievance.

Lawrence was well versed in the basics of Treasure Trove law, but a little mugging up was probably in order. Common law rules of Treasure Trove went all the way back to the time of Edward the Confessor; 'trove' taken from the Anglo-French '*tresor trové*', literally 'treasure that has been found' ('treasure' with an ancient Greek root, '*thesauros*', a deposit). In legal terms it meant gold, silver, plate, bullion or coins found hidden underground, or in cellars or attics, where the finds were old enough to presume that the true owner were dead and their heirs untraceable. In 1912, for a find to be Treasure Trove, it had to

be over fifty percent silver or gold. For a collection of treasures to be declared a 'hoard' in addition, their owner had to have buried them with the intention of coming back to recover them at a later date – '*animus revocandi*'. If objects had simply been lost or abandoned – or, as would happen at Sutton Hoo, where the objects were found in a burial ship and were not meant to be retrieved – then they didn't qualify as a hoard. (In Roman law, the split of any rewards between finder and landowner had depended on whether the treasure was found *fortuitously*, or by *deliberate* search. Presumably plenty of finds had been *accidentally-on-purpose* as a result.)

In practice, though it was technically the property of the Crown, the museums had first dibs on Treasure Trove, and, if a museum chose to acquire a find, the lawful finder normally received the full market value, and it was up to the Treasure Trove Reviewing Committee to put a fair figure on it. In a legal quirk in a country obsessed with the pre-eminence of title deeds, the law rewarded the finder over the landowner. If a museum passed on the opportunity to snap up a find, the objects were returned to the finder, again trumping the landowner. Everyone was expected to act in good faith and failure to promptly declare anything that turned out to be treasure would have serious consequences, not least forfeiting the finder's fee, which could be a life-changing fortune. Any name attached as 'finder' to these treasures would live on through the ages.

But this was a highly unusual situation. Thanks to an archaic charter, the City of London had the right to any Treasure Trove found within the square mile, and a trump card over any finder's rights. Miring the situation further, it was possible the find

would not qualify as Treasure Trove at all, on a technicality: the proportion of gold and silver in the objects was too low. In that case the Worshipful Company of Goldsmiths would have an obvious claim to the treasures, given their centuries-long proprietorship of the building at 30–34 Cheapside, although the paperwork for that would be difficult to track down, if indeed it had ever existed. Charles Wakefield, the formidable incumbent, might have something to say too, about where the treasures should go...and no one said no to Wakefield. Lawrence had to think very carefully about how he broke the news. Perhaps he was not yet aware of the labyrinth of technicalities involved, but he knew the City of London and the museums would fight and involve the law if needs be.

He hadn't yet informed the coroner, a Dr Waldo, as he was bound to do, and the treasures had been taken outside the City, the area of Waldo's jurisdiction, which was already a break with protocol. For now it was all still here, in the Lawrence family home above the shop.

May Lawrence joined the vigil. In 1912, the firm Carters of 127 Great Portland Street, 'Makers to H.M. the King by Special Appointment' and in the business of 'the alleviation of human pain', were advertising 'modern furniture' and 'every conceivable device for invalids' use', including 'wheelchairs and self-propelling bath chairs of every description'. The 1912 model, 'Esego', a lever tricycle wheelchair, offered 'easiest propulsion, perfect mechanism fitting and finish'. If May had a relatively new model, rather than an old-fashioned bathchair, it would have a wicker seat in a metal frame and adjustable back and footrests, but was still heavy and cumbersome. The first

motor-powered chair had just been developed, but remained a distant fantasy for an ordinary family.

May was dependent on others to help navigate her days, relying on family to carry her around the flat, from room to room or push her on short local excursions, and there was no lift or concierge, and certainly no palms, at 7 West Hill; just narrow stairs up to the flat, making daily life a struggle. Both Lawrence's eldest child, Frederick, and May were crippled, May from birth, Frederick likely from polio, which had been at epidemic levels when they were children; May was unmarried and had spent some time the previous year living with Fred's family in Southgate for a change of scene, respite for her parents and to help where she could with the new baby. The budget was tight, with so many people to feed, and now she was cooped up above the shop again, but for the moment she was occupied.

May and her mother had the little settee in the den to sit on, heads framed by the crochet 'antimacassar' to catch the aromatic smudges of oil from reclining gentlemen's hair. (The ubiquitous mane-tamer, macassar oil, was made from the macassar ebony, a flowering tree found in the Dutch East Indies, although it was increasingly made from easier-to-obtain coconut and palm oil and then fragranced, and it threatened to ruin the sofa-backs of the nation.) Whenever captured in photographs, the Lawrences had a familial look in common of lively curiosity mixed with determination to get on in the world, but now their attention was entirely focused inside the four walls of the den. Frazzled with the exhilaration of the day, still no one could sleep or concentrate on anything but the treasures in their care.

There then followed a short episode that made the papers after the war. Lawrence fed a first-hand account of it to the press.

Taking a break from the washing and, after some sitting about, he said, they had all begun to feel cold, even though it was a warm evening. A little later on, an 'art student' friend arrived to pay a call on the family. No sooner had the Lawrences greeted their guest and excitedly shown them into the inner sanctum than the guest took them all by surprise by asking who the old man was, standing by the table where the jewels were lying. 'A tall thin man in Elizabethan costume who looked very angry', the guest insisted. George and his family flatly denied that there was anybody there beside the treasures.

The guest, who claimed to possess psychic powers, insisted that there was an Elizabethan man, and said he heard the ghost say: 'Those are my jewels. What right have you to them!' Although they couldn't see the apparition themselves, or hear the spoken grievance, these words set the trio's overheated imaginations running on the question of who the treasures had belonged to originally.

At some point, the guest left 7 West Hill. They had various trams or omnibuses to choose from, depending on the direction they were travelling (a bicycle would be apposite if they were as avant-garde with their mode of transport as they were with their hobby). The family all got themselves to bed, Lawrence last, dragged there by Flo.

The pace of events soon swept out the overwrought atmosphere of the first night and Lawrence prepared to take charge and coordinate practical challenges.

In a day or two, other workmen turned up, carrying more knotted handkerchiefs full of jewels. May took the newly arrived pieces and washed them until they gleamed and sparkled. There were now so many to accommodate it seemed the den would not contain them, and objects were still arriving. With no bathroom at 7 West Hill, just a sink, a tap in the shop and no garden, it was a logistical challenge and there was nowhere to spread anything out. By 1912, middle-class families in Britain generally enjoyed indoor bathrooms but this family was not quite there.

Lawrence kept guard at home and the family carried on their domestic lives around the amassed pile of rings, jewels, chains and encrusted religious objects. For this period of time, however long it turned out to be, the flat above 7 West Hill was a museum, *his* museum, containing his own private collection. In his formal role at the London Museum he encountered globe-trotting aristocrats who had founded their own institutions on less than this. Lawrence managed to hold his own in the company of the 'greats' of archaeology, including Augustus Pitt-Rivers, a military-man-turned-ethnographer who had established an enduring legacy with a vast collection of everyday objects from around the world, displayed to demonstrate his theories on cultural evolution. This, in Pitt-Rivers's eyes, was a more elevated pursuit than the mindlessly greedy treasure hunts he watched others embarking upon. Lawrence was also on familiar terms with Canon William Greenwell, the plain-speaking Northumbrian archaeologist whose collection of artefacts, extracted from the barrow graves of Yorkshire, shed rare light on the enigmatic funerary practices of the Neolithic and Bronze Age. He'd even had dealings with the late, great Sir Augustus

Wollaston Franks, keeper of British and medieval antiquities at the British Museum, a man whose acquisitions made him a peerless giant in the world of collecting. But today, Lawrence stood tall at the centre of the collecting world.

After another short interval, the shop bell rang again and yet more handkerchiefs bulging with twisted Tudor gold chains slopped down onto the counter, the rings clattering after, so there was even more to wash. The jewels and gems continued to arrive, and May had a seemingly endless job.

Lawrence had grown up with other people's most valuable possessions in his house, so he was used to this kind of company. Throughout his Victorian childhood, he had watched as the items pledged against a cash loan – 'pawns' – travelled from the counter to the first floor via a chute, or 'spout', like a dumb waiter, to be stored upstairs, waiting to be redeemed for the loan-plus-interest (from which came the phrase 'up the spout', to mean something gone wrong or ruined). The first floor had also been the Lawrence family living quarters, so he and his parents and brothers and sisters had lived among these pledged items: anything from coats and boots to fancy plates and linens. There was jewellery too; necklaces and rings. Pledges worth less than a certain amount had to be kept for a year, after which Christopher Lawrence, his father, a bearded patriarch in the Victorian model, could offer it for sale. If they were worth over that amount, and still unredeemed after the year, then his father was allowed to sell them, but the sale would have to take place at a public auction. Christopher's son George was now over a half century in age but remembered the singular quality of his family's houseguests: other people's most valuable items that

were his to foster, that might be reclaimed later, or might not; possessions that he could imagine were his, or at least objects in a kind of limbo that both *did* and *didn't* belong to him.

The man surveying the great mountain of spangly trinkets, baubles and charms was still assimilating the death of his father the year before, in 1911. It would be natural for Lawrence to want to get word of recent events to his own son up in Southgate, and suggest he come to Wandsworth at the earliest opportunity, while they had the gems and jewels to themselves.

He continued to guard the treasure and May continued to wash everything that came in. Lawrence enjoyed tickling the ivories and singing show tunes. Perhaps he serenaded the family on the piano, a few bursts now and again while they waited for the next batch to arrive; a man with a sweet tooth, perhaps he passed round a custard cream or a bourbon or two, new biscuits in 1912. The *Daily Mail*, *Daily Express* and *Daily Mirror* were always there on the table to be read while meals were prepared at the gas cooker. He liked to keep abreast of the news, and he knew he would make those very pages soon.

The family were busily engaged with new responsibilities, guarding and washing the jewels, but they were also in various stages of crisis. Florence, Lawrence's wife, was still overwhelmed with disappointment that their son, Frederick, had made an unfortunate match not long back, marrying her niece – her sister's child – Rose Elsie Smith, his first cousin. The unavoidable, and enraging, fact was that this match had returned her son to the very same low-prospects family Florence had spent years escaping. She had hoped Fred would take a step up the ladder and do better. She had strived relentlessly to forge a decent life for

herself and her children in a better part of town than the poor Camberwell community she was born into, where her siblings brought her up after her mother's death, and Florence managed to scrape together piecemeal work as a milliner in Hoxton and get by. She married George, a man with a nose for business, also bent on making a good solid life for himself, and he had brought her to Wandsworth and got them the shop, and she had made herself a selection of wide-brimmed hats suitable for Sunday church services. But now this. Lending the situation a sharper sting for Lawrence's wife, Frederick and Rose had been thrown together when Florence invited her niece, then aged fourteen, to come and live with her, in already cramped quarters, to help her sister out of a tight spot. Rose stayed quite a while – she was at 7 West Hill overnight for the 1901 census – and so it was Florence herself who had unwittingly forced the relationship. Frederick was twenty-nine now, his wife twenty-five, and they were living in a small terraced house in North London, with their infant son Geoffrey and a brand-new baby, Gweneth, born the previous month. Fred was a clerk to the registrar of solicitors at the Law Society.

The Lawrence family harboured other secrets, feelings of shame to accompany these bitter regrets. Lawrence's younger brother, Alfred, was finding his feet after his discharge from an asylum. He had been admitted following a 'nervous breakdown' on a visit to England after several years in Australia. His wife and children were still there, left to fend for themselves on the other side of the world. Now based in Church Stretton in Shropshire, on the Welsh border where he had moved alone, Alfred lived a quiet life, styling himself as a charming English

country gent, neat and tidy, with a fob watch and delicate gold-rimmed spectacles, and enjoying musical recitals. He regularly visited his elder brother and his wife in London, squeezing into their home upstairs, catching up with May and Frederick, or taking lessons on antiquities in the low light of the Aladdin's cave, listening to tales of Egyptian, Roman and Tudor history. But he was a financial and reputational liability for his brother and rarely spoken of outside the family.

Lawrence was an upstanding Anglican and a teetotaller. When he was a boy in the East End, his Uncle Charles had been a publican nearby. Charles had a habit of going bankrupt and doing midnight flits with his wife and children to escape creditors. Lawrence had watched him fall into the vicious cycle of burgeoning debts, and numbing intoxication, that sent so many people from parishes like St Giles on the run, and kept them running. Men like Lawrence, who had determinedly avoided those traps, were steeled, knuckles clenched, against temptation.

The treasures were still in the den after more than a week. In an ancient Greek myth, a story retold in one of the classical tomes lining the walls, the gold ring of Gyges offers the wearer invisibility. The story follows King Gyges's rise to power. We meet him first as a shepherd in service of the present king. There's an earthquake while he's tending his flock and a chasm opens up in the mountain. Gyges enters and finds a bronze horse there, and, inside that, a corpse wearing a gold ring which he steals. He soon discovers that the ring gives him special powers – that he can disappear at will. He makes his way to the palace, and once indetectable, seduces the queen, kills the king and becomes king himself. Plato mentioned this story in his *Republic* – using

the tale to ask whether anyone would resist temptation if his wrongdoing went unobserved.

Standing guard over all of this for so long was a test of character straight from an Edwardian *Treasury of Myths and Fairy Tales for the Young*. There was no cellar at 7 West Hill, but there were floorboards with a crawl space underneath that could be jemmied up to create a hiding place if required – room, in theory, to hide something that would serve as a deposit for a rainy day. How respectable was Lawrence really? There were many days keeping late hours in stuffy confinement to consider this uncomfortable question.

The shop bell continued to ring from time to time with visitors to the shop. On balance of probability, though no diary confirms it, one of the bells that week signalled the arrival of Frederick. He had good reason to take advantage of this rare lucky break for the family and make a diversion from his offices on Chancery Lane in his clerk's three-piece suit and his bowler hat, with a neat moustache like his father, but darker, his hair oiled and ordered.

Each of Frederick's steps upstairs to see the treasures took time and labour, owing to his uncooperative leg and a heart condition. His father's study waited at the end of the thin corridor.

It would not have been an easy scene to take in, the gemstones spilling across the floor. His father was on hand to talk him through the extraordinary events of the past few days that had brought this array of spectacular objects here to the den.

At the Law Society, Frederick was a small administrative cog in the business of regulating solicitors, typing out the rules, dealing with complaints, keeping them on the straight and narrow

and maintaining the appearance of probity in the profession. He kept his head down. Like Leonard Bast, the poor young insurance clerk in *Howards End*, adopted, and then ruined, by the well-meaning Schlegel sisters, Frederick's position and the middle-class prospects attached were hard won and would be easily lost with the smallest misstep. In E.M. Forster's novel of 1910, the sisters pass on a business tip and advise Bast to leave his position before the company crashes. Bast resigns, but the company doesn't crash: it was only an idle suggestion made in passing by a rich man, and he's unable to find a new position in a crowded market where men with no current position must join the back of the queue. Unlike the wealthy and well-connected Schlegel sisters, he has no second chances and no safety net.

Frederick could not hide evidence of his fragile health, and had a wife and two children, toddler Geoffrey and new baby Gweneth, to provide for. Many were in his position. There had been peace in Europe for over a decade, but thanks to the Boer War it was no secret what a bad physical state many military-age men were in, and that they would struggle to hold on to the empire if called up to do so. The National Insurance Act of 1911 had attempted to remedy this by mandating health insurance to anyone over sixteen earning less than £160, with contributions on a sliding scale, but it's unlikely Frederick qualified. Above that income, a contribution of fourpence per week got a man ten shillings weekly sickness benefit and a woman seven shillings and sixpence, for twenty-six weeks, including treatment in a sanatorium for tuberculosis, and maternity pay of thirty shillings (women paid less in contributions but got less in return). Unemployment benefit was designed to catch only

the very poorest. Despite the existence of mental hospitals like Bethlem, which had recently accommodated Alfred Lawrence, and the new Napsbury hospital in Colney Hatch just north of London, near Frederick's home, treatment was not covered by the National Insurance Act. To get yourself into one would mean recourse to begging, or borrowing, or a Friendly Society if you were lucky.

Lawrence was available to pick out items of interest to either of his adult offspring as they looked through the collection. The treasures on the floor presented bewildering new opportunities and the question of value was pressing.

Lawrence enjoyed going to the theatre, and a play running in the West End would seem to have been written for him at this particular point in his life. The Vaudeville Theatre was staging a family saga running to packed houses called *Rutherford and Son*, starring the imposing Scottish star Norman McKinnel as the domineering capitalist patriarch Rutherford, who has built a glassworks in the north-east, trying and failing to control his children within his business empire. It was a play about a new generation wrestling itself free of their parents, by Githa Sowerby, herself a child of a northern glassworks family. The show was a sensation and Lawrence would have understood the intergenerational conflicts it dramatised. The pawnbroker's shop had been offered to him as the eldest son, but when he refused to take over the business, Christopher Lawrence, George's father, had thrown him out of the family home. Fanatical about archaeology, an idle gentleman's pursuit to his father, he had cast off on his own, without approval. As head of his own family, he grafted day-to-day to keep the enterprise afloat

and the family well-thought-of. He had a modest salary at the London Museum, leaving nothing for a rainy day. He and Florence fretted endlessly about their dependent daughter and what would become of her after they departed. The arrival of these treasures into his home was Lawrence's once-in-a-lifetime chance to make a name for himself and establish a legacy. He could not afford to squander it.

There's no one to tell us precisely who was in the room with the treasures over these next few days, but the most likely scenario is that Florence, May and Frederick were in and out as their father continued his lengthy and painstaking evaluation, Frederick going to his family in Southgate, and his work, then back to the flat when he could, to take his turn on watch, evolving plans together about what to do.

Lawrence held the gemstones and jewels up to the gaslight to reveal the details and refine his assessment (the difference being simply that a 'jewel' is the object cut out of gemstone and polished), returning to some of the more enigmatic stones, and finding new ones in the enormous pile. He was besieged by the cultural freight of each, reminded of the 'powers' contained inside them, reputations accrued over thousands of years. Lawrence was a scholar, and fluent in their symbolic language. He knew what people would do for the love of stones.

Many fragile copies of medieval 'lapidaries' had passed through Lawrence's hands at the Museum. These were textbooks presenting taxonomies of gemstones, laying out satisfyingly ordered charts of the multitude of jagged crystalline profiles, their colours varied across the spectrum like a proto-Pantone chart. These line-ups included the peaks and pyramids of the

durable quartz family, including amethyst and rose quartz, as well as the oranges of jasper. Also, the waxy whites and browns of the more fragile chalcedony, with crystals so small they are not visible to the naked eye, and its family of stones including agate, with its sunset-marbling stripes, or carnelian with cloudy red-and-white swirls; the parallel bands of black-and-white onyx, or its red-striped variety, sardonyx. The deep red of garnet, a pomegranate seed of a gemstone, forged under great pressure out of silica inside a rock and offering, appropriately enough, strength and protection.

Naturally the lapidaries did not refer to the chemical composition of the stones in modern scientific terms, as infinitely inventive arrangements of silica mineral crystals. Instead, they listed a stone's virtues. Underwriting the medieval texts had been the widespread belief that each was made to a heavenly design and possessed an intrinsic power. A stone's power might promote health, in which case the 'lapidary' would serve as a reference book for remedies; or relate to astrological forces, aligned with a specific sign of the zodiac, or, if a gemstone appeared in the Bible, its form was imbued with Christian symbolism.

Multiple meanings had attached themselves to each stone over the years. Different cultures had emphasised different qualities over others, and there was overlap between the stones, but nevertheless there was some consensus and a degree of favouritism. Quartz – the amethysts, jaspers, carnelians, stripey onyxes in front of him – had been prized by Jewish, Christian, Islamic, Buddhist, Mesopotamian, Egyptian and Greek cultures, for endurance, kingly strength, healthy blood, sexual potency, and much more besides. The Romans had put most varieties

of quartz into protective amulets, and on seals and made them into cameos (sculpted into positive relief), and intaglios (carved in negative relief) to be worn set into rings. The jury was out on black onyx, a stone with a close association with bad luck, though also seen as protective and able to absorb negativity.

As he sorted through, Lawrence found several pieces incorporating rose quartz, symbolising an unbreakable romantic bond. Lawrence's granddaughter did not remember a particularly happy union between her grandparents, Florence didn't share her husband's love of antiques, but the sentimental pale pink stone was popular and would have a market value reflecting that.

Lawrence was at his leisure to remove some of the many strands of chain and pull the links through his fingers to inspect them. It was human nature to pick favourites from a pile like this, even for a scholar, and his family likely had theirs. Tangled inside the shiny spaghetti of gold-and-enamel chains, with patterns of leaves and flowers as links, he spotted one necklace of particular interest to him with a recurring 'true lover's knot' motif.

Also in the pile were many yellow-brown 'toadstones', believed to form in the head of a toad but actually the fossilised tooth of a species of fish – *Lepidotus*. Drinking water after steeping a toadstone in it was believed to help with a diseased kidney. (The superstition had endured into the nineteenth century. On 4 April 1812, Sir Walter Scott wrote to Joanna Baillie, the Scottish poet and dramatist, about his mother's toadstone that she was in the habit of lending out to associates for 'protecting new-born children and their mothers from the power of the fairies'.)[2, 3]

Lawrence and his family no doubt tried some of the finger rings on for size; many featuring stones intended as protective 'amulets'. When the population had believed in witchcraft, and lived in mortal fear of it, amulets were a life-or-death necessity, not a decorative trinket. In his 1830 work *Letters of Demonology and Witchcraft*, Sir Walter Scott referred to the early astrologers and chemists who claimed to be able to harness the spirits of the elements (whilst denying any unlawful or black magic, of course) and 'imprison in a ring, a mirror, or a stone, a fairy sylph or salamander, and compel it to appear when called, and render answers to such questions as the viewer should propose'.

Some of the jewellery and other objects in the sprawling collection were studded with examples of 'big four' stones considered 'precious', prized for scarcity and the clarity of their colour. These colours were the gift of a trace element of impurity. A kiss of chromium coloured the rubies (for protection and passion) red; but turned emeralds (good against poison) green. Sapphires (chastity, wisdom, healing, prophecy) were blue from iron and titanium. A diamond was a simple carbon crystal, though a touch of boron could make it blue: a talisman of power, steadfastness and, eventually in medieval Europe, love.

But the semi-precious stones spoke even louder, even in 1912, nudging awake folk memories about milky orange jasper for peace of mind; earthy brown sard for courage; the dried-blood red of garnet for commitment; the warm-red of carnelian for luck and fortitude; red-and-white zebra-striped sardonyx for protection when travelling – most of the stones offered various kinds of protection, the promotion of good health or insurance against illness or the end of love. Many people still treasured a

gemstone, whether set in a buttery gold finger ring, or strung on a chain, reassured as it knocked against their heart, just as they felt the rising panic and intense pain of losing an engagement ring or a family heirloom.

A few of the stones in the den would have given any of the Lawrence family reason to hesitate as they handled them. The idea of a hex-carrying gemstone was back in the news in 1912, largely connected to newspaper gossip about the 'Hope Diamond', an enormous blue sparkler chasing around the world with a shady provenance and a curse riding pillion. The jewel had supposedly come from an Indian mine and travelled, via thefts and gifts, from Marie Antoinette in pre-revolution France, to the Hope banking family who renamed it, on to King George IV, but sold after his death to pay debts, and then to Harry Winston in New York, bringing 'Trouble To All Who Have Owned It', according to the *Washington Post* in 1908. In 1909 *The Times* called the lives in its wake the 'story of a long series of tragedies – murder, suicide, madness, and various other misfortunes'. Everyone was nervous of the symbolic power of a gemstone, despite themselves.

Some of the stones weighed particularly heavy in Lawrence's hands, calling to mind a short story by Sir Arthur Conan Doyle, 'The Adventure of the Blue Carbuncle' from *The Adventures of Sherlock Holmes*, on the bookshelves of so many of Lawrence's generation, first published in *The Strand Magazine* in 1892:

> He held out his hand and displayed upon the centre of his palm a brilliantly scintillating blue stone, rather smaller than a bean in size, but of such purity and radiance that it twinkled

like an electric point in the dark hollow of his hand. Sherlock Holmes sat up with a whistle. 'By Jove, Peterson!' said he, 'this is treasure trove indeed!'...

Holmes took up the stone and held it against the light. 'It's a bonny thing,' said he. 'Just see how it glints and sparkles. Of course it is a nucleus and focus of crime. Every good stone is. They are the devil's pet baits. In the larger and older jewels every facet may stand for a bloody deed. This stone is not yet twenty years old. It was found in the banks of the Amoy river in Southern China... In spite of its youth it has already a sinister history. There have been two murders, a vitriol-throwing, a suicide, and several robberies brought about for the sake of this forty-grain weight of crystallised charcoal.'

The Elizabethan 'ghost' who appeared to their guest that first night had called the family thieves by implication, angrily invoking his property rights – 'What right have you to them!' The words, even as spoken by a figment of a student's imagination, sounded a first note of caution about the legitimacy of having all of these treasures in the flat while ignorant of the identity, or wishes, of the person who had buried them. Heaped up in the den they must have looked, from certain angles, rather like stolen goods.

There were plenty of amethysts in the glittering pile, some set in jewellery, others loose. The (ironically, you might say) wine-coloured stone was the ancient symbol of healing and sobriety, taking its name from the ancient Greek word *amethustos*, literally 'not drunk'. Two of these purple stones in particular caught Frederick's eye. They were loose jewels, comparatively large in

size and warranted a Holmes-style closer examination. They were cut into a 'fancy' style, unusual for such old jewels, meaning they didn't have a flat 'table-top', but had been cut around with many facets into an octagonal shape, with a multi-faceted dome above, tapering below, very difficult to achieve without modern tools and techniques. Both were a bright, clear lilac. Each of the two lozenges 'shone out like a star with a cold, brilliant, many pointed radiance'.[4]

It would have been almost impossible for a man in Frederick's position not to demand a discussion about the value of two such stones in an auction or for cash on the street. A surplus of workers had impacted the already modest wages of a man like Lawrence's son, who could barely afford a single life let alone meet the needs of a growing family. Long hours, including half a day on Saturday, earned a clerk not much more than £200 a year. In 1912, the average price paid in London for a four-pound loaf of bread was 5.8d, a rise of thirty-three percent on prices in 1905, and coal was up twenty percent in the same period per hundredweight (equivalent to 100 pounds). Lower middle-class families would spend around sixty percent of their income on food this year. With no council housing available,[5] the vast majority of family men like Frederick Lawrence rented their homes from private landlords, with a contract letting them the property for a specified period, but no legal rights as tenants beyond whatever was written on that piece of paper. Home ownership was on the up (although it was still a small minority in a position to do this):[6] various Acts of Parliament had liberalised housing loans and extended the payback periods to break the cycle of dependence on the workhouses, and the proliferation

of building societies in Victorian times made mortgages more affordable. But even if Frederick were one of those with a home loan and had managed to get favourable rates in return for his contributions into a common fund, his rights stopped the minute he missed any repayments. The word 'mortgage' came from a Latin-to-Norman-French mix of 'mort' and 'gage' meaning 'dead pledge'. This referred to the old truth that if you died, the deal was off and the lender took the property.[7]

May had noticed the amethysts, too, when washing the Hoard. She had been born crippled, but always believed that she would be cured, and she knew amethysts were reputed to be a healing stone. The amethysts also provoked thoughts of the radical politics May read about in the papers, calling to her generation of women.

Amethysts were a talking point in 1912 as a result of jewellery designers wishing to demonstrate solidarity with the Suffragettes. Emmeline Pethick-Lawrence, no relation, a member of the Women's Social and Political Union and co-editor of *Votes for Women* magazine, had devised a three-colour scheme: white for purity, green for dignity, purple for hope, so amethysts met the brief. Wearing an amethyst incorporated into a piece of jewellery, together with a clear green peridot and a pearl or a diamond, wordlessly cheered on the scores of women who, aiming to prove the government cared more about property than women's lives, had recently smashed the windows on Oxford Street and Regent Street and disrupted the opening of the London Museum. Asquith's Liberal government had brought in radical new social legislation, but the prime minister was still not behind the Suffragette movement. His denial of the vote

for women, but willingness to tax them, had made his speeches a draw for violent protests.

When the 'Women's Exhibition' opened in 1909, a fundraiser for the Suffragette cause held at 'the Prince's Skating Rink' in Knightsbridge, it was decked with Sylvia Pankhurst's designs; allegories of adversity, courage and hope, like the iconic angel with the horn, in the suffragette colours: green, white and amethyst purple. Pankhurst had received a scholarship to the Royal College after training at the Manchester School of Art, and taken herself and her paints and pencils on a 'Women Workers of England Tour' in 1907, recording the working conditions of women up and down the country from the Scottish cotton mills to the Staffordshire potteries. She published what she found, in terms of poor working conditions and iniquitous wages, in the *London Magazine* in 1908, along with her paintings and sketches.

That May's 'psychic' friend was an art student suggests May was hanging around in progressive circles and maybe impatient for more than just the few rooms above the shop. The Central School of Arts and Crafts, inspired by the movement pioneered by William Morris and John Ruskin, was offering evening classes out of its premises on Southampton Row, meaning a student could work during the day and then acquire craft skills that earned a living like typography, calligraphy, illustration and costume design. Women had the Royal Female School of Art available to them and the Putney School of Art and Design was just up the road from West Hill. This movement included free-thinkers and independent women with Bohemian living arrangements and love lives.

*

The amethysts in front of May glowed with artistic and political change and possibility. She didn't take them, though; her brother did.

Various scenarios might explain how two amethysts ended up in Frederick Lawrence's possession. One is that, at some point while their father was not looking, or otherwise engaged making tea, or down in the shop thinking things over, placing another sherd of pottery into a Samian ware jug, or doing the accounts, Frederick slipped them into his pocket. Perhaps his father would consider it a pledge, a loan? May could have been accomplice. Alternatively, Lawrence handed them straight to his son. Somehow Frederick got the two dazzling purple jewels north of the City to Southgate, where Rose was at home with little Geoffrey and new baby, Gweneth. That's where they ended up, held on reserve, in a box or a drawer.

The days ran on, and then it had nearly been two whole weeks that the treasure had been kept above the shop. There's no record of Lawrence spreading the word about the find to anyone else beyond his family, and those who had called by that first afternoon. It is possible a select few other unspecified people, like his younger brother Alfred, had popped in and out over the fortnight. Their sisters, Ruth and Hettie, worked close by as clerks in the other branch of the Lawrence family pawnbroking business in Wandsworth High Street. But for these past two weeks, the jewels in the den were, essentially, a family secret. Dr Waldo the coroner was still none the wiser about any of this activity.

*

In the end, Lawrence decided to send a message straight to his superiors at the London Museum, bypassing Waldo and his court and associated bureaucracy entirely.

The next day, Lewis Harcourt and Reginald Baliol Brett, Lord Esher, the grandees in charge of the institution, rushed to the House of Commons and held an extraordinary trustees meeting. Both men were prominent Liberal politicians with close connections to Asquith's Liberal government of the day, and Harcourt was actually serving in the Cabinet. They hurried to a committee room to discuss the urgent matter, tailcoats flying behind, buttoned boots clipping on the tiles, maintaining decorum but twitching smiles betraying what must have been a sense of great excitement at the news coming from Wandsworth. After the meeting, they issued a curt memo back to Lawrence ordering that 'the entire gold treasure recently unearthed' should be brought the following Tuesday to Guy Laking's flat in Cleveland Row, just behind St James's Palace, for their inspection: another private home, away from prying eyes. Guy Laking, the eminent art historian and first 'keeper' (curator-in-charge) of the Museum, would be able to have a look and assess the magnitude of the treasures coming into their possession.

The London Museum and the Guildhall – the heart of the City Corporation – would shortly fight over the gems and jewels. There was one more night at the flat and Lawrence, Florence and May kept watch. The next day, the head of the family did his duty.

A crack squad of porters was required to go to Wandsworth and carefully pack up the whole lot, no doubt watched closely by the proprietorial family. Even with the Lawrences helping to

pack, and Ethel May coordinating, getting hundreds of objects into trunks, down the narrow stairs and out on the street to await transportation would have taken time, and many trips. Did Lawrence travel with the boxes to Laking's house? Regardless, he handed the collection over, 'in its entirety – with nothing missing!' The treasures left 7 West Hill and went into the custody of the Museum of London, and 'that's how the greatest hoard of Tudor and Stuart jewellery ever discovered was preserved for the nation', as Lawrence's best anecdote always finished.

Except that wasn't the full story at all. Unbeknownst to Lawrence, the navvies hadn't brought him everything on 18 June. Or on their subsequent visits in the days after that.

On the afternoon of the 18th (or shortly after) at least five items from the Hoard were already on their way to Percy Webster's, a clock and jewellery dealers at the Sign of the Golden Time and Dial, 37 Great Portland Street in the West End of London (just a few doors down from Carter's, purveyors of wheelchairs and other pain-alleviating technology to the royal family). The ornaments were presumably stuffed in one or two labourers' pockets as they made their way casually through the West End.

We know about this deal because when an agent of the British Museum bought the five pieces back from Webster ten days later, on 28 June, he asked for a receipt, discreetly gaining itemised evidence of what was stolen, and reclaimed, just in the nick of time. Those pieces listed on the receipt were: a gold enamelled fan handle in the form of the 'caduceus' – two snakes coiling up a staff, their two heads forming a crook, with flanking wings – the symbol of Hermes or Mercury; of thieves,

merchants and messengers. Also reclaimed from Percy Webster was a glorious pendant sapphire suspended from a gold-and-white-enamel setting and crowned by a 'cabochon' (a smooth-polished gemstone). Next, a gold finger ring, with a rosette of seven garnets set in a circular bezel (a bezel is the metal frame surrounding the gems) and enamelled on the back. The man from the British Museum also bought back a gold finger ring set with nine emeralds; enamelled on the back and on the hoop around the finger; and one more gold finger ring with an oval bezel and a setting for nine emeralds, though three had fallen out.

It would appear, then, that at least one person had stolen objects from the Cheapside Hoard before the collection even got to Lawrence's shop, and by the time the treasure was put in Lawrence's hands it was no longer the full complement. The boxes had been rummaged in, pieces creamed off along the way, trinkets slipped into bags.

Around this time the new Queen Mary also heard about the discovery. Something of a magpie, she had form for collecting gleaming valuables and 'repatriating' them to her palaces. She would be particularly captivated by some of the gold enamelled neck chains that were in need of a new home.

But one piece could not be accounted for in any of the boxes carted across to the Museum officials: the gold ring holding an opal cameo of St George and the Dragon.

From our vantage point, more than a century later, this ring is of special significance because it's the only object once part of the Cheapside Hoard we can confidently say is no longer in it. There is proof of it within the collection – it appeared in the

first proper catalogue in 1928, the description accompanied by an illustration plate with a small pen and ink sketch of the ring as well as a photograph. This is a blurry image, but you can make out the figure of St George on horseback inside a milky stone reaching down to spear his foe, as well as the detailing on the carved gold band. This ring was given the accession label of 'X5' when it was taken into the collection of the London Museum, an anomaly when all the other pieces from the Cheapside Hoard were given numbers beginning 'A14…', indicating it was not part of the first consignment. The current curator of the Tudor and Stuart collection at the Museum of London, who has been in post for over twenty years, has never seen this ring, and if she hasn't seen it, it is not with the rest of the Hoard anymore. The ring is somewhere out there, carrying an opaline portrait of the patron saint of England, a potent symbol of good defeating evil, and the insignia for the oldest and highest chivalric honour in Britain. Keep an eye out for this ring. It will turn up again soon, but then go missing, vanish, nowhere to be seen in any of the strong rooms or the show cabinets.

CHAPTER IV

The Jewels Go Out into the World

That high summer of 1912, Lawrence ushered the boxes of treasures from Cheapside straight into the hands of his employers at the London Museum, with nothing missing, he insisted... and these were powerful hands. Archaeology as a discipline was not yet professionalised and the London Museum was run by gentlemen of the empire, who look haughtily back from their portraits, gazes trained on the colonies; men who were also MPs and cabinet ministers – they were across it all.

At weekends Lawrence ran his private operation from his shop, but during the week he acquired objects for the walrus-moustached aristocrats in charge of the institution, with their top hats and tailcoats, oiled-down hair and thousand-yard stares; crossing town in hackney carriages between Parliament and St James's, men steeped in Edwardian gentlemen's clubs – a world of desk lamps, wingback chairs and menservants, rooms rich with brass, leather and wood polish. He was an invaluable asset to them, fielding antiquities and standing at the high tide of acquisition, when the flow of objects was still incoming, from mines, digs and trading posts across the empire. He was also there to intercept the artefacts bursting forth from the trenches in London's virgin clay, and steer them into the show cabinets (and storerooms) of their grand and capacious new Museum.

He was both a buyer and a seller to all the big London museums, a certain conflict of interest even in his own day, unconscionable now. But while the channels ran abundantly with antiquities from abroad and from under the Square Mile as fast as the spade-wielding labourers could throw them out, who was going to care about his methods or the optics? His superiors valued his street contacts and his polite-but-firm wheeler-dealing on their behalf during a lawless archaeological free-for-all, and no one cared how he got his results. And he had outdone himself now, it seemed. *Well done my man.*

As planned, the Museum trustees gathered at Guy Laking's flat in Cleveland Row, an imposing white stucco building conveniently positioned between palaces in St James's, to conduct a private inspection of the gems, jewels, necklaces and other assorted wonders. The treasures were laid out under high ceilings in more rarefied air than the stuffy quarters above the shop, but they were still a startling proposition to anyone who hadn't seen them before.

One of the men with his hands on his hips having a good look at the treasures was Lewis Harcourt, later Viscount Harcourt, known as 'LouLou', a co-founder of the London Museum and its commissioner of works. He wore his hair slicked back from a high forehead, and a spectacular moustache even in an age of spectacular moustaches, six foot four and unrufflable in waistcoat and tails, his loftiness accentuated by a tall stiff white collar which raised his chin to its maximum angle. Harcourt was actively serving in Asquith's Liberal government of the day, as secretary of state for the colonies, alongside Winston Churchill, First Lord of the Admiralty. Harcourt was part of

an administration introducing the social reforms, like a basic welfare state and pensions, for the first time. Asquith was the son of a Yorkshire clothing manufacturer and the first prime minister not to have a country estate. His chancellor, David Lloyd George, had grown up in rural Wales under the wing of his uncle, a cobbler, and according to *Tatler* the background of the top man at the Treasury proved that 'nothing is impossible to anyone who has application, ability, and a moderate amount of luck.'[1]

Alongside Harcourt, bending down to peer into the boxes in Laking's apartment, was Lord Esher, Harcourt's lifelong friend, co-founder of the London Museum and now, as trustee, one of the guardians of the spellbinding finds laid out before them. Esher was likewise an unreconstructed product of the old school grandee tradition. He was also an exponent of the theatrical moustache and high starched collar, but with a more inscrutable expression than LouLou's and a hairline further receded. Like Harcourt, Esher was a prominent Liberal politician and the moustachioed double act casting an eye over the glittering loot were both accustomed to life at the centre of power. They moved in the same circles, caroused at the same St James's gentlemen's clubs; both had attended Eton and then gone up to Oxford and Cambridge respectively. Harcourt's late father, William Harcourt, had been Liberal chancellor and, for a time, Liberal Party leader, and he had met Lord Esher, then named simply Reginald Baliol Brett, at Trinity College, Cambridge, and introduced him to his son.

The London Museum was Harcourt and Esher's joint vision, conceived as a thrusting rival to the older and even more

shambolic Guildhall Museum, where all the important archaeological flotsam thus far had washed up by default. (The London Museum would become 'the Museum of London' in 1976 when the two museums amalgamated.) It was a major coup to have the treasures in their custody, via their man Lawrence's steady hand, a game-changer for an ambitious cultural enterprise, and they seized upon them, piece by piece, picking through the boxes, asking Laking for his opinion, whisky and water in heavy crystal glasses, not tea and bourbon biscuits, to calm the nerves. As a whole, the collection represented a glittering centrepiece for their new Museum, an opportunity to show off the history of Britain's capital at the height of the empire's powers.

Guy Laking, the first keeper, circled the boxes of treasures alongside. His round face and wide, dark eyes made him appear younger than his thirty-six years, and he was considerably younger than the others, and his black hair was likewise tamed with the ubiquitous macassar oil. One of the finest art historical brains in the country, he took charge of the technicalities during the appraisal of the objects. He had learned his stuff at Christie's auction house and was expert in historic royal armour and a baronet to boot. (He attended Westminster School not Eton, but his father had been personal physician to Queen Victoria, King Edward and King George, so he was well inside the circle of trust. Edward VII had created the post of keeper of the king's armoury at Windsor specially for him.)

Laking was the sunniest and most charismatic of the three and enjoyed membership of the Garrick, a gentlemen's club for actors of the day to mingle with men of refinement like himself, founded in the previous century in the name of the

eighteenth-century actor manager of the Theatre Royal Drury Lane, David Garrick. Of an evening, Laking joined in lively conversation with the likes of Sir Herbert Beerbohm Tree, the leading Shakespearean actor-manager of the Edwardian age, handsomely melancholic and a fellow Garrick member, still with traces of greasepaint on his face having hotfooted from His Majesty's Theatre. Talk would naturally turn to his annual Shakespeare Festival, and this year's lavishly staged Shakespearean spectacles *Othello* and *The Merchant of Venice*.

Cigars lit, the gentlemen compared opinions, selected favourites and discussed next steps. Confronted now by the question of what to do with the objects found in the cellar, they had many practical challenges to consider and strategies to game out, in managing this good fortune. What to say in public, what to whisper between themselves only, what to keep completely schtum about in order to have the best chance of keeping hold of the treasure without falling foul of the law and protocols? The cache would disrupt the general decorum: others would covet such a perfect collection and forget their manners, and they were going to have to fight for it. When it came to such a bounty, few would hesitate to take their kid gloves off.

Their Museum was forward thinking, but not guaranteed to succeed. Harcourt and Esher saw themselves as pioneers in a movement sweeping up the vast private collections of empire-trotting aristocrats and putting them on display in national museums for 'the instruction and gratification' of an increasingly urban working-class public. It was a vision that had started with the Ashmolean in Oxford in 1683, housing the collection of the lawyer Royalist and antiquarian Elias Ashmole, whose

cache of curiosities, including the stuffed body of a dodo, were crammed inside cabinets alongside Oxford University's existing collection, and offered delights such as Guy Fawkes's lantern to thrill the visitors.

Until the 1820s the British Museum had been the only public collection in London, and the need for overarching governance of the City's antiquities was only a recent thought. For as long as anyone cared to remember, excavators had smashed through antiquities on their way down and there had been nothing more than a bit of shoulder-shrugging at the absence of a supervising antiquarian. Passers-by could take whatever they fancied unchallenged. But extensive civic works on deep sewers and the new approaches to London Bridge had brought a bumper archaeological yield, and the ensuing chaos forced City authorities into committee rooms to thrash out some new rules. Now building companies were expected to hand finds over to the Royal Exchange committee, an institution founded in the sixteenth century by the prominent merchant and financier Sir Thomas Gresham, to act as the centre for commercial activity in the City. Professional protocols were emerging, slowly, but the old connections forged on the street and in the pubs and dealerships were still the most expedient.

Harcourt and Esher had used everything in their power to finance their new Museum (the businessman and philanthropist Harry Waetcher had deposited £30,000, the equivalent of four million pounds, in a secret bank account for acquisitions, and was made a baronet the same year the Museum opened).[2] They had exploited their personal associations, and their silver tongues, polished at the despatch box, to secure royal patrons:

the new King George V and his consort Queen Mary, no less. Esher had been close to King George's father, Edward VII, and had helped to organise his coronation, so he was already a familiar figure in the new monarch's inner circle. He had even travelled up to Balmoral to sweet-talk the king into lending the state apartments at Kensington Palace, where Queen Mary had grown up, as a temporary first home for the collection. (This was not a stretch for Esher, whose connections were so fabulous, and reached so far back, that he claimed to remember sitting on the lap of an old man who'd played the violin for Marie Antoinette.)

This was London after all, *Londinium*, Shakespeare's London, Elizabeth I's London, at the centre of the empire – the centre of the world – and it demanded its own museum.

As luck would have it, the previous queen, the recently widowed Alexandra, already wanted a permanent collection for royal costume and Victoria and Edward's relics, and she and her daughter-in-law Mary agreed that a royal 'treasure box' could be part of Harcourt and Esher's vision. Just prior to the Museum opening in 1911, Esher had visited Queen Mary at Balmoral to catch her before she set sail for India and the 'Delhi Durbar'. They had sorted through her possessions, selecting pieces for the Museum and organising labels.

Esher had presented George Fabian Lawrence to the royal couple for the first time at the private event in advance of the opening in 1911, where Lawrence witnessed first-hand the queen's seemingly genuine passion for the project. They had stood opposite each other, just five years apart in age, although she was much taller. Meeting her, according to society diarist Henry 'Chips' Channon, was 'like talking to St Paul's Cathedral',

but they had a chance to size each other up, however fleetingly, and struck up conversation. Both considered themselves competitors in their extensive knowledge of historical objects and the joys and practical challenges of collecting, and others may just have been able to detect the early pulses of a mutual understanding and solidarity. Esher ushered the royal party along the line before either could overshare.[3]

The Museum's opening to the public at Kensington Palace had been put back following protests by Suffragettes. After smashing hundreds of windows in London's West End, the demonstrators made a detour to break some of the glazing in Harcourt's house on Berkeley Square, but Esher rallied the troops and orchestrated an opening fit for a new king and his queen consort. Queen Mary's personal interest in the development of the London Museum had been instrumental in raising its profile, and her passion for art, artefacts and jewellery had helped bring in the necessary funding from the gentry.

By 1912, Esher was no longer in the government, but he was a do-er with a top-drawer CV. In charge of national defence after the Boer War, he had served as permanent secretary to the Office of Works, where he had undertaken courtier-like duties to Queen Victoria in her older years. He was not easily intimidated or short of ideas for a workaround. If he wanted something to happen, it happened and he was an enthusiastic champion of new technology. He had overseen the construction of a lift at Windsor Castle to get Victoria – in her dotage – upstairs, and would push the queen around Kensington Palace in a wheelchair while she talked about her childhood years there. It was Esher who put electric lights into the London Museum.

Gathered in Laking's flat, the excited experts discussed a plausible burial date for the Hoard. An interesting technical question in itself, more importantly it was key to unmasking the identity of the burier and their possible motives. This enigmatic person's silhouette had already taken up lodgings in their minds. The group placed the date of the burial at the end of Elizabeth I's reign, going by the fact that many of the settings were Tudor. It was a tricky call. The constituent parts were a jumble of ages, evidently crafted at different points in time, collected up over years and years from many sources; ancient and medieval stones put into 'modern' settings, finally going into the ground all together.

Although the Hoard was a great mixture, there was an internal logic of design and style to the collection imbued with the personal taste of the individual who brought it together, and made it seem deliberate and a coherent whole. The burier was a strong presence as a result, even though they remained a faceless and nameless figure.

Laking confirmed that if discovery had indeed been made in a cellar under 30–34 Cheapside, the Hoard was more than likely the property of a working jeweller. The cellar was directly underneath the old Goldsmiths' Row, that had enjoyed a continuity of use since the fourteenth century. Some of the pieces in the collection were broken or loose, assumed to be in for repair or resetting, and there were tools and turquoise cuttings mixed in with the cache, bolstering this theory that the collection was a jeweller's stock-in-trade. The Goldsmiths' Company would have a claim, as could Wakefield. And the City of London. There was great reward at stake

but punishment if those in charge at the London Museum overstepped.

After the protracted meeting at Cleveland Terrace, Harcourt asked his aide to write a discreet note. 'Dear Mr Laking,' wrote Armstrong, on 4 July 1912, 'Mr Harcourt would be glad if you could bring the recent "find" here a little before 10.30am on Wednesday next, 10th, in order that he can show them to Sir Robert Chalmers and Sir John Mellor, the Treasury Solicitor, yours very truly'.

The treasures were then conveyed to Harcourt's home address, an elegant Georgian building on Berkeley Square in Mayfair, its smashed window now fixed. Here, the rumour was, he kept the gems and jewels on the shelves of a large, velvet-lined cupboard. Today the building is the Savile Club, still boasting one of London's great entrance halls. No doubt many strong drinks were ingested as the men discussed how they might stay on the right side of the laws and bylaws and keep hold of the treasures. For that matter, what were the laws and bylaws that bound them?

None of them would have noticed that a man's finger ring with an opal cameo of St George and the Dragon was missing from the consignment. They had no idea of its existence.

The treasures were then taken from Harcourt's residence to his bank, where two legal knights from the Treasury solicitor's department came to view them. Acting on behalf of the Crown they decided it was indeed 'Treasure Trove', and therefore Crown property. Still, no one had informed Mr Waldo the coroner, as they were obliged by law to do. Some of it was to be taken to the British Museum, where Harcourt was a trustee,

but the greater part was to remain in the custody of the trustees of the London Museum.

Officially, this majority portion of the treasure went into Harcourt's bank deposit box in a vault at Child & Co. The most conspicuous objects – the diamond and emerald salamander, the emerald pocket watch, the pomanders and the jewel-heavy earrings – probably went into a strongroom box. But a great many others did almost certainly not.

Likely Harcourt and Esher moved hundreds of treasures into the wood-panelled offices in the Museum's apartments at Kensington Palace. The men had an unwieldy volume of objects to marshal, and plans still to make. The back-room staff working around expansive mahogany desks in the warm glow of candles and kerosene lamps would not be consulted. The treasures, boxes and boxes of them, needed to be kept low profile while the disputes raged on. They were certainly not for display and were spirited away, probably behind a locked door, while the dust settled. It was now the middle of July, a month after the navvies arrived at 7 West Hill with a special delivery.

In the City, the legal paperwork was flying. The Treasury, on behalf of the Crown, had granted the Hoard to the London Museum, but apoplectic Corporation officials rifled through filing cabinets looking for the tea-coloured documents that would seal their rival claim to the title.

The treasures were testing the strength of the gentlemen's agreements to breaking point. Turns out – with treasures as beguiling as these – the 'good chaps' would not necessarily play fair. In the end, the Treasury's ruling on behalf of the Crown stood. The Hoard belonged to the Museum of London.

For now. An allegation began to circulate that Harcourt and Lawrence had been involved in nefarious activity to secure the Hoard and had agreed a private clause with the developer of Wakefield House. The rumour was they knew more about the details of the discovery than they ever let on. I don't think, on balance, they did. I think the rumours started because of the admittedly strange coincidence that the treasures had been found in Sir Charles Wakefield's building. It had to mean something. Chaos and cock-up was not expected of men like Harcourt, Esher and Wakefield, on course to be Mayor of London. And the silence encouraged the speculation.

The staff at the Museum offices at Kensington Palace each had a part to play. Harcourt, Esher, Laking and Lawrence had beaten the City Corporation to the lot and they all knew the drill, closed ranks and said very little to anyone. Required only to sit tight and ignore the legal memos, and if they said anything at all, to act with discretion and stay on message.

The eldest of the staff, now on Hoard guard duty, was Guy Laking's secretary, Frederick Harman Oates, a man with a steady hand on the tiller of the day-to-day Museum business, with a reputation for being something of a sycophant who would do the bidding of his aristocratic bosses almost before they had asked him to do anything. Laking and Oates had become friends before they became colleagues, and, although Oates at nearly fifty was over ten years older, with whiter hair and a rather joyless, come-on-enough-of-that-let's-get-on-with-it expression in photographic portraits, they had bonded over a shared passion for collecting antiquities, specifically finger rings. Oates's passion for rings overflowed the bounds of his official

responsibilities at the Museum. He could spot an interesting ancient gem on a finger anytime, anywhere. Laking and Oates had first encountered each other in a railway carriage when Laking admired the ornate decoration on Oates's hand, and Oates countered with 'I see you are looking at my ring. That ring belonged to Joan of Arc.' Quite the opener (and catnip to Laking, a scholar of armour as well as rings, who had written a precocious essay on 'The Sword of Joan of Arc' at prep school when he was just ten years old). Oates didn't have the scholarly prowess of his friend. His collecting was more of an anorak's obsession – and since the objects he chased with particular fervour were ancient finger rings, his reaction to the treasure's arrival, and the abundance of rings inside each box, must have been quietly seismic, his hands sifting carefully through the finer objects as he sorted them for storage, trying to control a trembling hand as he found each one, picked it up and examined it, ring after ring after ring, cameos and intaglios, with their little discs of coloured gems on ornate gold bands, reaching for his spectacles to see what tiny mythological pictures and scenes were scratched into each piece, or ingeniously carved out of a banded stone to reveal different colours. In the mix was a ring set with a cameo portrait of Queen Elizabeth I 'cut in a rather unusual three-layer onyx, the brown serving for the dress, the white for the flesh, and the black for the background'.

The previous year, 1911, a ring like this, the supposed 'Essex Ring', had come up for auction at Christie's and caused a stir. The band, a gold setting containing a similar 'cameo' portrait, was said to have been given by Queen Elizabeth I to her favourite

courtier, Robert Devereux; it was decorated on the back with enamelled forget-me-nots, secret knowledge for the wearer not the public. (This was a doubly poignant design: first serving as a poetic testament to the queen's devotion, but more so when you consider she eventually had Essex executed for treason.) It was bought for $17,000. So many rings in the Hoard were of comparable quality and interest.

Oates at one point in his past life had made his living as a 'commercial traveller', a timber salesman working on the road, and Esher and Harcourt enjoyed ribbing him. They gave him the nickname 'Titus Oates' after a seventeenth-century pauper priest, lampooned in his day as a fantasist, who invented a Jesuit plot to kill King Charles II, thereby starting a mass panic of anti-Catholic feeling. Still, the gentlemen at the Museum found Oates's skills useful when they needed to get things moving in and out. He was a good salesman, after all. And he knew what he was looking for to fill the gaps in his collection.

If a visitor had taken the opportunity to observe the men at their daily business, slipped into the offices at the London Museum and found a dark corner for a vantage point, the real sport would have been to spot the little trades between Lawrence, Laking and Oates, exchanges of rings particularly, cautious hands sliding small and intricate objects across desks into puddles of light spilled from the brass lamps, where they could be appraised and dated, specialist knowledge shared, the finer details argued over, 'gifted', one to the other, just for a day or two, put into a lockable desk drawer or a briefcase. *Here's one for you. You'll like this one, Sir. What d'you make of this?*

They held piece after piece up to the light, squinting, commenting on any unusual features, puzzling at origins, logging the consignment.

In close proximity to all this activity was young Maurice Edgar Read, the typist for the group, a working-class boy of eighteen, with a melancholy expression, smudges of fatigue under his eyes, only five foot three inches tall, a typical stature among his peers. Read lived at home with his father, the youngest of six children, in Stoke Newington. A visitor would observe him typing away, keeping himself to himself, listening to his employers process the objects and marvel when something really special emerged. Was Read allowed to look through the Cheapside treasures himself? The London Museum was a community in which absolute discretion was expected; a microcosm of the class system, with employees ready, or obliged, depending on where they were in the hierarchy, to turn a blind eye.

Harcourt, however, was not in complete control of this situation. Thanks to the British Museum agent with the receipt from Percy Webster's, he and his trustees knew the navvies had not brought Stony Jack everything. Far from it. The receipt proved that individuals way down the food chain had got first dibs. One faction at least had skimmed some pieces off the top and sold them on. Harcourt had to consider what else, if anything, they had taken. And what sort of thing they should now be looking for. Would the men have chosen pieces that looked to them exceptionally valuable? Or gone for those *less* obviously valuable and therefore less likely to be missed?

One witness claimed the navvies had continued to bring additional jewels from the Hoard to Lawrence at 7 West Hill

for a month, a full two weeks after the rest had gone into the custody of the London Museum. Why had the men kept these extra pieces, and not sold them on? Why the time delay? Had they developed guilty consciences, or fallen out over what to do, fearing they would be caught bang to rights? Some of the navvies 'were not seen again for months', suggesting they did sell other items, presumably to dealers like Webster. A piece of jewellery converted under the counter to a bit of cash offered a short-term reprieve for a person living within a fingernail of falling into a deep financial hole.

As soon as Lord Harcourt got wind of the workmen's thefts he instructed his trusty agent to hunt down the men, buy them out, and bring the items back pronto. Lawrence's portrayal of the ordinary man thrust into the limelight masked his role in a whole other drama, a sketchy business, playing out behind-the-scenes. A bartering and retrieval operation saw Lawrence traipsing from place to place in the rain, hat tipped down, his pockets full of cash in paper envelopes. All this pub-crawling and strong-arming was going on during the wettest British August on record, which culminated in storms and floods at the end of the month. Word leaked into some sections of the press that Lawrence had visited the public houses where the workmen drank (it was a circuit he knew well) and that he was out there scoping out the public bars, hunting the stray and stolen pieces himself, persuading, maybe warning or even threatening, to close the deal. He recovered the jewels by buying them back 'at a modest price', doing Harcourt's dirty work. Like the navvies, he was not closely supervised, and faced opportunity and temptation at every pub. On 12 August,

Harman Oates asked for a receipt for £1 3s 3d 'for the little oddments'.[4]

Lawrence was a man preparing for the future and would have expected prompt payment of account for services rendered. Harman Oates had already sent him a cheque for ninety pounds (around £12,000 today). Whether this was the full amount paid by the trustees for the Hoard is not clear. All parties made high octane back-of-the-envelope calculations: how much was this treasure worth? And what was Lawrence's cut of that?

Havana and cheroot smoke mingled behind closed doors at the Museum as Harcourt and Lawrence came to private arrangements. Harcourt appears to have agreed a reward-in-kind in return for Lawrence going the extra mile in search of the stray treasures. He apparently had no problem being vague with the paperwork if it smoothed things over and silenced any grievance. Lawrence, it seems, was allowed to 'retain' a piece from the collection if he agreed to 'loan' it straight to the Museum for exhibition. He secured technical ownership of a delightful gold-and-enamel chain with a 'true lover's knot' motif, if not its physical custody, so the collection would be kept together for the benefit of the public. There would be no suggestion of impropriety or need for any records.

It was a year for tall stories. While the stragglers from the Hoard were retrieved from the pubs of London, in Sussex an amateur archaeologist by the name of Charles Dawson was piecing together a Frankensteinian jigsaw of baboon and orangutan bones. He then contacted the Natural History Museum to inform them he'd found fragments of a human skull in gravel beds near Piltdown in East Sussex. This scheme to hoax the

establishment promised to put him in a line-up of the Great Men of science after Charles Darwin. In December, the Geological Society announced with great excitement the discovery of the 'missing link' between man and ape – remains of a jawbone and teeth estimated to date back 500,000 years.

Just up the road, the Hoard continued increasing in size, a piece at a time, in the offices at Kensington Palace. A month later 'Lawrence had somehow or other got hold of a few more jewels' and he brought 'four or five' more items to the top hats at the London Museum.

Which pieces were where, how he got hold of them and how he squared the delay with his bosses at the Museum we're not told. He was not mixing socially with men of their standing, sharing confidences gentleman-to-gentleman after hours in the clubs of St James's, so it's notable that they allowed him such leeway in terms of what he brought them, in dribs and drabs and extra 'oh, here's another one behind the sofa' style deliveries.

These four or five pieces could be evidence of very late second thoughts. That Lawrence himself had kept some back at the flat and omitted to include them in the original delivery to the London Museum. Was it Lawrence, believing he hadn't been paid enough for the trove, who took the five pieces to Percy Webster's himself, to sell? I think, on balance, the money talked as it was offered in the pubs and the original light-fingered navvies emptied their pockets.

The wrangling over mutually acceptable terms evidently continued for some time. There are hard facts to land on in the accounts book at the Museum. Lawrence received a salary increase, to £240 per year, which was forty pounds more than

Oates, and no doubt a shock to many, not least Oates. In August 1913 he was paid an additional forty-seven pounds for unspecified purchases for the Museum. H.V. Morton entered the discourse again, confident as ever, and put a figure on it. 'I believe Lawrence declared this as treasure trove and was awarded a large sum of money, I think a thousand pounds' (over £140,000 today).[5] Was this accurate and, more importantly, did Lawrence think it was enough? A fair cut of a world-recognised Treasure Trove was a life-changing amount of money. A fortune.

The trustees had to clamp down expectations about money – with treasure, a sense of entitlement could flare up and spread quickly through the ranks. In the event that staff griped about payoffs, the counter line was the trustees, the nation and future generations owed Lawrence an extraordinary debt of gratitude for preserving the Hoard and bringing it to the London Museum. Lawrence was the sort of salt-of-the-earth man upon whose conscientiousness the country and the empire was built. He had delivered a gift to posterity: a miraculously intact hoard of treasure, complete to every single piece.

Morton's account of the first evening is a journalistic impression: many details are true, but colour-tipped like a postcard of the period. It's clear some of the pieces we imagined Lawrence and May washing in the sink that first night were, in fact, still to make it to West Hill. No less real, the heaviness of their gold and the stones extant, just a little later than billed by Morton.

One of the 'four or five' items quietly added to the pile several weeks after the discovery was probably a ring with an opal cameo of St George and the Dragon. It hadn't arrived at the Museum with the original consignment. Lawrence had reason

to feel justified in retaining something small, as a deposit for a rainy day. He had not been paid a fortune for his role in the discovery and he always shared the spoils and expected fair dealing.

The George and Dragon ring could well have been 'his' on a similar arrangement to the gold-and-enamel neck chain with the 'true lover's knot', as another verbal agreement between gentlemen. Most likely Lawrence, a renowned expert, had thought himself best placed to care for a subtle and relatively plain ring whose value and importance others would overlook. With good reason. But then he thought better of keeping treasures at home, even second-tier ones, as it risked his livelihood and reputation, and decided to throw it back in the mix.

The ring had become separated from the body of the Hoard but had rejoined it, establishing a pattern of being in and out of the collection, and a contingent relationship to the rest of the treasures, that only enhanced its mystique.

For that matter, the Hoard itself would have confused anyone who attempted to account for its contents. The parameters around it were permeable, leaky, and there was no inventory, let alone a comprehensive one, or any official record of what had been added or taken after 1912. It was no longer possible to be sure what the Cheapside Hoard *was* and what, exactly, was in it or what might be missing.

Neither Lawrence nor the Hoard were solid or reliable propositions. The longer you look at the shopkeeper and dealer, really squint, the more unstable his unassuming 'everyman' image becomes. In one of his black-and-white photographs for the press he stands proprietorially outside his premises and looks back with blankly astonished eyes, deep as black holes, behind

the spectacles, as if he's seen a ghost, but polite enough not to scare it away. Outwardly calm, he lets you know his geniality is conditional, that unpaid dues are remembered, and they are accruing interest. For all the world he seemed uninterested in money, but he was a practised stockpiler, holding out, unwilling to surrender until debts were paid.

CHAPTER V

A Pawnbroker's Son

George's father, Christopher Lawrence, a 'dealer in unredeemed pledges', was born in 1836, on the eve of the Victorian era. His childhood was spent catering to the day-to-day needs of a slum neighbourhood packed inside the walls of the old City, and taught him all about the precariousness of survival.

His son grew up with his brothers and sisters above the family pawnbrokers at 49–50 Beech Street, next to the church of St Giles-without-Cripplegate, and served his apprenticeship in a business that taught him formative life lessons. The well-oiled Lawrence operation did its best to strip personal possessions of sentimental attachments and repurpose them as assets to leverage for cash, or as bargains for someone to snap up if they remained unclaimed.

The shop sign displayed three golden globes hanging from a bar and signalled the nature of the business. Theories swirl as to what the globes in the pawnbroker's symbol refer to. Some say they are three gold coins for Lombardy, where the pioneer pawnbrokers plied their trade; or the family crest of the Medici, Europe's powerhouse bankers and credit-fixers; or a nod to St Nicholas who supposedly loaned three impoverished young girls a bag of gold each as dowry. The shop's door opened discreetly on a side street so no one could see a client slink in or slink out,

and the jumble of unredeemed pledges in the pawnshop window would have looked at first glance much like Lawrence's antiquarian display in later chapters of his life. Dickens described a pawnshop window of similar vintage full of once-cherished possessions: 'several sets of chessmen, two or three flutes, a few fiddles...some gaudily-bound prayer books and testaments, two rows of silver watches...numerous old-fashioned table and tea spoons...cards of rings and brooches...cheap silver penholders and snuff-boxes...silk and cotton handkerchiefs, and wearing apparel of every description'.

A notice met you at the door, clearly stating the transaction offered on the premises: 'Money advanced on plate, jewels, wearing apparel, and every description of property.'[1]

People on their way to the Lawrence establishment would say with a wink they were off to see 'Uncle', a pun on 'uncus', Latin for 'hook', from the days before the chute, when pledges were lifted up and down on a hook. 'Uncle' provided a vital service, tiding a person over for food and lodging until they were paid again. For huge numbers it was the only way to raise enough cash to get through a week. Clothing, often Sunday best, was useful capital and was typically pledged on a Monday and redeemed on a Saturday when you'd been paid. Saturday, redemption day, was a busy day, just as it was for George and his navvies. You could then wear your best clothes to church on Sunday, and pledge them again on Monday, and so on.

Pawnbroking wasn't always such honest social work. Criminals would pawn things and never come back for them because they were stolen goods and had become hot property. A seasoned pawnbroker would be able to tell if a pledge was

a family possession, offered in the usual pattern of pawn-and-redeem, and would loan a lower amount for something that had been pinched. Christopher Lawrence will have known all the police, and many of the local criminals. His name appears several times as a witness at the Old Bailey in trials of alleged thieves. He taught his son the ways of the double agent.

The pawnbrokers at Cripplegate were a stone's throw from the northern entrance into Roman London, a little way west of Mile End, Christopher's place of birth. Sections of the old Roman fortifications were still visible and beyond it, the medieval church, St Giles-without-Cripplegate, dedicated its work to the disabled, lepers and beggars. The name of the area may have come from Old English 'crypel-geat', 'one who can only creep' – you had to stoop to get under the gate's low arch – or refer to the poor souls begging alms from travellers as they entered and exited the City, or, more prosaically, descend from the Anglo-Saxon 'cruplegate', a covered way or tunnel. The Roman gate became a storehouse and a prison and, when George was a child in the 1860s and 1870s, the area was crowded with businesses supporting the communities living even further East. The Roman walls were there to touch and climb and offered a view west, to less crowded parts of the City.

Christopher had been raised east of there, in Mile End, the son of a horse-collar maker – his father, William, had left his paltry effects to a creditor, a leather-worker on Drury Lane – and moved in the right direction, building a new business from scratch. He married Mary Fabian in 1859, a Wandsworth girl, and the root of the connection to the area, who had grown up around the 'noxious trades' there, the glue, soap, candles

and gasworks, and grafted for a better life. By 1861 they were living with their new daughter, Anne Mary, and earning a living through 'general sales', employing 'a man and a boy'. George was the eldest son, with his brothers Arthur and Alfred, coming after, two years between them, and got a few years of basic education 'for the commercial classes' at Finsbury College. As soon as they could, the Lawrences took their family – Anne Mary evidently did not survive – to a leafy area to the north of the City, near the fancy, newly laid-out Clissold Park and Crescent, where the family were not above the shop anymore, but in a house. By eighteen, George was a pawnbroker too; his brother Arthur was a 'meat salesman', and his younger sisters Emily, Ruth and Hester still at school. Alfred had been left over the pawnshop to run things back in Beech Street, Cripplegate. Christopher moved everyone again, setting the family up in a roomy villa in middle-class Brixton, and by 1891 the family had four servants living with them, the proof of middle-class status. The patriarch was now listed in the census as a 'Gold jeweller' and the business was in bigger premises, at 55 Wandsworth High Street, with its own three golden orbs out front (probably thanks to Fabian connections). George was a 'Pawnbroker Manager' and living above a new shop on West Hill with his wife, Florence Emily.

Alfred, George's youngest brother, a beautiful young man, the quintessential optimistic Edwardian youth, with blue eyes and fair hair, finally escaped the old shop in Cripplegate and emigrated to Australia where he quickly built an electrical company. The country was running enthusiastically into the electrical era and a rush to make Queen Victoria's jubilee a spectacle

meant boom time for the company. Alfred snapped up a savvy Australian wife, and a rich partner investor, the business went public, and then won the role of national provider, and soon scores of 'Lawrence and Hanson' branches were lighting up Australia's growing cities in festoons of blindingly bright bulbs. Alfred and his wife sailed back to England to see his gravely ill mother, Mary Fabian, who had also fought to make a better life for herself, but she died while they were at sea.

The lights quickly dimmed for Alfred soon after their return to Australia, as his health deteriorated. In the midst of the crisis he sold his stake to his partner Hanson, and left his wife and children behind, sailing back to England, where he was committed to Bethlem mental hospital in South London, near his brother George and the rest of the family, aged thirty-six. The admissions log described him as a 'Retired Merchant' and a 'Lunatic'.

The widowed Christopher Lawrence married again, to Emily Hall, and moved into a pretty terrace nearby, doing well enough to retain a servant despite the smaller household, and would often join the gatherings at West Hill until his death. Ruth and Hettie, George's sisters, took up positions as 'jeweller's clerks' on Wandsworth High Street, waiting behind the counter to see who and what would come in, wanting to buy an engagement ring, or desperately searching for a lost or stolen piece that might have washed up at the establishment. Or asking if it was possible to get a loan against a brooch, just until Saturday.

Lawrence and Flo remained vigilant for signs of Alfred's nervous troubles in his nephew, their son. He was coming up to the same age as his uncle had been when his illness began in

earnest. They had no expectations their son would take over the family business and he hung on to his position as a solicitor's clerk, but fortunes rose and fell in their family and it paid to be forewarned and prepared.

With his frequent visits from just down the road, Lawrence's father remained a powerful presence in an already densely populated flat. A new production of Shakespeare's *Hamlet* had opened at Drury Lane and, soon after, a silent film of the same production came to cinemas in Wandsworth and around the country, starring Johnston Forbes-Robertson, one of the great Shakespearean actors of his day, with aquiline nose, chiselled cheekbones, sweep of hair and huge almond eyes brimming with emotion and pain as he catches sight of the 'Ghost' of his father, an apparition achieved through double exposure of the film. Even after death, Christopher watched his son, challenging him to justify his actions.

At his desk at Kensington Palace, Lawrence appeared composed. No one at the Guildhall or the City of London Corporation was fooled by the line coming out of the London Museum or by Lawrence's vow of silence about what happened in the summer of 1912. A few of the most spectacular pieces sat in a vault at Child & Co., but most of the treasures were in boxes in the offices in the custody of the Museum of London, when the staff had the bounty to themselves, behind closed doors, easy to access, away from prying eyes, auditors or audiences. The location of any other pieces was anyone's guess.

CHAPTER VI

Insider Trading and the Egyptian Book of the Dead

Events would force far more public scrutiny. The arrangement with the royal family to occupy Kensington Palace came to an end and the philanthropist Lord Leverhulme offered new central London accommodation for the Museum on a long lease. Lawrence, Laking and their colleagues were obliged to set to work on the mammoth task of preparing the collections, including the Cheapside treasures, for the move across town. More than that, the attendant publicity would bring the Cheapside treasures to the front of people's minds, and prompt more questions as to their exact whereabouts. Now was the time to decide which pieces they could keep in their own considerable collections, and what would go to the new Museum site.

The in-house bargaining picked up pace and Lawrence was the impresario in the midst of it all; the whispers, brass handles clicking discreetly as doors closed. And a big game of furtive pass-the-parcel began. Rings set in simple designs with sapphires, emeralds and garnets, whose date and style winked to anyone who knew about such things they came from the Hoard, some of them missing a few stones out of the settings.

This casual circulation of objects relied on trust between gentlemen and the absence of any robust curatorial practice.

The staff had been free to make all sorts of off-the-record arrangements for further study or safekeeping off site; they were scholars after all, a piece or two in a briefcase or a Gladstone bag on their lap or in a jacket pocket. Lawrence and his colleagues were artfully casual with the recordkeeping, in relation to the treasures' movements and current whereabouts. The staff were given free rein to move objects in an atmosphere of laissez-faire.

Lawrence was an invaluable employee for his gentlemen bosses, a fastidious cataloguer when no formal system existed for identifying, authenticating or protecting objects. He was also well known to be partial to a vague description when it came to the provenance of the objects he intended to sell on, sometimes it was just a scribbled note with the date and the name of the street, but his impeccable eye for antiquities had been learned on the job, his expertise earned through the thousands of objects that passed through his hands every year. Lawrence's home life, playing out somewhere in the suburbs, held little interest for his employers. There was talk of a grown-up daughter confined to the small apartment, and a son stalked by an illness that ran in his family. Henderson the security guard would testify to the truth of the rumours that Lawrence's daughter, May, styled herself as a 'psychic medium', operating on the quiet out of the poky flat above the Lawrence business premises.[1]

The running inventory of the Hoard was in such a constant state of flux as to be of very little practical use or professional credibility, and the general lack of transparency suggests indifference from those in charge who were busy with political affairs. The men working under them had every motive to enjoy private access to such wonders as the Cheapside treasures for as long

as it lasted – these rings were a dream come true for a group of obsessive collectors.

Laissez-faire suited their employers. Both Harcourt and Esher brought money and political influence with them, but both left uncomfortable rumours of personal self-indulgence in their wake. 'LouLou' enjoyed as many house parties as any man of his era could possibly cram in around his parliamentary responsibilities, and was well known in society circles for what was euphemistically described by his friend Lord Esher as his 'ungovernable…desire for both sexes'. 'It is so tiresome that Loulou is such an old roué,' he wrote.[2] But he was tolerated, as dangerous men of his age often were, most vocally by the people who were products of the same upbringing. They enjoyed a boundless entitlement that was positively required of men of their class, baked into their emotionally cauterising boarding school education, so that they could run the country and keep the empire in check with the necessary cool head and firm hand. Esher had multiple extra-marital affairs, though unlike Harcourt he was open about his proclivities. Allegations against Harcourt were of a deeply disturbing nature and continued to mount, challenging the world to find them unpalatable. Edward James, who grew up to be a patron of the Surrealists, accused him retrospectively in his memoirs of sexual assault, calling him a 'hideous and horrible old man' and remembered 'something really awful happening' to him when he was 'twelve or thirteen' and on a weekend visit from Eton to Nuneham Park, Harcourt's country home. In his memoir, James also related Harcourt's assault on his fifteen-year-old cousin Dorothy Brett, Esher's daughter, a painter in the Bloomsbury group, and claimed 'the

poor girl got such a shock she became deaf'.[3] Harcourt's personal conduct leads anyone researching it into a dark place. I don't investigate it further as part of this story, continuing on the hunt for treasures, though I acknowledge the uncomfortable fact of this murky dimension. Life during this period was repressed and unpleasant in so many ways – truly another country – but Harcourt cannot be excused by his context. In his post at the Museum, as at home, he took for granted absolute authority to do as he pleased unquestioned, which helps to explain why he didn't care to know what was going on with the Cheapside treasures or to regulate things too closely, and the staff were expected to look the other way, maintain respectability and protect the place from scandal.

The author Samuel Hynes described the Edwardian period as a 'leisurely time when women wore picture hats and did not vote, when the rich were not ashamed to live conspicuously, and the sun never really set on the British flag.'[4] The well-to-do had an optimistic spring in their step. There'd been more than a decade without European war and the public naturally expected the peace to continue. Even the old enemies France, Germany, Austria-Hungary, Italy and Russia – the other 'Great Powers' in the world in 1912 – had been on relatively good terms for nearly half a century. In some ways life was as precarious as it always had been, not least due to the absence of penicillin, so any minor infection still had the potential to run rampant and carry off a person of any class, in a day or two. But for many there was time now, as never before, to enjoy the roller-skating rink in town and find distraction in the popular new indoor game of 'ping pong'. A golden age dawned for the theatre, be

that taking in a show at Drury Lane, or playing Dress Up at home at an elaborate costume party. A person of means with itchy feet could travel untroubled by national boundaries and didn't need a passport.

But there was another craze around town in 1912, along with roller-skating, lawn tennis and 'ping pong', one with a more esoteric flavour.

As Lawrence, Laking and Oates, fellow ancient ring enthusiasts, continued to circulate a few select pieces from the Hoard, a first wave of 'Egyptomania' swept through the country. This craze served as a distraction for the people who might have noticed what certain officers at the London Museum were up to. The years leading up to the war were a particularly good time for back-room trading at any of the City's museums, because many of those in charge were looking to North Africa and the ancient civilisations of the Nile. Some were packing up and going there in person. The parlours and gentlemen's clubs of London were abuzz with stories of long-lost Egyptian tombs discovered by intrepid trilby-and-linen-clad men and whispered hopes of elusive burial chambers still waiting to be found.

The previous century saw the prelude to all this, in the aftermath of Napoleon's Egyptian campaign, which kicked up wonders from underneath the sand, but this was Egypt in La Belle Epoque and a new golden age of Egyptian archaeology was just beginning. In 1912 you could collect John Player cigarette cards of the Ancient Egyptian kings and queens and swap them in the pub. Egypt was under *de facto* British occupation through a 'veiled protectorate', although officially still part of the Ottoman rather than the British Empire, and those with means beat a path

to North African digs, some powered by pure obsession, keen to join in the archaeological gold rush, whether as amateurs or professionals. Many shopped for artefacts at roadside Egyptian dealerships and brought them back in their luggage as souvenirs or to pass on to the museums or private collectors.

Back in Britain, dealers like Lawrence were on hand to receive travellers on their return, taking objects off their hands, and stacking them in their shops, curating a British version of Ancient Egypt for the home market, bits to pick and choose from, beads and mummy's black hands and the ever-popular 'amulets'; charms with supposed protective powers, to be worn in life or after death, in the form of animals like scarab beetles, symbolising rebirth, or body parts, and deities, made out of precious stones or cheaper 'faience' (a composite of crushed quartz, salts and lime). Lawrence's love of Ancient Egypt was there to see for anyone who passed by 7 West Hill. He had hung a Ka as a shop sign above the door years ago. Many shops still had pictures instead of door numbers, Percy Webster's establishment was at 'the Sign of the Golden Time and Dial', but when it came to fitting out his shop, Lawrence chose for himself a three-dimensional Egyptian figure embodying the life force or spiritual double of a person after death. He even handled mummies, like the one that stood in the corner of his shop, and sold them on, at the time a perfectly legal but unregulated trade.

It was probably thanks to his side hustle that Lawrence crossed paths with Howard Carter before the war. Both men were part-time private dealers, with contacts inside the British Museum, to whom they would pass objects. Carter was the archetypal dashing archaeologist, thirteen years younger than

Lawrence, moustachioed, naturally, with a slick of black hair and *de rigueur* Panama hat, billowing linen suits and rolled-up sleeves, a nostril-flaring hauteur and desert stare; he certainly cut the more glamorous figure.

Lawrence and Carter were circling the same feeding frenzy on all things Egyptian, tramping the same London antiquities trade routes, in and out of the Kensington museums, and it was inevitable they would bump into each other.

The international newspaper on Carter's Theban breakfast table in June 1912 told him of the fortuitous discovery of 'the Elizabethan Jewels' in a cellar in London, mentioning the navvies blindsided by what they found, and the shopkeeper Lawrence in passing, whom he would recall from their occasional encounters, for his part in the once-in-a-generation find.

Carter himself was years away from his own legendary breakthrough, still stabbing at the sand with his spade and flinging it impatiently away, hunting for tombs, jostling for positions, and for funding, in the heat and the sandstorms. He had been in Egypt on and off since 1892 and had already worked on high-profile excavations there. Unlike abstemious Lawrence, who used his modest geniality to forge connections, the whisky-toting Carter had acquired a reputation as a petulant loner with a bad-temper, but they had more in common than first appearances suggested, both street-smart with a single-minded drive.

Like Lawrence, Carter was not from the upper classes but he knew his way round them and found himself powerful patrons. Both Lawrence and Carter lacked formal training, Carter because he had been considered too sickly to attend school. Like Lawrence he had earned a living from the age of fifteen,

apprenticed to his father, a jobbing portrait artist. Raised and schooled by a succession of women within his extended family in Swaffham, Norfolk, he also spent a good deal of time at the Amherst family home at Didlington Hall nearby and, while his father worked on his animal portrait commissions, his speciality, Carter would wander around in the family's collection of Ancient Egyptian treasures and fell deeper and deeper under their spell.

Carter Senior had sent his son off to Egypt from Victoria station, aged just seventeen, to see similar objects in situ. He was travelling alone, under Lady Amherst's sponsorship, with help from the 'Egypt Exploration Fund', hired for his draughtsman's skills to copy the images on the walls of the tombs of Beni Hasan, and then Amarna, Akhenaten's sand-buried capital. His father died of a stroke before Howard returned.

Carter's big break came working as an artist for another British star of the Egyptian archaeological firmament. Flinders Petrie (another associate, and source, of Lawrence) brought him into the circle of the passionate amateur Lord Carnarvon, otherwise known as George Edward Stanhope Molyneux Herbert, resident of Highclere Castle, who was rich and Egypt-mad enough to fund ambitious exploratory excavations.

Carter couldn't afford to squander this opportunity, having spent several years out in the cold and unemployed as punishment for standing up to a group of drunken French tourists at the sacred site of Saqqara. The group had broken into the huts of Irish Egyptologist Hilda Petrie, Flinders Petrie's wife, but the 'cook boy' put up a fight, so they barged into an official's house and began struggling with a guard. Carter was called in

as the inspector, and while waiting for the police to arrive he took sides with the Egyptians. He was forced to resign for the undignified spectacle of letting a 'native' resist a Frenchman and his carefully constructed professional life came crashing down around him.[5]

As he scanned reports about Lawrence and the magnificent 'Elizabethan' Treasure Trove in London, Carter was thousands of miles away from home in the desert, and on an insecure footing, but plenty of his countrymen had come to join him out there. The few aristocrats with the money and time to fund an excursion were already on paddle steamers moving languidly between digs, exploring the new frontier, whisky-and-soda-waters in hand.

Not long back, Carter had encountered the Duke of Devonshire leading just such an archaeological party on a chartered steamer up the Nile. This particular boatful had escaped a rainy winter in England and were in Egypt to see and be seen, although the looking part of the trip was a struggle for some, battling the dust and the steep sandy inclines at each location. Ferdy Platt, the personal doctor to the Duke of Devonshire for the adventure, wrote letters home describing the 74-year-old duke, once so fun-loving he was known as 'Harty Tarty' by the Prince of Wales, as hot and cantankerous, and the duchess demanding to be carried up to see the tombs in her chair, under the baking sun. Sir Charles Cradock-Hartopp played cards without looking up, concentrating on his bridge hand as he floated past the ancient sites, and admitted that he had 'never been so bored in his life', and the Earl and Countess of Gosford and their daughter Lady Theodosia Acheson maintained a

disdainful distance from the doctor. Platt was an Egyptologist on the side and could have offered an entertaining and erudite running commentary on the sites were it not for his middle-class manners, which set the rest of the party's teeth on edge. It's a scene straight out of an Agatha Christie novel set on the Nile, and indeed a very young Christie spent the season there as a debutante around the same time and will have encountered many such bands of travellers. On the way, the paddle steamer picked up Asquith's under-secretary for the colonies, and Harcourt's colleague, Winston Churchill, on a stop-over from Uganda, and he hopped on board for luncheon. The steamer also encountered Howard Carter, at the time licking his wounds after the international row he'd caused, now referred to with a wince as 'the Saqqara Incident'. He was a dejected hustler selling watercolours to tourists when the steamer picked him up for the crew to feed and water.[6, 7]

When Ferdy Platt eventually disembarked the paddle steamer his mind was still touched with Egyptian fever and he set to work on a magnus opus translating the Book of Genesis into hieroglyphs. Lawrence and other dealers were the first port of call for culture vultures like Platt who had been trotting about the Middle East and found something interesting to bring home, and to test anything potentially important, many roads led back to the British Museum, and the leading Egyptologist at this venerable institution, Ernest Alfred Wallis Budge.

Budge had been instrumental in brewing the morbid atmosphere that now hung around town, his books disseminating ideas about Egypt and the afterlife. A vast, unwieldy man with a barrel chest and a square, jowly face crested with grey hair, chubby

cheeks and a mole-like expression behind spectacles, Budge was the prominent expert in London on Egyptian religion and hieroglyphs. He wrote many seminal books on these subjects, including *Amulets and Superstitions*, and notably, while in post at the museum in 1895, *The Book of the Dead: The Papyrus of Ani in the British Museum*.

Although there were many different versions, a 'Book of the Dead' was essentially a collection of instructions and spells intended to guide the deceased in the afterlife. These instructions were to be found in manuscripts or inscribed onto tomb walls or sarcophagi. *The Papyrus of Ani, from the New Kingdom of Ancient Egypt*, was considered the finest example of a Book of the Dead, discovered in Luxor in 1888 and smuggled out to the British Museum by Budge himself. Budge presented a translation of the hieroglyphs with a commentary to the illustrations on the papyrus, and a generation of writers, W.B. Yeats and James Joyce among them, took inspiration from the book.

A near direct contemporary of Lawrence, Budge, like so many of his peers, was interested in many aspects of the occult, and he joined a parapsychology and alternative religions study group with its roots at Cambridge University, called the 'Ghost Club'. The group had Charles Dickens and Sir Arthur Conan Doyle on its early membership roll, and Yeats joined in 1911, perhaps hoping to discuss the *Book of the Dead* with its author – a famous raconteur – in person. Budge was also a member of the free-thinking Savile Club at 107 Piccadilly (before it moved to Lord Harcourt's old house, where the Hoard had spent a few days in a cupboard), another melting pot of artistic and high society, where he captivated members with his stories of

Egyptian curses as well as English country house hauntings, and he became a highlight of many weekend parties at large estates, where, up-lit by a guttering candle, he could hold a packed room in the palm of his hand. Some of these guests would return to the Garrick, their club in town, where actors and theatre managers talked to Guy Laking about the technical challenges of staging Shakespeare's ghosts.

As the men packing up at the London Museum compared notes about *who* had *what*, and discussed how they might go about rationalising the paperwork, they heard snatches of gossip, second-hand stories from wives and picked up in public houses, about the 'Unlucky Mummy' at the British Museum, a wooden coffin lid painted with the image of an Egyptian princess, that brought death and disaster to anyone who owned or researched it. The rumour was that it had gone down with the *Titanic* as it was being transported to New York.

The stories of bad luck connected to the painted coffin lid with the enigmatic face had, in fact, been concocted by the journalist William Thomas Stead, a masterful spinner of tabloid tales, and the coffin lid had not been on the ship. This mistake is explained by the fact that Stead, in a horrible irony, *had* been on board, and when he was discovered to have drowned in the disaster, his made-up story was subsumed into the real tragedy. Nevertheless, the misinformation did the rounds, enhancing the heavy sense of horror and foreboding in the air, seeping in under doors and swirling around the offices at the London Museum.

The business of preparing for the London Museum's imminent move continued. Several of the gems set in the rings in the Hoard featured figures from Ancient Egyptian mythology,

recalling the first wave of Egyptomania that swept through ancient Rome, when the Romans went crazy for its gods and symbols (and pillaged their standing obelisks, leaving more surviving examples in Italy than in Egypt).[8] What was in or out? Certain items weren't going to make it onto the inventory or into the boxes for the move. Here, flashes of gold, there, a watery-grey stone, a delicate dark-red flower, a small green rosette between thumb and first finger. Some remembered pieces were missing, cue scratching of heads, winks and promises to have a look for this or that.

The men at the London Museum had waited backstage for two years, giving nothing away about when the curtain might go up on an exhibition. The trustees understood their obligation to show the Cheapside treasures to the public: that expectation had come when granted custodianship. But a show would mean telling the story of the Hoard, what had been bought, sold or stolen, and where it all was now, bringing pressure to stage an exhibition by way of a confident answer.

As the treasures from the Hoard circulated Museum offices, so did idle chatter about other so-called 'mummies' curses', with their warnings to archaeologists about the folly of taking what wasn't yours, of desecration, talk of punishment. All confections, but enough to make you think twice before breaching a burial chamber and taking something away. Conversations turned again and again to the very-long-dead, their possessions and the messages they had left behind.

In this atmosphere it was natural to wonder, as they picked up each of the individual pieces of Cheapside jewellery, who had made them, and who had commissioned the portraits, scenes and

symbols to carve out of them, what their intentions and wishes had been and what the repercussions for taking them might be.

Harcourt and Esher were seen more around the offices, buttonholed by Laking, who was keen to get ahead of the game to discuss plans for the exhibition of the Hoard once they were in. All hands on deck to label the crates, and these were brought out into the fresh air and loaded up, and the charabanc moved off through Kensington Gardens with the boxes containing the Cheapside treasures on board, heading towards St James's. The more spectacular jewels were still in the bank, but this collection would now have to face the public.

CHAPTER VII

The Hoard on Show in the Glittering Gold Room

In early 1914 the London Museum moved into Lancaster House, a magnificent neoclassical Bath-stone mansion on the Mall, near St James's Park, with Louis XIV rococo interiors echoing Versailles, the French palace an achingly fashionable 'mood board' when the Duke of Sutherland commissioned his London building in 1815. The Lancastrian philanthropist and soap magnate Lord Leverhulme had bought the mansion – with its spectacular sweeping staircase – for the nation under its original name of Stafford House, renamed it in honour of his home city and handed it over on a long lease to the Museum.

Laking clearly experienced some logistical challenges, not least persuading Harcourt to retrieve the high-profile jewels in his bank vault. On 4 January 1914 Harcourt wrote to him: 'As to our jewel find. Will it be inconvenient to you if I do not get them out of my bank till after the 21st January, when I will return to London for good [from Nuneham Park, Oxford]? If, however, you really want them earlier…'.

Guy Laking described the preparations that followed as 'Rather like a Drury Lane production, when the day for the performance is fixed, things are a little behindhand.' Rehearsals were fraught and not without technical hitches, pacing and

preening. He asked Harcourt to come for half an hour to 'walk quietly with me through the finished galleries. I do not mind telling you now I am feeling the strain a little, and a certain amount of responsibility.'[1]

The grandees had reason to be nervous as they practised the choreography of their graceful hospitality. The opening was a public assertion of ownership over the Hoard by the London Museum, but it would open them up to questions from the press about what had really happened in June 1912.

And then, in March 1914, in what was to those outside the Museum a dramatic and unexpected move, 'the Elizabeth Jewels' were finally put on display in a landmark exhibition.

The only public announcement of the exhibition appeared in *The Times*. The rest of the press were taken by surprise, but attended a reception on 18 March, and 'Mr Joicey', a generous donor to the Museum, 'thoughtfully provided champagne' for them. The next day the Museum was 'closed for cleaning'[2] and, the day after that, the royal family set out for a private view, arriving to the shutter-clicks of cameras hoping to capture them in the wild. King George V and the queen consort entered the building through the annexe, Mary caught by photographers in a splendid feathered hat and fur coat, George V in a top hat and tails, with their young prince and princess in handsome winter capes.

The king and queen were on constant high alert. That spring they had been running the gauntlet of the Suffragette demonstrations when travelling to public engagements and back again. Getting nowhere with Asquith, the demonstrators were

now claiming an ancient right to petition the sovereign and had besieged the monarch's carriage to deliver the paperwork in person. After the death of Emily Davison under the king's horse at the Epsom Derby the previous year, nothing could be taken for granted. The incursions caused a scene and looked undignified, and the queen was witheringly rude about the protestors – 'horrid' and 'tiresome' – but she would confess to family she found the incursions genuinely terrifying. '[A] constant and additional anxiety to our Tour', she told her aunt in a private letter, referring to a Scottish visit, '& tho outwardly I mercifully look calm, inwardly my heart goes pit-a-pat when a female dashes out to throw papers into the carriage.'[3] She was looking over her shoulder even as she swept regally into the London Museum, looking straight ahead, with her usual implacable expression.

It's worth considering that the queen liked to arrange secret pre-visits before her official ones. She had, for example, visited the London Museum in Kensington the night before the press photographed her at the official opening. If this past behaviour was anything to go by, she had also rehearsed this event, without her costume, and already picked her favourites out of the Hoard, perhaps even secured a few pieces on promise. One credible scenario is that Harcourt invited her to his house on Berkeley Square to have a look while he had the treasures stuffed into the roomy velvet-lined cabinet, or she forced an invitation, more welcome company than the coroner. She will have hunted the treasures down as soon as she heard about the find, but she feigned surprise and played fairly convincingly the part of someone who had not seen the show before.[4]

The London Museum had pulled out all the stops and put on a good show. A feast for the senses. The royal party entered the building and made their way up the grand curve of the staircase.

Their first encounter was with the costumes in the 'Seymour Lucas' gallery, the clothes arranged chronologically from 1600 to 1860. The effect of this collection, named after the artist and theatrical costume designer who donated it to the Museum, was described by a sketch writer as the 'Ghosts of the Gallants' – a line-up of headless garments, hanging in space.[5] John Seymour Lucas, a friend of Guy Laking, was a historical painter who excelled in realistic scenes of the Tudor and Stuart period, and naturally much in-demand for achieving historical accuracy with the costumes for the dramas gracing the stage. The collection, once used as dress props for Seymour Lucas's paintings in his Hampstead studio, had been taken out of silver paper and lavender for display and now confronted visitors with 'doublets which encased the courtiers of Elizabeth'. The sketch writer was particularly transported by the theatrical effect of a 'Buff Coat', a thick protective leather coat with a skirt, standard wear for officers in the seventeenth century, 'embroidered with silver lace, worn by a man who was killed in a duel in the time of Charles II'. 'The Buff Coat', he went on, 'carries still the rent of the rapier's thrust' and 'stains rusted the embroidery'. 'There are coats of cavaliers who fought for the first Charles in the Civil War,' he continues, 'and many other personal and evocative items of clothing.'[6]

The royal visitors continued past the room housing their coronation gowns until they reached the Gold Room and found the treasures from Cheapside staged to full theatrical effect: a

candelabra chandelier lighting them from above, framed on all sides by gilt panelling. A splendid gold clock by Thuillier of Paris marked the time for the full three hours the king and queen spent circling the enormous glass cabinet and asking questions.

The royals were escorted by Guy Laking, Harcourt and Esher, and invited to scrutinise the jewels close up. The top brass pulled rank, referring to Lawrence in a manner that implied he had been but a liaison officer, and he watched from the office. The keeper's office opened into the Gold Room, a good vantage point to observe both jewels and visitors.

The Hoard filled one very large glass show case, which was opened on request and anything the royal pair particularly admired removed from its display so they could peer even closer, hand-held lorgnette glasses at the ready. They were permitted to touch the objects, listen to the slink and rattle of the link chains as they lowered them into their palm, feel the freezing cold of a gold-and-enamel ring that would not easily slide onto a modern-sized finger, tap the ice-smooth facets of the gems, or trace the silky stone relief of the cameos or the little pagan pictures in intaglios, or the scratchy filigree patterns and knobbly jewels on the chalices and pomanders, encrusted like barnacles and catching on the skin.

The press and scholars vied for a good look that day too and were working up their reviews as fast as they could. A reporter for the *Westminster Gazette* predicted the showcase would 'long be the centre of attraction; for it contains what is, it can scarcely be doubted, the most complete and beautiful collection of old jewellery that has yet been secured.' Commentators swooned over 'a daintiness in the workmanship, as well as in the design, of

every piece that places them far above any other jewels that our galleries contain in artistic value'. The technical feat represented by 'clusters of emeralds and amethysts made into bunches, as of grapes' found admirers, and praise flowed for the 'delicate floral devices that make up the links of the necklaces', 'gold-work [with] something of the fineness and the delicacy of lace' and the 'fire and life' emanating from the multi-coloured gemstones against the white enamelled gold. This was clearly 'one of the most surprising and valuable finds ever made in City soil'.[7] Although commentators agreed the majority of the objects were of 'moderate intrinsic worth' that was 'not to decry its artistic worth for there is no piece not even the least significant that does not stand high in craftsmanship', and there were pieces spectacular enough for a Tudor or Stuart king or queen, for which the reviewers reckoned today's 'connoisseurs would willingly bid in three and four figures'.[8] There were some very rare and unique pieces in the mix, but the real value was the character of the collection as a whole and how it illustrated the kind of jewellery that 'may be supposed to have fitted the purse of the successful merchant class' of London 300 years before. Its significance, then, was 'not materially affected by the fact that it represents a jeweller's stock rather than the property of a single household' and 'it may be regarded, therefore, as an exceptionally complete and intimate index of the bourgeois culture of Elizabethan and Jacobean London'.[9]

There was much to see and take in and Harcourt and Esher hung attentively on every word, Laking giving answers to any of the trickier questions that arose.

Gold chains set with stones of many colours, fan holders and various ornaments were 'all alike delightful'.[10] Another kind of

wonder altogether was an oval reliquary featuring blood stones set in gold enclosed in a band of white enamel, bearing emblems of the passion. The figure of Christ and the Saints featured on several pieces, indicating that some of the objects came from the great numbers seized and sold abroad after the Wars of the Roses or, like the crosses garnished with pearls and amethysts, were Church treasures scattered after the Reformation. A watch 'of around 1600' set in a single large emerald stood out, and, among the smaller things, some crystal vessels were of 'marked beauty'.

The bulk and range of 'the Elizabethan Jewels' was unsurpassed and represented 'a new landmark in the history of the jeweller's craft'. 'There is no other collection of the kind in the country which presents so complete a conspectus of the techniques and material employed in the period.'[11] The objects were thought to be mainly British made but many showed European design influences. 'The chains of enamelled roses and daisies, may perhaps be regarded as native English in inspiration no less than in execution…most of the gems are of Italian or Italianate workmanship.' The treasures included 'emerald from Colombia, topaz and Amazon-stone probably from Brazil, chrysoberyl cat's eyes, spinel and iolite from Ceylon, Indian rubies and diamonds, lapis lazuli and turquoise from Persia, peridot from St John's Island in the Red Sea, as well as amethysts, garnets, opals from nearer home'. The objects showed 'a surprisingly wide range' and reflected 'the precocious expansiveness of European commerce at the beginning of the seventeenth century'. Here was Burmese ruby, Afghan lapis lazuli and Persian turquoise, the gleaming swag chivvied out of

mines across the empire, scooped into tea chests and brought to London by traders.

The pieces on display were a vivid demonstration of the secular sixteenth-century revival in decorative objects designed specifically to hang and drape about the person, a revival that came about in no small part thanks to the 'inordinate love of jewellery shown by Henry VIII and Queen Elizabeth'. Rings in the medieval period had been worn on first finger or thumb, but the Tudors wore them 'in profusion on every finger, and often on every joint, over and under gloves, the latter sometimes being split so as to show the bezel of the ring through them'. The Venetian ambassador described Elizabeth's father, Henry VIII, in

> a cap of crimson velvet, in the French fashion…the brim was hooped up all round with lacets and gold enamelled tags… Very close round his neck he had a gold collar, from which there hung a rough cut diamond, the size of the largest walnut I ever saw, and to this was suspended a most beautiful and very large round pearl… This mantle was girt in front like a gown, with a thick gold cord, from which there hung large gold acorns like a very handsome gold collar, with a pendant St George entirely of diamonds…his fingers were one mass of jewelled rings.[12]

The royals set the fashion and the merchants followed with toned-down versions of the kind of pieces now on display in the Gold Room, laid out in front of the present-day king and his queen consort. Everyone was awed to be in the presence of

these extraordinary delights. Looking at the amethysts the queen would not have been able to avoid thinking of the Suffragette colours and, perhaps, moving on quickly. The *Daily Telegraph* reported:

> [T]he King and Queen came to the gold and silver collections, and naturally sought out at once the museum's most recent 'find' of Elizabethan jewellery. Their Majesties inspected it closely, and commented upon the fact that the chief feature and real charm of the work lay not so much in the size or costliness of the jewels as in the skill and beauty of the setting. The King even went so far as to remark that modern jewellers might copy the general style of the work with excellent results.[13]

This may have been a plea by the king for some restraint in his wife, whose tastes erred towards the gaudy and ostentatious. Just before the First World War, jewellery was full-on fabulous, with stones set in elaborate bows and garlands, tone deaf to the clean architectural lines of the more utilitarian art deco era on its way. Many examples of the most fashionable styles of gems and jewels had gone down with the *Titanic* and a purser's bag later retrieved from the debris on the seabed contained typical pieces, demonstrating the lavish taste of the well-heeled: diamonds in curvaceous motifs; pearl stick pins and organic *art nouveau* flourishes. Also at the bottom of the ocean was a leather bag belonging to Englehart Cornelius Ostby, a Norwegian-born jeweller and co-proprietor of Ostby and Barton in Rhode Island New York. A leading maker in America, specialising in gold

cameo rings, he had been returning on the *Titanic* from a trip to procure gemstones in Paris. His cross-continental travels were testament to an enduring demand for the gems and jewels of the Old World with all their romance, although his bag and its contents – presumably a collection of colourful gemstones to cut, polish and set into necklaces and brooches or to craft into cameos for rings – has not been retrieved.

When the royal party wanted a first-hand account of the day the treasures were found, the queen would naturally want to speak to Mr Lawrence. She had likely read about the antiquarian from Wandsworth with the little shop and, given her passion for antiquities, remembered meeting a kindred spirit, at the Museum opening in 1911. He could offer the special guests a simple tale of the fortuitous events that led to the rescue of the treasures. He could also proudly confirm they were now assembled altogether, complete to the last brooch pin and ring. But, according to Lawrence's recollection, there were limits in what he could go into. 'The authorities thought it best that nothing should be said at the time.' The men in charge at the London Museum thought it best to change the subject if questioned too closely about precisely where the find was made.

Privately they had reached a consensus that the Hoard had been the property of a working jeweller, perhaps also a money lender as was common, or both, for the simple reason the cellar in which the treasures were found at 30–34 Cheapside was underneath the old goldsmiths' row, a busy strip of jewellery makers and sellers with display windows on the street, and workshops above, repairing or recycling, pawning and money-lending too, that had enjoyed a continuity of use since the

fourteenth century. They had dated the bulk of the jewels as Elizabethan and put the burial at around 1600. The in-house experts brushed over the related question of why the treasures had been buried, presenting it as another ineffable mystery and keeping solid details to a minimum. They nurtured their own working hypotheses on this. Commercial banks weren't offering to store valuables, so a hole in the floor was quite common, and used habitually during a working week. Some hypothesised the owner of the treasures had been fleeing one of the waves of plague that swept through the City, or had succumbed to it; others suggesting the owner had filled the hiding place a few years later and that they were escaping the Great Fire of London and had hidden the property away from flames and thieves.

Once the king and queen had swept out, members of the press who hung around for the royal tour had more questions, but were stonewalled and shown the exit. The journalists turning around their copy for the papers expressed doubts they had gleaned the full story about the circumstances of the jewels' discovery. Some were clearly sensing a lack of transparency and accused Mr Laking and Mr Lawrence and their trustees of resisting full disclosure. 'Curiously, little has been heard about the hoard,' reported the *Manchester Guardian* snarkily, 'as all the officials maintain an intense silence on the subject. No one seems to know anything about it... Many stories are current.' The *Daily Telegraph* alluded to the king and queen's private view of 'the most attractive and remarkable...wonderful collection of jewellery of about the first decade of the seventeenth century', but pointed out the cagey defensive answers given by Lawrence and Laking, the keeper, in response to the royal enquiries.

The story of this astonishing discovery cannot even yet be told in full, and yesterday Mr Laking and his coadjutors had to give guarded answers to the many adroitly framed questions of the specially invited company who enjoyed the most private of private views. But about two years ago there was found under the staircase leading to the cellar of a house 'within the walls' of London, the locality not being precisely stated, a decaying case containing about 150 of the most perfect examples of the jewellers' craft of that period that can be imagined. It can only be supposed that it was the stock of some famous jeweller of his day, placed there for safety, while he went forth, perhaps never to return, after some tavern brawl, or it might have been a thieves haul, that they dared not come back to take.[14]

The *Daily Telegraph* journalist raises a quizzical eyebrow at the vagueness of the line coming out of the Museum and its refusal to clarify where, exactly, the discovery took place. Somehow, the reporter had the idea that the treasure was found 'under the staircase leading to the cellar', a detail which doesn't appear anywhere else, in print or otherwise, but joins in enthusiastically nevertheless with the free-for-all of theories attempting to fill the vacuum of reliable information. His tuppence worth on the question of why the jewels had been buried and not retrieved was a 'famous jeweller' killed in a 'tavern brawl' or 'thieves' whose swag was too hot to reclaim. Another reporter noted the 'delicate gold mounts still waiting for the gems that were to have been set in them' and agreed 'there is every reason to suppose that they formed the contents of a jeweller's shop, and were

in some moment of emergency, hurriedly gathered together and crammed into the chest in which they were found.'[15] The *Manchester Courier* describes an air of 'a mystery surrounding the whole thing' that 'adds to its romantic interest' preferring a gossipy angle to any serious investigation into impropriety at the Museum. 'It is but a half secret,' another commentator confided to his audience who were enjoying said mystery, 'that the navvies privily took chunks of the richly bejewelled earth, wrapped in sacking, to Mr. G. F. Lawrence'.[16] For now the public was enjoying the artifice of a good story with ordinary men as the heroes: the navvies and a humble Wandsworth shopkeeper. The papers enthusiastically disseminated the myth of the Hoard's discovery and Harcourt was able to brush away any specific questions about where the treasures had been found, making them seem trivial, even common, as if the enquirer were missing the point rather. The Hoard's mystique was its rarest quality, its antiquities made trophies money couldn't buy, confirming his Museum as the ancestral home of the ornaments of the empire. He kept guard with an iron vigilance and poker face.[17]

CHAPTER VIII

The Queen's Private Views

The Hoard had captured Queen Mary's imagination. After enjoying that 'most private of private views' of the jewels she made an effort to stay in touch with her inside man at the Museum, G.F. Lawrence.

Lancaster House closed temporarily following threats of protest by Suffragettes but, after a coquettish false start, the doors opened more confidently for the enjoyment of the general public too, drawing huge crowds to the Gold Room, where the exhibition won their hearts too.

Thousands queued to push through the turnstile into the new Museum to see 'the Elizabethan Jewels', large numbers of working-class men and women among them wanting to hear the story of their discovery and discuss the mysterious motive behind their burial.

The public bypassed the thrills of the 'Chamber of Horrors' and the 'Ghosts of the Gallants', following delightedly in the footsteps of the royal visitors and shuffling through the hushed Gold Room, under the eye of the guards, as if to pay their respects at an altarpiece. Only two months after opening, 82,000 visitors had passed through the doors.

Queen Mary began making private visits to the exhibition, after hours, when the crowds had left, or before they arrived.

The threat of Suffragette demonstrations directed at the king and queen was now at its highest level yet, with scenes around their palaces and carriages often descending into violent unrest and police arrests.

Once safely inside, she had an agenda, and she knew her way to the Gold Room on the first floor, a room which faced out to the Mall and Buckingham Palace beyond. The view allowed her to check for any Suffragette demonstrations, but she was occupied with the vast mahogany display case and the Hoard inside, Lawrence following at a respectful distance. The exhibits were illuminated by Esher's electric lights so she was able to see them in sharp detail. It was a stark contrast to the soupy gloom of Lawrence's gas-lit shop, and in 1912 it was a novelty and delight even for a queen.

Having Queen Mary take an interest in the Hoard was a bit like hearing that Henry VIII had taken a fancy to your daughter. It would make anyone who knew of her reputation more than a little nervous. Certain affinities emerged between Lawrence and the queen, starting with the fact that Lawrence's daughter Ethel May was also known within the family as 'May'. The royal May had made an agent of Lawrence, her facilitator inside the Museum. She was an intimidating figure, towering over G.F. Lawrence, her favoured brimless 'toque' hat perched like a crown on her head made her even taller. May's signature look, designed by the House of Reville, was opulent but conservative, and the tailored ensembles from court dressmaker Elizabeth Handley Seymour were in lavish fabrics but muted in colour, with long skirts that resolutely did not move upwards an inch with the fashion.

Mary had a long-standing reputation as an 'avid collector' (this description spoken by more than one with a suggestively pursed lip, to insinuate that 'kleptomaniac' might be closer to it, albeit an upmarket one). Rumours went round that hosts of shooting weekends or house parties, forewarned of an imminent visit by Mary to their estate, would lock up their valuables in order to keep them out of her eye-line. If she expressed a liking for a particular piece, etiquette made it impossible not to insist she took the item with her, and she would have no compunction in taking it, or would expect the owner to 'donate' it to her. If she admired, for example, a well-turned Sheraton chair, you would be obliged to give her all twelve from your dining room set.[1] Warnings passed between antiques dealers to squirrel objects away, like the flustered aristocrats stuffing the silver in the attic, because she didn't always pay for the things she took with her.[2] If she saw an object that she thought rightfully belonged in the Royal Collection then no museum director would stand in her way, and she would politely request a 'permanent loan' of the item, which was an effective workaround to cover almost all situations.

Mary was certainly proudly committed to collecting, particularly 'royal' objects that had wandered off into the world, or gone astray thanks to marriages, divorces, deaths, wars or fire sales, and bringing them back into the palaces of the House of Windsor, places she had come to see as her personal museums. She drew up inventories of the royal collections so that if a member of the royal family of a previous generation, for example one of Queen Victoria's sons, had lent a piece out on 'permanent loan', she could now cross-reference her inventories

with old ones and pinpoint with laser accuracy which objects had never been returned. A letter would then be sent asking for that jewel, painting or vase back.

'My one great hobby', she called it.[3] According to her official biographer, James Pope-Hennessy, her collection included 'Battersea enamels, late jades, miniature elephants of agate with jewelled howdahs, small tea sets in gold or silver, papier-mâché workboxes, tiny watercolours of flower-gardens, glass paintings'. She had a little black book of curators and collectors to call on for help, all of whom were well placed to pass on discreet advice about dealing with her to others, like Lawrence, working in the antiques business.

She had a magpie's energy when it came to spotting or tracing objects she wanted and then swooping, building her collection with a work ethic reminiscent of Lawrence filling his shop-window in Wandsworth. Her eldest son, Edward, remembered her 'cosy room overflowing with personal treasures' in St James's Palace. In 1909 she wrote to her aunt Augusta, Grand Duchess of Mecklenburg-Strelitz: 'It is really rather wonderful what we have managed to collect & get together since we married, quite a creditable collection of family things…without spending much money over it. I confess I feel rather proud of our endeavours. I hope you won't laugh at me.'

Queen Mary quickly came to see herself as a curator at Marlborough House, the one-time residence of the Dukes of Marlborough, and the original home of the V&A, another vast neoclassical mansion opposite St James's Palace, now a royal residence adjunct to St James's Palace. She wrote to a fellow curator once she had become queen to say: 'It was

such a pleasure showing you my rooms on Sunday as you are so very appreciative of detail & worthy of all the beautiful objects which are ever a constant joy to me... It always seems strange to me that there can be people to whom these things mean & say nothing... I confess I pity them as they miss much in life.'[4]

This was more than a royal housewife's hobby. Staff at the Victoria and Albert Museum also had tips for Lawrence and his colleagues about Queen Mary's modus operandi. She gave an eclectic mix of items on loan from her own collection to the V&A, from Japanese masks to a hat for a doll. Some loans, however, she extended enthusiastically, once writing to Director Cecil Harcourt Smith:

> Dear Sir Cecil...we will discuss my inventory in the autumn. I had not realised that the large Sèvres vase was a 'royal loan', what a horror, I really cannot compete with it. Pray find a corner or rather space for it in the basement. I wish it could be smashed in the transit but horrors always survive!... some of the objects will do so well here.[5]

She went to some particularly extraordinary lengths to round up jewels and bring them back into royal custody, showing just how bloody minded she could be in 1910 when she set out on an elaborate diplomatic and legal assault course to retrieve a set of jewels that became known as the 'Cambridge Emeralds'. Mary's grandmother, Augusta, the German wife of George III's son, who became the Duchess of Cambridge, had won forty 'cabochon' polished emeralds in a raffle in Frankfurt. Augusta had

the emeralds set into jewellery, and they passed down through the family to Mary's mother, the splendidly broad-beamed Mary Adelaide, known unkindly as 'Fat Mary' to distinguish her from the many other Marys. The British crown had passed down the other side of the family, to the Cambridges' niece, Victoria, and the Cambridges had come to England to live on the margins of royal life. When Mary Adelaide died, by now married into the House of Teck, she left the emerald jewellery to her son, Francis of Teck, who was a notorious gambler and seducer of women, and died a bachelor aged thirty-nine after catching pneumonia at Balmoral. With no wife to give them to, he had left the splendid green stones to his mistress, Ellen Constance, the Countess of Kilmorey. Francis's sister Mary was not going to lose her family heirlooms to a mistress and she travelled across land and sea to meet Nellie and demand to have them back. Mary had her brother's will sealed by a court to hide the details of her negotiations with Nellie, but there were rumours of a whopping payment of £10,000. She wrestled them off Nellie somehow and sent the emeralds to the jewellers Garrard & Co., who set them in a spectacular new suite of jewellery, including a tiara and a necklace for her to wear at the Delhi Durbar in 1911. She put another inherited jewel to good symbolic use next to the emeralds in the necklace for the Durbar, one of the nine pieces cleaved from the 'world's biggest' diamond, the 'Cullinan'. The diamond was as big as a human heart when it was broken out of the ground in South Africa by Thomas Cullinan in 1905 and given to her father-in-law King Edward VII by the newly elected prime minister of the Transvaal as thanks for his loyalty. Mary hung her piece

of it from a double-roped necklace studded with her family emeralds, combining the two inheritances, the meaning clear for all the empire to behold.

The queen attended estate sales and bought gems and jewels, repurposing all manner of old sparklers into new decorative creations, tiaras into necklaces and vice versa, building an eye-popping collection over many decades and commissioning jewellery to be given as gifts to her ladies-in-waiting when they announced their engagements. Mary also understood how jewels could be reset to electrify her geopolitical messaging. For her coronation in 1911 she wore another unfeasibly huge diamond, its size and backstory the stuff of legend. The 'Koh-i-Noor', a mountainous Mughal-era jewel, had been handed over to Queen Victoria from the Maharajah, via the East India Company, as a spoil of war after the Company annexed the Punjab, and had come down to Mary. The journey to her was precarious – the British government agent responsible for shipping it back to England forgot to take it out of his waistcoat pocket when he sent the garment to be laundered; a valet discovered it just in time – but the jewel made it to England intact and took its place in her bespoke crown.

She read the newspapers assiduously and there was lots to talk about as she and Lawrence took another turn around the display cabinet in the Gold Room. The beadily curious royal patron of the Museum liked to keep abreast of the latest news on her visits and, in spring 1914, there had been another flurry of controversy around the 'Elizabethan Jewels', whipped up by the publicity surrounding their public exhibition. A paragraph in *The Times* had declared that the Hoard had been found in

the City of London. This had come as news to some, including Mr Waldo the coroner, and rekindled the intense rivalry among the institutions involved, sparking a furious row over the rules of Treasure Trove.[6]

It won't have escaped Mary's attention that Treasure Trove found within the City was the property of the Corporation only by virtue of a Royal Grant. The coroner's report was a good read for her, giving a roll call of the Charters in play and the monarchs who signed them: 'those of 23rd April 1550 (Edward VI) 20th September 1608 (James I) 18th October 1638 (Charles I) and 24th June 1664 (Charles II)'.[7] Waldo's report was underscored by his wilting sarcasm describing the 'alleged discovery of treasure trove at some place within the City Boundaries at a date that appears to have been within the last three or four years'. He notes the find 'has since been ascertained to be a hoard of jewellery of very considerable value' and insinuates as hard as he can, 'So far as we can ascertain, a sum of £100 was dispersed to secure the majority of the articles, but it is believed that some few of them are still unaccounted for.' The queen could confidently venture to guess that Lawrence now found himself in a tight spot.

The press coverage of the 'Elizabethan Jewels' had been breathless in its praise. On 18 April 1914 the 'Ladies Page' in the *Illustrated London News* raved about the exhibition and insisted that 'nobody coming to town for ever so short a time should miss going there'. 'The recent great "find" of Tudor jewellery, supposed to be the stock of a jeweller concealed for some reason, and lost,' it continues excitedly, 'is so fresh-looking for the most part that one half suspects a hoax.'

The queen always wanted the insider's line on antiques and antiquities. She knew perfectly well not everything had gone straight to the Museum via Stony Jack. Could Lawrence clarify for her the conflicting accounts of the discovery of the jewels? What they had been found in: a bucket or a box? How many of either container, was it both? Did they contain drawers or not, and how many jewels were there altogether? Was there something more at work here than simply the natural fallibility and subjectivity of memory giving rise to conflicting accounts?

Another talking point in the Gold Room was an article in the *Westminster Gazette* highlighting the best of the objects in the collection and telling the visitors who jostled politely around the show case what to look out for. Many visitors used reviews as reference points, committed to memory or cut out of the paper, and the queen liked to keep up with public opinion.

The article described the scope of the decorative objects on display: a dizzying array of gorgeous jewellery to beguile the senses, like the fashionable pendants with 'a setting of gold wire that allowed them to tremble at the slightest movement',[8] and a cameo bust of Queen Elizabeth.

It then pointed to a particular ring that was worthy of a special mention: 'A beautiful opal', it gushed, 'carved most minutely with a George and Dragon design.' This was the gold finger ring that had missed the first consignment of the Hoard to the Museum back in 1912.

Exactly when it had been thrown back into the mix was anyone's guess but, better late than never, it had arrived in time for this 1914 exhibition and here it was, in the Gold Room, behind glass in the show case. At the press view, Lawrence or one of

his colleagues had taken the journalist from the *Westminster Gazette* aside to regale them about the finer points of interest in this 'beautiful opal' and they had selected it as one of the highlights of the show. Queen Mary had seen it at the official opening, perhaps even at a secret preview before that, but it merited another look.

The ring wasn't showy. Next to more obvious eye-candy like the scent bottle mounted with rubies, topazes and diamonds it held back, unassuming, but in many ways more interesting. It was easy to overlook, but there was something about it that made it stand out from the crowd. If the queen wished to inspect it more closely, lorgnette in hand, Lawrence would of course oblige, taking a key from the pocket of his suit and opening the mahogany case.

Lawrence could answer any of the queen's questions and provide historical context, although Laking and Oates, with his burgeoning private collection of ancient finger rings, were on hand for another opinion.

He would have been able to date a cameo ring featuring this particular image to the point in time in medieval Europe when the cult of St George began to take off, at the earliest. The gem was far older than its 'contemporary' seventeenth-century setting, a typical hybrid creation by jewellers of the era; opaque rather than sparkly, but intriguing for it.

St George had strong, time-honoured royal associations the queen recognised the instant she saw the ring. St George was the emblem for the prestigious title of the Order of the Garter, created by King Edward III in 1348 and given by the Sovereign thereafter to his or her chosen elite of twenty-four knights for

exceptional achievements in public office or for personal service to the monarch.

The connection between the queen and the ring was enough to make its custodian uncomfortable under the serge collar, the more so the longer she held it under her glasses, closing one eye to study it intently.

There wasn't much to say about the original sainted 'George' except that he was probably a high-ranking officer in the Roman army who converted to Christianity and was tortured and killed in Lydda, Palestine, in about 33 CE. The Emperor Diocletian had demanded he deny his faith; he had refused and was beheaded and his head taken to Rome, where he was made a martyr saint for the strength of his faith.

The dragon-slaying legend with which his life story mingled came later, and had pre-Christian origins. There were a couple of alternative Christian versions: the Archangel Michael, killing his dragon, Satan, for example. Saint Theodore was cast first as the protagonist. But then, at some point in the eleventh century, George took over the starring role. He had ridden by chance into a village in 'Silene', Libya, where a dragon was terrorising the population. The villagers had made frantic offerings to assuage the dragon, giving first livestock, then their menfolk and then, in desperation, their children, chosen by lottery. Now the dragon was demanding the king's own daughter and was not satisfied with his silver and gold. Enter St George, who made the sign of the cross and rode into the breach, flinging the princess's own girdle around the dragon's neck and leading him subdued into the village. George offered to kill the dragon if the population converted to Christianity and thousands lined up to be baptised,

including the king, so George duly beheaded the dragon, and on the site of the killing, the story went, flowed a spring whose waters could cure all disease.

Crusaders in the Holy Land came across the legend of George as a Christian martyr warrior later and brought him home with them. While he was still overseas crusading, Richard the Lionheart invoked George's faith before a crucial battle, tying garters around the legs of his knights, and they went on to win, and made a mascot and a talisman of him.

In the hope of providing a unifying figure for a divided country, Edward III made St George England's patron saint in 1348, and his image adorned the flags fluttering above his men as they charged into battle. Subsequent monarchs continued to pin St George on their persons, wanting a visual association with a powerful symbol of faith, patriotism and the victory of good over evil, and they commissioned all sorts of jewellery and badges to decorate themselves and their associates.

Queen Mary peered through her lorgnette at the ring. Objects with these connections roused her acquisitive collector's spirit and may have roused a tight asthmatic cough or two from Lawrence. There was another St George in the display case, engraved on one side of a small black-and-white onyx, with a female saint kneeling in the wilderness on the other side, but the ring was far more intriguing.

In 1914, an association between St George and the royal family was worth wearing and polishing, linking the house of Saxe-Coburg-Gotha inextricably to England, and to Christianity, as well as to his legendary strength and protective powers, an unassailable continuity. Mary valued anything that would help

her family present as powerful and legitimate figureheads for the nation and its empire. Life before marriage had taught her vigilance and preparedness, and she had good reason to desire security and legitimacy from a ring like this.

Tethered as a child to her parents' life of ill fortune and fecklessness, Mary had grown up as a third-choice candidate for a royal match. Queen Victoria had been prepared to match-make her only with her grandson, Prince Albert, Duke of Clarence, because she viewed him as something of an inadequate who, as the second in line of succession to the British throne, urgently needed a bride and couldn't be choosy. Although she was a great granddaughter of another royal George, George III, through her mother, Princess Mary Adelaide, a cousin of Queen Victoria, her breeding and prospects were compromised because her father Duke Francis of Teck, a minor German noble, was a product of a 'Morganatic' marriage – an imbalance of rank between his parents – meaning his succession rights were denied. Mary, though a relative of the British royals born at Kensington Palace, inherited little wealth. In fact, her father's spendthrift attitude to the money he did inherit, and her mother's taste for luxuries, took the family so deep into arrears that they fled abroad to dodge debt collectors, moving between the homes of relatives, even living under false names, and it was a stormy parental pairing. According to the queen's lady-in-waiting, Cynthia Colville, May once witnessed her father hurl a plate across the table at her mother's head. The silver lining of a childhood spent flitting about Europe with her family was that Mary visited Florence and Greece as an impressionable and fiercely intelligent young girl, and these sites ignited a passion for antiquity. According

to Cynthia Colville, the Duke of Teck 'died insane' in 1900, a suggestion missing from the official histories. According to the Countess of Shaftesbury, Mary developed the unusual skill of being able to eavesdrop on thirty people at once around a dinner table, and the Marchioness of Cambridge observed her thrifty habit of recycling the flowers from the vases in the palaces rather than going to a florist.[9] As with Lawrence, the roots of her need to hoard antiques ran deep, and the business of acquisition appeared to provide some sense of insurance against a future reversal of fortune even after she became queen of a dominion so big the sun never set on it.

By 1914, for most, St George was a distant figure, barely recognised, and the national Feast Day of old, once one of the principal feasts of the year, reduced to a few low-key parades in hats and Sunday best, wandering through London and various towns and cities on 23 April, the crowds nostalgic for something only half remembered, the source of the legend similarly lost.

Mary understood iconography but she also had an eye to more modern public relations opportunities offered by the mass media. She was the first royal to routinely take a photographer with her on public engagements, to pop a flash bulb at her meetings with the ordinary public. St George still offered something useful to the royal family. King George V was the patron of the 'Royal Society of Saint George', set up twenty years back to promote English customs and ideals throughout the British Empire and breathe new life into the legend. Shakespeare had been born, and died, on St George's Day, they said, and St George and the Bard were currently appearing together on stage in *Merrie England*, the Tudor-style light opera, more popular

now than ever, in which one of Shakespeare's men arranged a performance of the 'Masque of St George and the Dragon' for the amusement of Queen Elizabeth I and the Earl of Essex. The costumes were no less spectacular than they had been when it opened in 1902, and still attempted a 'realistic' Tudor style, with Queen Bess's pale, painted face framed by a bejewelled high lace collar, with bow and flower motifs. Her crown, loaded with gems and jewels and carcanets, set off the width of her 'faerie wings', sparkling like cobwebs in the dew. Strung with pearls, her hands heavy with rings and their symbolic gems, her wide load came courtesy of a boned 'Farthingale', exaggerating her silhouette in all directions. The ensemble weighed a tonne and glinted under the stage lights, next to Essex in thigh-high boots, embroidered doublet and hose, a black hat with a dashing white feather. St George in chain mail and tights, with his tabard, cape and sword, struts on stage in the Masque with a trickster dressed up as the legendary ghost 'Herne the Hunter' lurking back-stage, terrifying in a black cloak and stag's antlers, waiting for his cue. It was the old pageantry restaged for a modern audience, with lots of songs and jolly dances, and people loved it.

Another St George was appearing in the latest production of *Where the Rainbow Ends*, the hit stage show still receiving rave reviews for the choreography and spectacle several years after its premiere in 1911, when it rounded off the coronation year. The production had a chorus of fifty children, in elaborate costumes (including, at one time, a young Noël Coward), fabulous sets and effects, as well as stirringly romantic incidental music, and was well on the way to becoming a resident seasonal classic in the West End. Audiences gladly returned to this story of four

children, and their pet lion cub, on a quest to reunite with their parents, and still gasped at the appearance of St George in a flash of lightning, sword held high, on call whenever his flag is flying, to provide assistance to the children on their perilous journey. The saint protector is a swashbuckling role for a heart-throb actor of the day, the costume pulled on in the first instance by the dashingly characterful star Reginald Owen, who co-wrote the piece, and the children think him 'ripping', but he informs them, humblebragging for England, that he is, in fact, considered old-fashioned these days, and is now just a simple soldier, neglected at home, offering his services abroad in the colonies, all the while speaking in Shakespearean blank verse. He successfully protects the children from a dragon king, a white witch and an ethereal will-o'-the-wisp hoping to lead them astray, and delivers them, riding on the magic carpet of Faith, to the place at the end of the rainbow where they will find their mother and father waiting. This does the trick, making him a hero to a new generation, who are also devouring the lusciously illustrated novel taken from the play by torchlight under their blankets.[10]

Right now, what the queen needed protection from was the 'horrid' Suffragettes. Emmeline Pankhurst's 200-strong crowd descending on Buckingham Palace with their placards was an all too recent memory, as were the violent struggles and arrests that followed. Any shouts and horns outside on the Mall warned of a potential further escalation of the demonstrations.

The queen already had many fabulous decorations in the royal collection featuring St George. When he founded the Order of the Garter, King Edward III commissioned an insignia out of George-the-Dragon-slayer's sword, to be worn by

gentlemen knights below the left knee, honouring a symbol of both martyrdom and chivalry.

The 'Great George' was a key part of the insignia, and Mary had seen hundreds of these decorative pieces featuring an enamelled, sometimes jewelled, figure of St George on horseback slaying the dragon, worn suspended from the collar of a Knight of the Garter. The 'Lesser George', also a badge, but smaller and more practical if you were out hunting, was hung from a ribbon or chain around the neck or from a sash on the hip and usually accompanied by the phrase *Honi Soit Qui Mal Y Pense*: 'Shame on him who thinks evil of it'. Mary had all sorts of examples from over the centuries, varying according to taste and budget, some cameos sculpted by the most skilful cutters out of dramatic gemstones like black-and-white striped onyx, mounted in gold and adorned with additional gems and precious jewels. She has seen the Lesser George worn by Charles I on the scaffold and the particularly blingy one owned by King George III, encrusted with rubies, diamonds, amethysts and sapphires, found in Queen Charlotte's bedroom after he died. George IV had left scores of 'Lesser Georges' when he died and Queen Victoria added many more to the pile.[11]

Her guide, Lawrence, had good reason to sense competition and want to return the ring to the cabinet and show her something else. She was one of a very select group, apart from the staff, who could get close to such a high-profile collection. No one would publicly question her motives and there would be no public appeals if anything was re-homed. He had reason to watch closely for any clues as to her intentions while she inspected the ring. She was interested now in the gemstone. She

wasn't in the mood for amethysts, with their tiresome champions assembling outside her palaces. This stone out of which the St George had been cut evidently had its own very particular appeal to her and she was peering closely at it again.

Mary knew of course all about Australia's great seams of opal, found in recent years, upstaging European sources, but this particular opal was probably from Ethiopia or perhaps Hungary, whose mines had supplied medieval Europe, with its burgeoning St George appreciation, and associated good-luck-icon merchandise.

Was it a 'precious' or a common opal? They held it to the light. Precious opals had the prized colour-play of light passing through the closely packed spheres of silica, reflecting and refracting, causing the colours to swirl and flash, much as light through water droplets produces a rainbow.

Did she know Pliny the Elder's line? – 'There is in them a softer fire than the ruby, there is the brilliant purple of the amethyst and the sea green of the emerald – all shining together in incredible union. Some by their splendour rival the colours of the painters, others the flame of burning sulphur or of fire quickened by oil.'

The gigantic black opal given to Josephine by Napoleon had just popped up again on the market, having disappeared after Josephine's death, acquired from an unnamed salesman by the Austrians. It was reported to flash bright red streaks and named 'The burning of Troy'.

As they swapped quotations and anecdotes from nights in the stalls, the moment in *Twelfth Night*, when Feste scolds Orsino for

his fickle mood came to mind, with the backhanded compliment 'thy mind is a very opal'.[12]

The conversation turned inevitably to the fact so many considered these stones bad luck. By 1914 the opal had fallen out of favour more dramatically than any other gem. A fact mystifying to May, for whom they remained the height of fashion. She ignored the rumours. Queen Victoria had loved them and worn them throughout her reign and the glow of her patronage lingered. Victoria had chosen opals to speak for her, amassing an impressive collection and giving them as gifts to her daughters, set in a wide variety of decorative pieces of jewellery.

Anne of Geierstein, the popular novel by Walter Scott, was to blame. The belief that an opal was bad luck came from a misreading of this work of Romantic literature from the last century. It featured an enchanted princess, Lady Hermione, who wore an opal talisman in her hair clasp that changed colour according to her moods. Opal-related disaster struck when Lady Hermione attended a christening and holy water from the font touched the opal, which then drained of all colour so that it looked just like a common pebble – Lady Hermione fainted and then, with unequivocal finality, turned to ashes. A later chapter revealed that Lady Hermione had actually died from poisoning, but the book was read in instalments and evidently many readers had jumped to conclusions and spread the word before they reached the reveal, and so the damage was done.

An ingenious marketing strategy by the British–South African diamond company De Beers was doing its best to tarnish what was left of the opal's reputation too, reflecting their terror that opals from the new Australian deposit would beguile the

European and US market and jeopardise the price of their diamonds. What the queen perhaps didn't know is that De Beers had followed up on an opportunity offered by Scott's novel, and the lingering suggestion that opals were bad luck, and vigorously promoted the misreading of the book. Word of mouth had done the rest. They also propagated the idea that opals were bad luck if they cracked, which they were prone to do as they were softer than other gems, containing more water, and they crazed, making cutters nervous for centuries.

Queen Mary was far too sensible a woman to believe any of the poppycock and she rose above any credulous talk of ill-fortune for opal wearers. For her, the opal's appeal was its association with the last monarch of the House of Hanover, Victoria. The British royal family's ability to set the fashion trends for Europe had turned out to be more powerful than the propaganda about cursed opals and Victoria's unceasing patronage had done a lot to counteract it. Continuing to like opals was a show of strength and continuity for Mary and the House of Windsor, as it would soon be known, and she determinedly continued to buy them – most famously a huge black opal, like Josephine's, at the British Empire Show at Wembley.

The opal's secret history, however, was a millennia-long association with exceptional beauty and power. An opal exhibited so many different colours within a single stone that some even believed that all the other gems and jewels, rubies, emeralds, sapphires, the lot, were grown inside it, making it a sort of universal mother gem that was long thought to possess supernatural powers. The name opal came from the Latin '*opalus*' and was

probably adapted from the Sanskrit word '*úpala*' for 'precious stone'. Or it could be from the ancient Greek word '*opallios*' meaning both 'seeing' and 'other'. The ancient Greeks believed it offered the gift of foresight and prophecy and guarded the owner from disease. In ancient Rome, the gem symbolised love, purity, hope and truth. Even the love-struck demi-god Mark Antony couldn't persuade Senator Nonius to give up his opal ring as a present for Cleopatra; he risked everything to keep it, and fled before he could be banished. An opal could make its carrier invisible if wrapped in a bay leaf and even possess powers of self-transportation, so that the stone could disappear and reappear somewhere else. Naturally enough, then, during the medieval period it became a patron gem of thieves.

Lawrence was braced for the request that so often came; perhaps a loan for the House of Windsor, for her husband, King George V, a man who would appreciate its God-Speed-and-more-power-to-your-elbow message?

But the queen now wanted to have a closer look at some necklaces. Not pearls, though she was famous for her set. Amidst all the chatter about the 'Elizabethan Jewels' – *Have you seen them? Oh, you must!* – she had come across the 'Ladies Page' of the *Illustrated London News* that pointed out some 'long enamel chains', which were particularly beautiful. There were thirty of them in all and they were must-see.

He would gladly show her the most impressive chains, gold lengths, exceptionally long to our modern eyes, some embellished with gems of different bright boiled-sweet colours, some with flower-and-leaf designs in green and white enamel, and help her get a better look at them. She was of course welcome to

inspect any length of chain she wanted, and move the strands in her hands, weighing them, as the gold Thuillier clock ticked at a whisper, chiming on the quarter hour, and she took her time asking about their decorative links and flourishes that winked, the enamel glossy under the chandeliers. Some of the chains were in shorter lengths, strands rather than complete loops, they had the same pattern so seemed to make a whole if reattached.

The queen was free to try on anything of her liking. She draped a few of the broken strands across the taffeta shelf of her bosom.

Queen Mary, her biographer Anne Edwards observed, 'because of her long graceful neck, her height, her bearing and her instinctive flair for elegance, had always been able to display an extraordinary quantity of jewels on her person'. Jewellery was a signifier of status and rank for the upper echelons of society but it also needed to tell good stories. All wealthy women had a string of pearls, with a provenance story telling of the previous owners, and the queen was no exception. She loved natural pearls, from Bahrain, Ceylon and Australia, and had a spectacular eleven-row pearl and diamond choker she was particularly fond of. These neck chains were charming in a different way. The rest of her private collection testified to her love of enamel work.

She was welcome to try any others around her neck, cold against a powdered cheek. Some she might try in her hair. A 'carcanet' was the name given to all necklaces from the fifteenth century on; they could be neck chains or ornaments worn in the hair, alternatively worn as collars or girdles by women and

men. In Elizabeth I's day they were lighter and more delicate: long neck chains, sometimes wound several times around the neck, hair chains and cap chains.

Sifting through more of the thirty strands, she was careful and considered as always with such antiquity. What did Lawrence have to say about a report of recent incident in the Gold Room? That a woman Spiritualist had been on a visit to the Museum to see the jewels and promptly fainted at the sight.

Yes, it was true. Just where the queen was standing, beside the display case. When the woman recovered, she said she had seen blood on a gold neck chain among the other gems and jewellery. She told him she sensed the woman who originally wore the necklace had been murdered for it.

May was an eminently sensible and pragmatic character and, apart from having her palm read at a party as a child, not too susceptible to these things. She liked these chains, the broken lengths particularly. She liked them very much.

A man like Lawrence did not say no to the queen, and certainly not to this queen. None of the staff would stop her taking anything. A permanent loan could be arranged without paperwork. He could have pointed out another long strand of enamelled gold also on display, with an interlinking 'lovers knot' motif, symbolising eternal union. This one was technically retained by Lawrence, declared as part of the Hoard, but he had loaned it back for display, so it was both his, and not his. Anything removed by the queen would likely be separated from the collection for good.

He should have referred the matter up to Guy Laking; or consulted Harcourt or Esher for advice on etiquette with these

things, but relations were strained thanks to his relentless trouble-making on the building sites.

He made a unilateral decision and helped the queen's attendants transport them safely across St James's Park. Or she left with a promise the items would be sent after her, but, by one mode of transport or another, several, long intricately linked and gleaming strands of enamelled gold from the Hoard found their way out. The distinction between the queen taking an object and it being given, promised or lent to her, was often an academic one. She didn't mention in her diary what she had seen displayed in the Gold Room and she certainly did not mention taking the chains home, but they landed in her private collection, most likely her rooms at Marlborough House.

In their new royal home, the broken necklace stands seemed to speak in a language of 'motifs' of flowers, leaves, knots, noughts and crosses, like a strip of Tudor code. The patterns of gold were, in fact, created with the iron tools of a smith, with a bench of tweezers, tiny pliers and cutters to work the stuff. The glossy pools of colour, making the leaves and flowers come to life, are created by human hands, smashing up pieces of glass in a pestle and mortar, and fusing them on top of the metal at a furnace heat point.

Lawrence returned to West Hill, a Tudor courtier trying to stay on the right side of everyone, smiling but with nails bitten to the quick.

CHAPTER IX

Who Will Protect a Man These Days?

Lawrence continued lurking around excavations over which he had no jurisdiction, acquiring finds without the legal owner's permission. The prominence of the Cheapside treasures at the Museum had thrown the spotlight onto him, but his routines did not change. As the crowds streamed in and out of the Gold Room to see 'the Elizabethan Jewels', Lawrence, Guildhall spies said, would 'poach and pry and whisper, and…conduct mysterious transactions behind hoardings and in the tap rooms of City public houses'.[1] 'There would be 'a swift passage of silver' and he would 'depart carrying his old brown bag and wearing the smile of a satisfied cherub',[2] stomping purposefully across the City to the next site, cheroot in mouth, which he invariably managed somehow to infiltrate.

The great success of the exhibition hadn't slowed him down or tempered his methodology, even with a more public profile. It should have done. The reality was that all antiquities found on a building site, apart from Treasure Trove, remained the property of the owner of the freehold, the ground landlord, unless they agreed to give it up. Any payment was nothing more than a reward, a legal fiction, and didn't give the collector any title over the object. Luckily, the freeholds of most City properties were

owned by the livery companies like the goldsmiths, or the banks and insurance companies, who were generally public-spirited enough to offer their antiquities for public view, but it was within their power to seek redress in the courts. But then, as Morton observed, today and yesterday were much the same to Stony Jack, who lived across epochs, disregarding the petty protocols of the moment. To Lawrence these areas of demolition, in flux between the end of one building and completion of the next, were raw opportunity and he wouldn't waste it. Officials from the Guildhall did not believe his excuses when they got close to catching him in the act, but they had no teeth to prevent him turning up at a dig down the road the next day. Privately, his employers were also tiring of his recalcitrant behaviour, regarding him with increasingly jaundiced eyes, and thinner smiles.

They had watched him at work, a scholar with a rare ability to communicate deep knowledge of ancient objects, and a nose for where they'd come from, in demand for his opinion, antiquarians around the world seeking him out. When the Museum was just starting to build its collection, Lawrence spotted a recently purchased flint arrowhead the seller had 'described as coming from Epping Forest' and put a word in Laking's ear. Laking then wrote to the dealer who had sold it, saying: 'I am assured by experts that it is a well-known South American type and hardly likely to have been found as alleged.' The dealer replied (we can imagine him looking at his shoes as he wrote) that it was 'just possible' the item 'got shifted off its ticket at stocktaking and been replaced by an American specimen' and was followed by a credit note.[3] Lawrence's expertise had stood between the Museum and anyone who wished to defraud it.

And yet he now seemed to be unable to stop making trouble, every time protesting he was only saving artefacts that would otherwise go to the tip. The days of archaeological free-for-all were coming to an end. Property owners had it in writing: what was theirs was theirs, on pain of prosecution. His employers were responsible for him, as the London Museum's inspector of excavations and again and again he was beckoned into the keeper's office to answer a new complaint.

Guy Laking, a debonair character with an upmarket touch, had always had a sneaking admiration for Lawrence's piratical ways.[4] The man didn't take no for an answer, once winning a licence to visit the port's dredgers above London Bridge with the preposterous excuse it was 'for the sole purpose of studying the geological deposits'. He was always looking for saleable antiquities. Laking had watched in awe as he stocked the collection with 1,600 objects: '[T]here has not been a building demolished or an excavation of any kind made within the London area, that he has not visited for this museum…his knowledge of certain subjects is astonishing.'[5]

But even this long-time comrade, and fellow ancient ring enthusiast, was losing patience, forced into giving him a regular *sit-down-look-here-old-chap* talking to.

Close up, Lawrence's neat exterior was getting a little threadbare. He worked on, kept his head down, keeping up appearances at work and at home, keeping busy, weathering the sneers with his customary geniality. He was playing the long game.

Life was not harmonious at 7 West Hill either, or in Southgate, where Frederick was struggling with old health problems, ones more insidious than his polio-wasted leg, but doctors and hospitals

were expensive and risked publicising his suffering. Various nerve tonics were on sale at the local druggist, and the papers carried advertisements for phenobarbital and other barbiturate 'sleep cures' to tempt sufferers with the possibility of relief.

Phenobarbital had been trialled in 1912 as a treatment for epilepsy too – the secret affliction of Queen Mary's youngest son, John, hidden away for years at White Lodge, in Richmond, a house gifted as a 'permanent loan' from Queen Victoria, and before that on a private farm on the Sandringham Estate in Norfolk, where he had been watched over by a governess. The treatment for his seizures remained rudimentary despite the trials, and really there was nothing to do but prevent choking and head injury.

Frederick, like John little discussed in public, had so far managed to hold on to his position as a solicitor's clerk, and keep a separate household for his young family (and two amethysts secreted somewhere inside) but the prospect of becoming dependent again on his father was real, as his doctors could do little to treat what afflicted him physically or mentally. Rose brought the children, Geoffrey, Gweneth and new baby Edgar, to West Hill more and more frequently, which packed an already crowded flat with more generations of Lawrences, and anyone looking for space downstairs had to share it with the Ancient Egyptians.

George's brother Alfred, too, was often to be found in the flat upstairs, on a visit down from Shropshire, playing the piano. At such close quarters, the comparison between his fragile state and that of Fred, his nephew, was unavoidable. Alfred would walk through the shop in the dim gas lighting listening intently to

his elder brother talk about the antiquities business, hiding with him in the deep past, away from thoughts of his wife and four children and his Australian fortune won and lost. The shame of his stint in Bethlem hospital had painfully and irreparably severed ties there and he was, officially anyway, dead to them.

Then, one afternoon in 1914, Alfred's wife Edith and young daughter Faye got in touch. They had made the journey over from Australia but Alfred had refused to see them. George and Flo caught up with their expatriate family's predicament and what they hoped to achieve by their visit. It wasn't clear whether Alfred's refusal to see her was down to feelings of shame, or the desire to preserve his local reputation. Edith had continued to send her husband money from overseas while looking after the four children on her own. In Australia, they had watched the Lawrence and Hanson electrical empire expand across the country, but had missed out on the bonanza pay-out: as Alfred had sold his shares prematurely. His son, another Alfred, had also sailed to England on another occasion and had managed to see him. He reported finding his father in Church Stretton, with a reputation as a talented musician who was called upon to play the piano in accompaniment to the moving pictures at the town's new cinema, improvising without a score to suit the mood of the film on the brightly lit screen. Flo and Lawrence sent Edith and Faye back to Australia without the reunion they had hoped for. If they learned of the Cheapside exhibition in town, and George Lawrence's connection to it, perhaps they visited Lancaster House before setting sail.

Responsibilities sat heavy on George Lawrence's shoulders, in charge of everyone now that his father was gone, and he carried

them with him from room to room in the small and populous flat, cornered. It was logical, once he was down in his shop, to retreat to the past. His relationships with the original owners of his antiquities were free of responsibility, not commercial, but just as vital to his survival. A population of fascinating interlocutors existed in an imaginative, spiritual realm in which he could escape the intractable troubles of his real life.

'To Lawrence the past appeared to be more real and infinitely more amusing than the present, he had an almost clairvoyant attitude to it,' Morton recalled, claiming never to have met anybody who looked back more affectionately.

Lawrence was a scholar, but he had never been trying to build a picture of Roman or Tudor London in an objective, academic sense. The ancient objects he handled weren't fragments of a greater whole to him; each piece had an intrinsic value, and above all, whether a sherd of pottery or an opal finger ring, offered an emotional connection to their long-dead owners. He was a commercial dealer, after a middleman's double cut, but these connections provided a lifeline, like the pawnbrokers did for the navvies.

A boyhood spent in and around Beech Street, Saint Giles, Cripplegate, behind the crumbling rubble of London's Roman fortifications, gave him the dead as neighbours and set the scenery for a Victorian Gothic imagination. The residents past were as present as any living ones, and, as the Victorian housing schemes robbed-out the walls, more and more of them wanted a word with him, and seemed eager to talk.

Lawrence and his siblings grew up with the story of the Cripplegate 'vampire', cribbed from the engraving on a

seventeenth-century stone memorial to 'Constance Whitney' in Lawrence's local church, St Giles's. The memorial depicted a shrouded lady who appeared to be sitting up in her coffin. Rumour was the young woman had been buried while in a trance and when the warden broke into her coffin, intending to rip a valuable ring from her finger, she surprised him by rising up. The horrified sexton fled. The lady in question, the story went, got out of the coffin, and went on to lead a long life, even bearing several children. This was a tale to scare even the most unimaginative children witless as they went about their daily business and make them pick up the pace and throw a wary look back at the churchyard as they hurried past.

Writing in his memoir of his visits to the shop on West Hill as a boy, Morton remembered Lawrence with a Roman sandal held aloft, one of hundreds of worn-out shoes pulled from the Walbrook river's preservative sludge, his head on one side, the cheroot obstructing his diction, speaking about the cobbler who had made it, the shop in which it had been sold, and the streets of the 'long-vanished' London it had known. Incredible as it sounds, Morton remembered the animal smell still clinging to the Roman sandals, which made them unpleasant to handle but, half-closing his eyes and holding an object found below the earth, Lawrence 'projects himself back in time until you feel that he must have lived in all the ages. He may speak of Roman London. He will make you see the roughly paved streets, the galleys coming up the Thames with wine and olives and the troop ships from Gaul with reinforcements, he may speak of Norman London, and you hear the church bells ringing from saint St Bartholomew's to the Tower. He may speak of Elizabethan London and you

hear the gusty laughter of taverns and the wind in the rigging of ships that have adventured to the Americas.'[6]

In his shop, Lawrence was an actor, performing his soliloquies to rapt customers, asking his audience to suspend their disbelief.

Upstairs in the busy flat, Lawrence was living at close quarters with his daughter's domestic experiments in an alternative religion, one whose express purpose was to commune beyond the grave, busy piecing together the Samian ware in another room while his daughter and her unconventional friends dabbled, holding hands with the lights turned down low.

Britain's population was still solidly Anglican, and the Lawrences went to church on Sunday down the river in Putney, George sometimes playing the organ for the congregation. They were part of the respectable proportion of the middle classes in London who still attended, but the mood music was lachrymose, a score written for an epilogue.

The British Empire was based on Christian faith and the St George carved on the opal finger ring, currently on loan in its case at Lancaster House, kept a protective eye over all soldiers, and now George in his shop across town in Wandsworth. St George was an old-fashioned character in 1914, and the ring didn't summon the roar of Henry V into the battle of Agincourt; it was rather a wistful memory of the old codes of chivalry from days of yore.

Almost everyone in London was a Christian of one kind or another, with a significant tranche affiliated with the evangelical Free Churches, and small minorities of Roman Catholic, non-denominational or religious non-Christians, leaving very few with no church affiliation at all. The Church of England

was failing to win the allegiance of workers who had moved into the industrialised cities. They had tried so hard to get their best clothes together for Sunday but unrewarded graft made them less inclined to participate. Lawrence remembered public demonstrations of 'table knocking' in London from when he was a boy, performed by the charismatic Fox Sisters, over from New York, who made talking with the spirits fashionable, but he would be sailing close to the wind to do more than observe his medium daughter now – fortune telling was illegal.

Lawrence and his daughter weren't the only ones trying out new methods that weren't quite respectable behind closed doors. There were wild currents running beneath the surface of many proud British institutions, and experimental new approaches to long-buried questions.[7]

The image archaeologists before the First World War left for posterity was of gung-ho, rational men of empire with charts and brushes saving artefacts in the British or Imperial soil and delivering them to the ranks of fogeyish museum staff for safe-keeping and showing off. But some of the behind-the-scenes operations were far stranger.

A gentleman archaeologist in Lawrence's circle had apparently just 'discovered' a lost chapel at Glastonbury Abbey by practising the new discipline of 'psychic archaeology'. Frederick Bligh Bond, just two years younger than Lawrence, had been respected as a sober and scholarly expert in the field, who specialised in drafting architectural sketches for the restoration of historic buildings. A few years earlier the Church of England had appointed him the director of excavations at Glastonbury Abbey in Somerset, a place famous as the setting for the legend

of King Arthur, king of the Britons, his Queen Guinevere, and the mythical island of 'Avalon', Arthur's burial site. The 'Edgar Chapel' had been lost in the mists of time somewhere in this pregnant landscape, and no one had been able to find it. Even the most determined archaeologists were left scratching their heads. Bligh Burgh decided to go in a new direction to try to locate the chapel. It was a surprising one for him to take. As the son of a reverend from Wiltshire he was hardly the 1910s version of a New Age woo-woo type, nevertheless he began a series of covert séances in which he asked the spirit world to tell him where he might find it.

Bligh Bond worked with his friend Captain John Allen Bartlett, who was then experimenting with 'automatic writing'. The men assembled around a table and Bligh Bond would put himself into a trance state while a 'spirit guide', who in this case they believed to be 'Johannes', a sixteenth-century monk partial to a glass or two of mead and therefore often inebriated, dictated directions using Bligh Bond's hands. 'Can you tell us anything about Glastonbury? Where should we dig?' Bligh Bond asked the spirit guide monk. Johannes answered: 'The East End. Seek for the pillars...the foundations are deep.' Bligh Bond drew a detailed map with these precise instructions and the men started digging. They apparently found the lost Edgar Chapel straight away, exactly where the monk had shown them. Bligh Burgh did his best to keep all this quiet. He knew that the Church of England would disapprove in the strongest terms with any attempt to 'contact spirits' on a holy site, and that his professional credibility as an architect would lie in tatters. To add further potential insult, the Church had paid for the dig. Archaeology

at this time was just beginning to assert itself as a scientific discipline rather than a gentleman's hobby, so he was right to worry and, sure enough, when word got out what he'd been up to as Glastonbury's chief excavator he was promptly fired. (He busted himself in his autobiography, *The Gates of Remembrance*, in 1919.) He always acknowledged, however, that his success with this controversial approach could have had a psychological rather than a paranormal explanation, and that the automatic writing had been accessing his subconscious. It was entirely possible he had already seen a map of the Abbey and forgotten, and he knew from his work how medieval cathedrals were planned according to set patterns, their designs replicated again and again over centuries, so he could have worked out rationally where a chapel was likely to be. He oversaw seventy séances in all, over ten years, and other archaeologists secretly adopted his practices, using it to look for Cleopatra and Alexander the Great's tombs, and the methodology has clung to the margins of archaeology ever since. Bligh Bond fled to the US but eventually returned to Britain where he lived under-the-radar, though he did join the 'Ghost Club' where he would bump into Ernest Budge, W.B. Yeats and George Fabian Lawrence.

Lawrence started receiving regular visits at 7 West Hill from another controversial figure of the era, John Sebastian Marlowe Ward, who was on the hunt for antiques. To many in the Anglican Church, Ward was a crackpot element, his beliefs a subversive brew of ancient knowledge, mysticism and Christian faith. He was as wildly eccentric in appearance as you would expect from a man who absorbed so many influences. More than twenty years younger than Lawrence, he

would pull up outside the shop in Wandsworth in full Anglican clerical garb, an innocent zeal in his extremely short-sighted eyes behind thick-lensed circular glasses. He still had one foot in the Anglican faith, believing his position in the Church didn't preclude an interest in mediumship and Spiritualism, although the Anglican Church did not feel the same way and would make him choose. Ward spent any spare minute driving around the country with his wife collecting antiques to fill his museum: a living history visitor attraction he called 'Folk Park' in New Barnet, in suburban North London. He was hard at work sourcing a mixture of old and replica buildings, and genuine antiquities, from many different eras for it. 'Folk Park' would become a major tourist attraction, the first of its kind, a proto 'immersive' historical experience, much like the open-air Weald and Downland Living Museum in Sussex today, staging historic structures, including a thirteenth-century tithe barn that had been disassembled, transported and re-erected in the Park. Visitors could wander 'in the past' at their leisure on the fringe of the City on a weekend, breathing in the atmosphere of the centuries. Lawrence was now firm friends with Ward and supplied him with most of Folk Park's Roman British antiquities; the eccentric cleric would load up the car outside Lawrence's shop, and head north, his vehicle packed with items from Roman Britain to join his growing collection. Queen Mary liked the idea of the 'Folk Park' and also supplied items.[8] Ward, in return, supplied Lawrence with ideas. He believed that ancient learning, overlooked by the medieval church, had been passed down instead through a variety of secret societies, the Freemasons among them, and wanted that learning

brought back into the fold in the hope it would encourage inter-religious harmony.

Ward wasn't the only renegade force in the Church in the run-up to the Great War. Archbishop Colley of Stockton, Warwickshire, had just been forced to resign as a member of the Anglican communion, in his case because of a stunt he orchestrated on New Year's Day 1912 inside his church. In a farcical scene, Colley, dressed in his full canonical wear, climbed into a custom-made glass-topped coffin and asked the pall bearers to process him around the nave. Then, as Mozart's Twelfth Mass played on the organ, he instructed the audience to prepare for the inevitable: 'Set thy house in order for you shall die and not live,' he boomed. The audience 'giggled hysterically' according to the *Evening Telegraph and Post* and some 'hastily left the church'. Some were 'so overcome by their emotions that they gave way to audible sobs'.

Colley was a Spiritualist as well as a High Churchman. He claimed to have foreseen the death on the *Titanic* of his close friend, the investigative journalist, W.T. Stead, a giant of nineteenth-century journalism who pioneered the 'tabloid' style to bring public opinion with him as he exposed the squalor of the slums and the evils of child exploitation, and campaigned for social welfare legislation. (He's also the man whose made-up story about the Unlucky Mummy got spun into myth.) Like Ward, Colley saw no problem inhabiting both positions. He was an archbishop and a friend of Sir Arthur Conan Doyle with social connections in the 'Ghost Club'. But the Church could not countenance his theatrics and his superstitions. Respectability and established order would

not be given up that easily. Like Ward, Colley was forced to resign.

The Anglican Church was under strain, though, struggling to keep insubordinate elements in check, their authority figures coming apart at the seams of their clerical robes. Impatience at the status quo had sent people down new avenues looking for spiritual guidance, and they were prepared to break the rules. Who would offer strong leadership, and, most importantly, protection?

Memories of a last, long, golden Edwardian summer in 1914 were not just visions through rose-tinted spectacles, they were based in meteorological fact. The hot summer of 1914 was the most glorious in living memory and looked back on by many as a prelapsarian Eden. Stefan Zweig had enjoyed few summers 'more luxuriant, more beautiful, and, I am tempted to say, more summery'. A heatwave sat heavy on London that last summer before the War, and the London Museum benches were full of flopped women visitors fanning themselves and puce-faced men stuffed in three-piece suits, making plans to retreat to the suburbs for lawn tennis after ticking off 'the Elizabethan Jewels' or another seemingly endless afternoon of croquet in straw boaters in Arcadia for the upper classes at their country houses.

Lawrence passed the opal finger ring in the show case in the Gold Room daily, and had a chance to glance at its St George. The object nudged anyone in the vicinity to think of its original owner, and, although war still seemed unlikely, it served as a reminder of good luck and fortitude required of an army standing up to his foe. Lawrence knew the language of rings and understood more than most how a ring could feel

like an amulet when worn on the little finger of a fist pushed down into a pocket.

Lawrence was forging new connections in the real world too, that hot summer of 1914, securing more practical forms of protection and insurance against any future difficulties. Probably at the encouragement of his friend John Ward, he was initiated as a Freemason at the 'Wolsey Lodge', No. 1656, at the suburban location of the White Hart in Hampton Wick, a few miles up the Thames to the south west from Wandsworth, an old inn built behind royal parkland to serve the great Tudor palace of Hampton Court; its function room was right above the saloon, the patrons' ales and port-and-lemons on the bar.

Membership here, however, put him in a brotherhood with the most powerful in the country and its empire. Gould's *The History of Freemasonry*, the definitive text on the movement, compiled in six volumes by a Victorian lawyer and freemasonry enthusiast, was dedicated to the Prince of Wales, the future Edward VII, who looked back from a tinted illustration plate in the book, a grand master of the United Lodge of England chain strung around his neck beneath an impressive beard, pinned all over with symbolic badges. The powerful were hosted in markedly more glamorous venues than the White Hart, Hampton Wick. Winston Churchill, now First Lord of the Admiralty, was a member of the 'Studholme Lodge', No. 1591, which met at the Café Royal on Regent's Street. The appeal of membership was clearly, at least in part, fun – much like what was on offer at the Savile Club or the Garrick and other establishments where men could enjoy brotherhood washed down with fine wine. This was an atmosphere swathed in the aromatic warmth

of Romeo y Julieta procured from Dunhill's on Duke Street. Frederick Bligh Burgh was a Freemason like Ward, as, indeed, was Charles Wakefield of Castrol Lubricants, whose refit of the building at the corner of Cheapside and Friday Street for his oil business broke ground for the discovery of the Cheapside Hoard in the first place. Being a member also plugged Lawrence into a network of lodges across the empire and opened up potential channels of mutual support between him and any of his agents abroad who happened to be Freemasons – a mechanism for preferential treatment for the ambitious, or aid and welfare packages in times of war. In 1914 it was ordinary for a man in a business like Lawrence's to join the 'The Craft'; it may even have been considered odd *not* to, and war was now talked of as a possibility although hard to believe in. Membership meant an insurance policy, where the state wasn't extending a hand. Brothers were pledged to put their loyalty to each other above other obligations, and it was logical to imagine that could include the law, but there wasn't yet an established story of institutional corruption and men wore their regalia with pride: it was a sign of respectability, not something to arouse suspicion and mistrust. For a man of Lawrence's contingent circumstances, Freemasonry offered the prospect of advancing your status in the world. The principal enticement, however, was the symbolic equality among the brotherhood that cut across social classes. Gloves were worn in the ceremonies, as the historian John Dickie suggests, 'so that no Brother can tell the difference between the hands of a duke and the hands of a dustman'.[9] Lawrence had put himself within the same brotherhood that had embraced the late King Edward VII, and would soon include King Edward VIII and George VI.

The secrecy and the soup of symbols in Masonic rituals – awash with references to the Ancient Egyptian gods, Babylon and the Knights Templar – confused the origin story and lent a suspect air to the operation, offering a chronologically scrambled and unconvincing account of where their knowledge came from, pointing at the same time to King Solomon's Temple, and to Euclid, the Greek mathematician teaching the Ancient Egyptian stone workers the tricks of the trade. Freemasonry as understood in 1914 was largely an eighteenth-century confection, that had adopted the sixteenth-century mason's manual of useful diagrams, mnemonics and proprieties set out earlier by James VI's Master of Works to keep apprentices in order, as well as a dash of King James's own mystical philosophy. There was a clubbable pleasure, of course, for Lawrence in gaining exclusive access to ancient hieroglyphs, in which is encoded the highest learning, originally preserved for the eyes of chief priests and not for the hoi polloi. But the appeal was about more than the childish fun of impenetrable cyphers and secret codes. In his classic history, R.F. Gould declared, in a definitive Victorian style, that 'Masonry is regarded as the direct descendant or is a survival of the mysteries of Isis and Osiris in Egypt.' Osiris was the Dying King, reborn, and beneath the preposterous medieval cosplay – the St George opal ring would not look out of place amidst all the nostalgia for chivalric traditions of yesteryear – the initiation rituals included a few moments for instruction and reflection on life's most difficult questions. One key ritual, according to John Dickie, who snuck in for the purpose of intelligence gathering, is the killing of the apprentice who is then 'reborn' as a mason, in the company of his new brothers.

Like Colley telling his congregation to 'Set thy house in order for you shall die and not live,' the Lodges provided a space for a meditation on death. The Lodge at the White Hart, just like the one at the Café Royal, was a self-help group for morbid Edwardians, all men welcome.[10]

The Freemasons were a secular and free-thinking organisation, with a gloss of the sacred. The 'Great Architect of the Universe' was invoked in the mason's prayer, and it was all mixed up together with the esoteric exoticism of Egypt, so it could all mean whatever Lawrence wanted it to mean, and he wasn't the only one to find the open interpretation useful in troubled times – as well as the contact list.

When Lawrence had business cards made up for 'G.F. Lawrence, Antiquarian', he subtly but clearly declared his allegiance in print. At the centre, he designed a distinctive personal logo, with his initials G.F.L. inside a shield. The insignia was in a distinctly 'medieval' style, the shield drawn as if it had been engraved, the font an imitation of 'gothic' calligraphy, and, incorporated within the shield, were the letters 'XX', reminiscent of some of the mason's marks in R.F. Gould's survey, the XX being very like a carpenter's company mark, or a variation on the square and compass, the key pieces of equipment of the masons and their most famous symbol.[11, 12]

CHAPTER X

The Treasures Go Back Underground

On 4 August 1914, Great Britain declared war on Germany. Lawrence watched the crowds in the Gold Room thin out. He was more often left alone with the treasures to think about what he should do next, and to look at the opal ring with its St George.

The country went into battle, like Richard the Lionheart or Henry V, with St George on the flags. Church attendance surged for a few weeks at the onset of the conflict. Churchgoers made up a disproportionate number of those who enlisted.

The first Zeppelins took London by surprise in 1915, cutting their engines and drifting silently over the City before dropping their bombs. Streetlights were hastily dimmed, no one knew what the Germans would send next, or when.

Just before hostilities, Howard Carter's patron, Lord Carnarvon, had won the concession to dig in the Valley of the Kings, and search in this pharaohs' graveyard in Upper Egypt for the tombs missed by other expeditions, including that of the pharaoh 'Tut-ankh-amun'. Carter was to oversee the work, the second chance of a lifetime, but he was diverted for the foreseeable future into the intelligence department at the War office in Cairo, working as a diplomatic courier and translator. Lawrence was on home guard in West Hill in Wandsworth with

Flo and May, and his brother Alfred, travelling around town on Museum and shop business, scoping out excavations, taking frequent looks up at the sky as he hurried along.

'It is far better to face the bullet than to be killed at home by a bomb,' read the recruiting poster slapped on hoardings all over the City. 'Join the army at once & help to stop an air raid. God Save the King.' The patriotic fervour spread fast, and women began handing out white feathers to men not in uniform to shame them into joining up.

Although he was in his late twenties, the services of Frederick Lawrence were not required for the fight. It will have been painful for Fred and his wife that he could not play his part. 'As lame as St Giles, Cripplegate' went the saying,[1] in a nod to the saint to whom the Lawrence family's parish church was dedicated, St Giles, the Patron Saint of the lame, a hermit depicted with an arrow in his knee, accompanied by the deer who once nourished him with her milk deep in the forest, whom he later protected from the king's hounds, taking a hunter's arrow intended for her. 'This proverb…in common discourse', explained Hazlitt in his *English Proverbs and Proverbial Phrases* in 1869, 'is spoken rather merrily than mournfully, of such who, for some slight hurt, lag behind; and sometimes is applied to those who, out of laziness, counterfeit infirmity'. It would not have amused Fred.

'The Volunteer', a poem of 1910 by Herbert Asquith, son of the prime minister and a City lawyer, written before the war and intended to boost recruitment, spoke to the lot of Frederick Lawrence. A man taunted with the chivalric glory he would miss out on – death being the best bit.

> Here lies a clerk who half his life had spent
> Toiling at ledgers in a grey city
> [...]
> With no lance broken in life's tournament
> Yet ever 'twixt the books and his bright eyes
> The gleaming eagles of the legions came,
> And horsemen, charging under phantom skies,
> Went thundering past beneath the oriflamme.
>
> And now those waiting dreams are satisfied...
>
> His lance is broken; but he lies content
> With that high hour, in which he lived and died
> [...]
> Nor needs he any hearse to bear him hence,
> Who goes to join the men of Agincourt.

Not for Fred a place in a brotherhood of brave soldiers, banded together across the centuries, fighting in the name of Henry V and England, under the care of St George. Heroism remained a distant dream, remembered from the pages of the books of legends for boys, like *The Seven Champions of Christendom* by W.H.G. Kingston, a fictionalised 'superhero' adventure featuring St George, St Andrew, St David, St Patrick among others, or *Where the Rainbow Ends*, with a colour-tinted St George on the cover, charging in to shield children on their dangerous quest to reach a magical destination. Death for this cause was transcendent, far preferable to an ordinary life 'toiling at ledgers in a grey city'.

In London, as searchlights stroked the sky, and barrage balloons took their position, the arguments ramped up over who had the right to a share of the Cheapside jewels, the claims and counter claims ringing across the council chambers and offices and bashed onto furious memos.

Officers from the Post Office had been tipped off about six Roman objects including a gold ring acquired by the London Museum.[2] On inspection they instantly recognised them as coming from the excavations at the site of the old General Post Office, in St Martin's Le Grand, just behind Cheapside, overseen by Frank Lambert, the Guildhall Museum Clerk. They had clearly been taken illegally, and Lawrence was called in for questioning by Laking. He stood accused of a clear infringement of the law: receiving stolen property, putting him in real jeopardy. Property owners were no longer relaxed about scroungers, it was a different world, and Laking implored Lawrence to understand the potential consequences – fines, even prison. And to top it all, Lawrence was a representative of the Museum of London which was already under fire from the coroner's office. Laking took the rap for the brazen theft and apologised profusely to his trustee, Lord Harcourt, for Lawrence's 'unintentional and overzealous error of judgement'. 'He is ever triumphant at finds when he secures them from other museums,' he wrote, exasperated. The Museum handed the finds over to Lambert at the Guildhall 'with a somewhat abject apology'.[3]

It was humiliation and heat when they could least afford it. The City of London was now requesting a formal inquest into the Cheapside Hoard.

On 4 March 1915, Dr Waldo, with the bit between his teeth, wrote to the County Purposes Committee at the City of London suggesting that the find, and attendant questions, be put in front of a jury as 'advised by the Law Officers…as a preliminary to enforcing by legal action the claim of the Corporation.' The threat was real, but 'Difficulties arose' frustrating them again. The treasures had been moved out of the City 'beyond the coroner's jurisdiction' years before Waldo knew anything about the discovery and there was no way of proving the precise location of the find spot to the satisfaction of a jury, who were 'not entitled to go into any question of ownership'.

Regardless, the City of London came back fighting, determined to expose disreputable activity at the London Museum, printing handbills reasserting its unique chartered rights and slapping them up all over town, next to the recruiting posters.

The Corporation of the City of London
TREASURE TROVE

Notice is hereby given that the Mayor and Commonality and Citizens of the City are, by ancient Charter, entitled to all Treasure Trove found within the City of London and the Town and Borough of Southwark, and that in the event of any gold or silver coins, gold or silver plate, or gold or silver in an unmanufactured state being found in any house, or in the earth, or in any private place within the aforesaid limits, *the owner of which is unknown*, such articles belong to the Corporation of the City of London, and Notice of the

discovery must at once be given to me, the undersigned, Town Clerk of the said City, at the Guildhall, London E. C.

In the event of any such articles being retained by the finder, or sold or handed over to any other person or Body, or notice of the discovery not being given to me, the person finding the same will render himself liable to prosecution. James Bell, Town Clerk. Guildhall, E. C. December, 1915.

No one could be in any doubt as to whom the campaign was directed at: a man loitering around the building sites with coins in his pockets, even now, with bombs falling nearby. The City were laying claim to anything silver or gold that did not have an owner, or found in a 'private place' on their land. No wall of silence would protect thieves from the law indefinitely.

But on 1 February 1916, the London Museum shut its doors. The staff dismantled the show case in the Gold Room and boxed up 'the Elizabethan Jewels', along with the other most valuable exhibits in the collection, fifty-three cases in all, and the fabulous exhibition spaces and dark corner offices in Lancaster House were taken over for war business.

The St George opal, trapped in the glass case for a few months, was free again, its destiny unsure, so an opportunity for Lawrence to take the ring back into his safekeeping. He could look after it for the duration of the war and it could look after him.

The porters carried the boxes across town and down into a tunnel that was under construction for Post Office trains. The contractors had good reason to worry about officers of the London Museum getting anywhere near their excavations, but

this time the Museum was making a deposit. The Hoard and the other boxes were duly stored inside the quarry that would form a new arm of the miniature railway for letters and parcels running between Whitechapel and Paddington.[4]

The City's claim extended only to the silver and gold in the Hoard, but they were not capitulating. The chairman and City solicitor requested an interview with Mr Harcourt 'with a view to some amicable arrangement…if possible…avoiding lengthy and costly litigation between the various public bodies concerned.' The years' long fight over the title to the Hoard was now at boiling point. The irritating civil servants would not go away. In April 1916, an urgent meeting was called at Harcourt's house, with representatives from all sides invited to thrash out a compromise.

On 5 April 1916, Harcourt wrote to Guy Laking: 'I think it would be a good thing if you were here at 3 O'clock on Friday in case I want you merely as a witness to the conversation with the City Solicitor and Mr. Stone about the London Museum jewels. I should ask you to sit in Miss Philips's room until I sent for you, which I might not find it necessary to do.'[5]

No minutes were taken, but despite a moment of caution beforehand, Harcourt evidently flung himself into a charm offensive and worked his natural magic, shrewdly reading the room as to which concessions and promises were absolutely necessary and which could be rejected with a brush of the hand. An imposing man on any day of the week, he held his chin even higher over his starched collar, aloof from the technicalities, nonchalantly dismissing the allegations, wilfully blind about where, precisely, the X on the map had been marked.

No doubt a significant number of whisky glasses were drained in the process.

On 10 April 1916 Harcourt followed up with a note giving some sense of the timbre of the meeting, and the arguments employed.

> When I originally acquired the jewels with the object of presenting them to the nation I was not so much interested in the locality of the find as in the urgent necessity of preventing their destruction. The evidence as to their place of origin was conflicting and contradictory and did not at the time convey to me the impression they were found within the City... The element of Treasure Trove is, as you know, extremely small, consisting only of the gold setting of the jewels, and the gold base of some of the enamels, but any attempt to separate the two would result in the destruction of the artistic and antiquarian merits of the collection. I have unfortunately lost any evidence I originally had as to the locality of the find and therefore am unable to combat – indeed I readily accept – your assertion that it was in fact found within City boundaries.

Harcourt repeats the ludicrous assertion that he somehow 'lost' the evidence, the map, which would show the world the location of the find, although surely he didn't believe it. He was stumped for a credible defence but didn't much care to think of a better one. A high-minded champion of artistic integrity, he warned the City off claiming their share of the silver and gold by pointing out the risk of creating a ring with two owners. They had 'one

object in common' he said with unctuous magnanimity, that 'the public should not be deprived of this most interesting find.'

On 17 April 1916 the chairman and solicitor, thoroughly charmed, reported to the Committee that they 'saw Mr. Lewis Harcourt, by whom they were most courteously received. Mr Harcourt explained that he had acted in entire ignorance of the rights conferred by the Charter upon the City.'

On 6 May 1916 the City solicitor sobered up and wrote a memo loaded with subtext to Harcourt thanking him for 'amicable settlement of what I am afraid would have proved a tedious and expensive dispute between the Crown, yourself, and the Corporation.'

But, finally, the impasse had been broken and the City solicitor and chairman of the Corporation's County Purposes Committee agreed a deal giving Guildhall some of the treasure. Harcourt filled Laking in on events, concluding, with waspish understatement, 'It has, I think, been a successful extrication from a rather tight place,' a rare admission that the years of fighting had ruffled his feathers.

There's a final dig in a 'Confidential' note from the City solicitor of 25 July 1916, nudging Harcourt publicly to acknowledge Wakefield in the labelling of the treasures for display. 'The Library Committee are very desirous of identifying the exhibit with the present Lord Mayor, Sir Charles Cheers Wakefield, upon the site of whose house (Wakefield House) curiously enough the treasure was found.' The innuendo is loud and clear, but I can find no evidence suggesting a close relationship, let alone a stitch-up, between Harcourt and Wakefield, so the curious coincidence it seems to have been just that – a coincidence.

Harcourt smartly reasserted his natural authority over proceedings. In return for the division, he was granted discretion to choose which pieces to send across, and his selection of sixty-eight pieces went over to the Guildhall with the specific instruction they be labelled as 'Presented by the Corporation of City of London and the Rt Hon. L. Harcourt M.P.'

Publicly the Guildhall celebrated the 'handsome selection' and a 'valuable acquisition' but there was cynicism about the itemised list when it came in, the Guildhall librarian, Bernard Kettle, noting archly that Harcourt's peace offering did 'not include some of the best objects found'. A careful cross-check would confirm the MP did indeed retain all the showstoppers. Of course, the Hoard was in boxes in the Post Office tunnels and would have to be divvied up later, but the treasure was now officially split between four museums: the Guildhall, the V&A – the British Museum, where Harcourt was trustee, already had its cut – with the lion's share remaining at the London Museum. There was clarity at last, at least officially.

It's hard not to gloss this fight over the Cheapside treasures as a proxy war. Wealthy men, too old to fight, putting City officials in their place. It's certainly jarring, this tussle over brooches and pendants played out so bitterly while sons and brothers were dying in foreign fields. These were wealthy men; why did they care? But the Cheapside Hoard was worth more than money to them. It mattered very much indeed, who won and who lost, more so than ever in the middle of a war. The Hoard was a trophy of grand Imperial inheritance, proof that it all mattered. That's the power of antiquities. It wasn't just the upper classes fetishising antiquities in 1916. Across town *Chu*

Chin Chow, starring Oscar Ashe as Ali Baba, a musical version of the Arab folk tale *Ali Baba and the Forty Thieves*, opened at His Majesty's Theatre in August, the surprise hit of the year. A story of marvellously colourful treasure hidden in a cave played to packed-out houses.

In June 1916 the Stoke Newington Recruiting Office wrote demanding an explanation for Maurice Edgar Read's failure to present himself for service with the regiment 'in accordance with the instructions sent you by post'. Read, the typist at the London Museum, had signed up at twenty-one in December 1915, along with two other members of staff. It seems to have been a reluctant step. He was given four days to provide an answer before 'your name will be posted in the Police Gazette as a deserter from His Majesty's Army'.[6] In 1916 desertion was punishable by death. Perhaps Read had seen an Order of the White Feather delivered to a man in civvies, or received one himself, or felt the heavy hand of one of the elders at the Museum like Lawrence, Laking, Oates, Harcourt or Esher on his shoulder (all over fighting age themselves and several, like Laking, chronically unwell). Conscription was about to begin, in March 1916, for unmarried men aged eighteen to forty, so he soon would have no choice. Read was a slight figure, at five foot three and a half inches tall but, after a few weeks' training, he was packed off to the Somme on 4 July 1916, where the 23rd Battalion of the London Regiment were on the offensive in the Battle of Flers-Courcelette. In total 29,376 men died there. Read was one of them, killed in action on 16 September 1916, and what was left of his body was buried in an unmarked grave.[7] The youngest of seven children, he left his father, John

Read, alone at home, his mother having died some years before. John Read sent a telegram to an officer in Maurice's regiment to acknowledge the receipt of Maurice's identification tag in the post:

February 20th 1917
Major G. F. Bartlett

Dear sir,
 I duly received 'Disc' by registered letter, belonging to my late son Maurice Edgar Read. I shall trust that you will forward me any other of his belongings, if they come to hand.
 He was five years at London Museum, Lancaster House, Kensington Palace, and it is painful to think this is the only article found belonging to him.

Yours truly,
John George Read

King George V and Queen Mary both took active part in the war effort. The king had been visiting the Western Front since November 1914 and returned a further five times; in 1917 Mary went with him, meeting Allied heads of state, inspecting troops and visiting the wounded.

At home he enjoyed the company of his pet African grey parrot, Charlotte, and whiled away many hours mounting stamps into his bound collections, a smaller-scale version of his wife's hobby, and at the Royal Riding School they hosted entertainments for over 2,000 wounded soldiers and sailors, with younger members of the family presiding over each table and

various artistes, including acrobats and conjurors, performing in front of the beleaguered men.[8]

The royal family had serious politicking to do too and dropped their German name, Saxe-Coburg-Gotha, mindful of the optics of their blood connection to the kaiser, to become the 'House of Windsor'. The same year, the government wanted to send a ship to rescue George V's cousin, Tsar Nicholas, and his family, but would not do it without the king's permission. George and Mary were concerned their familial relationships would channel Russian-style unrest to Britain, and, although by all reports tormented by the dilemma, they did not agree to this; the Romanovs were left to their fate at the hands of the Bolsheviks.

The king and queen tried their best to rally morale, touring industrial areas and ship-building yards while navigating ever more tense protests from munitions and engineering workers. In March 1917, the strike at the Vickers Gun Factory in Barrow, Cumbria, protesting about pay cuts, lasted long enough to delay the delivery of guns and ammunition to the front, and an even larger engineers' strike followed soon after in May.

Official connections with Russian family had been cut, but lines of contact continued through underground channels. As George and Mary tried their best to smooth industrial relations in Britain and secure the supply of vital equipment to the war, jewels belonging to the king's cousins were being smuggled out of Russia to him in England.

In the midst of the revolutionary uprisings of 1917, Albert Stopford, an expat high-society antiques dealer, had beaten the Bolsheviks to the Romanov safe in the Vladimir Palace in

Saint Petersburg. His friend the Grand Duchess Maria Pavlovna (Tsar Nicholas's cousin) had told him where to find her cache of jewellery, and he grabbed as many items as he could, and trafficked out over 200 pieces to England, including the grand duchess's 'Vladimir tiara', in two Gladstone bags. George V's aunt, Empress Maria, the mother of Tsar Nicholas, escaped to Denmark carrying a large box of jewels. The box included a multitude of exquisite and highly valuable pieces and she guarded it jealously, even sleeping with it hidden under her bed.

While the Cheapside treasures were stashed safely in the underground system, the general population got to work leveraging what possessions and services they could offer in exchange for what they needed to get by. The British royal family had the finest jewellery, rather than meat or carpentry skills to trade, but kept their property out of the fight. For them the conflicts raging all over the world opened up new opportunities for acquisition as jewellery collections were 'redistributed' between the European royal houses. George and Mary were, however, an anomaly, when viewed in the grand sweep of royal history, in not pawning their jewels to fund a war effort. Behind them was a long history of monarchs doing just that. Many of their regal predecessors had thrown assets into the rough and tumble of the international market, hiding jewels to transport them across borders for sale at open trading posts. Liquidating sparkly family assets had for so many been the difference between winning a war and losing it. Gemstones had given pre-Glorious Revolution English monarchs access to money to run the country, without the grubby necessity of having to go to Parliament for it. James I and VI and his wife, Anne of Denmark, inherited Elizabeth

I's debts and tripled them in ten years, largely thanks to their extravagant tastes, particularly Anne's love of fine jewellery. She put her jewels up as security for loans, establishing a system of credit with one of the court goldsmiths, George Heriot, who gave cash advances leveraged against the stones. When Anne couldn't clear her debts, she simply laid more to pawn, depositing additional jewels with Heriot, and since he was charging ten percent interest the debt ballooned. By June 1617, James and Anne owed Heriot £10,091, over two million pounds today.[9]

Three iconic pieces of jewellery were pawned several times by, successively, James I and Charles I, and his wife Henrietta Maria, to replenish the war chest: the 'Sancy' diamond, a gigantic, pale yellow sparkler; the 'Three Brothers', a pendant of three red stones around a deep blue pyramid-shaped diamond, and the 'Mirror of Great Britain', a brooch of rubies, diamonds and pearls.

The Sancy had supposedly been smuggled out of India in the fourteenth century by a Venetian diamond cutter. It was believed to bring good luck and strength to the Dukes of Burgundy who took possession of it for a few generations, and they rode with it into battle, until they lost a key encounter, at which point it was said to be cursed. The 'Sancy' was then hidden by the Bishop of Basel along with another fabulous piece, the 'Three Brothers', which featured three rectangular spinels (semi-precious stones, a pure bright red in colour, slightly paler than rubies, and known at the time as 'balas rubies'). The 'Three Brothers' came from the crown jewels of Burgundy, and it parted ways with the 'Sancy' and travelled, via a German banker, to join Elizabeth I's Crown Jewels of England. The

'Sancy' took a more circuitous route via Portugal and France, to the same owner, but Elizabeth I promptly pawned the diamond in Antwerp to support the Dutch in their campaign for independence from Spain. She never redeemed it. She kept a tight hold of the 'Three Brothers' and was painted wearing it in two portraits. In the iconic painting of the queen of 1585, she has it on her chest, suspended from a carcanet, or necklace. There's even a replica of the decoration on her marble effigy in Westminster Abbey. A Dutch collector called Nicholas Harlay de Sancy got his hands on the magnificent yellow diamond, and named it after himself, but having fallen on hard times he sold it on to James I who could well have been wearing the 'Three Brothers' as a hat pin, as he was wont to do, at the time of purchase.[10]

In 1603 James commissioned 'The Mirror of Great Britain', another dazzling piece, as a symbol of the new union between England and Scotland. It was made by George Heriot, repurposing jewels taken from an earlier Tudor piece in a new setting. The enormous 'Sancy diamond' was the star of the show. The piece was described in an inventory of Stuart jewels as: 'Mirror – diamond, ruby, lozenge diamonds, one the letter H of Scotland, garnished with diamonds and two round pearls and one fayre diamond cut in fawcetts of Sancy.'

James I left 'The Mirror of Great Britain' at his death to Charles I, who pawned it again in The Hague in 1625 when he needed money for his wars against the old rivals France and Spain. He redeemed the piece, but when he fell out with Parliament (a major point of conflict was his belief in the divine right of kings, which led him to consider the Crown Jewels as his

own private possessions) his Queen Henrietta Maria went back to Holland to pawn it yet again. She travelled weighed down with 'Treasure, in Jewels, Plate, and ready money' that Parliament complained would 'impoverish the state' but leveraged the Mirror as she had set out to do, along with other jewels including the 'Three Brothers', to raise funds in case war broke out. The 'Three Brothers' proved too well known, however, and buyers got nervous. Henrietta wrote to the king back in England: 'The money is not ready, for on your jewels, they will lend nothing. I am forced to pledge all my little ones.' The 'Mirror of Great Britain' was broken up there in the Netherlands, at the epicentre of the international gem trade, and scattered to the wind, with the Sancy diamond the only element to have popped up again later to be reclaimed, other elements still considered lost. As the Civil War raged, Henrietta Maria tried to pawn more jewels again in France but with mixed success.

In 1918, the Sancy was hung from around the neck of Lady Astor, who had been given it as a wedding gift by her father-in-law in 1906.[11, 12, 13]

Queen Mary was not called on to pawn her jewellery to help fund this war. That was the government's problem, and the only treasure with royal connections leveraged to help fill this war chest was the gold sovereign, at the time the most important trading coin in the world, with George V's bearded profile on 'heads', and St George and the Dragon on 'tails'. When the government needed to pay off war debts to the US in 1915, they asked the population to do their patriotic duty and hand in their gold coins to exchange them for paper notes, and people did as they were asked.

As the war continued to bleed the country, the vast country estates that had hosted Ernest Budge for his uncanny tales, or hidden their silver from Queen Mary, found themselves struggling to balance the books and with nothing left to leverage. The higher levels of tax demanded made them economically unviable, and a significant proportion of their workforce had gone to war and either died or moved into jobs in the cities rather than returning to service in the country.

In the summer of 1917, Sotheby's moved to its new expanded premises on New Bond Street. This was well-timed for business, given the rush of sales that would follow the break-up of so many country houses and their collections after the war. The moving vans carrying the auction house contents to their new home had to dodge a Zeppelin attack. The company had somehow acquired a black diorite stone bust of 'Sekhmet', the Ancient Egyptian warrior goddess and protector of the pharaohs, and they put her over the portico of the pretty stucco building to greet visitors. She looked straight ahead across New Bond Street, a lion's face on top of a woman's body; a steward through the afterlife.

The gigantic Gotha bombers terrorised on another scale altogether compared to the silent threat of the Zeppelins which were difficult to detect but carried a smaller bomb load. They caused little physical damage, but sent hundreds of thousands of Londoners rushing down to take shelter in Underground stations. The cellar at Wakefield House, where the Hoard had lain for 300 years, was useful again as a place to hide people or their property and protect them from danger. London's streetlamps were still dimmed and the jewels, down in the Post Office tunnels, deprived of light to catch off their surfaces, waited silently.

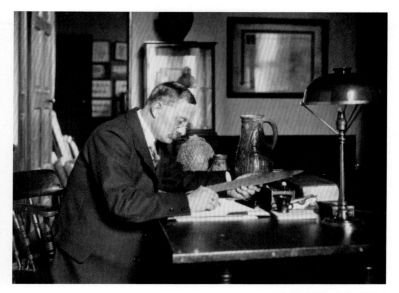

1. (*Above*) George Fabian Lawrence, 'Stony Jack', at work in the London Museum.

2. (*Right*) George Fabian Lawrence's letterhead, featuring 'XX' and other symbols similar to Masonic insignia.

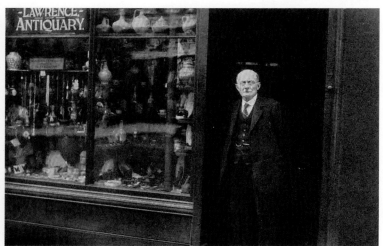

3. G.F. Lawrence outside his establishment, featured in the *Graphic* magazine, 7 July 1928. Photographer unknown.

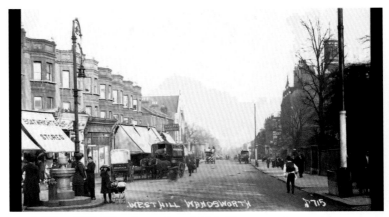

4. West Hill, Wandsworth c. 1904. Photographer unknown.

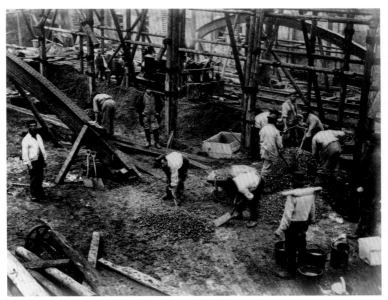

5. Navvies at work on a train line through central London. Late nineteenth century, photographer unknown.

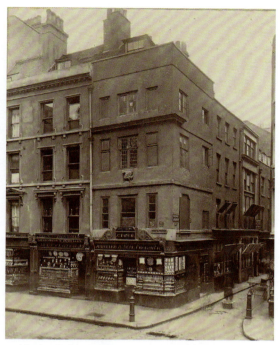

6. Cheapside by Friday Street, c.1880, photographed by Henry Dixon. It was here, beneath the building to the right of the picture, almost out of frame, that workers chanced upon the Cheapside Hoard.

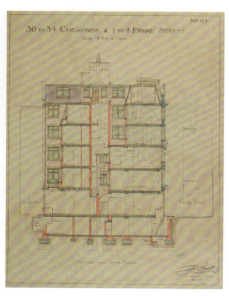

7. Architect Thomas Henry Smith's section plan of Wakefield House, including location of 'Old Vault' at 30–34 Cheapside and 1–4 Friday Street.

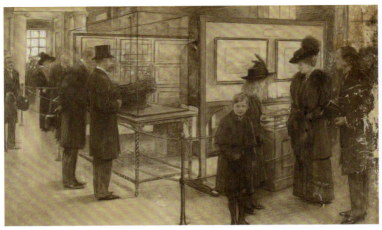

8. The Royal Family at the Inauguration of London Museum, Kensington Palace. Drawing by A. J. Balliol Salmon, 1912.

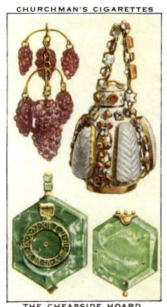

9. (*Left*) Churchman's Cigarette Card from the 'Treasure Trove' Series. No. 8: 'The Cheapside Hoard', 1937.

10. (*Right*) Sensational press surrounding the Elizabethan 'ghost' supposedly haunting the Hoard, *Evening Telegraph*, 1 December 1919.

11. Lord Carnarvon, off duty, reading in a cane chair at 'Castle Carter', Howard Carter's house on the Theban West Bank in 1923. Photograph by Harry Burton. Carnarvon's untimely death in 1923 fuelled rumours of a 'mummy's curse'.

12. Archaeologist Howard Carter examining Tutankhamun's sarcophagus. Photograph by Harry Burton, c.1925.

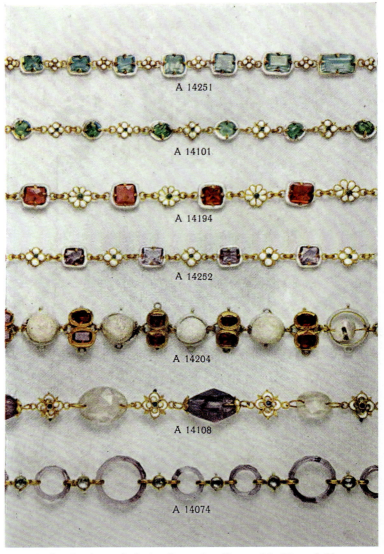

13. A selection of chains from the Cheapside Hoard. From *The Cheapside Hoard of Elizabethan and Jacobean Jewellery* catalogue (London Museum, 1928).

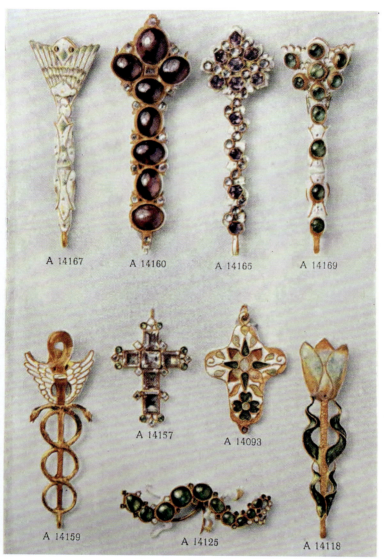

14. A selection of enamelled gold fan holders; a gold cross set with foiled and trap-cut amethysts, bordered by diamonds and emeralds; a gold reliquary in the form of a cross, and a hat ornament in the form of a salamander, gold, set with cabochon emeralds and small table cut diamonds.

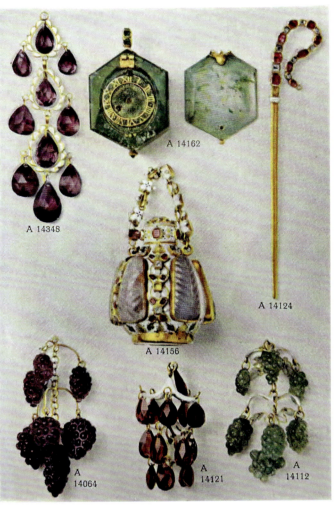

15. A watch set in a single large emerald of hexagonal shape, the loop set with small emeralds and white enamel, the face enamelled green. A selection of pendants, one of seven amethysts carved in the form of a bunch of grapes, another bunch carved in emerald; a hairpin in the shape of a shepherd's crook set with rubies and diamonds; a pomander of enamelled gold set with milky opal plaques, mounted with rubies and diamonds with a chain of spinels, sapphire and diamonds – an impressive luxury in early modern London.

Queen Mary was guest of honour at a magnificent housewarming for the new Sotheby's premises at which was staged an exhibition of works by wounded servicemen, and the women staff, who had been holding the fort, were told to take off their overalls and wear their best Paris dresses.[14]

In the midst of all this, in 1917, Harman Oates slipped out a catalogue of his private collection of finger rings, entitled *Catalogue of finger Rings brought together by F. A. Harman Oates, F. S. A.*

Putting those three letters after his name on the cover proudly advertised his status as a Fellow of the Society of Antiquaries, a 'look at me now' moment to anyone who'd sniggered at 'Titus Oates', and here were pages and pages of his most prized possessions, complete with photographic illustration plates so that every detail was there to see.

The game of pass-the-parcel with the rings had continued since 1912, shielded from public scrutiny, and now the music had stopped and Harman Oates was proudly holding several pieces reminiscent of the Hoard in date and style. In just a few years, under-the-radar, Harman Oates's fine personal collection of ancient finger rings, started before he got the job at the London Museum, had grown significantly.

Anyone who knew what to look for would have noticed several pieces that had a lot in common with the jewellery from the Cheapside cellar. Four rings with the hallmarks of the famous cache were there: a gold ring set with an octagonal 'table-cut' white sapphire, faceted into a lozenge, from the sixteenth or seventeenth century; another fine gold lady's ring with a 'table-cut' sapphire from the sixteenth century'; a ring, set with a cluster of emeralds, with two or three missing; and

a gold ring, set with seven dark-red garnets in a flower design, early seventeenth century.

According to the catalogue, Laking was the source of another rare lady's gold ring, from the early sixteenth century, featuring a soldier's helmeted head decorated with acanthus leaves on the shoulders.

Lawrence is cited as the source of yet another piece to make a person in the know tap their nose discreetly: a sixteenth-century gold finger ring set with a cameo of the head of Christ, beautifully carved out of a 'moss agate' stone (so called because the crystalline structures inside the stone look like spongy-fingered branches. This one is green with red spots, sometimes called a 'blood stone'). On the back are the nails of the cross cut into stone, alongside the letters *I. H. S.*, for '*Iesus Hominum Salvator*'.

Oates casually attributed many items of interest in his printed inventory to Laking and Lawrence. He published his collection before any comprehensive catalogue for the Hoard existed, so could blithely go to print with such loose talk. Although the argument over the title to the treasures was bitter and ongoing during the war, very few knew what was in the collection, not even the hawk-eyed officers at the Guildhall, and certainly not the coroner, and therefore what might have been taken out of it, so nothing would jump out from this catalogue. Oates's spare introduction states matter-of-factly, '[T]his series of rings has been formed by the writer during the last six years' and gives basic information about the age range – 'Egyptian, Greek, Graeco Roman', etc., and he offers some help on the technical vocabulary used to describe them, 'shank', 'hoop', 'cabochon', etc., but feels no need to expand on where things came from.

Many pieces suggestive of the Hoard in date and design were listed with no provenance whatsoever, or a misleading find site. He swept away the crumb trail through the forest that might lead to the previous owners, and only those with a trained eye would look twice at his actions.[15]

It's only fair to acknowledge, though, that 'provenance' was rarely mentioned in catalogues before the turn of the twenty-first century, so its absence from Oates's wasn't noteworthy let alone a dereliction of duty. Oates and his peers were not expected to keep unbroken records about an object's *provenance*, from the old French for 'origin' or 'source' and brought into English parlance in the eighteenth century. In its modern sense, it means a chronology of ownership; a 'chain of custody' in English common law, called upon to authenticate an object and assess its value for sale. (Science and expert opinion also count for something to that end today, but it's essentially a matter of paperwork.) For centuries, unless the big auction houses thought the name of a previous owner would pique the interest of a buyer, and therefore increase an object's value, it was considered irrelevant.

Howard Carter was released from his job in intelligence in Cairo and enthusiastically returned to Thebes in the autumn of 1917 to resume the search for the lost tomb of the pharaoh Tutankhamun. Lawrence continued about his business, stalking building sites and bomb sites sourcing saleable items. 'Stony Jack has a grim sense of humour', announced Morton in a feature for the *Daily Express*: 'During the war he took an omnibus ride with an invisible passenger,' our reporter teases, 'She was an Anglo-Saxon woman found in an ancient cemetery at Mitcham.

She must have been a magnificent creature 1,300 years ago, six feet high at least… Lawrence carefully gathered her skeleton in a suitcase and boarded the omnibus. "I laughed all the way home" he said to me, "as I looked at the placid, solemn faces of the faces opposite to me, wondering exactly what expression they would assume could they have seen inside my suitcase!'" Lawrence had all sorts in his suitcase, as he did at home. He played the fool, and there's a melancholy to the comedy, the bones a *memento mori* like Yorick's skull in *Hamlet*. But his greatest trick was knowing how to look ordinary and carry on doing private business, operating in plain sight, while the rest of the world was looking elsewhere.[16]

By the time the Armistice came, any theories about what the navvies might have taken from the Hoard that warm June day in 1912 and where any such pieces might be now, would remain speculation, probably forever, for the simple and sobering fact that the chains of provenance had been severed by the deaths of so many of the men who wielded the picks that day. The navvies were, for the most part, Irish Catholics, working in London, caught in the political crossfire, when the war broke out. Many would have expected a civil war in Ireland over Home Rule or independence before any European conflict, but when war was declared with Germany, many Irish Catholics in London enlisted, navvies amongst them, and the Irish regiments fought and died for Britain in the fields of France or Belgium, with them likely a number from the band of men who excavated the cellar. It's more than likely also that a few of the workmen had taken a piece or two for their sweethearts or their mothers and kept their mouths shut in the immediate aftermath, while all

eyes were on the 'Elizabethan Jewels'. At first, self-preservation kept the story a secret, but once the heat was off, and the truth could out, there was no one alive to tell it. As the men lay in a Flanders field, any trinkets they gifted sat in jewellery boxes, in any number of homes, and they were passed down in turn to the next generation, who had no idea whatsoever that the ring or brooch or chain or pendant had once been in the Cheapside Hoard. There's scant hope of a piece being flushed out if the owner doesn't know its history and has no reason to believe it worth declaring.

CHAPTER XI

The Show Must Go On

What caused the ultimate downfall of the Roman Republic? According to Pliny the Elder, a quarrel about 'a ring put up for sale by auction' between two Roman statesmen, Marcus Livius Drusus and Quintus Servilius Caepio. The resulting feud was, according to Pliny, the 'primary cause' of the Social Wars – ostensibly a rebellion by the Italians, a rival power base denied Roman citizenship – fatally weakening the all-powerful Republic.[1] The moment a decorative stone becomes a 'charm', a whole other language begins to speak, whispering in the ears of otherwise rational people, nagging at those who should know better. Small nuggets of coloured crystal silica set in simple gold bands. There is something not quite respectable about being in thrall to their code, but the ancient symbolism in apparently the most modest ring can tempt labourers, businessmen and royalty alike.

Four days after the signature of the Armistice in November 1918, Lord Harcourt ordered the boxes containing the London Museum's most precious collections, including the Hoard, to be retrieved from the Post Office tunnels, and portered back to Lancaster House. Lawrence and the rest of the staff were there to greet them and they unboxed and sorted the treasures once again so they could go back on display.

There followed several months of sorting order out of chaos, in which a member of staff could easily have taken a piece, or returned one they had kept, without drawing attention. This posed a dilemma for an unauthorised borrower who might be wondering what to do with a certain opal ring. Any losses of objects or documentation could be blamed on the confusion of the war. The jewels went back in their display case under the chandeliers.

Guy Laking, whose chronically poor health had deteriorated since 1914, died from a heart attack in November 1919, aged just forty-four, another major blow for the Museum. Laking had deftly held the institution together from the very beginning; he was liked and admired. His collection of ancient finger rings and other antiquities went back into circulation and his friend, Harman Oates, a safe pair of hands, both for the Museum and any homeless ancient rings, took up the post of keeper.

Harman Oates had kept a personal copy of the private ring collection catalogue published during the war, and continued adding items to it, with handwritten notes, as new rings came into his possession. The notes showed a collection continuing to expand slowly but steadily, with rings passed to him 'from GFL', including a late-sixteenth- or early-seventeenth-century gold ring, with an engraved skull over crossbones, and the words *Memento Mori*. The catalogue says the ring was found in 'Whitechapel', but find spots from Lawrence can be taken with a pinch of salt. As keeper, he could theoretically borrow a piece with ease and no one would be any the wiser. In 1919 Oates also 'acquired of Mr. Lawrence' a silver ring 'bearing the busts of Isis and Serapis'.[2]

During the war, Lawrence's antiques-sourcing had become reckless, a spectator sport to be watched through the fingers, and he continued to trespass excavations all over the City regardless of the countless warnings. He was openly called a scoundrel by some but had survived day to day, the Tudor courtier, nimbly and genially avoiding the deepest pitfalls that would see him slip fatally out of favour.

Harcourt had swallowed enough. He resented the capitulation of the London Museum over so many of the Cheapside treasures during the war. It was Lawrence's unruliness that had brought attention back to the old legal questions about the 1912 find. Lawrence had faced down the trustees' withering reprimands so far, recognising a note of jealousy and meanness that had been fermenting for years, but when the turnstiles reopened, and the Museum got back to work, he was sidelined.

The crowds returned to the Gold Room, a depleted staff on hand to greet visitors. The grand galleries of the old mansion in St James's were still standing, no one seemed to notice any alterations to the selection of items on display – any additions, subtractions or substitutions; but the Hoard looked different anyway to the men and women shuffling past.

The treasures in the glass case told a story of the glory days of the Tudors, gathering up gems and jewels from across the world to feed the aspirational classes' love of ostentatious jewellery, loading rings onto every digit of every finger, chains around necks and in the hair of men and women, pendants on belts and bosoms. Here was the same glossy and exciting exhibition offered before the war, offering escapist pleasure. The jewels' coloured facets still lit up the watching faces, but

now the viewing public must walk out of Lancaster House into a fractured world mourning its losses and facing decline, and some were reluctant to do so.

'There was always a feeling of sacred peace and quiet here... Everything here contributed to one's feeling of leaving the haste of modern life behind, of being sheltered from one's daily cares,' wrote Sergei Pankejeff, one of Sigmund Freud's patients, describing Freud's study in Vienna, full of archaeological treasures, including ancient intaglio finger rings with classical scenes that he gave to students.[3] As he watched from the wings, Lawrence would have had as good a shot as anyone explaining the peculiar fact that audiences still came in their thousands to look at ancient gems and jewels in a case. The exhibits had been made hundreds of years before any of them were born and would survive them for hundreds more. To look at them behind glass was to go face-to-face with objects that had endured over epochs, their makers and owners triumphing over time, in some way. It was of course also a salutary reminder that everyone was a dealer, rather than an owner, and all possessions were on loan, and would be passed on one day. But these gems and jewels offered sincere pledges of resilience: the owner's existence was undeniable and they were coming back for their things at some point. This was the same shiver of mystique experienced by a ninth-century Christian looking at an intaglio and its pagan markings. It made for a bittersweet experience that kept people coming back to the Gold Room for more.

Some visitors taking a tour of Lancaster House missed the glamour and fun of before the war. The tired and municipal atmosphere now prevailing was deathly to A.B. Walkley, waspish

drama critic at *The Times*, and his ennui set in before he even reached the dusty costume gallery. 'How strange to enter by a turnstile, with a man in uniform handing you a catalogue, where formerly you were received by a butler,' he lamented, who offered a 'splendid hospitality' to 'crowned heads and the biggest "swells" in Europe and the States, down to the humble "littery" gent'. Walkley had known the building from his days as a civil servant, when it was called Stafford House and was alive with prattling conversation, music and champagne. He had enjoyed the Duke and Duchess of Sutherland's hospitality in the lavish Louis XIV-style state rooms, where the jewels now were (Queen Victoria was said to have delivered a wry aside to the second duchess on arriving at Stafford House: 'I have come from my house to your palace'). The Sutherlands were liberal minded and 'It was a house for show, stars and garters and polychromatic crowds,' he went on. 'That great double staircase where now you are prosaically bidden by a noticeboard to keep to the right, what brilliant crowds surged up it to pay homage to the gracious lady on the landing!' The new-money northern industrialist Leverhulme had bought it and opened the doors to the general public. 'It is the London Museum now, with exhibits of things instead of people, and with something of the melancholy – the *lacrimae rerum* – that one is vaguely conscious of confronted by glass cases filled with rigid rows of what were once domestic treasures, bibelots of dead women scattered at random in forgotten homes…the added melancholy of reminiscence'; and Walkley pondered the current arrangement, describing the costumes that 'grimly adorn' one of the 'big saloons', where once 'Apache dancers from the Moulin Rouge'

appeared, or one might run into 'a gentleman from the "halls" in "immaculate" evening dress whistling for all he was worth.'[4]

Lawrence had managed to keep hold of his role as inspector of excavations at the Museum, by the skin of his teeth. He went back to work, kept his head down in the back office, out and about on the usual business at the excavations, passing the Gold Room from time to time, remembering his days as host to Queen Mary's private visits before the war.

In Wandsworth, with the client base for May's work as a self-styled psychic medium expanded, the readings now took place in the sitting room above the antiques emporium. A typical séance would be conducted in semi or total darkness and often begin with a prayer (to enhance spiritual positivity). The participants then formed a circle and joined hands in order to maintain a flow of energy. The medium would take control of the circle while becoming entranced and contact with the dead would then be sought. May was a private, commonly known as 'domestic', medium operating at home – to keep it respectable she did not charge.

Spiritualism was enjoying a revival, and the word 'séance' did not need to be *sotto voce* anymore. May had been dabbling before the war, but those who had once flirted with the idea of making contact with the dead in spirit were now participating in a committed and overtly hopeful manner. Many had not been able to visit the place of death of their loved ones, or retrieve the bodies, after the war, let alone hold a funeral. They were disillusioned with the churches for failing to prevent or shorten hostilities, and more and more were joining the search for alternative forms of spiritual expression, middle classes too. Working-class women,

the first to lose faith with the Church of England in large numbers, took up this new option enthusiastically.

'The credence in the phenomenon of Spiritualism is very general,' lamented Edward Cecil in the *Globe* on 29 October 1919, in an article explaining 'The Popularity of Spiritualism', 'Belief is common. It is widespread. It exists amongst all sorts of people, from the highest to the lowest. You find it in Mayfair, and you find it in the remotest village.' All classes had been cut down and all classes were desperate to bring their loved ones back home and talk to them, whether that meeting was in a tiny parlour, or the grandest of drawing rooms.

The experience of hearing a message from her late son via a hired medium was described by Lady Glenconner as being like 'when a wished for letter arrives; when a door swings open and a treasured presence is before one.'[5] John Ward of 'Folk Park' sought out the spirit of his dead brother, Reginald, 'Rex', killed in 1916, writing *A Subaltern in Spirit-Land*, in which he attempted to help his brother in the afterlife, a bit like an updated 'Book of the Dead' for Brits. Sir Arthur Conan Doyle, half mad with grief at the death of his son, Kingsley, who survived wounding in France in 1916 only to die in the influenza pandemic, took to the stage in April 1919 to address one of the meetings of the Spiritualists National Union packing out the Royal Albert Hall, triumphantly announcing to the crowd, who hung on his every word, that contact had been made with a man from the 7th Division.[6] Queen Mary was grieving the loss of her own son, Prince John, who was not a war casualty, but had died of a seizure at Sandringham on 18 January 1919, aged just thirteen. Who knows if she found any comfort in the possibility of making contact.

Not everyone was prepared to play along – a Reverend T. James in Warrington talked scathingly to his congregation about 'the pathetic side to the eagerness with which people are buying up what Sir Arthur Conan Doyle can tell them about immortality.'[7] But the public were hungry for accounts of spirits returned, had an appetite for ghosts, and May Lawrence and her father were able and willing to oblige.[8]

Lawrence sat at home with May and Florence in the gloomy flat above the shop, remembering the excitement of 1912 and frustrated with his marginalisation in the business of the Museum. The public were still enraptured by the treasures from Cheapside and curious about their original owner, and the mystery of the burial.

Lawrence had not enjoyed mothballed life in the back office. 'Discoverer of the Hoard' was the role he was famous for, but he'd been consigned to the wings: 'third catalogue-carrier'. It was a moment to bring the legend, and its ghost, to the stage, and he had plenty of friends in the press encouraging him to seize the narrative.

His contacts among the hacks of Fleet Street, H.V. Morton chief among them, were keen to spin more copy about the marvellous buried treasure from the cellar. A good ghost story would play well. Morton wished to promote the old story of the Hoard's discovery and his own part in it as witness to the events as they unfolded at the shop. He got out his reporter's notebook and set the scene, shaping Lawrence's persona in the Victorian Gothic model for the reading public as a white-haired old man telling spine-chilling stories by the fire. He cast Lawrence not just as the conduit for the jewels but an intermediary between

this world and the next, and his Wandsworth premises, where it all began, as a place of mystery and magic, as if it warranted a stop on a spooky London tourist trail along with the Tower of London.

Writing in the *Daily Express*, Morton beckoned to the readers of his newspaper column: 'Strange things have happened in this shop,' he whispered suggestively. 'Some may not be told… countless all the queer stories…of the weird things psychic people have discovered there from time to time. No man except G. F. Lawrence has any idea of the treasures which the soil of London has given up.'[9]

Lawrence was delighted to play along. 'Many people are inclined to label "dry-as-dust" everything and everybody connected with museums,' he told the *Weekly Dispatch*, getting into character. 'But I feel sure they would soon change their minds if they knew of only one-tenth of my strange experiences as private collector and…as Inspector of Excavations to the London Museum.' He offered the readers a vignette from the flat above the shop concerning a 'little Tudor shoe brought to me by a Finsbury Navvy, put down as an ordinary child's shoe of the period'. 'That evening, seated in my sitting room, in the gathering gloom of a dismal November day', he continued, 'a psychic friend of mine had no sooner held it in his hand than he became greatly excited, insisting on coming round later in the day for another inspection… [M]y friend and I held a kind of séance over the pathetic little object, at the end of which he announced triumphantly that he had solved the mystery. The shoe, he declared, had fallen from the foot of a child victim of the plague as it was carried to hospital. Sceptic as I was, the

circumstances of the story and the impressive way in which it was told combined to send a shudder down my spine!'[10] Lawrence always took pains to present himself as a sceptic, and perhaps he was, or perhaps he believed he had witnessed strange things and was quiet about it, but either way now he was only too delighted to come out of hiding and play the role.

Morton was a man with a talent for placing himself at the scene of the most important archaeological events of his age. Now it was his old friend Lawrence's turn, as he told, for the first time, the origin story of the great discovery of the treasures from Cheapside, and put himself right there at the centre of the action. He offered an interview to the *Dundee Evening Telegraph* for 1 December 1919, revealing details about what had really happened in the heart of his humble home near the Wandsworth gasworks back on that first sultry June night after the treasures were dug up in 1912. The paper teased out: 'Remarkable statements concerning a fine collection of Elizabethan jewels in the Gold Room of the London Museum…made by an authority in full possession of the facts who desires to remain anonymous at present in view of the possibility of his statements being ridiculed by sceptics.' The extraordinary event (touched on in an early chapter of this book) had taken place in the study of the family flat where the jewels were being stored.

> About ten o'clock although it was a warm June night the official and his wife and daughter experienced a sensation of shivering cold in the room in which the jewels had been placed. Later an art student friend, who claimed to possess occult powers called at the house and was shown into the

study where the official and his wife and daughter were and the student presently startled the family group by observing that he could see standing by the jewels a person whom he described as a tall thin man in Elizabethan costume who looked very angry.

The art student visitor then heard the ghost shout: 'Those are my jewels. What right have you to them!' The family were shocked but could not see anything themselves.

The Tudor spectre had appeared in the living room in doublet and hose like Herbert Beerbohm Tree in one of his productions at the Shakespeare Festival, an elusive antagonist among the *dramatis personae*. Lawrence's story, that first account of a man in Elizabethan costume, returning to reclaim his treasures, went to press and into circulation. It was a brief diary story to send a chill down spines, a perennially popular column inch in the papers, but in 1919 the kind of story the public craved. An account of a dead man returning to an ordinary family home.[11]

The 'anonymous' source presented himself as the authority on events of the evening in June 1912, careful to appear a sensible and reluctant witness, all too aware of how hard this was to believe, conveying the facts such as they were for readers to judge for themselves. It was an old rhetorical trick only likely to make the story more credible for an audience desperate to believe.

Lawrence went a step further when he spoke to the correspondent for the *People's Journal* for 27 December 1919, casting himself as 'one of the officers of the museum' and adopting a pseudonym: 'Mr Francis H. Townley'. 'Francis Townley's account of the night contained some significant differences to

the first version, including cast changes. The 'psychic' art student friend of May Lawrence was now 'a student from one of the hospitals' and our source at the Museum specified that he was male. This student 'called on Mr Townley and was shown the collection' a full two days after the jewels arrived. The sensational headline read: 'I Defy the Curse!':

> This gentleman who was keenly interested in the occult and was claimed to be possessed of powers of a medium, on entering the room where the jewels were, astounded Mr and Mrs Townley by asking 'Who is that old man standing over there?' and he proceeded to a table where the jewels were lying.
>
> 'There is no one,' said Mr Townley.
>
> 'Yes,' exclaimed the young student. 'See, he is looking this way. His hands are on the table.' Mr and Mrs Townley with their daughter experienced a repetition of the chilly shivering sensation and had noticed that our young friend trembled violently. The student said that as he entered the door of the room where the jewels were, he saw the form of an old man standing beside the table. The man he described as tall, thin and wizened, with a white pointed beard, resting on a stiffly starched ruffle which was round his neck. He was dressed in a dark blue doublet and wore tight fitting pants of grey. The apparition looked at him and the student understood him to ask – 'What do you want with these? They are my property. I struggled to obtain them.' 'I asked him to tell me something regarding them,' said the student, and the apparition said – 'You have no right to them, they are mine. They are cursed forever, but I defy the curse.'

This time the newspaper's source gave a more detailed description of the Elizabethan man in the Lawrence living room. He was elderly, 'wizened' with a 'white pointed beard' and dressed in a dark blue doublet, with grey 'pants'. The ghost was still complaining bitterly about an injustice relating to the theft of his property and there was now mention of a curse.

Lawrence's choice of pseudonym cannot have been random. 'Francis Towneley's Ghost' was a famous ballad telling the story of Francis Towneley, a prominent colonel in the Jacobite uprising of the 1740s, backing the Old Pretender James Stuart's claim to the throne. He was executed, and had his head put on a stick on London Bridge, but came back from the dead to guilt-trip his killers, and generally give everyone the jolly old creeps. Lawrence was enjoying playing historical dress-up and mischievously tweaked the name's spelling.

He then placed another story of an Elizabethan ghost in the papers, a ghost to corroborate the first one:

> Two or three years later, long after the jewels had been placed in the London Museum, there was a curious sequel. A professional medium, who knew nothing of what happened, while visiting the official at his house, declared that he saw a man standing beside his daughter, who, he said, does not like you (the girl) and might do you an injury. His description of the man tallied exactly with that seen by the art student. The daughter, it should be said, used to clean the jewellery when it was in the house.[12]

As Lawrence told it via his intermediary, the ghost had been even angrier on his second visit, holding a grudge, and threatening May, who had transgressed by washing someone else's property. This time the witness was a 'professional medium', not an art student or a medical student dabbler, and presumably therefore to be taken more seriously. According to Walter Henderson, the security guard at the London Museum, May had been involved in originating the legend of the ghostly jeweller with her father, and in this report they were both intimately connected to events on the first night, and the original owner, the ghost menacing their living room.[13]

George and May excitedly updated the press with what happened next. The treasures had moved from Wandsworth, and the Elizabethan ghost had followed, in doublet and hose, to Lancaster House, where the stage had already been set for a West End transfer. The mansion was grand in scale, the scenery lavishly decorated. The ghost made his entrance through the costume gallery from across the ages, the line of headless gallants, the garments fusty and well-worn and strikingly small compared to those for modern people, including the 'buff' leather coat with rusty blood stains on the embroidery from a Civil War rapier. It passed directions to the 'Chamber of Horrors', too, put together by Laking, featuring two wooden cells from an ancient prison in Wellclose Square, Stepney. The ghost reached the Gold Room, where the crowds were gathered.

After a briefing from the Lawrences, the *Dundee Evening Telegraph* on 1 December 1919 ran the headline: 'GHOSTLY MUSEUM TREASURES'. Under it, the paper carried a story of 'Haunted Gems', an 'Elizabethan "Ghost"' and 'Blood

on Neckchain', reporting a 'curious incident' in the Gold Room just after the 'Elizabethan Jewels' moved there in 1914. It had begun when 'A woman Spiritualist', there to look at the treasures in the case, noticed one particular piece and promptly fainted. 'On recovering, she accounted for her illness by explaining she had seen blood on a gold neck chain among the jewels, and that she had "sensed" that the woman who originally wore it had been murdered by somebody who wished to gain possession of it.'[14]

The stories were getting more sensational. Word spread about a ghost haunting the jewels at the Museum of London, and members of the public flocked there hoping to catch sight of him, and solve the mystery of who he was, and what he wanted. A flurry of further reports inevitably followed, and the *Daily Herald* sent a journalist to investigate, running a piece on page two of the paper on 2 December 1919, subtitled: 'AMONG THE GHOSTS "Daily Herald" Man's Clues!':

> A *Daily Herald* man visited the Museum and attempted to unravel the mystery and perhaps obtained a clue. He heard the story of how people experienced a cold and shivering sensation in the room in which the jewels were first placed, of a psychic person's vision of a 'tall thin man in Elizabethan garb, guarding the jewels and claiming their ownership' and of a medium fainting at the very first sight of them. The collection fills a large glass case, and consists of delicate enamelled gold chains, pendants, rings, opals, turquoises, rubies, amethysts and diamonds. There are also little odds and ends – a crystal tube, a crystal vase and a crystal chalice. The

Daily Herald man paused when he came to this crystal, and gazed long and intently, in hope of seeing some swaggering Elizabethan. The crystal suddenly seemed to glitter, he grew cold, and then he heard –

'Some spirits, eh?'

He jumped with a start, and standing behind looking into another case of old bottle labels…were two visitors reading the labels…whisky, brandy, gin, rum, vino-de-rey and names of other delicious vintages long since fallen into disuse.

'Some spirits, eh?'

And the *Daily Herald* man went home to ponder his clue.

The man from the *Daily Herald* gently ribbed his readers over their insatiable appetite for spooks, but nonetheless his report helped reinforce the stock image of a tall, thin man in Elizabethan garb guarding the jewels. A detailed description was circulating in newspaper print, shared over tea breaks, in canteens and saloon bars, and on the trams and omnibuses. There were some discrepancies in the reports but the main elements – the Elizabethan man, the stolen property, and a length of chain – remained constant, these 'clues' appearing in multiple papers for several weeks, inspiring various theories and offering some spine-chilling light relief from daily life.

The population reading the newspapers were at the sharp end of a malfunctioning economy and the stories about a ghost haunting the jewels at the London Museum sat among other headlines that shouted about the cost of living and industrial unrest. Page two of the *Daily Herald* on 2 December 1919 reported the 'criminally high' price of milk: 'Shilling Milk

Must Go!' 'Cheap Milk or Strike' and the Women's Union in the Rhonda Valley who were setting about organising action. 'Will Gas be Cheaper? Yes but Not Yet'. There was an urgent warning about a coal shortage: 'No coal trollies were to be seen in the S. E. district of London'. Some were showing clear signs of war trauma. Page six of the *Dundee People's Journal* for 27 December 1919 ran the story of the ghost at the Museum next to an article headlined: '"HAVE I HURT HIM?" Shooting on an Office Stair', about a London doctor who had shot his friend, out of the blue and with no obvious motive. The friend 'was unable to account for the occurrence but believed that he was suffering from shellshock. The two men were on perfectly good terms… He had made the doctor's acquaintance on a ship, and they had arranged to go out to lunch together.' Also on page two of the *Daily Herald* was an article subtitled 'EVICTION SCANDAL!' telling of a community fighting an injustice done to a 'War-broken' veteran:

> Having lost a leg and an arm in the war, much sympathy is felt for Stephen Walters, the occupier of a cottage in the grounds of the Netherne Asylum, Merstham. The Asylum Visiting Committee having obtained from the magistrate an order for ejectment which becomes effective on December 11, there is much feeling in the district at the attitude taken up by the members of the Committee. Waters, who has a wife and two children, was in the service of the Asylum's Committee when the war broke out. He joined up and returned so badly maimed that he was given the position of assistant hall-porter. He was told he was physically unfit and

granted a war pension by the Committee of 5s weekly and asked to hand over possession of his cottage. Mr P. S. Stephens, who took up Mr Walters' case at the Parish Council meeting, contended if the man was evicted it would be a great scandal as the public resented the worst disabled soldier in the district being driven from his home like a hunted man.

The Merstham Parish Councillors were standing up to authority, but most families like Frederick and Rose's were fully occupied trying to keep their households afloat. The cost of living, food and fuel combined, was up 179 percent on what it had been in 1912.[15]

As well as mourning the dead, the population was having to adjust to the permanent disability of the survivors. Walter Henderson, the security guard at the London Museum, had returned to work from service missing his left hand. Carter's of Great Portland Street had seen orders for equipment to aid the disabled increase beyond their ability to manufacture it. Just down the road from West Hill at Roehampton hospital, a specialist unit of American workmen was making and fitting prosthetic limbs for returned soldiers. Artificial legs were an American speciality, using technology developed during the Civil War. The London branch of J.E. Hanger, named after the Civil War veteran and manufacturer from Virginia, sold a patented wooden leg design with a wide leather strap to attach to the leg and secure around your neck.

According to sources at the *Dundee People's Journal* the Elizabethan ghost at the Museum had turned violent. 'The curator' had given a more detailed and sensational account

of the fainting visitor. The man in doublet and hose had been seen prowling around near to the case containing the glitziest exhibits at the Museum. 'TALKED WITH A GHOST' 'Apparition Guards Haunted Jewels' declared page six of the paper on 27 December 1919. 'Sceptical of the wonderful stories which have been related concerning the wonderful jewels in the London Museum,' the correspondent caveated, 'I visited the museum where the gems now repose and from the curator I heard something of their story.' The correspondent, like the source, was careful to display a fitting degree of scepticism, but reported:

> [P]erhaps the strangest incident of all in connection with the gems is that which took place when a well known spiritualist medium was visiting the Museum. She knew nothing regarding the mystery of the jewels, save that they were found in the City of London. As she looked at the gems, she started suddenly and then fell backwards in a dead faint. The lady was carried out of the Museum, and when she had recovered consciousness she explained that as she was examining a gold and jewelled necklace, she saw a terrible sight. A beautiful girl was struggling with a wild-eyed man who had a dagger in his hand. The man plunged the dagger into the girl's breast, and tore the necklace from her neck. The ornament was red with the lifeblood of the girl, and the medium declared that the rightful owner of the ornament had been murdered by a man hundreds of years before in order that he might possess himself of the necklace.

The 'medium' had witnessed a protracted struggle, the victim fighting to get away from her assailant, and a knife had been used to carry out the murder. The earlier report had only mentioned a vision of a bloody necklace, and the traces of a garrotting on the chain, but the violence had been off stage. This was all far more dramatic. The swoon had become a 'dead faint' and the 'medium' had been 'carried out of the Museum' to recover, presumably by the curatorial staff, including Lawrence and the security guards. The 'wild-eyed' man struggling to dominate the 'beautiful girl' was an image straight from a silent film of the era, with a coy Lillian Gish cringing, the back of her hand to her head, while the thief leered, and 'Villain! What right have you to have it!' trembling on a title card at the bottom of the screen. This time a thief had murdered the rightful owner of the jewellery in the act of stealing her chain from round her neck. It was a melodramatic and grisly tableau, a ghost returning to expose a crime that had been committed against them, exhorting the public to bear witness. It's not clear if the 'medium' or the journalist embellished Lawrence's story, and swapped the cast round, but it was well pitched to garner emotion from an audience already at a state of high anxiety over property – that which had been stolen from them in recent years, or the spoils of war that perhaps made them the thieves.

The *Evening Telegraph* drew the press frenzy to a polite close: 'Since then', it reported 'there have been no further strange manifestations. From a psychical point of view it is considered that the original owner of the jewels does not object to them remaining where they are, as they are national property and not in the possession of any private individual. The same is held to be

true of images of Buddha taken from Indian temples and placed in the Indian section of the Victoria and Albert Museum.'[16]

British thefts from the empire over the past few hundred years are summarily justified and put back in the box. Wilkie Collins's novel *The Moonstone*, about a diamond stolen from the head of an Indian god to be sold, had left its popular readership with lingering questions about 'unassailable' British claims to the world's treasures, playing on the story of the Koh-i-Noor. The ghost at the London Museum serves as an ugly manifestation of guilt, and a pardoner.

Their version of the Cheapside Hoard ghost, a fan of public museums, also delivers warning, in Lawrence's genial manner, to anyone thinking of claiming the treasures and nervous of curses. Leave the jewels where they are, or else. What better way to put people off once and for all than to present the Hoard as a locus for a vengeful and violent spectre?

A ghost in 1919 was good for bringing visitors through the turnstiles and raising G.F. Lawrence's profile. But each of these ghosts at the Museum was still a man of unknown identity; the nagging questions surrounding the original owner of the jewels went as yet unanswered, and was a man without a name, whose intentions remained mysterious. An unquiet soul.

CHAPTER XII

The Question of Identity
and the Original Owner

If Lawrence's ghostly public relations offensive was intended to secure his position at the Museum, it was not successful. According to the census of 1921, on 21 June George Fabian Lawrence was sixty years old and a 'boarder' at the Plough Inn, at Icklingham near Mildenhall in Suffolk, an old flint pub, staying in one of the rooms upstairs. Although still technically the 'inspector of excavations' at the London Museum, he languished in exile in a quiet rural East Anglian outpost, miles from the clubs of St James's, or the familiar faces of West Hill, and spent his days plodding about on Mitchell's Hill barrow, an early Anglo-Saxon burial site. He was considered a liability in London, his employers watching him closely and breaking their pencil nibs at the mention of his name.

Downstairs at the Plough Inn men stared into cloudy pints of bitter. He couldn't break the City laws here. Like his friend Howard Carter in Egypt, whose patron Lord Carnarvon was losing patience with the fruitless search for Tutankhamun, he was running out of options. Away from home, his wife in Wandsworth holding the fort, he walked daily between the Barrow and the Inn where he wrote up his findings behind a small, latticed window. In that census, Florence was listed as a 'dealer in antiquities' in

her own right, but Ethel May still had 'no occupation' and Fred, thirty-eight, and his wife and three children, were now living in Edmonton in a smaller home. Lawrence needed his position at the Museum for a few more years, and to keep his private antiquities business a going concern, placing adverts, soliciting objects – it had to tick over. He was not pensionable yet.

Questions connected to the Cheapside Hoard, and the attendant affair, followed him everywhere. Made-up stories and real-world problems started to blend into each other.

To unpack – or throw a pick into – the real story behind the burial opened a box full of uncomfortable questions. Was it death that had stopped the burier of the Cheapside Hoard returning to reclaim their property? Maybe, like a body laid to rest, the contents should have been left where they were, sixteen feet underground, and the navvies should never have removed the boxes but instead covered them back up with the chalk-flecked clay. The treasures had been hidden in the cellar to be reclaimed. They had not been carelessly lost.

A name had eluded him since June 1912 (as, probably, had a fair cut of the money). Privately, Lawrence had been ruminating for years about the original owner, or owners, of the treasures, and what their intentions had been.

Since 1912, many had ventured a guess as to the identity of the original owner. Why had they buried the treasures and why did they not come back for them? There were many tall stories about this character now, some with his own embellishments. But there had been a real person to know, a real name.

One of the more imaginative suggestions doing the rounds was taken from a book of cautionary tales for children: 'According

to legend', wrote the special correspondent for the *People's Journal* in 1919, 'the jewels were found on the spot where years ago the bones of a rich city merchant had been buried, a man of miserly habits, who had left instructions for the casket to be buried unopened with his body. The story goes that the old merchant had collected the stones and jewellery after years of strenuous labour and that he would spend his time admiring his property, sleeping with the casket fastened to his body by chains.' There was a warning attached (in case you missed it) against the worship of sparkly objects: 'According to an authority on occult matters', they continue, 'the theory is held that the original owner of the jewels continually haunts his property, which during his lifetime he made his god.' This story replaced rotten wooden boxes with storage far stronger and more secure: 'The box was studded with nails and the corners protected by iron. An ancient lock was fastened and this was ultimately broken open with the aid of a crowbar. Inside this box was a second box made of oak. Antique gold necklaces and precious stones, pendants, ancient signet and jewelled rings… Obviously they were the collection of some squire of the period of Queen Elizabeth.'[1]

More prosaic and logical explanations remained on the table, however. London's tumultuous seventeenth century was peppered with crises, when it would have been common sense for a person to stuff their valuables somewhere safe and flee as fast as they could, never to return. Escaping the plague, the Great Fire of London, or the reprisals of a burglary gone wrong were all plausible motivations. In addition, Lawrence and his colleagues thought it likely a few items in the Hoard had been removed from the wreckage of the dissolution of the monasteries, one of

the largest land and property transfers in English history. But after much ruminating and chin scratching they still shrugged, ultimately defeated by the question of the circumstances leading to the burial. Since the owner had died without disclosing his secret, they were forced to conclude that the answer was lost in the vicissitudes of the seventeenth century.

At this point comes a dramatic aside, stage-whispered for modern ears only. More than a hundred years on we know more than he did thanks to the telling clues turned up by modern scholarship and detective work. The breakthrough came thanks to an analysis by Museum of London staff of a small red intaglio gemstone seal in the Hoard. A sharp eye noticed that a small and chipped carnelian seal, previously overlooked, was engraved with the heraldic badge of William Howard, the family insignia of a swan standing on a wreath, topped by a viscount's distinctive coronet of nine pearls, marking his elevation to that rank. William was the only Viscount Stafford ever to have existed and since the badge was part of the Hoard, it meant the date of the burial couldn't have been before 1640, when Howard was ennobled.[2] In addition, and scuppering one of the early theories, the burial had to have happened *before* the Great Fire of 1666. The conflagration gutted the building above but spared the deep cellars and, when planners rebuilt after the fire, they used the old cellars as foundations. In 1912 the navvies discovered the Hoard in one of these cellars, which had remained intact, like a time capsule.

What of the contents of the Hoard? The constituent parts, although they had a commonality of taste and design making them clearly one collection, would inevitably have come from

different places and joined the pile at different times, being an evolving stock-in-trade. Assiduous detective work principally by Kris Lane, historian at Tulane University in New Orleans and Hazel Forsyth at the Museum of London linked some of the most spectacular treasures in this jewellers' stock-in-trade to a story of a dastardly murder on the high seas.[3]

The story introduces us to an intrepid Dutch gem merchant named Gerard Polman. Polman had been trading in the East since the turn of the seventeenth century, sourcing jewels in the colonies, assembling his collection in the emerald markets of India and the amethyst, garnet, turquoise and agate markets of Persia, until he was dragging around with him a great sea chest crammed full of spectacular gems and other valuable commodities like silks. Polman's chest contained an amazing range of gemstones, reflecting the pan-continental reach of the agents who worked the intersecting trade routes of the various empires vying for the very best. Polman had private Dutch backers for his enterprise, but the East India Company routinely contracted its own British jewellers, specialists who knew what to look for to establish the quality of a gem, to travel to far-flung outposts on their behalf. At some point in the early 1630s Polman crossed paths with the crew of the East India Company's ship *Discovery* in Persia and gave £200 to the ship's master to take him home with them to Europe. And so it came to be that he was 'hitching' a lift back with the East India Company (at eye-watering personal expense) loaded up with his great sea-chest of treasures.

Inevitably, the crew noticed the chest and wondered what it could contain. Wary of prying eyes, Polman had tried to secrete as many of the most precious items as he could on his

person, even wearing some of them when he went swimming (and losing a vast diamond into the sea as a result) but this had only drawn more attention.

The ship's carpenter, a Christopher Addams, noticed Polman standing guard over his possessions with a high level of vigilance and a sweaty brow, so on one occasion followed him, and found him beavering away in his cabin, cutting and polishing and setting jewels, next to two small boxes and twenty bags filled with precious stones and pearls as well as pouches brimming with gem-set rings. According to Addams's wife's deposition during later legal proceedings, when the big black box was opened the gems were so shiny that he 'thought the caben [sic] was a fire'.[4] Addams also saw a large, white, heart-shaped stone 'which did cast in the dark an extraordinary great lustre'.[5] Others who had been there when the lid was lifted, revealing a shiny glow and prismatic sunbursts, said they could read by the jewels' brilliance. The accounts by the slack-jawed, saucer-eyed crew recall the navvies who thought they had 'struck a toy shop, guv'nor!' when they first clapped eyes on the treasures 300 years later. The gems served the avid readers on board well, but not Polman, who was soon floating dead in the sea. As accusations later flew over the murder, most of the shipmates pointed at the ship's surgeon, Abraham Porter, who they said had poisoned Polman, and then robbed him, before throwing his body overboard.[6] Another allegation was that Christopher Addams the carpenter had seen his chance and jumped ship once the vessel got near to the coast of Kent, rowing to shore with the chest. Other crew members went through the remaining boxes and bags and helped themselves. A clutch of dealers and

jewellers had already arrived at the dock by the time the ship finally returned to Gravesend, ready to barter and race back to London with the gems.

When the East India Company got wind of the skulduggery, they naturally claimed the treasures for themselves, but on inspection found the chest half full. The contents, even though not the full complement, were still staggeringly valuable, worth millions of pounds in today's money. The Treasurer of the Company, the 1st Earl of Lindsey, quickly secured 'letters of administration' over the cargo and went after Addams into the jewellers' quarters of London, chasing accomplices as well as anyone who would dare to try to sell the jewels on. Addams was in and out of London, trading the jewels he had creamed off, initially with a man named Nicholas Pope with a shop off Fleet Street. He also took some of the swag to the house of an associate, a Susan Bradaye, in 'Hockley in the Hole', Clerkenwell Green, an area notorious for vice of all varieties, including bear-baiting, and hid an enormous rough emerald he had nicked from the ship (he said it was seven inches by two to three inches) among 'old shooes' under the stairs. There then followed a series of frenetic under-the-counter flash sales of the hot jewels throughout the City's jewellery district, as Addams and the other thieves from the ship got rid of as much as they could, bartering and pawning, and hiding pieces within their existing stock. It was treasure whack-a-mole for the earl and his agents, and the East India Company tracked them through the streets where the goldsmiths and pawnbrokers worked, and one member of the *Discovery* crew was reportedly so flustered when emptying his pockets of stolen jewels at the Three Tun

Tavern in Fleet Street he dropped an enormous pearl through a crack in the floorboards. Addams was ordered to report to authorities by the Feast Day of St George on 23 April. When the East India Company finally caught up with him they had him in prison before his feet could touch the ground.

In the manner of Lord Harcourt and Guy Laking whipping the Cheapside Hoard off to Laking's flat in 1912, the earl took the gems from the Custom House to his own private house in Westminster for safekeeping, where he assembled a team of the best gem cutters in town to spend a month faceting the gems. The earl seems to have identified a personal opportunity, as well as honouring his professional responsibility to the East India Company to retrieve the goods, and set his team of jewellers to work cutting the huge chunks of rough emerald into smaller rocks to set into rings. One skilled member of the team cutting the gems at Earl Lindsey's home was Herman Marshall, a jeweller and money lender from St Giles, Cripplegate. Like many goldsmiths at the time he also provided cash to his clients in exchange for jewels. Marshall was plying his trade just inside the old wall of the Barbican at the edge of the City, offering short-term financial relief against jewellery, just as Lawrence and his father would on the same spot in a few hundred years. The earl also asked Marshall to appraise the value of one of the showstopper emeralds.

Addams's deposition in prison ties some of Polman's gems to the Cheapside Hoard. The *Discovery* cargo had included, he said, 'a greene rough stone or emerald three inches long and three inches in compass'. He confessed the emerald 'was afterward pawned at Cheapside, but to whom he knoweth not'.

It's a convincing match for the jewel carved into a watch case that Lawrence handled in the flat that fateful night in 1912. It is plausible some of Polman's enormous stash, via Addams or one of the other thieves, ended up in the buckets or boxes in the cellar under Cheapside. The theory goes that our jeweller, whoever they were, joined in at some point with this under-the-counter trading and bought some of the jewels from the *Discovery* robbery which he added to his existing stock, and that, at a later date, they buried it all as a job lot in the cellar on the corner of Cheapside and Friday Street.

Did the navvies who found it down there 300 years later feel the melancholy dread that overcame Jim Hawkins when he encountered freshly disturbed treasure? 'How many it had cost in the amassing, what blood and sorrow, what good ships scuttled on the deep, what brave men walking the plank blindfold, what shot of cannon, what shame and lies and cruelty, perhaps no man alive could tell.'[7]

Was the opal St George and Dragon ring on the *Discovery* and stolen from the murdered Polman?

And what about a name for this jeweller who brought the treasures together?

Cheapside had been a key processional route in the City, running east–west from Old Jewry to St Paul's Churchyard, useful as entry into the City for royalty and as part of the circular route for the annual mayoral procession.

This had been where the most expensive and elaborate pageants took place. The Cheapside Cross had been erected in 1290 by Edward I to honour his wife, Eleanor of Castile, and

her carved and gilded image looked askance down Goldsmiths' Row, from three stories high. It was one of many crosses laid down to mark each point her body was set down on its way to Westminster Abbey, until it was smashed in 1643 as Puritan fever swept through London during the Civil War.

The Row was built to the east of the cross, by Thomas Wood, a goldsmith and Sheriff of London, who conceived a magnificent wooden structure containing fourteen shops and ten houses, 'the most beautiful frame of fair houses and shops in England', according to John Stow in his *Survey of London* in 1598. Wood gave the building to the Goldsmiths' Company in 1491. The medieval alleys joining Cheapside to the left and right of Goldsmiths' Row each had their own specific trade monopolies, strictly policed: Bread Street, Milk Street, and so on. Friday Street was for fish.

Jewellery sellers on the busy strip showed their work off to the street in spectacular window displays, and above, behind the handsome facades, were warrens of counting and gilding houses, and storerooms, domestic bedrooms, and workshops for making, repairing and recycling, with spaces for pawning and money-lending on the side, too.

Artisan jewellers had long commanded respect and not a little awe.

The King James Bible told the population that the Lord 'spake unto Moses', to declare he had selected the craftsman Bezalel 'to work in gold, and in silver, and in brass. And in cutting of stones, to set them', preparing the Tabernacle and the Ark of the Covenant, two of the holiest structures, and 'filled him with the spirit of God, in wisdom, and in understanding,

and in knowledge, and in all manner of workmanship'. God chose an artisan jeweller, not a warrior or a priest, for this job.

By the time King James was on the throne, the strip had moved past its prime and diversified into new trades and services. The king loathed the flea-market ambience. He needed to corral the goldsmiths so that he could keep check on the gold, and keep the riff-raff out, and by 1628 his Privy Council was locking up non-goldsmiths who refused to vacate.

A directory of goldsmiths compiled in the seventeenth century shows a tavern on the site of what became Wakefield House, known as the Black Moor's Head.[8] (The boundary is approximate of course: the configuration of buildings was different before the Great Fire.) The rooms in what had been the Black Moor's Head were leased by various goldsmiths, plate-workers and jewellers over the years. (A building, once an inn, kept the name even when use changed, unlike shops.)

A Goldsmiths' Company lease for the site at 30–32 Cheapside on the corner with Friday street mentions '1 shop, 4 cellars of which 2 are arched with brick', it's a higgledy-piggledy arrangement of different properties, and subletting was common, so one can't be certain who was actually on any one premises at any given time. The neighbours are of interest in our search.

Meticulous detective work by historian Dr Rosemary Weinstein, mapping tithe records (everybody had to pay tithe) and Goldsmiths' Company rent books for the 'Wakefield' site, gives a good idea of who was around and about in the time period we're interested in, between 1640 and 1666, and yielded names.

Some of the leaseholders were goldsmiths – plate-workers – some jewellers, or connected to jewellers. A Mr Frith lived on a property butting up to our 'Wakefield site'. Mr Gibbon had a lease over a large area also next door. (A smooth operator in the City, in 1632 he presented an ornate silver-and-gilt 'salt' dispenser to the Goldsmiths' Company just after they had conducted an extensive search of the row looking for evidence of substandard gold and illegal 'strangers', and seems to have got his son William into the Company shortly after.)

Goldsmiths' Row had seen a lot of coming and going over the years in question. The craftsmen on Cheapside were mainly itinerant workers from the continent, many of the cutters French, Italian or Dutch, fleeing religious persecution, looking for work outside the jurisdiction of the livery companies, moving from place to place.

These men would not have signed any visitors book. It was against Goldsmiths' Company regulations to employ 'strangers'. The cutters, each in demand for their different specialisms, arrived with new tools, pitching up from Antwerp with cutting rigs, propelled by hand and foot for continuous rotary motion. The Italians offered expertise in techniques on the grinding wheel for creating more elaborate cuts, a step up from the simply polished 'cabochon', showing apprentices how to cleave off the top of a gem to create the required flat surface, then cut further facets off that table, into points, or a 'table' or a puzzle of 'rose' or 'brilliant' cut facets, and other daring styles, using specialist iron tools, or diamonds on diamonds. They knew about using different metals to grind different stones and had small pots of

diamond dust to mix with a variety of oils to experiment with finishing polishes.[9]

Large numbers worked shoulder-to-shoulder in small spaces and the population was transient. However, an important clue had been left, long ignored, in an obscure lease document for a Mr William Taylor who took premises on the 'Wakefield House' site in 1654. The document contains a passing reference, back-namechecking one Francis Simpson, a jeweller, as the previous holder of the leasehold in the 1640s.[10] He had lived there with his brother John for many years, under the terms of their father Thomas's lease, the Simpsons now therefore an established family of working jewellers on the Row, supplying fashionable pieces to both the court, and more modest services to the merchant class.[11] In 1641, Francis had refused to pay to renew the lease on the 'Wakefield' site that was about to expire, arguing the improvements he had made to the building 'new ordering of the hall' offset the cost, and his fine for late payment. The Court of the Goldsmiths' Company had not concurred, and he would be out by Michaelmas if he didn't pay up. With a raft of subsequent fees and fines accruing, the lease inevitably lapsed, and Simpson was now renting the premises.

With the outbreak of Civil War hostilities in 1642, Francis Simpson, a staunch Royalist, left London with his brother to travel with King Charles I to Oxford, leaving his employees to run the Cheapside business. Encamped at Oxford, Simpson was soon promoted to royal jeweller, his brother John assisting in the work. 'For making of Badges of Honour, possibly including the "Garter" badges in an ample manner'. He was around fifty years old, and riding high.[12]

Back in London, the Goldsmiths' Company faced increasing pressure to make loans to Parliament and demanded the rent money from Simpson. Not wishing to fill the parliamentary coffers, Simpson *in absentia* again refused to pay the outstanding account. When the Company Court demanded to know when to expect payment, he replied, with curled-lip machismo: 'Doomsday.' By 1645 the rent was still outstanding and the Company wanted him out. In March the newly established 'Sequestration Committee' came into action.

While Simpson remained in Oxford, the bailiffs arrived on site and bashed at his door, instructed to confiscate his property. This would be the moment for his employees or associates to hide the stock-in-trade of jewels he'd left behind, before the bailiffs got inside. Somewhere out of the way, at the back of the building, butting up to the boundary with the neighbouring property, in a sturdy brick-lined cellar. The Company offered Simpson's premises at the corner of Cheapside and Friday Street to somebody else without further warning.

Simpson's decision not to take the jewels with him to Oxford can be explained by the fact that he was at the time making diamond-heavy decorations to the highest possible specification for the royal court, and the pieces, and loose stones in the Hoard, were, with a few exceptions, not sufficiently grandiose to be of use in his work in progress. They were, for the most part, made for his merchant clientele, and the few rarer pieces would be safer in a cellar than on the road to Oxford in 1643. He wasn't to know they would change the locks while he was away.

When the Royalist stronghold of Oxford surrendered to the Parliamentarians in 1646, signalling the end for the king,

Simpson returned to London and attempted to regain his premises, but was arrested and sent to prison. He had 'taken up arms' and automatically lost rights over his estate and he still owed money. He appears to have come to a financial arrangement and was released from Wood Street gaol, but in 1650 he remained an enemy of the state, with no rights in Cheapside, and took a lease outside the City on Drury Lane, listed under occupation as a 'delinquent' (meaning a Royalist). Delinquents were granted passes to go abroad, to join Charles II's covert diplomatic efforts there, but Simpson's whereabouts in the 1650s are unclear.

He returned after the Restoration, now on the front foot, again petitioning to have his Cheapside lease back. He wasn't successful; he hadn't paid his rent when the lease expired. Undeterred, in court he demanded £20,000 'for the sequestration and plunder' of his property – jewels that he had left on his premises and been denied access to, a vast sum testament to the value of the contents of the boxes.[13]

The Simpson brothers were eventually reinstated as royal jewellers, though never got themselves out of debt – the previous King Charles still owed them money for diamonds – nor back inside their old home on Cheapside, and moved to Axe Yard near Westminster Abbey to continue their work fashioning beautiful objects for the royals and trying to settle accounts, thinking of what was left behind. The brothers had ten children between them.[14] And then, in 1666, the Great Fire ripped through Goldsmiths' Row and every spindly wooden frame was consumed, contents assumed to be lost forever. Those mourning their livelihoods had underestimated the thickness of the bricks in that cellar ceiling. Francis died shortly after the Fire,

in December 1666, in his mid-sixties, and was laid to rest in St Margaret's Westminster, his property lying unharmed where his employees buried it.

The Civil War connected the interlinked mysteries surrounding the burial of the Hoard. So many others had left, like Simpson, to be a soldier, and then died, or survived but were unable to reclaim their property.

The Earl of Lindsey fought Polman's heirs on behalf of the East India Company for rights over the murdered dealer's property, but the litigation ended without resolution when he died in the Battle of Edgehill in 1642. Lindsey was well acquainted with Francis and John Simpson, as well as James, the eldest brother, also a jeweller, and all three were there to witness the arrival of the Polman treasures onto the market. Through his team of international workers, Simpson would naturally have heard rumours and tip-offs about treasures like Polman's in the City in the 1630s and hurried to the front of the queue to pick out a few pieces for his high society customers. According to the brothers, on one occasion a year after the *Discovery* and the flash sale of the gems, Lindsey took them aside to show them a large rough emerald given to him 'bought of a gentleman'.[15] Simpson employed Dutch and Swiss cutters and no doubt knew the artisan who later used their technical mastery to cut a pocket watch out of it, before Simpson bought it, under the counter, and added it to his finest stock for his best clients.

The Civil War could also explain the existence of the Stafford gem in the Hoard. The Howard family, high-profile Catholic Royalists, knew Simpson as a favoured jeweller to the court and he was then a natural choice to repair a chipped cameo or reset

a jewel. They had more compelling reasons to deposit family treasures in the keeping of a fellow Royalist before the confiscators came knocking, and there are other items in the Hoard that could belong to the family, most obviously the religious vessels.[16]

Out of all the derring-do and fabulation steps a real person trying to stay nimble-footed enough to avoid a wretched end. The wealth of circumstantial evidence lets us put Simpson's face on the photofit for the owner of the Cheapside Hoard (although the burial of the treasures in this scenario was performed by others on his behalf), half a century in age, in a doublet and coat, with a tall wide-brimmed hat and feather, a beard and moustache, or a simpler shirt and cloak. Simpson lived through a tumultuous political nightmare, and his knack for making useful connections, especially royal ones, kept him safe. That is until he found himself on the losing side of a war that ripped Britain apart, when even his exceptional skills fashioning exquisite jewellery and military insignia couldn't prevent his downfall, although he escaped with his life.

Francis Simpson stood behind Lawrence in the chain of provenance, and behind him, the gem traders of the sixteenth and seventeenth centuries, the men gathering up gems across the empire. These men were the 'Stony Jacks' of their day, his counterparts, and sometimes they were also the middlemen for the royals, depositing the gems on the market for kings and queens who needed ready cash. Thomas Cletcher and Joachim de Wicquefort, Dutch gem dealers in the Hague, both well known to Henrietta Maria and Charles, were good candidates for the conduits of the 'Two Brothers' when it was laid to pawn. Cletcher had already dealt in the broken-down

parts of the 'Mirror of Great Britain'. Polman may well have known Cletcher.

Lawrence and the others who found the treasures in 1912 had never heard of Polman, and since they had the burial date too early, would not have connected the Hoard to a Francis Simpson, if indeed they knew about the talented and loyal jeweller to the Stuarts. Simpson was jeweller to Charles I, while the 'ghosts' in Lawrence's flat and in the Gold Room at the London Museum were all 'Elizabethan'. Yet the real story behind the Hoard was much more thrilling than anything even a seasoned storyteller like Lawrence could have invented.

It's a bittersweet dramatic irony. The chain of provenance connecting Lawrence to Simpson and Polman is visible to us now but had been severed long before the treasures reached Wandsworth. There were countless other chains, connecting people to the other treasures in the Hoard, also broken, thanks to wars, lost papers and the codes of silence between those who traded them. When he received the Hoard's treasures in 1912, Lawrence became the man holding a tangle of these supply chains, after numerous purchases, thefts, sales and resales without receipts. But he remained in the dark, unable to see any of the faces, or, most poignantly, hear Simpson's story, after a decade enquiring.

CHAPTER XIII

The Chance of Escape

Under a showcase containing a late medieval crossbow-puller at the London Museum, the note reads: 'Found in London Wall'. This dry curatorial statement in the autumn of 1920 would seem harmless enough. But it was incendiary. The City solicitor was scrambled and wrote to the Museum demanding the item's immediate return on the grounds that 'recent excavations in London Wall have only taken place on City property'. Ipso facto, it had been taken illegally. Lawrence was pulled in and yet again asked to explain himself. He was in a very tight corner indeed with this one, and he confessed all to his embarrassed superiors, but pushed his back even tighter against the wall in the process: 'The thing was *not* found on Corporation property,' he said, 'It really came from Finsbury Circus which is a stone's throw from London Wall, but it was labelled as from the latter place, as the Guildhall man was watching the Circus site and I did not wish to call attention to it.'[1]

London offered too much temptation. Like an alcoholic left alone in a pub, Lawrence had been unable to resist the draw of a promising crater; his compulsive collecting leading him to ruin.[2] He would not be allowed back into the inner circle of trust, certainly not a proprietary role over the Museum's star exhibits, and the trustees would keep him under a close watch

until they could send him out to pasture. The shop at 7 West Hill and the flat above had to contain him.

Then, in 1922, an invitation arrived from Howard Carter. Carter was leading excavations for Lord Carnarvon in 'The Valley of the Kings' in Upper Egypt and he was asking Lawrence to join him. He was looking specifically for tomb KV62, the tomb belonging to the Pharoah Tut-ankh-amun – 'Tutankhamun'. Carter had all but exhausted his options looking for the pharaoh's last resting place; his work had been not only unproductive, but expensive. His patron had now set an end date for the whole endeavour. The feeling was the tomb would probably never be found, and that anyway it had likely been raided in antiquity, or else already uncovered at some point and found to contain nothing of significance. In less than a year Carnarvon would pull the plug, and this was the last chance to go out and join him. He should get himself out there to see it all for himself.

Lawrence's passion for Egypt was there for all to see in the Ka sign swinging above the front door of his shop and confirmed by the boxes of scarab amulets and bowls of Egyptian beads on the tables inside, which rattled with the trams as they passed up and down West Hill. He discussed Carter's proposal with his wife. May and Alfred had their opinions too. It was quite an offer. He would take a train from Victoria, and make his way east via boats and trains and a felucca across the Nile and, finally, a work-weary donkey, across the desert to the Valley of the Kings, far from the London clay and the surveilling eyes of the City authorities; far from the barrows and bleached skies of Suffolk. This was a chance to feel the sand-laced air of the Middle East

on his face, to touch the cool walls of the tombs with his own hands, to witness artefacts brought out of the ground in front of him. Florence had heard all about the 'Unlucky Mummy' going down in the *Titanic*, the journalist researching the stories of bad luck who then died prematurely, and the other mummies' curses at the British Museum. She hated the mummy's shrunken black hand in the shop more than ever, and the mounds of other miscellaneous Egyptiana with their impenetrable symbols, and had come to distrust their effect.

There was a lot to do and to look after at home. Plenty to be getting on with in London. Flo managed to dissuade him. He would have to make do with the pieces of Egypt already downstairs in his shop.

On 28 February 1922, Lawrence's evening paper announced Britain's recognition of Egypt's Independence (with a few points of foreign policy pending – a pre-emptive move intended to quell the nationalist movement but maintain influence). And on 30 November, Lawrence picked up *The Times* to read of an extraordinary find. After slogging away at painfully unrewarding excavations in the Valley of the Kings, Howard Carter had decided to take one last roll of the dice and look again at one particular line of huts, asking workers to remove the structures and the rubble underneath, thousands of tonnes of it. In the midst of this activity, a boy carrying water had tripped over a stone. The hazard turned out on inspection to be the first step of a staircase. The team dug out the rest of the stairs the next day, and they soon found an antechamber, a treasury and a door to a tomb. Carter kept the discovery quiet and telegrammed for Lord Carnarvon, who arrived with his daughter, Lady Evelyn

Herbert, two weeks later for the big reveal. On 26 November, Carter described in his diary how, holding a candle in one hand with trembling hands, he 'made a tiny breach in the upper left hand corner' of the doorway with a chisel. 'At first I could see nothing, the hot air escaping from the chamber causing the candle to flicker,' he reported, but as the mist cleared he was 'struck dumb with amazement, and when Lord Carnarvon, unable to stand in suspense any longer enquired anxiously "Can you see anything?" it was all I could do to get out the words "Yes, wonderful things!"' He could see by torchlight 'strange animals, statues and gold – everywhere the glint of gold'.[3] Electric lighting was installed in the tomb, a revelatory innovation, and numbered cards were put next to each of the artefacts and the scene carefully photographed by Harry Burton of *The Times* before Carter made an inventory and then packed the contents up.

The Times correspondent splashed the news of the sensational discovery and heralded it as a turning point for archaeology. Now the world would know about the later kings of Egypt of the Eighteenth Dynasty, and Tutankhamun specifically, who, with his father, had reverted to the worship of one deity, Amun, the sun god, ending Egypt's long-standing polytheism. Egypt was asserting its independence from Britain and insisted the artefacts remain in Egypt, and they managed to maintain control of the antiquities, against Carnarvon's expectations. He had already signed a commercial treaty with *The Times* for exclusive photographs, running roughshod over Egypt's rights over their own archaeology, and Egyptian officials made their anger known. Cataloguing of the antechamber continued for

months, under the beady eye of Pierre Lacau, the director of the department of antiquities of Egypt.[4]

The next report, enough to make Lawrence spill his tea as he clattered it down into the saucer, was a scoop in the *Daily Express* written by his old protégé, H.V. Morton. The newshound had hotfooted it to Egypt, sent to chase the story by his paper. After checking into a charming hotel in Luxor, taking a boat across the Nile to get to the West Bank and hiring a donkey to carry him the five miles to the tomb on unmade tracks, he got there just in time. May remembered Morton at the shop and joined her father to read the astonishing reports, Florence busied herself with other things as they pored over the headlines and read excerpts aloud to each other.

The radio and the Imperial telegraph took the news straight across the world, illustrated by Burton's captivating black-and-white photographs. The tomb was packed full but had evidently been burgled very soon after the king's burial, the contents chaotically jumbled in the process, before it was promptly resealed. The newspapers reported the king and queen had sent a telegram to Carter's team and were waiting eagerly on news. When they opened 'King George's Park' with its new 'lido' open air swimming pool that spring, just around the corner from Lawrence's shop, if the queen had cared to look on her way to or from the event, she could have seen its Ka sign swinging above the door, and its front window packed with a confusion of ancient history, appearing much like the cluttered tomb in the photographs coming out of Egypt.

On 16 February 1923, Carter broke through into the burial chamber, the second great reveal. This time, Morton got there

before Burton and scooped *The Times*, which had exclusive rights, for the *Daily Express*. He won the front-page splash on 17 February, which ran with the headline: 'Pharaoh's Coffin Found!', 'Wonderful Treasures!', 'Golden Sarcophagus!', 'Dead King Guarded by a Giant Cat', 'Awe Provoking Sight'. With the same breathless first-hand wonderment employed to describe the arrival of the multi-coloured treasures in the 'iron football' of clay at 7 West Hill, Morton reported that the

> romantic secret of the tomb of Pharaoh Tutankhamen [sic] in the Valley of the Kings at Luxor was revealed yesterday when, for the first time in 3,000 years, the inner chamber of the tomb was entered. Every expectation was surpassed. Within the chamber stood an immense sarcophagus of glittering gold, which is almost certain to contain the mummy of the king. Wonderful paintings, including that of a giant cat, covered the walls. A second chamber was crowded with priceless treasures.

Carter had also found all the equipment the king would need for the afterlife (but no Book of the Dead). A few days later, on 19 February 1923, Morton filed a report updating the paper with a detailed account of the marvellous 'Pharaohs' Jewels' on an inside page of the paper. Morton knew a story that would captivate a generation when he saw it and worked hard at the typewriter to establish his connection to it.[5]

The pictures ignited 'Tutmania', and before long the motif of Tutankhamun's golden coffin was everywhere, the symbols in books and buildings, redolent with exoticism, mysticism and

romance. Carter burned the midnight oil in the design studio and was soon advertising an Ancient Egyptian-style jewellery collection in the *Illustrated London News*. In Upper Egypt, a moneyed crowd of Tut tourists checked into the local hotels for a look, many Americans from the film industry among them. The story of a child king touched hearts in ordinary households across the country.

There's a wonderful photograph taken by Harry Burton of Lord Carnarvon, off duty, reading in a cane chair at 'Castle Carter', Howard's house on the Theban West Bank. A house that Lawrence would never visit, although he had the invitation. Carnarvon is wearing a woollen three-piece suit and an extravagantly curvaceous fedora with a cloth sash around it and a plaid dressing gown is hanging on a hook behind.

It was not all so convivial. Carnarvon and Carter disagreed with the Egyptian authorities about management of the tomb and it was temporarily closed down.

When Lord Carnarvon returned to England he was invited to Buckingham Palace for a personal audience with the king and queen. But he returned to the scene of the action shortly after, and, on 5 April 1923, he died at the Continental-Savoy Hotel in Cairo, aged fifty-six, of blood poisoning after nicking a mosquito bite when shaving. His death less than six months after the opening of the tomb inevitably triggered rumours of a curse.

On the ground, there was a great deal of unfinished business. The Cairo Museum and the British government argued bitterly over how to divide the contents of Tutankhamun's tomb. 'Tut' was now a symbol of Egyptian national pride, freed from British

protection, and they were not going to relinquish the treasures as they once would have been forced to.

When the Egyptians found a Fortnum & Mason crate packed with a life-size wooden head of Tutankhamun in Tomb no. 4 that was not on any of Carter's finds lists, a rumour began to circulate that Carter had actually broken into the tomb before the official entry and helped himself to a few bits and pieces. The branding on the crate looked to some like a dead giveaway, given Carter's British tastes, but he always denied taking anything.

In January 1924, Carter broke the seal of rope tied around the handle of the doors into the inner necropolis of the tomb, revealing the burial shrines inside and the sarcophagus. The breaking of the seal, a clear transgression, sent the world's press into a new order of rumours about a curse, and then on 12 February, Carter lifted the lid on the sarcophagus. A planned preview tour of the site for the wives and families of the British excavators was an appropriating step too far for the new nationalist Egyptian government who went to court to stop the visit from happening. Carter in turn took offence, had a lock put on the tomb, and walked off site. The Egyptians broke the lock but Carter sued the Antiquities Service, and the bitter legal arguments that ensued stopped work until the following year.[6] Carter's rights restored, he was straight back in the tomb for a fourth season, working in situ, as the materials were too fragile to be moved. He set about opening the nest of the three coffins-within-coffins, one by one, resorting to the use of a hammer and chisel as everything was stuck together by the libations that had turned into a pitch-like glue over time. And then, on 28 October 1828, he got to the innermost coffin,

which was solid gold, and lifted the lid to see the king's golden mask, with its painted, winged eyes, and headdress striped with lapis lazuli, the goddesses Nekhbet the vulture, and Wadjet the cobra, protecting his brow, on top of his linen-wrapped body. Carter described the discovery in his journal for 28 October 1925 as a humbling one: 'a very neatly wrapped mummy of the young king, with golden mask of sad but tranquil expression, symbolising Osiris. The similitude of the youthful Tut.Ankh. Amen, until now known only by name, amid that sepulchral silence, made us realise the past... Attached to the throat of the golden mask, beautifully wrought with juvenile countenance, are three massive gold and faience necklaces, a pendant heart scarab placed between the hands, crossed over the chest, which hold the flail and the crook.' Before them was a real person, his arms making a cross about himself, and around him, the vulture goddess Nekhbet with fully spread wings reaching across his body, to protect him on his journey to the Underworld, which Osiris, the god of death and resurrection, would preside over. On the back of the mask was written spell 151b from *The Egyptian Book of the Dead*. The transition from death to the Underworld was fraught with danger for the Ancient Egyptians, and this spell was concerned with the burial chamber and emphasised the need to protect the head. The Jackal, Anubis, tended to the body and the four sons of Horus guard the embalmed organs.

On 11 November 1925, George Fabian Lawrence and Queen Mary in London waited on news while a large team of officials assembled in the tomb for this momentous day in the history of archaeology, including the ever-vigilant Pierre Lacau, Tewfik Boulous, the chief inspector for the antiquities department

of Upper Egypt, Dr Derry and Dr Saleh Bey, professors of antiquities at the Kasr El Eini School of Medicine in Cairo, representatives from the Cairo Museum, and various Egyptian officials from the dig team. Carter and the photographer Burton joined the group in the tomb, and they began to unwrap and examine the mummy.

Dr Derry was the doctor in charge and, scalpel in hand, cut through and then peeled away layers of linen, everything again stuck together with the libation liquids that had set hard as tar. Every layer was dressed with amulets, necklaces and anklets, some inlaid with carnelian, some with jasper, green calcedony, and amethyst. The last layer of linen lifted to reveal his mortal remains, a fine cambric linen skull cap, and then a glimpse of his bare skin, and the bones of his 'beautiful and well formed features'. 'The head shows strong structural resemblance to Ak-en-Aten', Carter wrote, confirming that he was likely Tut's father, or a close male relative at least. After Burton had measured and photographed this young man, they were able to estimate his age – nineteen. He had ruled from the age of nine. He had been a boy king, and the cause of death was thought to have been an infected leg, although future tests suggested malaria. Carter wrote on 18 November 1925 that he would be 'reverently rewrapped and returned to the sarcophagus' and then it would be conveyed to Cairo.[7]

The world was watching and growing more uncomfortable about the whole enterprise. The idea of a 'mummy's curse' gained more traction. Sir Arthur Conan Doyle, whose most famous creation, Sherlock Holmes, was famed for his reasoning and scientific empiricism, had never recovered his senses after

his grief at losing his son in the war. He worked up the press with his assertions about the existence of an 'evil elemental spirit' protecting the mummy.

No evidence of any written curse set above the door to deter tomb raiders was ever produced. Nevertheless, the press went to town with the idea that Lord Carnarvon's death had been predicted. The month before he died, the popular English novelist Marie Corelli had published a letter in *New York World* magazine with a stern warning on her pet subject of mummies' curses. 'I cannot but think some risks are run by breaking into the last rest of a king in Egypt whose tomb is specially and solemnly guarded, and robbing him of his possessions,' she declared, going on to explain that, 'According to a rare book I possess...entitled *The Egyptian History of the Pyramids*, the most dire punishment follows any rash intruder into a sealed tomb.' Corelli quoted another line from the same obscure author: 'Death comes on wings to he who enters the tomb of a pharaoh,' claiming the book, no longer to be found, if it were ever in print, named 'secret poisons enclosed in boxes in such ways that those who touch them shall not know how they come to suffer'. 'That is why I ask', she goes on, 'Was it a mosquito bite that has so seriously infected Lord Carnarvon?'

Corelli was made famous by her first novel *A Romance of Two Worlds*, a wild supernatural science fiction romance, swirling with meditations on Christianity and mysticism, resurrection, prophecy and eternity. To call Corelli's work melodramatic would be an understatement – they were psychedelic – but her books were bestsellers, outselling Arthur Conan Doyle at the time, and she was read by Churchill and members of the

royal family as well as the general public. She was well placed, then, to whip up her huge readership into a reverence for the symbolism of the Egyptian afterlife and make them believe in a curse for anyone who failed to respect it. The quotation she cited, of mysterious origin, about death on wings coming for the tomb raiders, travelled far and wide and lodged in the public imagination as fact. Arthur Mace, a member of the excavation team, apparently died of arsenic poisoning in 1928, and there was a story that Carnarvon's dog Susie had died on the same night as her master, as well as talk of an associated murder, assassination and suicide. Carter dismissed it all as 'tommy rot', but Carnarvon had taken the occult seriously and had even employed a personal 'psychic' named 'Velma' who wrote about their consultations and claimed that she had begged him not to go back to the tomb. As with the Cheapside Hoard and its associated ghost stories, the political and legal arguments continued to rage in counterpoint to overheated talk of curses. Carter sued, petitioning to be allowed to take objects away from the excavation, and lost, giving Egypt control as an independent country for the first time.

In 1925, while Howard Carter was in London lecturing on King Tut to rapt crowds, Queen Mary visited a popular reconstruction of Tutankhamun's tomb, staged in the 'Amusement Park' at 'The British Empire Exhibition', which had opened in Wembley Park, North London, on St George's Day the previous year. The Exhibition was running in a purpose-built stadium in Wembley Park, the open space filled with a panorama of pavilions, each representing the culture and architecture of different countries and dominions within the empire. Conceived

at a time of declining interest and power – America and Japan were overtaking Britain on the economic front and in naval prowess – this exhibition, the largest ever put on, had been designed to encourage trade and boost Britain's image on the world stage. Two thousand men had been employed to construct the site and twenty-seven million people visited. Many were not playing ball for obvious reasons. Gambia, Gibraltar and the Irish Free State did not take part and, when the Exhibition opened in 1924, the Indian pavilion rejected J. Lyon's catering monopoly and insisted on retaining an Indian chef, bringing in the Anglo-Indian restaurateur, and ex-army officer, Edward Palmer as adviser.[8] The Indian government pulled out of the second year of the Exhibition, but Palmer's London restaurant Veeraswamy continued to run at the show through 1925, with long queues at lunchtime. The Pears 'Palace of Beauty' sold soaps as souvenirs and brought in the crowds with a line-up of staged 'rooms', each containing a model dressed as one of ten great beauties from history: 'Helen of Troy', 'Cleopatra', 'Scheherazade', 'Dante's Beatrice', 'Elizabeth Woodville', 'Mary Queen of Scots', 'Nell Gwyn', 'Sarah Siddons', 'Madame de Pompadour', and the last room for 'Miss 1925'. After her visit to the 'Tomb of Tutankhamun' (which was in the 'Amusement Park' because Egypt was no longer a British Protectorate and didn't get a pavilion), Mary made a beeline to an exhibit close to her heart. The king's cousin Princess Marie Louise had commissioned a doll's house from Edwin Lutyens for Queen Mary, to be shown in 'The Palace of Arts', complete with running water and electrical wiring. In the petite 'strong room' of the doll's houses were miniature replicas of the crown jewels, including

a miniature Koh-i-Noor diamond. The queen also took the opportunity to go shopping while at the Wembley Exhibition and went walkabout in the vast array of retail outlets, in search of one in particular, at which she bought a large black opal to take home. According to the *Aberdeen Press and Journal*, 'the purchase did much to break down the tradition of bad luck attaching to opals.'[9]

In the flat above the shop in Wandsworth, Florence told Lawrence that she felt she had been right to stop him going to Egypt, when this trip proved ill-fated for the health of some of those on the trip. While Lawrence may have ducked the 'curse' of Tutankhamun, the prospects of the family had not improved.

Laking was gone, and Harcourt was now also dead, the rumour circulating that he had taken his own life with an overdose of the sleeping draft Bromidia, over a scandal around his improper advances to an Eton schoolboy.[10] Lawrence was a straggler from the Old Guard now, and although the staff shared secrets, there were fewer and fewer in the building prepared to cover for his characterful errors of judgement, even through gritted teeth. He had continued his forays into the City, scoping out the excavations, and the procession of navvies to Wandsworth on Saturday afternoons – lugging mysterious objects wrapped in spotted handkerchiefs and flinging them onto his desk for inspection – did not dry up.

He had managed to hang on at the Museum, with a little help from his remaining allies on the staff and the guiding hand of St George. But then Harman Oates retired, to his marvellous ring collection, and Lawrence himself turned sixty-five and was forced into retirement, described tersely in the trustees'

meeting minutes on 20 May 1926 as 'superannuated on a very small pension'.[11]

On his way out, carrying his box of personal effects, he inevitably passed the Gold Room. There was no one in the offices to miss the St George ring, or the lengths of chain or ask after their whereabouts. No one there to know the deals that had been struck at the beginning. It was all lost in the desk drawers and cupboards full of un-filed papers and vaguely labelled objects.

The treasures lined up under the lights were so familiar to him. No one was any the wiser about the various pieces that were not where they should be. He took his secrets with him, through the costume gallery, down the great staircase through the turnstile, shaking hands with Walter Henderson and O'Connor at the door, and made his way back to his shop on West Hill under its Ka sign, through the door, leaving the mess behind him.

How is it possible there was no catalogue for something so important? Harman Oates had taken rings. Laking had taken rings. Harcourt didn't want paperwork done – he tended to 'lose it'. The treasures were better here by gentleman's agreement. Mystique was the thing, and the sense of rightful inheritance, the details lost in the mists of time. The chains were still with the queen and I think, in all probability, that day the ring was with George Fabian Lawrence.

CHAPTER XIV

A Reckoning

In July 1926, following Harman Oates's retirement, Robert Eric Mortimer Wheeler was invited to fill the vacancy as keeper of the London Museum.

Wheeler, known as 'Rik', an imposingly tall, whiskered man in his late thirties, with a rakish charisma and penetrating eyes, had served in France and received the Military Cross for his service with the Artillery on the Western Front. He had been considering a return to London while in Cardiff running the National Museum of Wales, and he jumped at the offer of the post at Lancaster House. The Roman site of Verulamium in Saint Albans would make him famous in the 1930s. He had the killer instincts to embark upon a clear-out, open-the-curtains on the whole institution. He knew all about 1912 and the rumours of a deal and he would fumigate the moth-eaten costume gallery, smoke out the secrets, and sort through the disorderly piles of paper.

Wheeler could size up a man, or a landscape, at ten paces. His roguish energy was perfect for the streets of St James's, where he would stride, fag in hand. Agatha Christie's husband, the archaeologist Sir Max Mallowan, remembered him as 'a delightful, light-hearted and amusing companion, but those close to him knew that he could be a dangerous opponent if threatened with frustration'.[1]

The historian Francis Sheppard appraised Wheeler's approach with nervous admiration. 'The museum was regularly cleansed and frequently (but often unexpectedly) scrutinised by its formidable keeper, who after one of his frequent absences might suddenly reappear and be found striding round the galleries like the commanding officer of a battalion on inspection parade. A new and much better system for the numeration of accessions was introduced.'[2] His gruff delivery and flamboyant whiskers would make him a celebrity in the 1950s as a panellist on a popular BBC archaeology game show called *Animal, Vegetable or Mineral?* where the experts try to identify and date an intriguing artefact, usually an object from a museum's basement store. For his co-hosting of the archaeology series *Buried Treasure* he would be named Television Personality of the Year in 1954.

In 1926, Wheeler set up home in a flat in Victoria with his wife, another eminent archaeologist, Tessa Verney Wheeler, and their thirteen-year-old son Michael, but he frequently stayed late into the night at work in the Museum, on a mission to move from the old habits of acquiring beautiful objects for the romance of it, to actively solving questions from the past. He and Tessa introduced meticulous scientific methods into their digs and invented the now-standard 'grid system', superimposing a three-dimensional chessboard on the excavation site so that the area could be methodically worked through and the finds logged, in situ, in the correct 'box'. Together, the Wheelers 'professionalized the London Museum'. Wheeler was determined that the Museum be cleaned up, catalogued and rationalised pronto. The theft of Oliver Cromwell's silver watch from its show case on 30 August 1926, just after he took

up his post, ignited his fury at the state of affairs. The thief had got past O'Connor and Walter Henderson the guard, and though the watch's connection to Cromwell was shaky, it was an embarrassment for the Museum and an outrage to a military man like Wheeler.[3, 4]

Wheeler had inherited mountains of evidence of Lawrence's methods. It was everywhere, in every filing cabinet in Lancaster House, and nowhere, in the gaps and the oh-so-brief and evasive descriptions; a legacy he waded through, slowing his progress.

Things had to be put straight, questions answered, and letters were written, conversations initiated, off the record.

It's not clear if spot checks threatened, or he simply wanted to show willing, but within weeks of Wheeler's arrival Lawrence had relinquished technical ownership of the gold chain with the true lover's knot motif he had 'lent' to the V&A all those years ago. There was no need for him to do anything, it was not in his possession. A letter of authorisation would do the trick.

This chain joined other strands from the Hoard which had been given to the V&A from the London Museum with two different flower-and-leaves designs in green-and-white enamel. Queen Mary did not feel the need or the obligation to return her strands of gold-and-enamel chains to the collection. But then, who was going to ask her to?

Lawrence kept his head down, wary of more questions. He had elegant new business cards and letterheaded stationery made up to advertise his services as 'G. F. Lawrence Antiquary', a man for hire. The cards presented a brief curriculum vitae of

the Museum positions held to date, his address and telephone number, Putney 5868, and instructions for taking public transport to the shop: Motorbus no. 39 from Tottenham Court Road, or District to Putney Bridge Station and then Tram to West Hill Wandsworth. At the centre was his insignia, the shield containing his initials incorporated with a mason's mark: 'GFLXX'.

He occasionally worked out of another address, 1 Lowther Gardens, South Kensington SW7, the address appearing on some of his invoices and letterheads, with the same 'GFLXX' insignia he'd had since before the war. Lowther Gardens was a short walk from the V&A and also from 19b Collingham Gardens, where Howard Carter was now living, when he was not in Egypt finishing up the years of excavations of Tut's tomb. The two were once again thrown in each other's path and confronted with their relative successes and failures.

Carter was back and forth. He was connected above all others to one particular and notorious find which, overall, had proved a blessing, despite the talk of curses and the endless arguments with the Egyptians and their continuing accusations he had taken items from the tomb.

Running into each other on the street of Kensington, the opportunity to share sources as well as stories about the good old days in private would have been too good to miss. Both men had world-famous discoveries to their names, and international press cuttings to compare and spar over, the Cheapside Hoard recently garnering publicity from as far away as Australia. Following the publication of Wheeler's 'interesting little book descriptive of the "find"' one Adelaide-based correspondent had drawn attention to the exceptional qualities of the 'Wakefield

House Treasures', declaring that the Hoard 'in bulk alone... exceeds any other collection of its kind in Great Britain.'[5] But the two men also had secrets, and competitive pride in their top pockets, and neither could afford to let his guard down for a minute.

In 1932, the decade-long clearance of Tutankhamun's tomb complete, Howard Carter retired to a Mansion flat at Albert Court near the Royal Albert Hall, but wintered in Luxor, making the two men even nearer-neighbours in Kensington. Carter's new address was one of the very first Mansion flats, with deeper foundations, built in London in the frenzy of redevelopment that exposed so much of London's hidden history. Constructed in red brick with a fancy white brick trim and columns shading balconies, its reception hall was resplendent with palms.

Despite the elegance of his accommodation, Carter, like Lawrence, was a man in the professional wilderness. He had gathered a trunk load of heady memories to keep him company, from times when he played tour guide out in the desert to a global cultural phenomenon and figures from science and literature flocked to him like moths to a flame. In 1931 Agatha Christie and husband, Max Mallowan, had sought Rik out on their travels and Christie, already a passionate archaeologist, had been captivated by the story of the tomb and the Boy King, even inspired to write a play *Akhnaten* about Tut's antecedent who brought Egypt to the worship of the Sun God. She loved the mythic stories revealed by the digs. The rest of the world, however, had lost interest in archaeology and, consequently, in Carter and Lawrence. At this point in their lives they were like two ancient mariners, full of tales, but any accounts they

swapped of their past adventures and transgressions remained off the record.[6]

Carter's personal life was opaque: no one had ever been sure where his romantic passions lay, and if he had, as rumoured, enjoyed a relationship with Lord Carnarvon's daughter, Evelyn. If Lawrence happened to see Egyptian artefacts in Albert Court that were suggestive of objects from Tutankhamun's tomb, he never mentioned it publicly. And if Carter – a man who knew all about temptation and opportunity – asked Lawrence for the truth about what happened in the days after the Hoard was found, Lawrence kept any answers to himself.

And then, apparently out of the blue, another two items from the Hoard came back onto Lawrence's radar. They were closer to home than he may have expected or liked.

He'd last seen this pair of fancy-cut amethysts years before.

The standard way for a stone to find its way back to Lawrence was via another dealer. A man with a Gladstone bag; a little box or stuffed handkerchief, coming by his shop on West Hill on a Saturday, one of a steady stream, to let him know that he had two jewels for sale and asking if he was interested in having a look.

Sales through middlemen were often anonymous, the broker arranging things on behalf of someone who wanted a low profile, sellers sometimes referred to with a wink in auction catalogues as 'A Gentleman in north London' or, 'Property of a lady'. Lawrence knew from his extensive experience that there was always a reason for the anonymity, and the seller was not necessarily a gentleman or a lady, but they definitely wanted a sale and wanted it quickly, no more questions asked.

However, the person returning the stones was his son, Frederick. Most likely Fred confessed, keen to sell them, or Lawrence stumbled upon the amethysts on a visit to his son's family in North London. Regardless of the circumstances of his reacquaintance with these two jewels, they would need to devise a strategy for what to do next. Stray pieces of the Hoard, emerging after fifteen years, would demand an explanation.

What had Fred done with these two sizeable treasures for so long? Where had he kept them hidden?

The General Strike had made things worse for a man like Fred Lawrence, punitive legislation had been quickly put in place to prevent any further organisation. The effects of unemployment and a suddenly disempowered workforce spread across most sectors. With an overcrowded job market, now including women, a man in a fragile mental and physical health would not be re-employed easily. Harsh economic reality was biting and all over the country people were trying to escape it. This was the year H.V. Morton published his bestselling travelogue *In Search of England*, in which he motored up and down the country mixing with high society and labourers alike, peddling England as a land of chocolate-box thatched cottages, merrie pubs and apple-cheeked vicars. It was an instant bestseller. The unprecedented national disruption of '26, playing out as he wrote it, is barely mentioned, and he neglected to visit any industrial cities.

Most likely, the discussion between father and son regarding the amethysts involved Frederick scoping out the option of selling them. But that was now unthinkable given the profile of the Hoard, which had only grown in the past fifteen years. Keeping the jewels back, as compensation for unfair division

of the money in 1912, was more easily justified. And what was the good of something on the side for a rainy day if you didn't sell it when the rainy day arrived? Lawrence could force his son to return the amethysts, but giving them up could mean scandal. Questions of family legacy were on both men's minds. Lawrence's brother, Alfred, had just died in Shropshire, his reputation never salvaged. Lawrence could take the rap himself. Perhaps they had both given up on the magic protective powers of amethysts?

The two stones under consideration were a purple variety of mineral quartz, these both a zinging lilac; with amethysts ranging in colour from lavender to a deep purple, the deeper colour traditionally considered the most valuable. A poet of the French Renaissance, Rémy Belleau, invented a myth to explain the colour in which Bacchus, the Roman God of wine, pursued the unwilling maiden, Amethysta. She prayed to the chaste goddess Diana, who rescued her by turning her into a stone of quartz. Bacchus, overcome with remorse, poured wine over the stone as an offering, staining the crystal purple. Another version has him crying wine over it, with the same effect. It's an intoxicating story, although reality has more to do with underground chemical reactions. The colour comes from iron inside the crystal, which turns purple when exposed to radiation and heat.[7]

Something to consider in 1927 was that amethysts would not make as much money as they once garnered, perhaps tipping the balance of risk when deciding whether or not to sell them. They had once been ranked as a 'precious' stone along with the big four of diamond, ruby, emerald and sapphire. The value

only fell when Brazilian settlers discovered vast deposits of the beautiful purple material in the nineteenth century. Scarcity had always been the amethyst's calling card, and purple possessed the long-standing cachet of exclusivity, purple dye being fiendishly difficult to produce and popular with the decadent elites of Rome. The Tudor Sumptuary Laws, dictating what the population could wear according to social standing, made purple the preserve of royalty, and commoners could not have worn amethyst jewellery (in the unlikely event they had any to wear). The Ancient Egyptians loved the purple gem, for medieval Christians its colour alluded to the wounds of Christ, and soldiers, aware of its reputation as a healing stone, wore amethysts into battle as a pre-emptive balm for their wounds. In 1927 the popularity of the subtle and ever-so-slightly maudlin amethyst had waned, cast into the shadows by the sharp bling of the diamond.

Did either man now consider the amethysts bad luck? Lawrence will have heard the rumours that swirled for decades about a large amethyst lozenge known as the 'Delhi Sapphire' that was supposedly cursed. The backstory had been written down by its one-time owner, the polymath scientist and Persian scholar Edward Heron-Allen, in a note that he put inside a bank vault with the boxed-up gem, to be read after his death. 'To – Whomsoever shall be the future possessor of this Amethyst', it read, and proceeded to tell of how the stone had been, in his own words, 'looted' by a British Officer in the Bengal Cavalry, from the Temple of Kanpur, India, during the brutal suppression of the local mutiny in 1857. The officer had then brought it home to England, whereupon he and his

family suffered a litany of financial disasters and illnesses. The officer's son passed it on, with rather too much enthusiasm, to Heron-Allen in 1890, who promptly lent it out, and again it brought bad luck with it, and was returned, by now very much unwanted, to him. Exasperated, he threw it in Regent's Canal but it was dredged out, and returned to him yet again via a 'Wardour Street dealer who bought it from a dredger'. 'It remained thus quietly until 1902', wrote Heron-Allen, 'though not only I, but my wife, Professor Ross, W. H. Rider, and Mrs Hadden, frequently saw in my library the Hindu Yoga [sic], who haunts the stone trying to get it back. He sits on his heels in a corner of the room, digging in the floor with his hands, as of searching for it.' It was, Heron-Allen said, 'stained with blood and dishonour'. 'I had it bound round with a double-headed snake...and two amethyst scaraboei of Queen Hatasu's period, brought from Der El-Bahari (Thebes).' He set the ring with charms and Ancient Egyptian amulets to mitigate its power and boxed it up with the letter, signing off: 'Whoever shall open it, shall first read this warning, and then do so as he pleases with the jewel. My advice to him or her is to cast it into the sea. I am forbidden by the Rosicrucian Oath to do this, or I would have done it long ago.' The note was signed and dated: 'Edward Heron, 1904'.[8]

Heron-Allen had crossed paths with Lawrence in London's museums and antiquities dealerships and Lawrence had perhaps kept a wary eye out for the gem on the market. Like Lawrence, he was a man with an interest in the symbols and practices of Ancient Egypt, like its protective amulets. He was evidently a member of the brotherhood of the Rosicrucians, another group

who believed they'd had the ancient learning of all ages and traditions passed down to them. The story of the true owner of the jewel, a Hindu Yogi trying to get it back and haunting Heron Allen's study in front of his wife, has many parallels to Lawrence's own tale about an apparition in his den in Wandsworth demanding his property back, in front of his family.[9]

Whatever the circumstances, in November 1927, G.F. Lawrence sat down at his desk and wrote a letter to Mortimer Wheeler. He enclosed the two gorgeous lilac stones. Presumably he dropped the package at the Museum, the cargo being too precious for the post.

1 Lowther Gardens, South Kensington, S. W. &.
7 West Hill, Wandsworth, S. W. 18.
18 November 1927

Dear Dr Wheeler,

My son wishes to give the Museum these two amethysts from the Cheapside find.

Would you please send letter of thanks to him.

F. Lawrence
61 Muswell Avenue
Muswell Hill, N10.

I have got the best part of a beaker, (from B Abercrombie) from the Thames to show you one day,

Kind Regards,

Yours sincerely
G F Lawrence.

Lawrence decided in the end on a matter-of-fact-whistling-nothing-to-see-here tone, of the 'never apologise, never explain' variety, learned perhaps from his dealings with the royal family. Perhaps Mortimer Wheeler had forced his hand and this letter was just for show, but, at face value, Lawrence brazened it out, doing the right thing while denying any embarrassment.

21 November 1927

Dear Mr. Lawrence,
Your father has sent me two amethysts for the Cheapside find. I am most grateful to you for them and shall have the greatest pleasure in adding them to the collection. It is indeed very good of you to have sent them.
Yours very truly, Keeper and Secretary

Given the significance of the Cheapside Hoard to archaeology and its status in the world, Wheeler's faux-casualness at receiving back two of its constituent parts out of the blue is extraordinary. Not unlike mustering only a polite smile when handed one of Tutankhamun's stolen personal effects, returned after many years, or an Anglo-Saxon dish from Sutton Hoo, as if they were a novelty mug or a souvenir stick of rock. The note's strange tone shows conversely just how important it was for Wheeler to get a grip on things and present as a responsible defender of the nation's famed Treasure Trove without advertising the scandalous lack of attention that went on before.

Dear Lawrence,

Many thanks indeed for the amethysts. I have written to your son. It was more than good of him to think of us.

With kindest regards, yours sincerely

The whereabouts of the opal ring was another matter.

CHAPTER XV

Making the Catalogue

In early 1928, Mortimer Wheeler summoned Lawrence to Lancaster House on urgent business. He wanted to produce a comprehensive catalogue of the Hoard found at Cheapside, sixteen years previously, in 1912.

Lawrence had reason to be nervous, having retired under a cloud. Then again, no one knew more about these treasures than he did. Laking, Harcourt and Oates were gone. He may never have been the keeper at the Museum but he was the keeper of the secrets connected to the treasures from the Cheapside cellar, and Mortimer Wheeler knew it and needed his help and an insider's information.

Walter Henderson was there to greet him as he arrived through the annexe door of Lancaster House and made his way up to the keeper's office, next to the Gold Room, where the Hoard sat ready to receive callers.

This was Rik's territory now. A mountain of a man in comparison to Lawrence, he had his feet well and truly under the desk at the Museum, and a gruff and direct manner; the mission clear. Rik was also a heavy smoker, so any meeting between these two men took place in thick fug that got quickly thicker, Lawrence reaching for cheroot after cheroot, with the usual odd fit of tight, asthmatic coughing. Wheeler fiddled with his horizontal

whiskers, staring Lawrence down with his glitteringly ferocious attention. According to his granddaughter, Gweneth, and despite their conflicting approaches, Lawrence considered Wheeler to be a 'whiz kid'. He had after all been spectacularly successful in working out a professional methodology for acquiring and authenticating the Museum's collections. Rigorous professional oversight was a boon. However, what Lawrence knew couldn't be methodically collected.

Rik remained determined to tidy things up, but he went in gently, expressing his high regard for Lawrence, the only man able to assist him with the crucial job at hand, with his first-hand knowledge of the Hoard as it had arrived, piece by piece, into the Museum all those years ago. It was, frankly, astonishing that there wasn't a catalogue already. The Cheapside Hoard had taken its place as the most important archaeological discovery of its kind ever made. The anomaly – a brazen negligence at best – was there for all the scholars and world history writers to see and comment on. If it stuck in his craw to ask Lawrence for help, he couldn't afford to show it. Lawrence agreed to help him in any way he could with the monumental task. He would be the trusty right-hand man.

Lawrence held extra leverage because, the Hoard's sketchy paper trail notwithstanding, he was exceptionally good at catalogues. His first job had been at the Guildhall Museum where he had meticulously revised and condensed the manuscript catalogue, and for fifteen years he had catalogued newly discovered archaeological material for this institution.

Wheeler took a typically canny approach. A lot of water had passed under the bridge since the events of 1912, and looking

back over it all required a careful touch to flush out any stray treasures from the Hoard. He was obliged to ask Lawrence about the old rumours of a deal with the developers at Wakefield House, but promised discretion; after all, it would invite public scrutiny and legal troubles to open those files again and pick over what may or may not have happened to secure the title to the Hoard. Whatever Lawrence chose to share behind closed doors, Wheeler would remain 'officially reticent' about the details of summer 1912. Lawrence had been good enough to organise the return of the amethysts and it would be a shame if the catalogue were missing something which rendered it fatally incomplete. If there was anything from the Hoard that should be included, it was best to declare it now. Call it an amnesty.

Wheeler had become aware of a piece that no one had seen since the first exhibition in 1914, before the war. It had been described in the press then as one of the highlights of that show, a 'beautiful opal carved most minutely with a George and Dragon design'.[1] If anyone would know where it was, Lawrence was the man. Stubs mounted while Lawrence considered his answers. There was an item that was part of the Hoard that he had kept an eye on, as per a private arrangement, one of many gentleman's agreements made back in the day which allowed for a certain amount of retaining and lending back. That was the way of things at the time.

The work on the catalogue began. There was a lot to arrange. The men went back and forth between the desk in the keeper's office and the treasures in their glass case in the Gold Room next door, removing the objects, studying them afresh under desk lights, beginning an inventory.

J.L. Douthwaite, curator at the Guildhall, responded to Wheeler's request: 'It will be quite convenient for you to send your photographer at any time for the purpose of photographing the watch and jewelled cross in our treasure-trove exhibit. Shall we say the first bright morning we have, at 11 O'clock?'

W.T. Gordon, professor of geology at King's College, London, and a Mr Charles W. Matthews arrived to help with identifying the pieces and drafting the descriptions. Wheeler commissioned an illustrator and photographer to record some of the most important and interesting pieces for the publication. Illustrations were to be life-size.

The office was busy with people and paperwork, the lamps rigged over drawing boards. Gordon used a small refractometer to help identify stones by observing how the light bent through them.

With the production line analysing and illustrating the pieces in full swing, Lawrence was able to add a small object to the queue. The illustrator had a look at this new object, as did the photographer, each taking it between his thumb and first finger. It was a man's finger ring, set with an opal cameo featuring St George and the Dragon in relief. Good triumphing over evil. Plain but interesting. Under the refractometer it went. Opaline calcedony, a hard quartz, was easily mistaken for opal. Opal was softer and would scratch. They reported a true opal. Someone no doubt had heard it was bad luck. A light was directed, and its picture taken, its image drawn, the ring captured, details preserved forever in the publication in this snapshot of time in 1928.

Wheeler, Lawrence and the others then got on with the next task on the agenda: discussing its key features (it was intricately

carved if you looked closely) and coming to an agreement about how to explain it succinctly in the new catalogue. There was no record of where it had been for the fourteen years since its first exhibition, or before that, in those years between 1912 and 1914. This was only its second official appearance. They settled on a description, calling it simply: 'Gold ring, with white enamel and set with a large opal cut to represent St George and the Dragon.'

Now they had to give the object an accession number. This was tricky because it had been separated from the rest of the Hoard. The number should reflect that.

With the labelling decided, the catalogue of *The Cheapside Hoard of Elizabethan and Jacobean Jewellery* went to press, a charming booklet bound in cream paper and on sale for one shilling net, *London Museum, Lancaster House, St James's SW*. On the first page, Dr Wheeler wrote a foreword promoting the Cheapside Hoard as a collection 'of outstanding importance', a class above any of its kind in Great Britain and 'salved in 1912 largely through the efforts of Mr. G. F. Lawrence', namechecking him as the 'without whom' figure of the affair. He pressed on to give a potted history of the jewels and gems and a crib sheet on historic cutting styles and techniques for gemstones.

Under both of the two images of the St George and the Dragon opal ring that appear in the catalogue, the photograph and the drawing, is the accession number that Wheeler and Lawrence decided upon for the object, its unique label marking its arrival into the Museum collections: 'X5'. This label gave very little away, and didn't suggest a date of acquisition, as many such numbers do. It was a bureaucratic name for such an unusual and beautiful object, exceptionally unromantic and

chivalry-free, but its bespoke numbering within the catalogue made it both part of the Hoard, and not – useful if the object's whereabouts were a grey area.

In the same catalogue there's an 'Earring' labelled 'X9', incorporating two more fancy-cut amethysts with gold links. And a 'hat ornament' called 'X4', white enamelled at the back, and set with foiled amethysts, both flat and rose cut. Could it be that these additional 'X' accession numbers were also separated from the Hoard, and in the custody of the Lawrence family on provisional loan, amethysts being a family favourite, on condition they were returned to the fold when requested? 'X5' made the ring both his and not his. Did Lawrence have his cake and eat it too?

After the St George opal ring was captured in this 1928 catalogue, it vanished again from the records and has not been seen since (or at least no one has publicly admitted seeing it).

King George and Queen Mary tried to rationalise their collections at the end of the twenties, too. In 1928 King George V sold off his Romanov cousins' jewels. Empress Maria, the mother of the murdered Tsar Nicholas II, had managed to get to Denmark with her sizeable box of beautifully crafted and extremely valuable jewels, keeping them secretly stowed away under her bed, as the ill-fated Polman had attempted on the *Discovery*. Maria had turned eighty and was in the throes of her final illness and a British agent had convinced her daughter, Xenia, to hand over the box for safekeeping. They would be in the care of George V and he would sell the jewels on behalf of Xenia and her sister, Olga. The box was opened in Buckingham Palace, but no proper inventory taken. What happened next

was no more transparent and fanned the flames of suspicion after the event that Maria was short-changed in the process. The jewels were sold, some to Queen Mary, but there's no reliable paper trail or official numbers to put to these sales and prove that Mary paid a fair price for every piece, as she always insisted she did. Olga claimed not to have received anything, Xenia £60,000. Mary had already purchased a piece – the 'Vladimir tiara' – from Empress Maria's smuggled collection, back in 1921. She revamped the tiara in 1924 by adding some of her Cambridge Emeralds. The ten stones that had been set atop the Delhi Durbar Tiara were removed and hung as drops on the Vladimir, along with five more, a work in progress telling her story in lines of sparkling jewelled notation.[2]

CHAPTER XVI

The Auction of Rings

Lawrence tried to stay on the wagon as regards his collecting habit. Then, three years after handing over the reins to Mortimer Wheeler as keeper at the London Museum, Harman Oates died. On Wednesday 20 and Thursday 21 February 1929, Sotheby's hosted the posthumous sale of his possessions, including his very extensive collection of ancient rings.

Cabs and trams and a few cars made their way to the auction house in New Bond Street and deposited their passengers outside the fine symmetrical white-stucco building.

To enter Sotheby's, auction attendees had to walk under the black diorite stone bust of the Ancient Egyptian warrior deity Sekhmet, which sat above the portico. Sekhmet, a warrior deity and goddess of plagues and healing, had the head of a lioness, framed in a headdress, and gazed proudly out onto the busy Mayfair street. Protector of the pharaohs, she led them into warfare and escorted them through the afterlife. The statue dated from around 1320 BCE, possibly during the reign of Tutankhamun, probably Amenhotep III. The urban legend already around town was that the bust had been sold at Sotheby's in the 1880s for £40, among other Egyptian antiquities belonging to pioneer archaeologist Giovanni Belzoni, but never collected by the purchaser, and that when Sotheby's

moved into its new premises in 1917 they put it above the door as a mascot. No paperwork tracing the provenance of the statue has been found, however, and no trace in any Sotheby's catalogue, so who actually brought it out of Egypt, and who put it up there, is anyone's guess. A steady stream of punters made their way in underneath her, a few taking a quick look up before they disappeared inside to collect their bidder numbers and take a seat.

The auction room was already busy, an animated sea of trilbies and bowler hats. Furtive looks and cursory hellos flickered around the crowd, collars goings up as men sank into their chairs and buried their heads in the catalogue. A man with white hair in a neat if tired three-piece suit and steel spectacles slipped in at the back. He was putting his head above the parapet but he could not resist it. Lawrence, now a free agent cruising the salerooms for clients, would not miss a chance to pick up something Oates had treasured. Especially any objects Oates had been left holding when the music stopped in the game of pass-the-parcel some of them had played under the desk with pieces from the Cheapside Hoard.

Some visitors that day had already been in to preview the rings, which had been sitting on display in another room at the auction house, and had smartly registered for the sale at the same time. Some, like Lawrence, already knew what they looked, and felt, like. The rings were now in a display tray at the front in the saleroom, and attendees craned their necks to have another quick look.

Word had spread around London between people in the business that objects from the Cheapside Hoard might be

coming back onto the market. The sale was not being advertised as such, of course, but those with any knowledge of the insider trading around the time of the Great War knew what Oates might have. The Cheapside Hoard was a famous national Treasure Trove and, if any items from it were resurfacing in the sale, there was every reason to be careful about the wording of the lot descriptions. It wouldn't do to draw attention to their provenance. A year after Wheeler's 1928 catalogue more dealers had a sense of the kind of pieces in it and keen eyes could spot its signature characteristics.

The last time a similar sale caused as much excitement in London had been Edmund Watertown's collection of 600 rings. Watertown, a foremost nineteenth-century ring and gem collector known for his extravagance, had put his collection to pawn with the jeweller Robert Phillips, but had found himself unable to pay up at the end of the term and the V&A acquired the whole thing in 1871, before any of this crowd were in the game. Today's auction had extra cachet because of its intriguing backstory and they were all contenders.

More people entered clutching their sale catalogues, and others shuffled down to make way and sat nervously waiting for the auction to start, sizing each other up, looking for old faces they might recognise. Some had to stand in their overcoats and mackintoshes. A telltale, tight asthmatic cough announced the identity of one.

Sotheby's, always trying to be as posh as Christie's with its fine art pedigree, was represented front-of-house by one of its directors, Montague Barlow, a barrister, and MP Felix Warre, a banker, both smart in suits for the event, which was a bit of

an unknown quantity. The women staff too, part of the intake who had arrived during the war to replace the men and stayed, stood by in drop-waisted dresses and cloche hats, no longer seen in the porter's blue overalls they had worn during the war.

The auctioneer arrived and took his position at the lectern with gavel, and a hush descended, punctuated by a few more nervous coughs.

The auction started, clients shifting in their seat, their noses in the catalogue, or focused straight ahead, papers poised to bid.

Catalogues went up and down as the auctioneer proceeded through the lots, an assistant holding up each of the rings between thumb and forefinger, turning slowly left and then right to show the whole room. Some lots sent the hands ping-ponging across the room, others went for a single bid. Each time the gavel clacked down on the lectern the audience checked the sale price against the estimate to see whether the penny had dropped about the provenance of some of the treasures within.

Lawrence had his eye on 'lot 50', described as a 'fine' sixteenth-century gold ring with a table-cut sapphire, with no provenance attached. He recognised the ring, and he recognised the man bidding for it as an agent for the V&A, Mr Koop. The agent won it for nineteen pounds (about £1,500 today). This was getting interesting. The air was thickening with tension and the damp winter coats drying out.

Then next, 'lot 51', was another one to watch: a lady's gold ring with an enamelled hoop, set with a cluster of emeralds, '[P]lease note two or three stones are missing from the setting.' The ring was shown to the audience. The lot included another

ring, early seventeenth century and set with a flower of seven garnets, duly held up for the crowd. The man from the V&A joined the bidding and won both. He paid forty-one pounds (over £3,000 today). After a short break, head down, nose in his catalogue, he was the successful bidder on 'lot 58', a gold ring set with a table-cut white sapphire with lozenge-shaped facets, in an oblong octagonal bezel, dated from 1550 to 1650. The gavel fell at thirteen pounds. The man from the V&A showed his bidder number and went back to his catalogue.

Lawrence also watched the bidding on 'lot 55' with interest, out of the corner of his eye. Someone by the name of 'Bois' started bidding for this gold ring, set with a cameo head of Christ in a 'bloodstone' of a moss-green agate with spots of red. The ring was turned by the assistant to show the reverse, on which were engraved the nails of the cross and the initials 'I.H.S.' (*Iesus Hominum Salvator*). Lawrence knew this ring. He had given it to Harman Oates, before the war. In fact a careful reader of the catalogue would have spotted many nods to Laking and G.F. Lawrence in the descriptions, citing them as sources to certain pieces, testament to the circulation of items behind the scenes at the Museum that went on over several decades. 'Bois', who was also spending good money at the auction, was the successful bidder for the cameo of Christ, at fourteen pounds.[1]

When the auctioneer called 'lot 56' Lawrence recognised the man bidding as Colonel Brett, Lord Esher's son, and an assistant keeper at the London Museum (a controversial appointment with some harrumphs about nepotism, although he was equally disgruntled not to have jumped straight into the top job). Colonel Brett won the auction for the gold lady's ring, featuring a small

soldier's head wearing a helmet, projecting to the front, and acanthus leaves to the shoulders, described as 'early 16th century, rare'. Lawrence had seen this ring with the knight in armour before and watched it pass through Laking's hands before it got to Oates. The gavel came down with Brett having pledged six pounds and ten shillings (about £500 today).

Lawrence had come prepared for a spending spree on his own behalf. Up went Lawrence's catalogue for 'lot 72', containing 'a fine gold ring...at the centre of which is an antique intaglio surrounded by an inscription, "Ave Maria", late fourteenth century.' The auctioneer nodded at Lawrence and called 'sold to the gentleman' at forty-four pounds.

When the auctioneer called 'lot 145' Lawrence looked around then tipped his catalogue again to catch the auctioneer's discreet attention, bidding for a fine English sixteenth-century 'pomander' (the name a corruption of the French *pomme d'ambre*, or 'apple of amber', after the waxy whale product ambergris used to preserve the fragrances), an exquisite openwork silver container with 'petals' which opened to reveal the names of various perfumes engraved inside, the base of the object 'decorated with a rose'. The auctioneer's assistant duly held the object up in front of the assembled participants and carefully opened each of the 'petals' to display the receptacles where pieces of perfume-soaked cotton would have gone (a truly gorgeous piece of technology to carry around – surely enough to make any modern-day catalogue browser want to travel back in time to open each petal and inhale each individual scent – this one a floral rose, the next warm, musky civet and cinnamon, or the spicy heat of cloves?). Two early seventeenth-century scent

bottles came with the lot. His was the successful bid, for forty pounds (over £3,000 today).

The auctioneer announced the end of proceedings, and the crowd began gathering their hats and coats together and exchanging pleasantries. Successful bidders were instructed to visit the office, settle their accounts and collect their lots, and the rest of the crowd shuffled out, under Sekhmet, and onto New Bond Street again, arranging their hats. Lawrence would return tomorrow for the second day of the Harman Oates sale.

In the back office at the auction house a day or so later a secretary began to type up the list of buyers' names and what they had paid for each lot. It was a snapshot of the sale and gave some sense of the most coveted pieces, allowing anyone reviewing it to infer which items were considered the most interesting and valuable, even if the written description remained coy about provenance.

'Koop' was the name typed onto the buyers' list against the four gold rings set with gems: two with sapphires, one with garnets and one with emeralds. These four rings all ended up in the V&A, so perhaps this was A.J. Koop, of Pembroke College, Cambridge, who was an associate curator at the museum for a time, and a good choice as an agent for them at the sale. The ring set with emeralds, three of them missing, was later described in the V&A catalogue (accession number: M.16.1929) as 'From the Harman Oates Collection' and of 'Historical importance: Similar in date and treatment to the rings in the Cheapside Hoard, Museum of London.'

The V&A was less coy about the provenance of the ring set with seven garnets that Koop bought with 'lot 51'. It was

described in the V&A catalogue when it arrived (accession number M.17-1929) as 'Ex Harman Oates Collection – probably originally from the Cheapside Hoard.' None of these rings have any alternative lines of provenance attached to them. The Hoard had drifted up to the surface again.

It was less clear with other items. The table-cut white sapphire ring 'Koop' bought as 'lot 58' was described in the V&A catalogue (accession number M.19-1929) as 'Found in the City of London, part of the Harman Oates Collection.' In Oates's 1917 catalogue it was described as 'Purchased in Nottingham.' It, too, is strongly suggestive of the Cheapside Hoard and the fact the backstory wasn't straight only made it more likely that it came out of the cellar in 1912.

The name on the buyers' list next to 'lot 56' was 'Brett', that being Colonel Brett, the assistant keeper at the London Museum. He must have considered the ring with a helmeted soldier and acanthus leaves of historical importance and worth securing, as he paid a substantial sum to bring it back to the London Museum. Perhaps he was told to go and get it by others at the Museum, or his father, Lord Esher, who was ill and would die the following year. Either way, he settled the invoice and brought it back to Lancaster House.[2, 3]

'Webster' is listed as the winner of 'lot 63', a sixteenth-century Venetian ring set with sapphires and rubies with a white sapphire in the centre. This 'Webster' paid seven pounds ten shillings, over £500 in today's money, for the piece. Percy Webster, the clockmaker, jeweller and dealer in antiques, was still in business on Great Portland Street 'At the Sign of the Golden Time and Dial', working with his son, Malcolm. Could this Webster be

part of the same family to whom the navvies first brought a few handfuls of treasure in June 1912? Had they got wind of the sale and, knowing the names of Harman Oates and his connection to G.F. Lawrence, come to see what else might be in circulation from the Cheapside Hoard all these years later?

Lawrence's name appeared next to twenty-nine objects on the buyers' list, mainly rings. He had spent over £300 altogether, nearly £25,000 today. Most of his purchases were of objects listed with no provenance, just an approximate date, suggesting a solid confidence in what he was buying.

CHAPTER XVII

The Bank of England

In 1933, Wheeler recruited a 32-year-old Martin Rivington Holmes as a shorthand typist at the Museum. A can-do professional, a kind smile in his eyes behind frameless glasses, always with a jaunty handkerchief in his top pocket, he was promoted quickly through the ranks. His curatorial responsibilities grew numerous and varied: robes of state, arms and armour, the topography of Elizabethan and Stuart London, and he was soon put in charge of developing the costume collection at the Museum. He possessed an encyclopaedic knowledge of the crown jewels and regalia, but his first love was the theatre. He had grown up in Kensington, in an artistic, theatrical environment, the son of the director of the National Portrait Gallery, with a mother who staged plays and operas; he wrote the book for her librettos in his spare time as well as songs. All of it commanded his interest, shared with wondering colleagues 'without ever a hint of superiority and with an endearing blend of enthusiastic delight and sometimes Rabelaisian wit', his former colleague and typographer of London Francis Sheppard recalled. As well as a formidably capable curator, Holmes was a Shakespeare scholar with courtly manners and a part-time historical playwright. He was told with a wink to look out for the ghost of the previous owner of the treasures in the Gold Room or lurking about in the costume gallery.

From behind his desk as the keeper's secretary, Holmes began to hear one particular ex-employee's name invoked more and more frequently in crisis meetings. The question threatening Wheeler's equilibrium was what to do about a certain Mr G.F. Lawrence and his incorrigible law-breaking. He had not gone quietly after all, and was still straying onto other people's turf. Ash and expletives flew within earshot of the Gold Room and its visitors. Holmes caught snippets about his past misdemeanours and continuing exploits, as well as his friendship with Queen Mary.

The archaeological golden age in London was over and very little was coming out of the ground anymore. Wheeler ultimately thought it best to keep Lawrence close, harnessing his undoubted skills, like a tech giant employing a hacker, and appointed him as the London Museum's representative to watch over the excavations for what would become Battersea Power Station. It was a characteristically canny decision. Lawrence took the earliest opportunity to pay him back. He published 'Antiquities from the Middle Thames' in *The Archaeological Journal* in 1930, an account of his finds from a stretch of the river from Hampton Court into London, representing a significant contribution to knowledge at this location (although 'maddeningly imprecise' in places),[1] then harnessed his greater profile to help his old boss organise excavations at Brentford, West London, persuading the *Daily Express*, presumably through his contacts with Morton, to pay for them.

Lawrence maintained a respectable persona, keeping up his correspondence with the British Museum, bringing them antiquities from Iran, and expanding his network overseas,

dealing internationally for some of the world's most prestigious organisations. He was made a life member of the Metropolitan Museum of Art in New York in 1929, an appointment which he put proudly on his business card next to his 'GFLXX' insignia, and became the valuer of Roman and Greek artefacts for Sotheby's. Despite these eminent positions, however, he continued to hustle closer to home, unable to break his old habits. He was regularly placing low-rent advertisements in *The Illustrated Sporting and Dramatic News* and *The Antique Collector* soliciting any old objects to be brought into the shop and offering cash for them. He was still preparing for what was to come, still gathering as much as he could around him in his little shop in Wandsworth. As he checked the classifieds, he could catch up on the next instalment of a serialised short story running that year called 'The Opal Ring' by Rosaline Masson, featuring a stone like the one carved with St George on his ring, possessing 'The fires within – the flash of flame, the changing blues of summer seas, the grass green of leaves with the sun through them, the reds of sunset – all glowing-Alive –.'[2]

He had retreated, but was still defensive of his legacy and reputation. An interview with Dr Wheeler of the London Museum in the *Observer* in June 1930 made him choke on his breakfast and sent him to his desk to fire off a furious letter. In the newspaper's profile, Wheeler declared sweepingly that the time for saving 'bric-a-brac' from building excavations was past. Lawrence registered this reference as a personal attack, and proof that, although he had his uses for the catalogue, he was forever to be patronised and written out of history: 'The old heresy that I was merely a *liaison officer* of the Museum and not

deputy everything creeps out in the "Observer",' he wrote. 'The old envy, hatred & malice against me is an unconscionable long time dying.'[3, 4]

The complaints were still coming in, and, in July 1931, Wheeler confronted Lawrence with the allegation he had been passing himself off as an employee of the Museum, in order to raid an excavation on King William Street in the City: '[Y]ou have greatly disturbed the peace of mind of the Phoenix Insurance Company who have been very excited about your salvage efforts on their site,' he said, 'You seem to have left an impression upon their minds that you were acting as our representative.' Lawrence replied tartly: 'I was quite candid to them and gave them my card (late of the London Museum) and I also sent them two large boxes of Samian fragments, which I really did save out of the rubbish… I at last realise that where there is any risk, the game is not now "worth the candle" as I should not like to be "hauled up" and bothered by a charge of receiving stolen property.' Rounding off his caustic apology he declared, 'Antiquaries often lose the sense of proportion in acquiring things from excavations &…there is, nowadays, a greater risk of trouble, as owners of property at once raise a fuss if anything is published as being found on their site… However, I have refused everything from there since the bother & shall not do so much "scrounging" from London in the future.' He appeared affronted by the ingratitude, but amidst all the huffing and puffing was bafflement at a world fixating over who owned a patch of land and not the wonders that may be buried underneath. Wheeler pushed him for details of the provenance of a mosaic and Lawrence closed down entirely: 'I bought the

mosaic from a Mr. Bell…he was "down on his luck"…*I have no particulars*.' We can hear a metaphorical door slam and probably a few real ones at West Hill too.[5]

In 1934, the Bank of England was about halfway through its twenty-year rebuilding, following the demolition of the original John Soane-designed masterpiece. Lawrence had been able to watch since the mid-1920s as 'The Old Lady of Threadneedle Street' was knocked down, excavated and rebuilt with a steel frame, the vast site slap bang in the heart of the oldest part of the City, taunting him with the hidden treasures behind the hoardings. The Bank owed its nickname to the popularity of a 1797 cartoon by James Gillray, depicting the prime minister, William Pitt the Younger, wooing an old lady representing the Bank of England and wearing a dress made of one-pound and two-pound notes. Gillray has the old lady sitting on a chest of the Bank's gold reserves – the true target of Pitt the Younger's advances, he suggests – lampooning the government's continual begging of loans from the Bank.

By 1934, Sir John Soane's neoclassical facade was all that remained of the 'Old Lady'. Even at the time there were shudders from onlookers at the destruction of the original. The architectural historian Nikolaus Pevsner called it 'the worst individual loss suffered by London architecture in the first half of the twentieth century'.[6] Soane's sumptuous temple of a Bank was not fit for purpose at one-storey and made way for a seven-storey edifice of pale Portland stone. 'Art Moderne', later called art deco, had arrived to guide the architect's vision, with its futuristic, streamlined rectangular forms, demonstrating

confidence in technological progress, rejecting the more organic style of 'Art Nouveau' and William Morris's 'Arts and Crafts' movements, and causing public outcry at the hubristic vandalism. Contemporaneous photographs show a peeled-back landscape of cranes and ladders rising up from the deep to the heights, the excavations at different levels around the site, scaffolding holding things up, and the occasional line of labourers' bags and clothes hanging off the frame, cloakrooms in the void. The steel structure was rising quickly at the intersection of Lothbury, Tivoli Corner and Princes Street, and the dome and lantern of the Sub Treasury nearing completion. On top of the Sub Treasury was a statue of winged Ariel, after Shakespeare's character in *The Tempest*, standing tiptoe on one foot, balancing forward, arms behind as if in flight. The new building was to the design of the architect Herbert Baker, who had worked in India with Sir Edwin Lutyens on the government buildings in New Delhi. He embellished his domineering stone construction with poetic symbolism in choosing Ariel, a figure from the Elizabethan stage, for his 'magic ethereal spirit' and used him, he said, to mirror the 'ethereality of market credit and paper money'.[7]

In 1934, part of the excavation was being overseen by the professional archaeologist G.C. Dunning. On 8 February, J.L. Douthwaite, curator of the Guildhall Museum, reported to the Bank that a Mr L.W. Carpenter of 16 Fish Street had noticed suspicious meetings between workmen and a visitor who looked as though he was trying to purchase items from them. A prime suspect for the would-be poacher sprang instantly to mind: a well-known figure, now a mature gentleman, in

a mackintosh over his three-piece suit, and a trilby partially covering his face.

He had caught the attention of the Bank of England, a far more powerful adversary than his old one, the Guildhall, who had dobbed him in, and together all the interested parties resolved to put a stop to his activities once and for all. It was to be an archaeological intervention for a treasure-hunting addict. Douthwaite, Quintin Waddington his assistant, and a Mr Pillar of Holloway Bros, the Bank's contractors, decided to arrange a stake-out.

A few days later, men installed in Carpenter's office kept watch and observed the comings-and-goings at the site. This was no mean feat, with the vast zone teeming with people and noisy equipment and obscured by dust and debris.

The men on lookout barely had time to make a pot of coffee to see them through the shift before the suspect was spotted. Douthwaite wrote: 'Within a few moments of our arrival a man appeared, whom I recognised as Mr G.F. Lawrence, a dealer in antiquities… He was immediately approached by a workman whom Mr Pillar knew as an employee of the firm. A piece of pottery was produced which Mr Lawrence examined and was about to pay for.' That was when Mr Pillar broke cover and marched down through the building site. Other workmen appeared, one of whom had another vessel to sell. Pillar intervened, stopping the transaction, and informed Lawrence that he was busted, along with the employee from the Bank's contractors holding the piece of pottery behind his back. He obtained the names of several other workmen who were 'obviously there for the purpose of trading with the dealer'.

Armed with witness statements from Mr Pillar, working on behalf of the Bank, Douthwaite hauled Lawrence in to answer for himself. He 'made full admission of his misconduct' at interview.

Given his bitter correspondence with Mortimer Wheeler, the sorry-not-sorry apologies his letters contained, we can assume some petulant backchat and recrimination accompanied this 'full admission'.

The navvies would no doubt have helped him if they could, paying him back for his fairness to them. Nevertheless, this was his professional rock bottom. He faced public humiliation and financial ruination as a man well into his eighth decade. Following the National Insurance Act of 1911, to compel people to make their own provisions, pensions for the over seventies were means-tested so low that to live on one put you beneath Rowntree's 'poverty line'. A successful applicant also had to have worked their 'full potential' with no clear definition of what that meant, so short periods of unemployment could disqualify you.

As the Bank of England organised the paperwork to bring a prosecution against him, Lawrence retreated to West Hill and the shop, with all the Roman lamps and Samian ware jigsaw pieces he was slowly and painstakingly building back into jugs and bowls. He could run, but this time he could not hide with the mummies and the statues and the Tudor shoes and bowls of amulets and beads. He needed the St George opal ring for protection. Would it help him now?

Douthwaite called Lawrence back to his City office. In a shock last-minute reprieve, he had advised the Bank not to prosecute Lawrence: 'Mr Lawrence…is now a pensioned official

of the treasury. He is very well known and, I think, generally respected by many people in high places, and I feel that every effort should be made to save him from disgrace. If the prosecution failed, his enmity would be active for the rest of his life, and I suggest it is better to earn his gratitude by saving him from the consequences of his fault than to take steps to punish him, which might possibly fail.' He had promised if pardoned 'never in any way to transgress again', and on 19 February 1934 he returned over one hundred objects, mainly Roman. The Bank decided not to prosecute but did not, however, agree to reimburse Lawrence twelve pounds and ten shillings for the time and money he had spent cleaning the finds.[8]

That he had the brazen cheek to ask for expenses to be paid for washing the items he had stolen suggests Lawrence had considerable influence and he knew it. The City did not want to make an enemy of Lawrence. He was a man who could hold a grudge, with contacts in the press and many friends 'in high places' that had clearly made Douthwaite and officials at the Bank of England nervous. A certain contact sat in one of the highest places in the world.

According to the Bank of England resumé of the incident: 'Mr Douthwaite even mentioned that the queen might object if strong action were taken against Mr. Lawrence.'[9]

The report suggested Queen Mary had kept a close eye on his well-being all these years since the war, or even that Lawrence had manged somehow to get word to Queen Mary that he was in trouble and she had responded and come to his rescue.

If Queen Mary really did have a hand in sparing him a public shaming, the question is why. Was it simply that she understood

Lawrence, and shared his drive to acquire objects to surround himself with, as insurance for the future? He had helped her gain access to the Hoard. She repaid the debt.

And Lawrence remained an astonishingly accomplished dealer, despite all the conflict. His most significant contribution to the British Museum's Roman collection came in 1934 when he sold 100 objects from the bottom of the Walbrook river found 'during recent years' including wooden writing tablets, one inscribed in Latin with the words 'Issued by the Imperial Procurators of the Province of Britain',[10] to add to the helmet cheek-piece from the Thames and the marble grave slab with a Greek inscription 'from Lambs Conduit Street' just North of the City.[11]

His Brothers in the Freemasons may have had something to do with it, too. Men in the construction industry were, of course, the core of the brotherhood, and Lawrence's allegiance was clear for all to see on his shop card, his initials incorporated with the XX in a shield, a variation on the square and compass. Builders still needed these tools in the 1930s, for straight-edge corners, and compass-drawn arch constructions, but construction materials and accompanying techniques had changed radically since the navvies overhauled Wakefield House and found treasure as they worked by hand in the brick cellar. Now reinforced concrete, and steel frames, both mass-produced in prefabricated pieces off site, required labourers on site for assembly, speeding up construction, and giving buildings extra curves and new heights, the foundations dug by mechanical excavators, ripping down through who-knows-what as they descended deep through the clay.

CHAPTER XVIII

Stage and Screen

In 1937, a packet of Churchman's cigarettes on sale at the tobacconists next to Lawrence's shop contained cards from a 'Treasure Trove' series. Cigarette cards, designed to collect and swap, ubiquitous since the end of the nineteenth century, offered charming, colour-tipped illustrations on a theme: 'Castles and Abbeys', 'Ships and Sailors', 'Cricketers' and 'Film Stars', with rosebud lips and flashing starlet's eyes. These cards disappeared during the Second World War, to save on paper, never to recover, but 1937 was the zenith for the pastime, and card number eight of fifty in the series was 'The Cheapside Hoard'. On the front of the card were hand-coloured illustrations of three of the showstoppers from the collection – a bright purple amethyst 'grape' pendant, a white enamelled pomander or scent bottle, pocked with scarlet rubies, and blinking with topazes and diamonds, and a vivid green watch, the body crafted from a single hexagonal emerald, the three gaudy images popping against a yellow background. A member of the public who turned the card over could read the copy on the back which described them as 'three of the most interesting articles now in the London Museum' and offered a potted history of the find, talking of 'a few Roman and Egyptian pieces' and stating that 'the average date of the collection was around 1600' and that it

probably belonged to an 'Elizabethan Jeweller'. The image of this jeweller had taken up residence in the public imagination.

Thousands took a trip to Mortimer Wheeler's shipshape London Museum in St James's to see the wonders of the Cheapside Hoard, of cigarette card fame, up close, pushing through the turnstile and purchasing, for a shilling, the little cream catalogue he had put together with G.F. Lawrence, and using it as a reference for their visit. Some will have looked for exhibit 'X5', an opal ring. It's not clear if they would have been able to see it lit up in the display case at any point during the 1930s or if queries would have been met with the information that it was being cared for off site.

George Fabian Lawrence was keeping a low profile following his narrow escape. Had he picked up cigarette card number eight from Churchman's 'Treasure Trove' series, left behind on a waiting room table or on a tram or bus, he would not have found himself namechecked. The only mention of a finder was 'a workman digging on the site'.

He knew more about one particular object from the Hoard than anyone, its whereabouts for a start, and he kept it close as he went about his daily work in the shop, or talking things over with May and Flo upstairs. He needed the St George opal ring for something.

It was around this time Queen Mary befriended Martin Rivington Holmes, Mortimer Wheeler's witty and erudite assistant. She was still a patron at the Museum and, in Lawrence's absence, had soon adopted him as her new man there and found his love of theatre, as well as his enthusiasm for the trappings of royalty, a much-needed respite from the crises gripping her family.

She needed diversion in the mid-1930s. King George V died of lung cancer on 29 January 1936, and her eldest son, Edward VIII, ascended the throne and then, in just less than a year, abdicated to marry a divorcee, Mrs Simpson. Queen Mary soldiered on, indulging in her 'one great hobby' and looking for distraction at the V&A, and in the Gold Room at Lancaster House, where the Cheapside Hoard dazzled the public, who were unaware the exhibit was missing some strands of chain, or that she was looking after them.

Like his predecessor, Martin Holmes lived in the past, but his was a theatrical past. The Costume Gallery, with headless gallants sporting Seymour Lucas's get-ups from across the centuries, was no moth-eaten space to him, rather a playroom of form and fashion, a world of wonderful make-believe.

The two forged a natural acquaintance. He was a perfect companion for the dowager queen down on her luck, a quick learner and now an 'expert in the niceties of courtly conduct' as a close acquaintance observed, and he was complimentary about her intelligence and memory: 'She doesn't suppose, she knows', he said.[1]

He penned historical dramas on the side and had authored a play about Queen Elizabeth I and the Earl of Essex, *When Essex Died*, with the '1930 Players on Sunday' performing a spin-off called simply *Essex*, at the Wyndham's Theatre in 1932. The play featured an ageing Queen Elizabeth and her favourite courtier, Robert Devereux, the Earl of Essex, who had just returned from Ireland, and was raising an army to usurp Elizabeth's throne. The pair had been confidantes for years, enjoying all sorts of entertainments together, dancing and playing cards

while he was 'Master of the Horse', a role that sounds like an honorary and rather jolly role, but actually put him in charge of all the queen's transportation needs, the job from hell, of mind-scramblingly complex logistics, back-to-back national and international conferences including her annual 'progress' around the realm, and the training and equipping of her many magnificent steeds. She had given Essex a gold ring after the expedition to Cádiz, set with a cameo portrait of the queen, that he should send to her if ever he was in trouble, with blue enamelled flowers on the back, carrying with it the implied motto, 'forget-me-not'. The relationship broke down entirely after his attempt to overthrow her and her government. Awaiting execution, in a desperate attempt to save himself he smuggled the ring out of the Tower of London to ask her for help. The Countess of Nottingham received it, but at the instigation of Essex's enemies, kept it to herself, and the queen never got the message. Essex was executed and, when the queen eventually learned of his plea, she flew into a frenzy, shaking the countess violently by the shoulders, utterly distraught.

Various exquisite cameos of Elizabeth I lay in the display case in the Gold Room which Mary could ask her friend the curator to make available to her if she wished and compare. The long, enamelled chains and their intricately pretty designs were also on display. Memories of George Fabian Lawrence were there too, of their tours, and the rumours that she had stepped in to save Lawrence when he faced prosecution and public disgrace.

Holmes was an enthusiastic expert in all things Elizabethan, whether that was the Elizabethans themselves or Edwardian versions of the kings and queens and courtiers of Shakespeare's

day on the stage, and he loved operettas. He was, at a leisurely pace, becoming her confidant. Her 'walker'. She visited the London Museum regularly and he escorted her to the theatre, in her most sombre clothes. There was plenty for the pair of them to see on the London stage. The auditoria were alive with historical plays, and all eyes were on the Old Vic and the multitude of West End theatres, where some of the most acclaimed actors and actresses of the century were bringing them to life. John Gielgud dominated in the history plays and his *Hamlet* was revived on stage five times in a performance that defined the role for a generation. Holmes was on hand to entertain her at the interval as a prodigious quoter of The Bard.

Often to be glimpsed in the audience during these years, in a red-velvet, flip-down seat in the shadows further back in the auditorium, was George Fabian Lawrence, the ghost of Hamlet's father reflected in his spectacles. Next to him would usually be his loyal and long-suffering wife, Florence, although Lawrence's granddaughter Gweneth remembered how Flo hated going to see plays with him because he was always critical of the endless parades of historically inaccurate costumes. Laurence Olivier was there to be studied closely for accuracy as he gave his Romeo, opposite Peggy Ashcroft at the New Theatre in 1935, swapping roles with Gielgud, who was playing Mercutio, after the first six weeks.

We can only imagine what Lawrence made of the more modern takes on the Tudor era on the London stage. At the Queen's Theatre in 1932, John Gielgud played Richard II in *Richard of Bordeaux*, written by Elizabeth Macintosh under the pseudonym 'Gordon Daviot', a retelling of Shakespeare's

play with the medieval characters speaking modern English. In this version, Richard's relationship with his wife, Anne of Bohemia, took centre stage and Richard was portrayed as a gentle character in a brutal environment, a man struggling for peace. The public loved it, although we can picture an elderly Lawrence groaning with exasperation at every anachronism and his wife whispering curtly to him to be quiet and try to enjoy the performance.

In 1937, Gielgud played Shakespeare's version of *Richard II*, a man who believed in the divine right of kings to rule:

> The purest treasure mortal times afford
> Is spotless reputation; that away,
> Men are but gilded loam or painted clay.
> A jewel in a ten-times barr'd-up chest
> Is a bold spirit in a loyal breast.

These words from the king would have spoken to Lawrence, now in his mid-seventies, across the footlights of what he had made of the opportunity presented to him in June 1912. 'I'll give my jewels for a set of beads,' Richard says.

Martin Rivington Holmes assisted with the costumes for the Lyric Hammersmith production of *Richard II* in 1936, providing historical outfits for the creatives to copy. He managed to persuade the dowager queen to attend performances of his own plays at theatre clubs, recalling with pride when words he had written caused a tear to drop from Queen Mary's eye, and borrowing lines from the garden scene in *Richard II* to describe the sublime sensation and satisfaction: 'Here did she fall a tear;

here in this place / I'll set a bank of rue, sour herb of / grace.' He didn't shy away from putting kings and queens on stage in the most poignant theatrical scenarios.

In 1936, shortly after becoming a dowager, Queen Mary returned some loose strands of enamelled gold chain to the V&A. She left no explanation for the record. Neither did she attempt to explain why the strands were broken when she gave them back; whether they had always been loose or whether the links had snapped, either in her care, or back in the 1600s, which would explain why they were at the jeweller's getting fixed before they were buried. The spare description of one of the exhibits read: 'part of this chain was presented to Viscount Esher as a gift'. They were given an accession number with the Hoard signature, A14073, stating that chains 'A–D' had been 'reattached'. Perhaps the shadow of a displaced childhood had lifted a little, and, with it, her need to keep close hold of ancient things. Perhaps she decided to give them to Esher on a whim and a 'permanent loan' was such a standard arrangement it was not worth mentioning. She did not always feel the need to make a clear distinction in the records between official gifts, held for the nation, and her own private collection. Even the very richest, the ones who didn't need the money, went a little misty-eyed with the gems and jewels from Cheapside.

Another popular fixture back on the London stage was *Merrie England*, currently running at the Princes Theatre and guaranteed to cheer a person up. The long-running hit by Edward German, with a libretto by Basil Hood, set those well-trodden love rivalries at the court of Elizabeth I to music. Endlessly revived since its premiere at the beginning of the century, it was

already a cultural reference point for Martin Rivington Holmes when he wrote his own play about Queen Elizabeth I and Essex. The costumes were just as heavy and bejewelled as they had been before the war, in an 'authentic' Elizabethan style, with rings set with bright gems on every finger, and carcanets strung in the hair; sparkly bodices and doublets, feathered hats and boastful hands-on-hips. Its players tell a Tudor story, packed with nods to the plays of Shakespeare, and the action is jollied along with a lively chorus, ballad songs, duets and romantic arias. Leading the cast in the singing and dancing is 'Walter Wilkins', a travelling member of Shakespeare's company of actors. Sir Walter Raleigh sets the action in motion by sending a love letter to Queen Elizabeth's lady-in-waiting, Bessie Throckmorton, a letter which ends up in the queen's hands, who has set her cap at Raleigh and is jealous of his attention to another woman. The ambitious Earl of Essex decides to capitalise on Raleigh's predicament and reveals the affair, to the queen's predictable distress. Meanwhile 'Walter Wilkins' has been working hard on a stage version of the legend of St George and the Dragon, to perform in front of Elizabeth and Essex. He conspires to trick the queen into changing her mind and sparing Raleigh by having another player dress up as 'Herne the Hunter' and appear in front of her during the show. Herne is the legendary ghost of a keeper-turned-poacher haunting Windsor Great Park, said to appear when a monarch contemplates committing a crime. He is the wild huntsman from the myth, excessively fond of the chase, now doomed to be on the hunt forever, riding his horse through dark and stormy nights with a stag's antlers on his head, troubling cattle and rattling chains. Herne appears,

on cue, during the show and everyone but the queen denies seeing the apparition. The trick has worked, and the chastened queen forgives Bessie and Raleigh and deigns to love Essex instead. There's a good dose of pageantry and jig as well as lots of historical inaccuracies. At the end they all take part in a reconstruction of Robin Hood's wedding to Maid Marion.[2]

The dark auditorium of a theatre in the 1930s was a good place to take one's mind off the cares of today and enjoy a gentle walk down memory lane. Cynthia Colville, Mary's long-serving lady-in-waiting, intimated that the real love of Queen Mary's life had been the seventh Earl of Hopetoun, John Hope, who had died quite suddenly in 1908 of pernicious anaemia aged forty-seven, rather than either of the two British royal brothers she was matched up with. (She was betrothed first to George's elder brother, Albert, Duke of Clarence, who died suddenly of pneumonia after influenza, at the age of twenty-eight.)

The Tecks had stayed several times with the Hopes when Mary was a teenager; and he clearly made an impression strong enough that Hope's sisters noticed the princess set her girlish cap at him. Later Queen Victoria appointed Hope the first Governor General of Australia, and there is a photograph in Mary's own collection of her visit to Melbourne in 1901, by which point she was a married woman and Duchess of Cambridge, on the royal tour of the British Empire. Mary and George are standing outside Government House, next to Hope and his wife, the Hon. Alice 'Hersey' Everleigh de Moleyne, a viscount's daughter and his childhood friend. The men wear bicorn naval hats. Hersey, like Mary, is in a high-necked corseted gown sporting a fancy feathered hat and sash and trying very hard to look relaxed

and dignified for the camera but her face screams *awkward*, in contrast to Mary's confident, level stare.

As Governor General in Melbourne, Hope had a reputation for ostentation and overdoing it with the pomp and ceremony in what was a delicate political situation. When Hope asked for astronomical expenses to pay for it all, and the request was refused, he resigned his governorship and quit Australia.

Mary and George had six children in their by-all-accounts happy marriage, and if she ever recalled a young crush on Hope it was in the context of a grand and enduring loyalty to the king.

They all loved operettas and *The Two Bouquets* by Eleanor and Herbert Farjeon was on at the Ambassadors, about two lovers whose lives become frightfully complicated when bunches of flowers are delivered to the wrong women.

Lawrence and Flo had plenty of opportunities to run into Martin Rivington Holmes at performances like these, and perhaps on rare occasions to see the dowager queen in the royal box, the ebullient and charming Holmes at her side. It's easier to imagine the Lawrences scurrying out to the tram through the foyer than it is to picture them asking to be introduced to the queen, and her friend, the Shakespeare scholar with a quotation for any occasion or mood.

In December 1937, the queen took an eleven-year-old Princess Elizabeth to the Holborn Empire to see *Where the Rainbow Ends*, a Christmas staple, now loved by several generations, and direct rival to *Peter Pan* as the family treat of the season. The public joined the royals in their enthusiasm to watch and re-watch the story of four children and a pet lion cub on a quest to reunite with their parents, who are waiting for them in a

land at the end of the rainbow. Anticipation built to the moment in the play when the child protagonists, Rosamond and Crispian, were offered wishes by the genie but summoned St George, by way of a travel insurance policy. Audiences swooned at a heroic matinee idol as he descended, the latest of a succession over the years cast in the role, now with glossy, rippled hair and a smirk, sword brandished, glinting breast plates, and a cross-emblazoned white cape tied around his neck and flowing behind.

There was great entertainment value in *Where the Rainbow Ends* and *Merrie England* and another strong draught of nostalgia for many. The tableau of the 'Masque of the Legend of St George', and the heroic figure arriving in a thrilling flash of stage lightning to take his sword to the Dragon Army, burned into the imaginations of rows and rows of children seeing it for the first time, as it had their parents'. Lawrence didn't need reminding. He lived in the past, and more chivalrous ages mapped onto the pavements before him as he walked along them, with a certain object on his mind, or maybe even heavy on his finger. He wanted it for something important.

Holmes was still finding anomalies in the London Museum's most celebrated collection of treasures. A black-and-white onyx intaglio in the Gold Room showcase had drawn his attention, engraved with St George and the Dragon on one side and a female saint kneeling in the wilderness on the other, labelled 'A14262'. It was not of particular interest except that it brought to mind another St George ring. Being well acquainted with Wheeler's 1928 catalogue, but browsing it for the umpteenth time, he found the two illustrations again, featured on a couple of the pages that had escaped his close attention before; a man's

finger ring with a large oblong opal, and the accession number 'X5'. The label caught his eye because it was not in keeping with the accession numbers for the rest of the Cheapside Hoard which started 'A142...' The most likely explanation for this, he imagined, was that the ring had been separated from the other pieces in the London Museum and not been part of the original consignment. The parts of the Hoard that went to the V&A, the British Museum or the Guildhall were all itemised in the appendix at the end of Wheeler's booklet. Turning to the back he could confirm the opal and its St George was not listed there. None of the staff seemed to recall seeing it recently, even though it had been a star of the show in 1914 and had evidently been back in the building to be photographed and drawn for Wheeler's catalogue in 1928.

Martin Rivington Holmes was temporarily diverted from his responsibilities over the Cheapside Hoard to prepare the royal robes of state for the coronation of George VI. Lawrence too was pulled away from private business to advise the avant-garde new medium of television on historically accurate costume for new plays, when they were first broadcast from Alexandra Palace. Beginning an extended sabbatical from collecting, he entered a new faster-paced world filled with technical camera equipment, lights and cables and uncensored words from harassed production staff, working tight deadlines, an entirely different ambience from the muted rooms of Lancaster House and the showcases whose contents seemed to lie beyond constraints of time.

He was something of an anachronism about the place, still wearing the same style of clothes he favoured in 1912, though his expertise was no less in demand. On 7 December 1936, the

twelfth-century garb of the clerics, knights and kings in *Murder in the Cathedral* was by Lawrence's design, transmitted live by television from a tiny studio, with a cast of just five who had only a few costumes and props to work with. He also put his stamp on the eighteenth-century tricorn hats, wigs, britches, coats and epaulettes for the television play of *Clive of India*, broadcast on 9 February 1938, telling the story of Major General Robert Clive and his role in establishing the rule of the East India Company in Bengal, the transfer of the region's wealth to Britain, and the subsequent rule of the British Raj. He gave an expert steer on what civilians would have been wearing in 1908 for *When We Were Married* by J.B. Priestley, which came live from the St Martin's Theatre on 16 November 1938, featuring three couples from the north of England about to celebrate their silver wedding anniversaries who discover they were never legally married.

G.F. Lawrence even had his own show, briefly, in 1937, delivering a series of ten-minute radio talks for the BBC entitled *Underneath London*; he was listed in the *Radio Times* 'programme' as the 'well known antiquary'. The talks were live, and no recordings made, but men of his generation with an East End background had a precise, polite formality of expression and manners in public, with a neutral, very slightly nasal, accent, rather than the clichéd cockney twang. Thanks to his contacts in the media, the man who brought the world the Elizabethan Jewels could wax lyrical on the crackling wireless about other mysterious objects trapped in the substrata.[3]

But by 1939 he was back at the shop, and the flat above, making final preparations on private business. The songs from the comic opera *Merrie England* were so popular by the 1930s that

Columbia released a 78-rpm recording so the public could listen to the ballads and duets at home. But May's niece, Gweneth, remembered George at the piano in the flat playing a musical number from another popular entertainment: 'Indian Love Call', the hit song from the American musical film *Rose Marie* starring Jeanette Macdonald and Nelson Eddy, adapted from a twenties Broadway musical. This was a romantic western, set in the Canadian wilderness and a box office smash. It had started life as a stage operetta, and the refrain, which returned many times during the film, was a soaring romantic duet; a call and response between the two love interests, an opera singer looking for her jailbird brother, on the run in the wilderness, and a Canadian sergeant she meets there. The pair are alone by a lakeside campfire when the local sergeant, played by Eddy, tells out-of-towner Rose Marie about an aboriginal Canadian legend. A long time ago, lovers from different tribes – a Romeo and Juliet style situation – were sentenced to die, but their spirits lived on. To this day, the courting sergeant says, if a man calls down into the valley to the girl he wants to marry, the spirits will echo the call until it reaches the woman he loves. They continue back and forth until, playing the title role in *Tosca*, she hears the Indian Love Call refrain and faints clean away with the emotion. It's touching to think of Lawrence belting out the tenor part of Nelson Eddy: the melodramatic crooning required, the sense of romantic longing common to the hits of the day. Who took Macdonald's part? Did he duet with Flo? Or May? According to her great nephew, May's 'spirit guide' during the séances she presided over was a 'red Indian' – Native American – a people associated by the movement with spiritual purity, and believed

to help white Spiritualist mediums navigate the other world just as they had supposedly helped settlers navigate the New World.

With or without the help of the song, May summoned Charles Hardy, an 'Assistant Hairdresser' from Wimbledon, as he was recorded at the end of the thirties in the census. Perhaps he came into the family circle after offering his haircutting services to one of the Lawrence family. He started to pay her regular house calls. May's niece remembered him as having been very kind to May, and to the rest of the family. And then May married Charles. The 1939 records show the couple living in Wimbledon together. She was never cured of the affliction that prevented her walking unaided, but she did get to leave the flat above the shop and establish a small household of her own. After her years largely confined to the upstairs at 7 West Hill, she deserved a wedding like Robin Hood and Maid Marion's at the end of *Merrie England* with dancing and song, but it will have been a very simple affair.

Her father's thoughts returned to St George.

CHAPTER XIX

What We Leave Behind

On 16 February 1939 'Stony Jack' died at home of heart failure, aged seventy-seven, spared the bitter sorrow of watching London ravaged by the Blitz. Although he'd never been in what anyone would call rude health, because of his lungs, the end was unexpected. Despite Lawrence's fame, the family had never moved from the cramped flat above the shop. His only travel was in his imagination, and endless wandering through the underground world of London, of course. He left just over £1,000 to his wife in his will; not nothing, but not a thief's fortune.

George Fabian Lawrence's funeral was held at Putney Vale cemetery, between Richmond Park and Wimbledon Common, a couple of miles from the shop at West Hill. The large number of wreaths brought to the funeral – thirty-three in all – came from friends and family, including someone who signed themself 'Braveheart'. Was this 'Braveheart' tribute, presumably referring to William Wallace or Robert the Bruce, also known by that name, from Queen Mary? Or perhaps it was a compliment from the Scotsman Arthur Conan Doyle?

Florence was there as the chief mourner, receiving condolences, with May, now fifty-three, and her husband Charles Hardy, who was helping to get them both to the cemetery and

home again to Wimbledon, where the three now lived together, Florence finally having been persuaded to abandon the shop. 'No one can carry on the business because my brother was a specialist,' Miss Lawrence, one of his two sisters, told a reporter. 'We have kept the shop open for the time being and many of his old friends have called to buy little keepsakes.'[1] Rose Elsie Lawrence was helping host the event, with her children Geoffrey, Gweneth and Edgar.

Rose's husband, Frederick Lawrence, was not among the mourners on that cold day in suburban South London. Records show he was 'incapacitated' in Napsbury hospital, near St Albans. The census has Rose Elsie occupied with 'unpaid domestic duties', and indicates she would have been returning home to Muswell Hill after the service with her two younger children, Gweneth, now twenty-seven, working as a typist and Edgar, twenty-five, a bookkeeper, pedalling together to keep the household afloat. The eldest, Geoffrey, was unmarried, working as a 'solicitor's cashier book keeper and trust accountant' and living at the Woolpack Inn, in Chiltern Candover, Buckinghamshire.

Among the other friends, family and ex-colleagues who came to the cemetery were representatives from Sotheby's and the British Museum, and a 'Mrs Wheeler', probably Mortimer Wheeler's second wife, Mavis de Vere Cole (Tessa Verney Wheeler had died, in her early forties, in 1936). Mavis, his new bride, a famous platinum-blonde beauty with an extraordinary provenance, would have been quite an attraction at Lawrence's otherwise rather staid and stuffy funeral.

De Vere Cole had started out in London as a scullery maid and advanced to the position of long-term muse, and mistress,

of the painter Augustus John, who was leading the artistic *avant-garde* (and a magnificently Bohemian lifestyle) at the time. She was also the ex-wife of Horace de Vere Cole. Horace had been invalided out of his army career and, with time and an inherited fortune to waste, became famous for staggeringly audacious pranks, often involving other Bloomsbury-ites. Most notoriously he had dressed up himself and his friends, including Virginia Woolf, as the Abyssinian royal family, to prank the commander-in-chief of the navy's home fleet into giving them an honour guard tour of the flagship, HMS *Dreadnought*. Wheeler would soon divorce Mavis on the grounds of her adultery with Lord Vivian, a theatre producer, whom she shot in the abdomen in a jealous rage in 1954, going to prison for six months for the crime. It was entirely fitting that she was there, turning heads over the tea and sandwiches; a disruptive force at the funeral of a man who hid such surprising dimensions beneath an otherwise conventional exterior.[2, 3]

To remember Lawrence, outwardly a humble, hardworking shopkeeper and conscientious museum employee, in a blue serge three-piece suit and spectacles, was to consider the possibility that hidden drivers operated beneath the tidy, oiled and genial exterior of many an 'ordinary man' of the late-Edwardian era. Lawrence had kept his true loyalties close to his chest, but his relentless treasure-hunting suggested a man preparing for something like his life depended on it, anticipating what was to come.

A local newspaper reported, 'His wife, a daughter, and two sisters survive him.' It may have been an oversight, but Frederick, his son, who also survived him, was expunged from the records.

George Fabian Lawrence was laid to rest there, at Putney Vale, in an unmarked grave, number 726, block X. Whether this lack of a marker was a result of financial constraints, or by design, is unclear. There was much to contend with, as well as a war.

Frederick Lawrence died in Napsbury hospital on 7 February 1943. His cause of death was recorded as 'bronchopneumonia and myocardial degeneration', but Napsbury hospital was a hospital for mentally ill patients. Florence Emily died the same year, near where she grew up in Camberwell, aged eighty-five.

George Fabian Lawrence's reputation was salvaged in the press thanks to a word or two from the London Museum's biggest names, conceding that countless objects now in the British Museum, the Guildhall and the London museums would have been either broken or lost without him. 'It is London's good fortune that one man should have devoted his life' to the preservation of London's material history. Mortimer Wheeler concluded that: '[N]ot a tithe of the objects…would have been saved for knowledge. If a remote landowner may in the process theoretically have lost some trifle that was his just due, a higher justice may reasonably recognise that, the important prehistoric, Roman, Saxon and medieval collections…are largely founded upon this work of skilful salvage.' H.V. Morton, by now Britain's premier travel writer, improved Wheeler's backhanded compliment: 'Some day it will be realised that "Stony Jack" has done more solid work for the preservation of London's antiquities than any living man. Many people have written books about ancient London, but he has actually produced the antiquities and put them under glass, the property of the

public forever.' He was the right man in the right place to save London's heritage.[4, 5]

Living to serve the institutions he worked for, he spent a lifetime filling them with magnificent objects. There were 300 objects catalogued under his name at the British Museum, including an ancient Ocean God, a cornerstone of the Roman collection, and a curse tablet; and 1,200 at the Museum of London. He saved a staggering 15,000 objects for the nation, all told, and there was no evidence the buyers paid over the odds. Lawrence's real claim to fame, of course, and his enduring legacy, was an intimate connection to one of the century's greatest archaeological *coups de théâtre*: the 'Cheapside Hoard'.

On 23 May, three months after Lawrence's death, and the week before the auction of his shop's contents, a sleek, black Daimler crashed into a lorry carrying steel piping at the intersection of Wimbledon Park Road and West Hill Road in Putney, a few hundred yards from 7 West Hill, and turned over on its side. In the back seat was the Dowager Queen Mary, and she was helped from the overturned vehicle by a painter who happened to be working nearby, who propped his ladder against the car to allow her to scramble free. The *Sphere* carried photos of the overturned vehicle, as well as of the queen as she was later driven away from the scene. She was escorted to a nearby house to rest while another car arrived to take her home.

Just days from her seventy-second birthday, the queen had been returning from a solo visit to the gardens at RHS Wisley, while her son, King George VI, was in Canada with Princess Elizabeth, trying to establish lines of assistance should war

come. She had been very close to Lawrence's shop at the time of the accident. Had she wanted to have a look at what was left in there, before it was removed and auctioned? Was she looking for something in particular? Perhaps she simply wanted to look into the window at the wonders stacked inside and admire the Ka sign above the door before it was unscrewed and taken down, imagining the arrival of navvies with their bundles of treasure back in 1912.

The medical bulletin issued after she returned to Marlborough House reported Her Majesty 'suffering from bruising and shock as the result of an accident this afternoon in which Her Majesty's car was overturned'. It reassured the population with the news that 'Though the bruising is considerable, and will need some days' complete rest, Her Majesty's condition is this evening satisfactory.'

The *Aberdeen Evening Express* carried the queen's own, rather drier response to the incident, and the offers of assistance, as reported by several concerned bystanders: 'I am going to have a cup of tea and that is all I want.'

But it wasn't all she wanted. She could not stop acquiring, hunting down objects, like Lawrence, the man she had not forgotten. Queen Mary certainly didn't need the money, but hoarding insulated her from the world and its dangers, just as it did G.F. Lawrence.

Lawrence had spent his life trying to communicate with people through the objects they had left behind, and the auction of his shop's contents allowed those coming after him to return the favour.

The auction of Stony Jack's worldly goods commenced on Thursday 1 June 1939, at one o'clock sharp. Part of the west gallery at Sotheby's on New Bond Street had been turned into an 'old curiosity shop' for the sale of his possessions, organised by his family; his grieving widow Florence Emily, his daughter Ethel May, and his sisters, who were unsure what else to do with it all, given that none of them was an expert. They kept themselves scarce for the sale itself.

That first day of June was a sunny twenty-one degrees, much like it had been on 18 June 1912, after an unusually hot week – the day before the mercury had hit thirty on the thermometer in London, but despite the light summer clothes, the talk was heavy with war, which was exactly three months off, to the day.

Those who had heard the news through the grapevine came fresh to the auction that day under the black stone bust of Sekhmet. An auction is where something private becomes public and, in that sense, to walk in was like attending the unearthing of buried treasure.

Lawrence's last collection was laid out in the gallery, just as it had been in his famous shop near Wandsworth High Street, an amusing reconstruction for the public, absurdly incongruous in this grand building, but touching nevertheless: hatboxes, and a hundred or so shoeboxes, full of excavated bric-a-brac on tables (and a lot more under tables), the overspill stacked on the floor. This was the stock-in-trade of George Fabian Lawrence, antiquarian, and the finder and preserver-for-the-nation of the Cheapside Hoard, the largest collection of Tudor and Stuart jewellery ever found.[6]

A Sotheby's sale catalogue in cream paper was available to attendees at the door for a shilling and, armed also with their bidding numbers, they began skimming through it as they walked through to the saleroom: *Catalogue of Egyptian, Greek and Roman Antiquities etc. comprising the property of Mr. G. F. Lawrence, 7 West Hill, Wandsworth.*

There were ninety-eight lots altogether, each containing between half a dozen and a hundred objects, from a two-foot-high pottery jar to a half-inch scrap of bronze labelled, plainly, 'Foot of a Hawk'. In one box Ancient Egypt, Queen Anne and classical Greece and Rome lay all jumbled together, like the historic silt in the windows at West Hill. Most of the articles still carried the price ticket, in Lawrence's elegant, blue-inked handwriting, just as he had attached it. A beautiful little Roman lamp in red ware, one of 130 in three lots, was marked 1s 6d. 'Seven-and-six would seem to have been Stony Jack's favourite figure after two-and-six', one of the journalists who had come to preview dryly observed. He had never been very interested in accurate pricing. Vases large and small, Greek and Roman, were also marked at these prices, as were ancient snake rings, assorted amulets, gods and goddesses from tombs, and strings of beads in peacock blue and golden yellow, undimmed by the centuries. If held very close there was still a hint of cheroot on some of them; the noxious trades of Wandsworth too, and the dust of ancient plaster and cobwebbed linen. There was no sign of the Ka that had hung for so many decades above the shop's door, but presumably it had been removed along with everything else. It was an eccentric display, for such a distinguished West End

auction house, bordering on dilapidated, but Lawrence had been providing in-house valuations for them for years, as a sideline, and they had made an exception for him.

Since the last war, a team of specialists at Sotheby's had become so good at arranging swift and efficient on-site sales of country house collections, as they were broken up, they were known as the 'the Flying Squad'. For the regular sales the crowds were smaller and more subdued than they once had been, especially for the kinds of Egyptiana furnishing Lawrence's table. The directors were keeping a low profile today, or they were distracted, off-site, overseeing another flash sale in the country. But those in the know, arriving with a catalogue tucked under their arm, would have been pleased to see the sale not attracting too much attention and competition.

The room was slowly filling up, brogues tapping on the tiles, dewy brows despite summer suits, a few women in tea dresses, their hair set in ripples under jaunty summer hats, the odd slash of red lipstick, catalogues fluttering as makeshift fans.

Were they looking for anything in particular? It was a chance to pick something up while most people were looking the other way. Busy preparing for what looked now like another war, many had forgotten the story that was on everyone's lips in the 1910s. It had been ten years since the sale of Harman Oates's ancient finger ring collection echoed in the same room. Some here had already slipped in on one of the preview days to pick through the boxes. Some of his close associates had visited his shop to take sentimental keepsakes, likely including the Ka shop sign, since there was no mention of it here, and wanted to see what else was left. People who knew about these things,

who knew what George Fabian Lawrence had collected, about his close association with the Cheapside Hoard, and had ever wondered what he may have kept, will have hoped there would be treasures among the junk; treasures that would go cheap, without a fight, especially with everyone so distracted with scoping out their cellars, or enjoying the sunshine while they still could. Cellars were experiencing something of a revival in 1939, back in fashion, with another war looming. H.V. Morton remembered how people would 'show you theirs' in 1939 and how even a visit to his tailor had resulted in a tour of the man's basement. For some, memories of what had come out of the cellar in Wakefield House flooded back.

Some of the dealers, some old faces, and others with intelligence from the street, were asking themselves if any orphans from the Cheapside Hoard languished inside these boxes.[7]

The participants watched the porters convey the lots from the gallery to the saleroom in their derelict packaging. Eyes flicked to the door and around to see who was joining the sale at the back or standing discreetly at the side. Reassembled next to the auctioneer at the front of the saleroom, the boxes and their contents, Lawrence's stock-in-trade, were a pleasing reflection of the objects the navvies dug out of the cellar a quarter century before, and Lawrence's hoard posed many of the same questions. Why were these items in particular left behind? Where had they come from? What had he, the owner, intended for them, and urgently, who would he want to have them now? There was also the question of how valuable they were, and whether there was more still to be found. His death had been sudden, but while he may not have had long to arrange his affairs in the traditional

sense, his stockpiling had been single-minded and intentional and it was for others to ask the questions, as he had done of the objects he'd dealt in.

Who were the people at the sale, waiting to bid? The American collectors and philanthropists Ada Small Moore or William Gedney Beatty? Or Dolman of Hendon, London, who was actively assembling a fine collection of Egyptian antiquities. Hugh Fawcett, a GP and antiquarian who frequented the salerooms at the time, or Edward Hildyard, the archaeologist and collector with a growing stash of antiquities?

Were Mortimer Wheeler or Martin Rivington Holmes among the men with upturned collars and downturned trilbies scrutinising the catalogue, or had they sent an agent to bid for the London Museum? Were any of the people in the saleroom the same as those at the 1929 auction of Harman Oates's collection? And was anyone yet looking for the opal cameo ring depicting George on horseback in the act of impaling the dragon; the ring that had been in the 1928 catalogue of the Cheapside Hoard and not seen since? Was it poker-faces all round?

A quick scan of the catalogue showed that also for sale, along with G.F. Lawrence's possessions, was the property of the marmalade magnate and archaeologist of the Avebury Stones, Alexander Keiller, including his Egyptian figures. Princess Ducas's 'Egyptian torso in black basalt' could also be yours, as could some 'Property of a Lady' including a 'Very Fine Roman Silver Ring' with an amethyst intaglio, and finally the possessions of Basil Puckle, Monsieur Cajot, Brigadier-General J.G.H. Hamilton and Hugh Constable Esq.

The property of G.F. Lawrence was up first.

The auctioneer took to the lectern, nodded to the assistants standing by with the boxes, and, with the audience settled, began proceedings.

If you were in the know about Lawrence's intimate connection to the Cheapside Hoard, your scanning eye might well have passed the Italo-Greek and Cypriot pottery and fallen on the section entitled 'Engraved gems'. You would wait patiently, as the sale moved through the lots, the assistant rummaging in the relevant box and pulling out the lots one by one to show to the assembled audience some examples of the contents only to save time, with people standing to get a better look inside. As the auctioneer called 'lot 73', you would take your bidder's card in your hand and prepare to join in: 'A Sard – Horse in Sassanian style' (sard being a gemstone of red-brown calcedony quartz) and 'another – Cock; and sixteen others (18)'. The gavel came down, on to the next.

74. A Green Jasper – Lion and Deer; an onyx; four others and a cylindrical seal (7)
75. A Crystal – Bird; a sard; an Amethyst; and about twelve others
76. A Crystal – Lion, in oriental style; An Onyx; and six others (8)
77. An Onyx – Two Figures late Roman; an Onyx; a Soapstone – Sphinx couchant, Minoan; A red Jasper; and one other
78. A Sard – Quadriga; another Sard; and a Crystal; all late Roman (3)

These sorts of items were ten-a-penny in dealerships in 1939, and their modest estimates – just a few pounds – reflect that. Then again, loose stones were to be found in the Cheapside Hoard. There was an amethyst in the mix as well as crystals, and gems featuring classical scenes like the one here engraved with a four-horsed chariot: a 'quadriga'.

The sharper eyes of those who had been paying attention for the past twenty-seven years, or received a recent tip-off, alighted on 'lot 86' in the catalogue. This lot was the first in 'A Collection of Earrings and Ornaments, some in gold and set with agate and other stones.' It would be worth standing up to get a better view as each piece was removed from the box and presented to the audience. When the number was called, certain hearts raced. What was it worth? Hard to say. Even if it matched the Hoard in date or design, how could anyone be sure one way or the other? How could one ever prove it?

A few days after the sale, a printed list of all the buyers' names and prices paid for each of the lots was available to buy from Sotheby's for two shillings. This piece of ephemera did not, it seems, survive the war – it's not in any of the libraries that stock Sotheby's archive. There may well be a copy of it, slid into the back of an old catalogue, left on a shelf somewhere, that may yet answer the questions of who came to the Lawrence sale, who bought what, and for how much. It's a tantalising possibility as it would offer more clues about what exactly was in the collection of earrings, ornaments and other stones. For now we can take only an educated guess.

The war just down the track, like all wars before and after, unceremoniously broke the chains of provenance attached to these

items. Without the paperwork, the beneficiaries would never know the story of their journey, and the treasures likely sat in drawers, or jewellery boxes, posing as something unremarkable.

On 2 March 1939, just over two weeks after Lawrence's death, Egyptologist Howard Carter also died, of lymphoma, aged sixty-four, in his mansion flat in Albert Court next to the Royal Albert Hall in Kensington. His great discovery back in 1922 was now, like the Cheapside Hoard, considered an archaeological landmark. The Egyptians, however, had long suspected Carter of breaking into the burial chamber earlier than he declared, helping himself to treasures, including jewellery, and sealing the space up again before staging an 'official' opening. He always insisted that he hadn't taken any treasures from the excavation and that the chamber had been robbed in antiquity; the Egyptians had never believed him. As it turned out, they were bang on the money and his close associates had discovered the thefts back in the thirties.

A letter sent by Egyptologist Alan Gardiner to Carter in 1934 settled the matter, when it was finally published after nearly a century in private hands. Gardiner had been a member of Carter's team in 1922, translating the hieroglyphs found on the walls of Tutankhamun's tomb, when Carter had given him a '*whm* amulet', an offering to the dead, while assuring him it had not come from the tomb. In the private correspondence of 1934, Gardiner directly accused Carter of stealing, citing hard proof. He had shown the amulet to Rex Engelbach, the director of the Egyptian Museum in Cairo, who had been able to match the amulet decisively with other samples from the tomb that came from the same mould. Gardiner had no choice but to agree with

Engelbach's authoritative conclusion that the *whm* amulet was 'undoubtedly stolen from the tomb of Tutankhamun'.

After Carter's death, there were at least eighteen items found in Albert Court, which looked to have been taken from Tutankhamun's tomb without authorisation.[8]

When probate was granted on Carter's estate on 5 July 1939, papers referred to him as 'Howard Carter of Luxor, Upper Egypt, Africa, and of 49 Albert Court, Kensington Grove, Kensington, London', keen to show that he had kept a foot, and perhaps his heart, in Egypt. He was in a lonely state at the end of his life and although he had always dismissed the so-called 'curse' upon the people who broke into the tomb and loathed the persistence of the rumours for taking attention away from the find, the discovery had certainly not brought him unbridled happiness. The second grant of probate was issued in Cairo on 1 September 1939, and the executors spared Anglo-Egyptian relations by discreetly presenting, or selling, the suspected-stolen items to the Metropolitan Museum of Art, with most eventually going either there, or to the Egyptian Museum in Cairo. The artefacts at the Metropolitan Museum were later returned to Egypt. Other items from the tomb have come up at auction on the Egyptian antiquities market from time to time since then, notably pieces of a golden beaded collar that was photographed by Harry Burton on the chest of Tutankhamun and later spotted in an American museum collection, other beads resurfacing at a British auction restrung into a necklace, suggesting the collar had been divvied up and sold by Carter, or someone close to him.[9]

When war broke out, in anticipation of air raids the Cheapside Hoard was packed up again, removed in handcarts

and taken back down underground, this time into a deep tube station, at Dover Street, to spend the war in relative safety. Martin Rivington Holmes and Arthur Trotman, the fourteen-year-old conservator, took two weeks to execute plans to get the collection safely into storage in a disused corridor, although it was moved again to Piccadilly Circus where it sat things out in a passageway. Other precious pieces in the collection were hidden in a strengthened section of the basement of Lancaster House and most of the Museum's costumes – also Holmes's jurisdiction – evacuated to the Rothschild family home, Waddesdon Manor in Buckinghamshire. There, Alice von Rothschild had taken on the legacy, and museum-world affiliations, of her late brother, Ferdinand Rothschild, the great private collector of art and antiquities and British Museum trustee. She offered a hand of friendship, and ample square footage, to accommodate the delicate fabrics in their silver paper boxes.

Also portered down into a tube station that summer of 1939, in anticipation of the war, were the treasures from another iconic find of the century, with the *Daily Mail* hailing it as 'Britain's Tutankhamun'.

A self-taught archaeologist, Basil Brown, working for Mrs Edith Pretty for thirty shillings a week, had discovered an Anglo-Saxon burial ship full of treasures on her land in Suffolk, after many months of excavations. Brown's employers at the Ipswich Museum had offered his services to Mrs Pretty, who wished to excavate burial mounds at her Sutton Hoo estate. Lawrence and Brown had been circling the same turf, hunting buried Roman and Anglo-Saxon settlements in Suffolk, connected to the same local museums and no doubt sharing hunches. The son of a

wheelwright and farmer, Brown had earned himself diplomas in geography, geology and astronomy via the 'Harmsworth Self Educator' correspondence college, a magazine published in forty-eight issues, and, alongside the hunt for the Romans, had continued running his late father's smallholding with his wife, their life becoming less and less financially viable. This discovery attracted the attention of the British Museum and then the world, and Brown and Pretty became another unlikely pairing, from different ends of the social spectrum, united by a shared passion. The treasures they unearthed from inside the ship represented power, both on earth and in the afterlife, and demonstrated the craftsmanship of a master goldsmith. Along with a decorated ceremonial helmet, in fragments of gold, silver, iron and bronze, was a great gold buckle, intricately worked with gold and garnet; ornate shoulder clasps, and the pattern-welded sword of a great leader.

After an inquest into the Treasure Trove, Pretty donated the finds to the British Museum, but they were diverted en route down into Aldwych tube station, across town from the Cheapside Hoard which was in storage in Dover Street station, and then Piccadilly, both sets of boxes kept safe, deep under London, while the Blitz played out, waiting for the all-clear.

CHAPTER XX

The Postwar Ghost
The Letter

On 5 May 1948, in the Museum offices of Lancaster House, Martin Rivington Holmes thumbed through a handwritten letter. Now a renowned scholar of forty-two and the officer in charge of the Tudor and Stuart collection, his eyes sloped down behind frameless glasses at the communication in his hand. This was not his usual kindly expression. The letter related to the most famous acquisition in the Museum's history.

The Museum was in the process of being evicted from the building by the Foreign Office, who had requisitioned the real estate during the war and were now refusing to budge. Holmes and his colleagues were squatting in a few ground-floor rooms with access only to their offices, library and basement storage.

Staff and exhibits had decamped from the gilt-panelled exhibition galleries upstairs, where the Museum had shown its wares for thirty-four years. The lease from Lord Leverhulme was at an end and Attlee's new government needed the state rooms for postwar conferences, notably make-or-break peace negotiations led by Foreign Secretary Ernest Bevin between the Allied powers, putting the Soviets face to face with the others across a monumental mahogany table.

The Gold Room hosted harassed civil servants now, who scuttled in and out. The State of Israel was about to be declared in Tel Aviv with the end of the British Mandate, and officials were holding their breath for conflict.

Colleagues could easily have assumed the note in Holmes's hand had something to do with the urgent business of finding a new permanent home for the Museum. But the contents were far more intriguing. Holmes set about reading the seven closely written pages. The letter was in pencil on paper torn from a notebook, in neat, looping script. Its author addressed the Hoard's mysterious backstory, claiming to have new information from an unlikely source:

> 5th May 1948
>
> On Wednesday last I made a point of contacting the old man… He told me several things about himself. As far as I can ascertain, this is his story…

The Hoard was temporarily stacked in the office in packing trunks, along with the rest of the Museum collection, and the purposeful staff dodged round the boxes. The treasures, objects of primary importance, had been in these trunks since the outbreak of war in 1939. Trundled out of hiding. All had yet to be sorted through. The Hoard had lived an itinerant life since it was dug out of that cellar in the City of London in 1912, packed and unpacked countless times. It was waiting yet again.

As the man in charge of the Tudor and Stuart Collection, Holmes, eminently capable, would preside over its next move.

He had honed his already impressive practical skills over the past few years – having enlisted as a private he ended the war as a major, and spent the later years working in the personnel department of the Intelligence Corps in Cairo.

A passage in the handwritten letter related to a specific question that had stumped scholars for the thirty-five years since the find – to whom had the gems and jewels originally belonged? The letter claimed to have discovered an identity.

> He was a jeweller in the time of Elizabeth and a prosperous one at that…patronised by many wealthy people… Gradually his reputation became known amongst the rich nobles & he had many orders for his workmanship… [H]e got involved in political affairs – not directly, but through his customers. He tried to back out…

Holmes was clearly on friendly enough terms with the correspondent, and knew perfectly well who was writing to him. (We don't, as, frustratingly, the letter has lost its final page along the way, with a sign-off and a chance of knowing the name.)

The correspondent had more to relay about the Elizabethan jeweller, this time related to his misadventures in creating new designs for his pieces:

> In the course of his studies he became very interested in the Black Art & discovered many ancient formulae for charms and the like. He was curious to experiment but desired no evil purpose so he tried to make charms for good, incorporating his formula into his craftsmanship…

He started by making a pendant for his niece…her wish was gratified quickly… A ring he gave an apprentice so as to better his workmanship… [H]e was slow to learn and a little clumsy with his fingers. Within a month this apprentice had surpassed the craftsmanship of those who had been apprenticed twice as long…

Now being thoroughly absorbed in the subject, the jeweller decided he must try an evil charm… Not wanting to harm any person he fashioned a jewelled collar to put around the neck of a dog… The dog became ill and died within three days. The old man was rudely shaken…

Then people began to ask him to make evil charms & offered to pay him well. At first, he was troubled about it, but the people were powerful & influential & in the end he didn't dare refuse them… [He] wanted to use his powers only for good again, but those who employed his services threatened to have him put on trial for sorcery…

It explains to me his character and why he visits the museum so frequently…

A twist then, at least for us. The correspondent was not a historian reporting to Holmes about their research in the archives. They were claiming to be a 'psychic medium' and their source for all this new information about the Hoard was a 'ghost'.

This was a sober, cold-light-of-day moment in postwar London and the City was busy preparing for the Olympics in the summer. There was a lot to organise and the London Museum was a professional environment. It had been 'cleaned, expurgated, and catalogued; in general, turned from a junkshop

into a tolerably rational institution'[1] by Wheeler and Holmes as his right-hand man and fixer of fifteen years.

Wheeler had not returned after his service. Rising to the rank of brigadier in the North African campaign, he'd led his men bravely in action with a swaggering and ruthless discipline that earned him the name 'Flash Alf' from the troops who served under him. He had spent time as one of the so-called 'Monuments Men' in Libya, saving ancient Roman sites from destruction, but was pulled out after 1944 to run the British Archaeological Survey in India. Having witnessed the horrors of Partition, he returned to the Indus Valley, now Pakistan, to excavate the ancient site of Mohenjo-Daro, one of the world's earliest cities, contemporaneous with those of Ancient Egypt. He had also, testament to his indefatigable energy and sex drive, managed to squeeze in more drama in his love life, filing for divorce from Mavis de Vere Cole after finding her in bed with a rival, who referred to Wheeler as 'that whiskered baboon', and marrying his third wife, the archaeologist Margaret Collingwood.

Holmes continued reading. According to the 'psychic' intermediary, the Elizabethan jeweller who wished to identify himself to Holmes as the skilled artisan behind the Cheapside Hoard also wanted to offer an explanation as to why he had hidden them, another subject much debated by scholars for decades, and why he had continued to guard them so closely after they were dug up, following them around.

> It looks as if he were expecting arrest more than murder, for he buried all his charms, good and bad, besides other pieces…

He must have known only shortly beforehand, for he tells me he buried the jewellery in haste, before telling anybody where they were or which pieces were tainted...

After his death he learnt his true responsibility for the jewellery & realised the risk of them being discovered & falling into the hands of unsuspecting people... He is glad they have not found their way into private ownership, where some of them may cause misfortune to the owner. On the other hand, until they are destroyed, he has to keep an eye on them.

Incidentally, he seems to have attached himself to you. Whether it is because you have the care of the jewellery, I don't know. More likely it is because you are interested in the times he lived in more than anybody else here...

[A]ppalled at the things he had brought about, he wanted to reform & finally stood out against his clients. They carried out their threats, no doubt wanting to be rid of him for the knowledge he held. Either he was brought to trial, or else he was murdered...

[He] died in 1602... I know he did not die a natural death. In any case he says he knew he was going to die & he hid the jewels he had been working on. He says some of them were completed charms for good & some for evil.

Colleagues still sometimes discussed the stories of an Elizabethan ghost and his visits. Some visitors and staff did report seeing the 'ghost' at Lancaster House, from time to time, even post '45. The letter was part of a casual ongoing conversation about what might be behind the apparent 'sightings'. The investigation, if

you could call it that, was an informal arrangement. The letter doesn't confirm if Holmes had commissioned it, or just gamely indulged it.

As a prewar veteran at the London Museum, Holmes was popular among the staff, always happy to help the younger ones, and fill them in on past business. He was often to be seen at J. Lyons off Piccadilly for breakfasts with the new keeper, Wheeler's successor, William Francis Grimes, known as Peter, a vibrant man who had spurned a bowler hat and a neatly furled umbrella for check trousers, a green waistcoat and a flower in his buttonhole, a match for Holmes's snappy dressing.

A generation of young women had kept the Museum ticking over in the men's absence. Margot Eates, trained by Wheeler's first wife Tessa Verney, had been the sole caretaker-curator during the war. Jean Macdonald, Grimes's secretary, was a rising star of Roman and prehistoric scholarship. George Dugdale was looking after the medieval collection, and the teenage conservator, Arthur Trotman, had learned fast in a few short years. There were costumes to organise too. Holmes oversaw a team of dressmakers and their apprentices nervously peeling back the layers of silver paper and lavender to check that the exceptionally fragile garments, the doublets, 'buff' coats and royal robes, had survived so many years in storage at the Rothschild family estate at Waddesdon.

Thanks to the war, many of the younger staff had never seen the contents of the boxes on display and this was their first prospect of peeping at the legendary Cheapside Hoard with their own eyes rather than in the catalogue. They had relied on descriptions of the chandelier-lit glass showcase upstairs

from the old-timer staff at the Museum, like Holmes and the ex-servicemen security guards O'Connor and Henderson.

The letter conjured up the old regime and, above all, a certain person. Holmes could not avoid thoughts of G.F. Lawrence, the 'finder' and first guardian of the 'Cheapside Hoard'. It was Lawrence who had started the stories in the first place, about the 'ghost' of the original owner following the Hoard around. The first 'sighting' had been over thirty years previously – an encounter in the Lawrence family flat above the shop in Wandsworth.

Lawrence was a legend of the institution in his own right now and he loomed large over Holmes's shoulder. In the spring daylight of 1948, he seemed a character from another age, but his legacy still commanded a rousing gentleman's chorus of *chapeau* even in Holmes's professional world and a raising of 'top hats' (a mimed gesture, mind, no one was wearing them anymore). He'd retired by the time Holmes arrived, but back in the thirties they would have seen each other at the theatre sometimes.

At face value, the letter in Holmes's hand was just another rehashing of the legend put about by Lawrence in the newspapers after the Great War, when that sort of thing was all the rage. The old-timers at the Museum had regaled Holmes endlessly with hackneyed tales of a pantomime Elizabethan spook visiting the Museum and making visitors faint.

Holmes had often wondered about the effect of the Cheapside Hoard on Lawrence. He had to consider that it might have ruined him. Lawrence, who had treasures beyond his wildest dreams come to his door, but never left his shop, and had so little to show for it at the end – just a few hatboxes. The auction in

'39 had not thrown up much of interest. He'd never discovered the identity of the original owner, despite decades of enquiry. His Elizabethan ghost had entertained the crowds and brought press attention, but the reality of his life at the end made rather a pathetic scene.

Accompanying the letter, on a separate piece of paper, was a pencil sketch of the jeweller in full Elizabethan costume, with attention to all the technical and historical details, down to the smallest buttons and trims. This sketch was on better quality paper than the rest, with a letterhead blind embossed at the top: *Dieu et Mon Droit*, George VI's royal coat of arms, with holes where staples had been, suggesting scrap Foreign Office paper recycled from the piles in the conference rooms upstairs. Several of the pages had dressmaker's notes on the back, including a pattern for a 'foundation sleeve', the kind of sketch found all over Holmes's department where apprentices learned the craft and conservation of historic costumes. The description to go with the sketch was equally detailed.

> He is about five foot seven inches in height and of narrow build. His hands are very fine and he conveys the expression of extreme dignity. His face is very finely moulded though old: his small beard is grey, also his eyebrows. His eyes are a pale blue…he seems to wear a solemn expression. Even when he smiles he does not smile with his mouth, but with his eyes.
> Undergown of fine black cloth, buttoning to just above the waist, no belt or girdle. Straight sleeves, fuller at the top. Buttons are covered in black silk worked in squares. Overgown

is of a stiff silk material, with hanging sleeves. It is trimmed with black silk and braid in a diagonal pattern. The caps and shoes are of black velvet. The ruffs at neck and wrists are not white but a creamy yellowy colour.

Here was Lawrence's Elizabethan jeweller again, thirty-five years after he first appeared in the den at 7 West Hill. He was still old, thin and white-haired with a stiffly starched ruffle. But now he was an austere and dignified figure, wearing a black velvet overgown, not pants and a blue doublet as he had in 1919, and no mention of a hat this time. The correspondent ventured a name, 'William Twysdale or Twysedale', adding more pleasing detail to the portrait, but they did not seem confident on this point, explaining 'mostly he doesn't seem interested in names. He is far more concerned with the history of the jewellery.' If the name rang a bell with Holmes, a man with an encyclopaedic knowledge of Elizabethan society, he didn't register it.

Of course from our way of thinking it is difficult to decide whether these 'charms' did have any actual influence upon the people intended, or whether those things would have happened anyway. On the other hand, the jeweller says he never had a failure, except in the beginning before he had fully developed his so-called powers… That they are influential to some extent must be true, or he would not take such pains to guard them… What your own opinion may be, I have no idea… When I get the chance I will have a look at some of the jewellery & then I shall most probably get a clearer opinion…

Holmes might well raise a wry smile, suspecting a hoax. This was a period piece of a letter for him to receive in May 1948, like a prop from a music hall variety show back in the day. The letter had the outlandish plot and melodrama of one of Drury Lane's best. The 'ghost' was likewise a stock Elizabethan character from the Edwardian stage.

Still, the 'psychic' was trying their best to sound convincing, 'trying to do a bit of investigating… I have looked through the catalogue since he told me these things.' They reference 'other psychic investigations' from 'a few years ago'. Elizabethan life and costume were Holmes's passion, so if anyone was likely to be happy to play along with a charade like this, it was him. This, though, was the stuff the previous generation got so carried away with in dark, dusty parlours around the time of the Great War. 'The Fraudulent Mediums' Bill was now making its way through Parliament, intended to stop 'psychics' cashing in on the vulnerable and credulous.

The correspondent had been careful to acknowledge a sceptical wind blowing. They claimed they themselves did not know what to make of the message from the jeweller, and acknowledged Holmes may dismiss the information offered. People laughed at that sort of thing now.

The general public had turned on 'mediums' in recent years, in large part because of a few high-profile exposés. On the other hand, 'mediums' were very much in demand as stock characters on stage and on screen. *The Amazing Mr X*, a film featuring a scam Spiritualist, was playing in cinemas in 1948, as was *London Belongs to Me*, starring a newcomer, Richard Attenborough, and Alastair Sim, in another lead role, about a Kennington boarding

house with a fraudulent 'psychic medium' tenant who takes advantage of the widowed landlady. As a light alternative to Laurence Olivier's *Hamlet*, opposite Vivien Leigh in the cinema, Noël Coward's *Blithe Spirit* had audiences hooting at this situation comedy-of-manners, starring a 'psychic medium' house guest from hell, 'Madame Arcati', who contacts, and then accidentally manifests, her host's ex-wife, Elvira, a woman hell-bent on tormenting his current one.

Holmes evidently found himself unable to throw the letter away. Even if the contents were laughable, the idea that the ghost had 'attached himself' to you would be disconcerting to the most level-headed.

Holmes read on. The ghost's attachment was apparently because the man in charge of the Tudor and Stuart collection was a kindred spirit,

> interested in the times he lived in more than anybody else here... He says he was a predecessor of yours, not in family, but in a subject you are investigating... No doubt you will know more...than I about the historical times of Elizabeth... One story he told me...he said would interest you particularly.
>
> He says I am to tell you that out of the many plots upon Elizabeth's life, the Earl of Essex had a plot of his own... [B]y it Essex hoped to have the throne...some ideas about gaining power in Scotland & Ireland at the same time... [He] went personally to the jeweller and asked him to make an evil charm, which was to be a present to the Queen. The jeweller says that he did not know who the charm was intended for at

the time, but in the course of tracing all his charms, besides those he buried, he discovered the truth of the matter.

The charm itself was made as a hairpin. He showed me what it was like & I've made a sketch of it. It is in the shape of a crook, set with rubies, a single drop ruby at the end.

I have looked through the catalogue since he told me these things & have seen a picture of one very similar in design but not the same. It is easy to find an evil symbol from the pin. One can almost imagine it being driven into the head and the blood dripping from it. Otherwise it looks very beautiful and attractive.

It was presented to the Queen, but fortunately, the jeweller says, it was only worn once, to please the Earl of Essex. For some reason Elizabeth took a dislike to it & put it away. Later she gave it to one of her ladies who liked it & wore it constantly. From that time she lost health and died within a year.

The letter-writer clearly knew all about Holmes's passion for this story of political ambition and high emotion from the court of Elizabeth I, and was playing to it.

Holmes had staged his own version of the events in his play *How Essex Died* back in 1930. Everyone knew the tragic love story of Elizabeth I and her favourite courtier, of course, be that from the bawdy comic version in *Merrie England*, or the grand cinematic rendering in *The Private Lives of Elizabeth and Essex*, starring Errol Flynn, Bette Davis and Olivia de Havilland.

A following story he told me to the first, rather appealed to my sense of humour & to his, I believe.

Evidently, somebody tried to employ the same means of disposing with Essex to more effect. A cameo ring, or at least that's the nearest I can describe it, was given to Essex. The head was that of Essex & there was some design, portending the same omen of ill luck to his head. The jeweller says execution wasn't intended, only miscarriage to his plans, but as it turned out, not only did his plans go awry but he lost his head because of it.

Here was a confection to delight the likes of Martin Rivington Holmes. There was also food for thought in it. The jeweller had claimed to be his 'predecessor'. His actual predecessor, as the man in charge of the Cheapside Hoard and the rest of the Tudor and Stuart collection, had, of course, been George Fabian Lawrence, dead for nearly a decade.

Since the war, Holmes had energetically resumed his role as confidant to the dowager queen, endeavouring to lift her spirits with a selection of the dozen historical plays penned in his spare time. He still cast the kings and queens of England as protagonists. His latest was *The Road to Runnymede*, described in the programme as 'An Historical Play in Three Acts', about King John and the story of Magna Carta in 1215, in which the barons bring the all-powerful monarch under the rule of law. The queen, her own health failing, was nursing her son, King George VI. She and the king had just relinquished their titles as the Emperor and Empress of India, becoming the more prosaic king and queen of India and of Pakistan, and were conscious of a loosening grip. Holmes was working on a new play to interest her, *Sword of Justice*, following the dilemmas of an executioner

in Germany who has inherited his onerous responsibilities from his father, due to open in April 1949 at the Gateway Theatre Club in Westbourne Grove, West London. The form for Queen Mary's attendances at a Holmes original first night was a seat at the front of the auditorium where the stalls had been cleared to make way for armchairs and a table, set with a bouquet of flowers, for the royal guest and her ladies-in-waiting. The theatre clubs operated independently and could show plays of a more experimental nature, without having to be previewed by the Lord Chamberlain to get a licence.

West End audiences were looking back, with a mixture of nostalgia and fury, to the very year the Cheapside Hoard had been lifted from the cellar floor. They flocked to the West End to see J.B. Priestley's new play, *An Inspector Calls*, an unflinching take on the period before the Great War. The drama, set in the spring of 1912, put the spotlight on the Birling drawing room, an upper-middle-class family hosting a port-and-cigars engagement party for their daughter. 'Inspector Goole' enters, intent on interviewing each of the family about the suicide of a young working-class girl, Eva Smith, a worker at the machine shop in the Birling factory, her downfall precipitated by unsuccessful collective demands for a wage increase. The inspector's interviews reveal that each of the Birlings, although initially self-righteous, had in some way contributed to this fall. The play's cry for fairness and accountability ends with sensational twist regarding the identity of the inspector who has implicated them all. *An Inspector Calls* was also playing in cinemas in 1948, with Alastair Sim as the inspector who leaves the family in no doubt they will be held responsible for their actions. Audiences

peered into the rooms of this genteel Edwardian world of 1912 as if into an old doll's house.

The correspondent's 'source' had some very particular new information about certain items the navvies took from the cellar that first day in June 1912:

> He says…that two of the pieces were stolen when they were found. One of them was a pendant of garnets set in an uncompleted cross – not uncompleted in workmanship, but purposefully designed that way & the other was a pin of emeralds and diamonds. He says the first was evil & the second good. The man did not sell them as he had intended, partly because the hoard has proved important & partly by the jewellers [sic] own influence. He said he thought one would outweigh the other, but, as before the evil proved strongest and the owner suffered permanent injuries in the following year. Apparently there are other examples of his manufacture all over the place. He must have a busy time, checking up on it all… [U]ntil they are destroyed, he has to keep an eye on them, so he knows that the end of his task can only come with their destruction – at least the destruction of the evil pieces…
>
> It was obvious to me that he wasn't the ordinary sort of ghost, either with a grudge, or ignorant of their own state. He was quite clearly learned in the matters of the hereafter & yet he had tied himself to the earth for over 300 years.
>
> Now somebody knows about them, he most probably will not keep such a constant vigil on them, unless they are taken out. He knows I would let him know if anything was

happening to them. He says he wishes the hoard had not been split up since it makes his task more difficult…

When I get the chance I will have a look at some of the jewellery & then I shall most probably get a clearer opinion.

Holmes had to wonder where these two lost items had got to. The Museum had lost track of so many over the years. What of the other pieces out there? In terms of the Tudor and Stuart collection, no one knew where anything was. There had been ample opportunity to steal from the Hoard during the war, to call an item 'lost' in the pandemonium.

Holmes had a job on. He had been looking back at an old copy of the 1928 catalogue of the Cheapside Hoard, drawn up by Mortimer Wheeler. Holmes knew the catalogue backwards after all those years at his side sorting everything out, but there were some anomalies that he had never been able to reconcile, the 'X' accession numbers above all.

The story of what really happened with the Hoard remained opaque. The paperwork relating to the treasures, what there was of it, was dusted with anomalies and gaps, hinting at a twilight zone of back-room trading.

Holmes could not miss a warning in the letter, amid the playfulness, to leave the Cheapside treasures where they were, and not to go looking for the strays himself. It was a dangerous business keeping track of them, was the gist. Some of the pieces would cause you harm and you wouldn't know which ones.

There's no one to tell us what Holmes made of it all. Why would someone write a letter like this, apart from for fun? There

were several 'clairvoyants' working the society circuit. They didn't ask for anything, even to be believed.

The dress-pattern sketches on the back of the letter strongly suggest the author was someone Holmes knew in the historic costume department. And then of course Holmes's royal connection had brought court dressmakers, like Elizabeth Handley Seymour, long-time favourite of Queen Mary, into Lancaster House. Handley Seymour was retired but Queen Mary had asked her to make the coronation dress for her daughter-in-law, Queen Elizabeth (née Elizabeth Bowes-Lyon). Also in Holmes's orbit were Handley Seymour's protégée Avis Ford, a petite, shy South Australian girl who dressed Queen Mary and, latterly, Norman Hartnell, the dapper leader of the British fashion set and Mary's new favourite following Handley Seymour's retirement, who had just made the wedding dress for Princess Elizabeth. Designers had made a beeline to Lancaster House to see the costumes and robes for decades, wishing to copy them for the stage, and Handley Seymour provided historical costume sketches for theatreland on the side, the models posing in long skirts, corsets and hats, arms out to the side with hands tipped up coquettishly at the wrist.[2]

There was one more thing the letter-writer wanted to communicate to Holmes, left until last:

> He wears a ring on the first finger of the left hand. The ring has a large flat oblong stone set in a frame of gold. It looks something like a moonstone but is almost too transparent. I believe there is some design cut on it although it is not cut on the top surface but the underneath. The upper surface is quite flat and smooth.

> This seems to be a recent acquisition, or else something he wanted to show me, for he was not wearing it when I first saw him. Similarly, the red lines I saw on his wrists & neck have vanished.

The Elizabethan jeweller had apparently insisted on showing off the ring. It was a stagey reveal, some 'ring business'.

Coincidentally, however, there was a ring Holmes knew of that closely matched this description. A man's finger ring set with an opal cameo of St George and the Dragon. It had caught Holmes's eye, before the war, in the 1928 Wheeler catalogue, with a photograph and a pen-drawn illustration. It stood out because it had an 'X' accession number. Holmes had not seen it in all the years he had been at the Museum. Wheeler had occasionally insinuated that Lawrence had the ring in his possession.

What had Lawrence wanted the St George ring for, if indeed he'd taken it, as per the old rumours, of all the more spectacular pieces of jewellery to choose from? Did Lawrence believe the opal ring to be bad luck, or good luck? He had died with very little money, so much good it did him. Holmes never raised the contents of the letter in a meeting with minutes taken, and if any of the other staff saw the missive, they never mentioned it publicly.

He stashed the letter away, somewhere it would not be found until June 1966, when it turned up among his papers in the 'M. R. Holmes Room', so called to honour his exceptionally long service at the Museum of London. Someone then took the trouble to put the letter into a cardboard folder, gave it the accession number A-14000-367, the signature of the Cheapside Hoard,

and for ease of reference labelled the folder 'The Cheapside Hoard, The Ghost of'. The title says a great deal about how the contents were regarded. The air quotes around the 'ghost' are pronounced. They shoved it back on a dusty shelf.

CHAPTER XXI

Looking for the St George Opal Ring

The St George and Dragon opal ring has not been seen in public since its appearance in the 1928 catalogue. Tony Smith, Gweneth Lawrence's son and George Fabian Lawrence's great grandson, remembered meeting his elderly great aunt, Ethel May, only once, for tea at the Festival of Britain in London in 1951, four years before she died, and confirmed she told people privately that she was a 'medium'. It's possible it was May who wrote the letter to Martin Holmes in 1948, though there's no proof of that. She could have kept in touch with her father's successor at the Museum over the years. She was able to get out and about in a new chair. She had the drawing skills and undoubtedly knew things no one else did about where certain treasures ended up. There was pleasure in teasing her secrets, maybe her knowledge of the whereabouts, of a man's ring. She had a motive to continue the story, and keep her father's legacy going.

For those of us now in possession of a name for the Hoard's original owner, there's dramatic irony. Francis Simpson, jeweller to King Charles I and II, was a living, breathing person who didn't pay his rent on time and had his home and its hidden stock confiscated during the Civil War. The 'Cheapside Ghost',

a stock Elizabethan, fades in comparison; two dimensional rather than three.

But the Cheapside Hoard had captured May's artistic imagination as a young woman, and it had certainly captured the imagination of whoever penned the letter, and in so doing wrote a new chapter of the London Museum's House Ghost Story. In the correspondence, the 'Ghost' was a man fit for 1948: an Elizabethan just like the previous versions, but now a responsible figure, trying to do the right thing. Guilty of self-enrichment, of aiding and abetting political intrigue, this spectre wanted to clear up the mess he'd made.

It would be nice to think May visited the 'Cheapside Hoard' that year, as it had just gone on display, in the Museum's new home back at Kensington Palace, which opened with fanfare as part of the Festival of Britain. George VI had been too ill to officiate as hoped, but had offered fifteen years' accommodation in an assortment of rooms, although the warren of the Palace did not help the chronological displays make sense. The collections belonged to the government, given by the trustees in a deed of loan, and they were now partly responsible for the upkeep. A selection of the dowager queen's small gifts to the collection were on show with the Cheapside Hoard; her interest fired up once again. She had paid a private visit to the galleries the night before the opening, with Martin Rivington Holmes at her side. The Cheapside Hoard was there to receive her, in its new home, in one of the larger rooms. She went back one more time, bringing her granddaughter to look at the royal robes in anticipation of her Coronation as Queen Elizabeth II. Holmes was again there to escort them and share

memories of treasures of the Cheapside Hoard, and stories of the resident ghost.

Tony Smith, Lawrence's grandson, remembered no evidence of any money growing up, or any jewellery, and certainly no opal ring. As an adult, he emigrated to Canada where he married Teresa, built a prestigious career as a mathematician and a physicist and they had a family. They were kind enough to share Gweneth's memories of her grandfather, George, and to tell me that they have a plaster – faience – sarcophagus given to Gweneth by George Lawrence, which got broken along the way, but that nothing more was handed down to them.

Family wills and probate records show that Lawrence left his entire estate, of just over £1,000, to his wife Florence Emily, and in turn she left hers to her grandson Geoffrey when she died, her son Frederick having pre-deceased her. Fred had left his estate of just under £250, plus effects, to his wife, Rose Elsie, and when Rose died in 1954 she left all her money to Geoffrey. So Lawrence's grandson, Geoffrey Frederick Lawrence, inherited everything from both his mother and his grandmother. He married, and his son, Michael Lawrence, became chairman of the London Stock Exchange in 2000. Geoffrey Lawrence died in Buckinghamshire in 1998 and none of the family recall seeing or hearing about any items from the Hoard.[1]

I have continued looking for a man's finger ring set with an opal, or a moonstone, cameo of St George and the Dragon, but enquiries of Hatton Garden, archived online auction catalogues and ancient jewellery stores have all drawn a blank. Putting the two images of the ring from the 1928 catalogue into Google Lens has not found a match either.

The search did turn up some suggestive items in international museum collections. In the Metropolitan Museum of Art in New York, for example, is a 'Roman rock crystal lion in oriental style', given as a bequest by the collector and philanthropist Ada Small Moore in 1955, that could conceivably be 'lot 76' from the 1939 Sotheby's auction of Lawrence's stock-in-trade. There's also a Roman sard intaglio featuring a 'quadriga' (a four-horse chariot) given as a bequest to the Met by William Gedney Beatty in 1941, that could be 'lot 78' from the same sale, but it's all circumstantial.

The real pleasure in this story is that anyone could unwittingly be harbouring a piece or two from the Cheapside Hoard. Have a look in your grandmother's jewellery box, maybe she was the granddaughter of the sweetheart of one of the workmen in the cellar that day in June 1912; there could be an ancient gem from the Hoard with all the telltale signs, hiding at the back of the lower tray, although it would be difficult to prove. You might find a fragment on eBay. Some of these jewels and gems are scattered in the digital sea of objects, glinting in the flotsam and jetsam waiting for a well-briefed eye to spot them.

As well as the ring, it is rumoured that a selection of 'toadstones' (muddy coloured fossilised teeth of an extinct species of fish *lepidotes*, polished into a cabochon) were missing from the Hoard that were due to come to the Museum of London, but never arrived. Such stones were believed to have formed in the head of a toad and to work as an antidote to poison and to change colour and 'sweat' next to the skin when worn protectively as an amulet.

It's the central mystery of Lawrence's life: why he never moved out of his apartment above his shop. An upgrade to a Mayfair postcode was never an objective. He never travelled either, despite his interest in ancient cultures overseas and his contacts.

The Hoard came to him in 1912, brought literally to his door, the ultimate prize for a Victorian boy mudlark. But even unmatched treasures couldn't sate his compulsion to collect or make him feel he had enough. In the end it all shook down to a few boxes, and no serious assets. He had failed to capitalise on his good luck. He couldn't keep a penny in his pocket.

That was the ascetic Lawrence, however, focused only on his work and on acquisition. There was another Lawrence, a man who enjoyed puzzles and codes and buried mysteries to unearth and solve. Was there something else stopping him from leaving 7 West Hill? Had he played a masterful practical joke, to pay off after he had died, and put shoeboxes of treasure under the floor of the shop for future hunters to find like the navvies did in 1912? His turn to play the game now, others to unbox, sifted through, interpret, the provenance of each object argued over. Had the man who took a Viking woman's skeleton in a suitcase on the omnibus gone one better?

I took a bus to 7 West Hill, in some hope of an answer, then walked from Wandsworth Town, along the South Circular, past the sprawling Southside Shopping Centre and the site of the old Ram Brewery, now the 'Ram Quarter', down Wandsworth High Street and the site of the first of the two Lawrence pawnbrokers in the area, which has made way for a large office block.

The parade of shops that includes number 7 West Hill is dominated utterly by the traffic that thunders past; a relentless stream of cars and lorries heading down to the A3. Amidst the fast-food shops and the dust are a few survivals from Lawrence's day – 'W.G. Child and Sons High Class Tailors' at 106, 'civil and military tailors since 1890' – and there's a modern pawn-shop further along, with an array of rings and necklaces and electrical equipment and a notice announcing gold bought for cash. The flats above the shops look much as they would have done, except for the sealed UPVC windows, and the bricks are finally losing the war against the traffic. Next door to number 7 is Kathmandu, a 'Nepalese and Indian' restaurant, and there's fast food of all kinds, a lot of 'To Let' signs, barbers and a few empty premises.

Number 7 West Hill, where Lawrence's shop once operated, is a nail bar.[2] There's nothing to tell you of the old shop window, no trace of the Ka sign, just a bright pink acrylic lightbox, announcing 'Katie's Nails'.

Inside the nail bar it's sparsely decorated, with a bank of torn leatherette recliners on one side and nail varnish stands on the other; a few old magazines and laminated posters of women's splayed hands modelling jewelled nail art. All of the Victorian features have been ripped out, including the mouldings, and the floor taken up and laminated. There is still a little sink at the back and a toilet cubicle. Was it all taken away in 1939? Or was the tomb robbed straight away? It seems very small. There's no garden – prefabricated buildings come almost to the back window. The young female nail technicians do not speak English and are anxious when spoken to. The upstairs flat, where the

Lawrence family once lived, is now split into two, with basic, neutral furnishings common to all rentals with a high turnover of tenants and no one answers the door. The freeholder is a company in Thailand.

I wonder about the feasibility of commissioning a geophysical survey of the floor at 7 West Hill and then, like the archaeologists out of options on a dig before the Great War, consider an alternative approach and wonder how much a site visit by a medium would cost. Just for a moment. Because there's no sign of any treasures, and no evidence there were ever any left. No sign of any opal ring. It's all gone.

Howard Carter was laid to rest three miles south of West Hill, at Putney Vale Cemetery, in grave forty-five, block twelve, the plot a stone's throw from G.F. Lawrence's. Nine people attended his funeral. He was living a reclusive life and in poor health at the end, and interest in Tutankhamun had waned over the years since 1922. Lawrence's life had run in parallel with Carter's, their paths crossing occasionally, and they were, poetically, laid to rest close by. Both men's love of antiquity had remained strong despite the changing fashions.

Carter's black granite gravestone bears his name with the simple description, 'Egyptologist' and then, beneath, 'Discoverer of the Tomb of Tutankhamun'. An epitaph is engraved into another part of the stone; a quotation taken from an alabaster chalice found in Tutankhamun's tomb which was named the 'Wishing Cup' by Howard Carter. It reads: 'May your spirit live, may you spend millions of years, you who love Thebes, sitting with your face to the north wind, your eyes beholding

happiness', and continues, 'O night, spread thy wings over me as the imperishable stars.'

George Fabian Lawrence, lying a few dozen feet from Carter, is in an unmarked grave, in section X of the cemetery.

Lawrence – Stony Jack – was a man who liked the letter X. He appreciated symbols and cyphers and was never thoughtless with them. He had put a double X insignia on his business card, and the accession number he agreed with Mortimer Wheeler for the St George and Dragon opal ring was 'X5'. The unmarked grave in which he lies in Putney Vale was in a part of the cemetery labelled 'X'. If it was a coincidence, it's a coincidence he would have enjoyed. Lawrence loved a treasure hunt, and all treasure hunters know that X marks the spot.

Lawrence was a great survivor of life's knocks, although, ultimately, he was left with little to show for all the work. By all the modern metrics of success in this life – money, real estate, health – he was all but ruined, a loser of the game, and the Cheapside Hoard did not protect him, let alone make him.

But, given the age he lived in, and his beliefs – a foreign land in so many ways – he was, in a way, a winner. Maybe his greatest secret, and the reason for his most furtive activity, was that his preparations were not a defence against the slings and arrows of this life, but arrangements to survive something else. With the Ka sign above his door for nearly forty years, he had been hiding in plain sight.

When the navvies handed him the opal ring, fresh from the ground in 1912, he carried it with him into the commercial world, along with the myriad gems and jewels from the Cheapside Hoard that attended it. For all the trading, none of

the pieces afforded him a comfortable life in this realm. His last available leverage, his best chance of success, was to keep it with him – to take the ring down with him, back into the London clay from whence it came, to secure his passage through as yet unknown challenges. So he's wearing the St George ring, on his little finger, as an amulet, as he lies down there, at peace, six feet beneath the ground, in his blue serge suit, a trace of a genial smile on his lips.

Postscript

Queen Mary died in her sleep, after a long illness, at Marlborough House, on 24 March 1953, aged eighty-five, just ten weeks before the coronation of her granddaughter Elizabeth. After lying in state in Westminster Hall for three days, she was transferred to Windsor, and interred in the Royal Vault, next to her husband, in the North Nave aisle of St George's Chapel, beneath a tomb effigy sculpted into the realistic forms of the king and queen in life. She left Martin Holmes an eighteenth-century Sèvres porcelain chestnut 'basket' in her will.[1]

Mary's eldest son, the abdicated King Edward, reflected on her death that he was 'afraid the fluids in her veins have always been as icy cold as they are now in death'.

She was hot-blooded about her collection of antiques, however, and the treasure she had acquired over the decades, and arranged for her personal possessions to be displayed in the State Apartments after her death to illustrate her personality and interests – the things she most relied upon. If there was any of the Hoard still in her possession, none of the items was recorded as such.

The same year, to mark the coronation, 500 amateur companies staged productions of the comic opera *Merrie England*. Local theatres and church halls across the country were prancing and duetting simultaneously, the auditoria echoing with ballads, bawdy laughter and romantic arias from a 'Tudor' pageant, presenting yet again the old favourites Queen Elizabeth I, the Earl of Essex, Sir Walter Raleigh and the Shakespearean player 'Walter Wilkins', with his 'Masque of the Legend of St George' and the ghost of Herne the Hunter thrown in for good measure, lifted with a wedding, and a jig, at the end. *Where the Rainbow Ends* played at the Princes Theatre off Shaftesbury Avenue and continued in amateur and professional productions all over the country until the end of the 1950s, when it finally fell out of favour.

Both Queen Mary and George Fabian Lawrence missed the two great discoveries of 1954: Cripplegate Fort, chiselled and brushed out of the ground, next to Lawrence's boyhood home; and the Roman Temple of Mithras in the City, both of which Lawrence would surely have been stalking, watching from behind a car. Mary was, however, here to read in the paper all about the hoard of thirty-four pieces of Roman silver unearthed by ploughman Gordon Butler in a field in Mildenhall, Suffolk, in January 1942. Butler was using a motorised plough, allowing deeper-than-ever furrows for planting beets, and struck great plates and bowls down there. The details were uncertain, it was wartime after all, but commentators, Roald Dahl among them, described Butler lugging the silver to Sydney Ford, the tenant farmer employing him, who took it all home with him, washed it, restored it, even using the Great Dish for family

occasions, apparently unaware of its importance, or perhaps not wanting to share it with his ploughman. The story went that a visiting friend who knew about these things noticed two Roman silver spoons on Ford's kitchen table quite by chance, and triggered an inquest, and the find was declared a 'Treasure Trove'. The British Museum bought it and Butcher and Ford were each awarded £1,000 as co-finders, although it had been Butler's plough, and less than the full value because they had not reported it in time.

Both were elsewhere when 'Piltdown man' was exposed as a forgery, in November 1953, bringing together many of the figures on the periphery of the Cheapside story in a kind of archaeological finale to the period. The skull, 'found' by the amateur archaeologist Charles Dawson, in East Sussex, and hailed at the Royal Geographical Society in 1912 as the 'missing link' between man and ape, on closer scientific inspection, turned out to be a selection of human and orangutan bones fused expertly together. Sir Arthur Conan Doyle happened to live near Piltdown and played golf at the site, and there were, naturally, rumours of his involvement in the hoax, although his proximity was no more than a coincidence. Predictably, given his track record, Horace de Vere Cole was also suspected of being behind it, but modern scientific sleuthing suggested Dawson alone had pulled off the *coup de théâtre*, for reasons unknown, and nearly got away with it. Winston Churchill fell for it and put 'Piltdown Man' into his first draft of *A History of the English Speaking Peoples* as the 'first Englishman'. Fortune smiled on Churchill, however, and he decided to send a proof manuscript to Mortimer Wheeler, who had just caught wind of the exposé,

and he just had time to delete the reference from the text before it went to press.

In 1976 the Cheapside Hoard moved with the London Museum when it amalgamated with the City Corporation's Guildhall Museum, reuniting the long-separated treasures inside the renamed 'Museum of London', in the Brutalist concrete building put, poetically enough, directly on top of Beech Street where the Lawrence family pawnbrokers once operated.

The Hoard appeared altogether at home in a wonderful exhibition in 2013, reunited with yet more of its constituent parts from the British Museum, the exhibits masterfully hung so that a visitor could walk around the treasures and see them from all sides, thereafter keeping a low profile for a decade.

At time of writing, treasures of the Cheapside Hoard are in boxes again, between homes, waiting to be portered to a new purpose-built Museum on the site of the old Smithfield Meat Market at the northern edge of the City. The objects are being reevaluated and reorganised and it's a good moment, a good vantage point, from which to look back at the story of their discovery, and consider their meaning to the people who found them, coveted them, sold them and hid them over the following decades.

Recent thefts from the British Museum have shown us how treasures act on the imagination and what they can make us do. The thousands of stolen antiquities date back to the fifteenth century BCE and include semi-precious gems featuring classical scenes, with some of the gems set in finger rings, others loose, and bright gold necklaces from ancient Greece, objects very like those in the Cheapside Hoard, though not from the collection.

They represent more proof of the value and influence of ancient treasures well beyond their market value.

The thief could only have come from inside the institution, and whoever got so many objects out of the Museum strongroom at such a slow and steady pace had been working there for a very long time. Long enough to suggest a sense of duty and vocation, but that – at some point – the temptation grew too great.

The stolen objects were uncatalogued, referenced only occasionally by academics, and whoever stole them knew they would likely not be missed. They were spirited out of a strongroom over several decades and trafficked onto eBay, scattered to the wind, out to sea. Some have been found, others could be anywhere in the world.

The man in the dock for this, a curator at the Museum, of decades' experience, is someone with a puzzling profile for a suspected thief, since their lifestyle, like G.F. Lawrence's, has remained seemingly modest, unchanged over the decades during which so many objects were smuggled out of the building to market.

The thefts may well trigger a reverse force in the flow of antiquities stronger than anything the thief, or thieves, likely intended. If the treasures are not safer in our flagship national institution than in their countries of origin, the British Museum forfeits an excuse not to give them back, and some of the world's most significant objects will be returning in greater and greater numbers to where they came from. The 'Parthenon Marbles' and the 'Benin Bronzes' are first in line.

In the meantime, the British Museum has recovered many of the stolen items, and has already curated an exhibition of the

retrieved items – proof, if any were needed, that the charisma of an ancient gem or jewel is only enhanced if it's been lost, and then recovered, becoming more valuable still if we can observe it in a display case and wonder what happened to it and who might have owned it before – and why they let it go. It's the same mystique that we see in the Cheapside Hoard, the treasures offering us the pleasures of escape, a sense of continuity, a good origin story.

Acknowledgements

Pinpointing the moments individuals took pieces from the Hoard, separating them from the rest of the collection, is fiendishly difficult. They were, necessarily, private deeds, taking place behind closed doors with few if any witnesses, for the most part in cellars or the corner of public bars. The act of the taking was either spur-of-the-moment or very carefully planned, but either way clandestine, maybe regretted, and unlikely to be documented for the historian. More often than not all we have to navigate by is the moment someone else notices an object is missing (usually a slow-burning realisation) or when an object pops up in a sale catalogue (and disappears again). Sometimes the starting point is the moment an object returns, and we have to work backwards. I have attempted to join the dots between the all-too-rare appearances by establishing character, ascertaining possible motives and opportunities, piecing together the sources: the Museum and auction sale catalogues (and the gaps in those catalogues), the diaries and shop receipts, and the family memories generously offered by descendants of George Fabian Lawrence. This is my account of what most likely happened, based on the evidence, but the only objective

witnesses are the gems and jewels themselves, which 'speak' loudly but not necessarily in a way that's helpful to a detective's purposes. Similarly, several of the key personalities, Lawrence's daughter Ethel May and his son Frederick Lawrence, appear on the radar with frustrating infrequency in the censuses, in hospital admissions, marriage, death and probate records, and where there is omertà I have endeavoured to build a picture of how things may have played out for a person of their class and situation. I am therefore indebted to many archivists and librarians who have helped me: at the London Metropolitan Archive, the British Museum Library, the Goldsmiths' Company Library and Archive, the Art Library at the V&A, the Natural History Library, the London Library, and Helen Whittle at the Museum of London.

Above all, I have to thank my brilliant editor at Oneworld, Sam Carter, fiercely clever, funny, kind and endlessly encouraging.

Huge thanks are also due to Rida Vaquas for her invaluable insights; to Ross Jamieson for casting his skilful eye across the manuscript; Hannah Haseloff and Matilda Warner for their ideas and help; Paul Nash, and all the team at Oneworld, a wonderful place for a writer to find herself. Thanks also to my agent, Luigi Bonomi and all at LBA Associates for their support of the project from the beginning.

Several texts are key sources for this book and I am indebted to them: Firstly, Francis Sheppard's *Treasury of London's Past* from 1991, and Jean Macdonald's paper on 'Stony Jack's Roman London', included in *Interpreting Roman London* a volume in memory of the archaeologist Hugh Chapman. I owe a huge debt of thanks also to Rosemary Weinstein and her extensive

research into the identity of the original owner of the Cheapside Hoard, particularly her breakthrough discovery, published as 'A Goldsmith's Row Mystery' for the London Topographical Society in 2021, giving us a name for our mystery man. My thanks are also due to Kris Lane for his research into Polman and the fate of the jewels on the *Discovery*, in his 2010 book *Colour of Paradise: The Emerald in the Age of Gunpowder Empires*.

I'm so very grateful to Hazel Forsyth at the Museum of London, a great support, who has generously shared with me her research and peerless expertise about the Hoard and its period. It was she who tipped me off about the missing St George ring, and the existence of the 'Cheapside Ghost' letter in an unopened file – and let me read it! Her writing on the Cheapside Hoard has been a touchpoint for me throughout the writing of this book, including *The Cheapside Hoard: London's Lost Jewels*, the companion work to her 2013 show at the Museum of London, where I first came face to face with the treasures, hanging suspended in space so that it was possible to walk around them, and encountered 'Stony Jack' and felt inspired to dig deeper. Thanks are due to Tony and Teresa Smith for sharing their personal cuttings archive and their memories of Gweneth Lawrence.

Thank you as ever to Mohit (who always carries a 'lucky' stone in his pocket even though he thinks that sort of thing is nonsense) and Kit, a charm of a child, for cheering me on and keeping the home fires burning. Thanks also to my parents, Ann and Jack, and to Nora, Esmee and Rose; Katie and Jo, and all my family and friends for keeping us company and listening to this story as it unfolded.

List of Illustrations

INTERIOR

1. St George and Dragon ring from 1928 catalogue photographs. Author's photograph.
2. St George and Dragon ring illustration from 1928 catalogue. Author's photograph.
3. Cheapside Hoard 'Ghost letter' folder cover. Courtesy of the Museum of London.
4. Cheapside Hoard 'Ghost letter', sample writing page. Courtesy of the Museum of London.
5. Cheapside Hoard 'Ghost letter' pencil drawing of Elizabethan ghost. Courtesy of the Museum of London.

PLATE SECTION

1. George Fabian Lawrence, 'Stony Jack', at work in in the London Museum © London Museum.
2. George Fabian Lawrence's letterhead. Author's photograph, taken by kind permission of the Museum of London.
3. G.F. Lawrence outside his establishment, featured in the *Graphic* magazine, 7 July 1928. Photographer unknown.

4. West Hill, Wandsworth *c.* 1904. Wikimedia.
5. Navvies at work on a train line through central London. Alamy Stock Photo.
6. Cheapside by Friday Street, *c.* 1880 by Henry Dixon. Courtesy of the Yale Center for British Art.
7. Thomas Henry Smith's section plan of Wakefield House. The London Archives, City of London.
8. The Royal Family at the Inauguration of London Museum by A. J. Balliol Salmon, 1912 © London Museum.
9. Churchman's Cigarette Card from the 'Treasure Trove' Series. No. 8: 'The Cheapside Hoard', 1937. Artist unknown. Author's collection and photograph.
10. Sensational press surrounding the Elizabethan 'ghost' supposedly haunting the Hoard, *Evening Telegraph*, 1 December 1919. Courtesy of DC Thomson & Co Ltd.
11. Lord Carnarvon, *c.* 1922. Alamy Stock Photo.
12. Howard Carter, 1925. Alamy Stock Photo.
13. Plate from *The Cheapside Hoard of Elizabethan and Jacobean Jewellery* (London Museum, 1928). Photographed by Hayley Warnham.
14. Ibid.
15. Ibid.

Notes

PROLOGUE

1 Jung, Carl, *The Collected Works of C.G. Jung*, Volume 14 'Mysterium Coniunctionis' (Princeton University Press, 1970), p. 531, para 756.
2 Baudrillard, Jean, *The System of Objects*, trans. James Benedict (Verso, 1996). First published as *Le système des objets* (Editions Gallimard, 1968).
3 Cavendish, Margaret, 'Of Many Worlds in This World' and 'A World in an Earring', *Poems and Fancies* (J. Martyn and J. Allestrye, 1653).

THE CELLAR

1 London Metropolitan Archives, Trollope and Colls Limited (Builders), including 'prime cost' book for Debenham and Freebody. See John Mowlem and Co. Ltd, Messrs Higgs, builders, and Holliday and Greenwood, building contractors, for interesting comparison. Reference: B/TRL.
2 See Dahl, Roald, *The Mildenhall Treasure* (Jonathan Cape, 1999) for a non-fiction account of the discovery of a hoard of Roman silverware by farmers Butcher and Ford in a beet field in Mildenhall, 1942. First published 1947 in an article 'He Ploughed up $1,000,000' for U.S. magazine *The Saturday Evening Post*.

3 For variation in the second-hand accounts of the discovery of the Hoard, including confusion and controversies as to the details, see Sheppard, Francis, *The Treasury of London's Past* (Museum of London, 1991); Gosling, James G., 'The Cheapside Hoard Confusion', *The Journal of Gemmology*, Volume 24, No. 6, April 1995. Bell, Walter G., 'City Hoard Tudor Jewels Buried in Cheapside', article to mark publication of Mortimer Wheeler's catalogue of the Hoard, March 1928 (taken from Lawrence family cuttings, title of publication obscure); 'Cityhood to the Jewels Buried in Cheapside', *The Museum of London Handbook*, 1985; Murdoch, Tessa, *Treasures and Trinkets: Jewellery in London from Pre-Roman Times to the 1930s* (Museum of London, 1991); Evans, Joan, *A History of Jewellery 1100–1870*, Vol. 2 (Faber & Faber, 1953); Jobbins, E.A., 'The Gemmology of the Cheapside Hoard', *Goldsmiths Technical Digest 1990/91* (The Worshipful Company of Goldsmiths, 1991), pp. 22–5; Forsyth, Hazel, *The Cheapside Hoard* (Museum of London, 2003); 'England's King of Collectors', *Daily Express*, 27 June 1928; *Dundee Evening Telegraph*, 1 December 1919, p. 4.
4 Stevenson, Robert Louis, *Treasure Island*, Chapter XXXII, 'The Treasure Hunt – The Voice Among the Trees' (Cassell & Co., 1883), pp. 267–75.
5 Rider Haggard, Sir H., *King Solomon's Mines*, Chapter XVII 'Solomon's Treasure Chamber' (Cassell & Co., 1885), pp. 202–213.
6 *Treasure Island*, Chapter XXXIII, 'The Death of a Chieftain'.
7 The navvies would also have passed near the Sackville Gallery in Piccadilly. In March 1912 the venue had hosted an 'Exhibition of Works by the Italian Futurist Painters', an *avant-garde* showcase of four young Italian painters, in the heart of the Old Master art world of the day. The exhibition had come from Paris and was continuing in Berlin, startling audiences with its reforming energy, and it was a sign of a changing mood in the country and abroad, one that many did not want to acknowledge. The local press deflected the artists' 'professed artistic and professional anarchism' and framed it as 'harmless entertainment'. (See Pezzini, Barbara, 'The 1912 Futurist exhibition at the Sackville Gallery, London: an avant-garde show

within the old-master trade', *Burlington Magazine*, 2013. Also Somigli, Luca, *Legitimizing the Artist, Manifesto Writing and European Modernism 1885–1915* (University of Toronto Press, 2003), pp. 168–74.)
8 Morton, 'The Shop Which Sells the Past, The Magic of London – 4', *Daily Herald*, 21 January 1932.
9 Morton interviewed for a book programme, 1975.
10 Museum of London (MoL), Port of London Authority Library File, 13.
11 *Daily Herald*, Thursday, 21 January 1932.

THE JEWELS MAKE AN ENTRANCE

1 In his memoir *In Search of London* (Methuen & Bird, 1951) H.V. Morton claimed to have been there to witness the arrival of the treasures. See pp. 16–19; p. 18 for appearance of navvies.
2 Morton, 'England's King of Collectors', *Daily Express*, 24 June 1928; 'H.V. Morton Finds the Shop that Sells the Past', *Daily Herald*, 21 January 1932. Morton gave various alternative accounts of the arrival of the treasures at Lawrence's shop at 7 West Hill over the decades.
3 Morton, *In Search of London*, 1951.
4 Ibid.
5 Morton, *Daily Express*, 24 June 1928.
6 [Lawrence] 'understood networking long before it became a buzzword, and leveraged connections like a latter-day Fagin.' JoAnn Spears, 'The Cheapside Hoard', On the Tudor Trail (online), 23 February 2012, accessed 14 December 2024. See also Mike Dash, 'Stoney Jack and the Cheapside Hoard', A Blast from the Past (online), 19 August 2013, accessed 10 December 2024.
7 'Samian' taken from the Aegean island of Samos, famous for its tableware, also known as 'Terra Insigillata', meaning 'clay impressed with designs'.
8 Morton, *In Search of London*.
9 Morton, *Daily Express*, 24 June 1928.
10 Morton, *In Search of London*.

11 Ibid.
12 Lawrence reminiscing with Morton about the arrival of the treasures at his shop, *Daily Herald*, 21 January 1932.
13 Morton, *Daily Express*, 24 June 1928.
14 *Where the Rainbow Ends*, by 'Clifford Mills' (Emilie Clifford) and 'John Ramsey' (Reginald Owen), with music by Roger Quilter.

THE LAWRENCE FAMILY GUARD THE TREASURE

1 Morton, 'England's King of Collectors', *Daily Express*, 24 July 1918.
2 For folklore and prevalent superstitions about toadstones see Dalton, O.M, *Franks Bequest Catalogue of the Finger Rings, Early Christian, Byzantine, Teutonic, Mediaeval and Later, Bequeathed by Sir Augustus Wollaston Franks, KCB* (Oxford University Press, 1912), pp. xlvi, 142–143.
3 Lockhart, J.G., *Memoirs of the Life of Sir Walter Scott*, Bart. Vol. 1, p. 415 (Carey, Lea, & Blanchard, 1837), p. 415.
4 Doyle, Arthur Conan, 'The Adventure of the Blue Carbuncle', in *The Adventures of Sherlock Holmes* (George Newnes, 1892).
5 The Housing Act of the Working Classes, 1900 gave local councils the power to purchase land and build houses (London had enjoyed these powers since 1890) and some estates had been built.
6 Between ten and twenty percent owned their own homes pre-First World War. See Holmans, A.E., 'Historical Statistics of Housing in Britain' (Cambridge Centre for Housing and Planning Research, 2005). See 'A Century of Home Ownership in England and Wales', Office for National Statistics, 2011 Census Analysis.
7 Sheppard, Ronald and Newton, Edward, *The Story of Bread* (Charles T. Branford Company, 1957).

THE JEWELS GO OUT INTO THE WORLD

1 *Tatler*, 25 September 1912.

2 See Sheppard, *The Treasury of London's Past*, Chapter IV, 'The London Museum'.
3 Channon, Henry, ed. Rhodes James, Robert, *Chips: The Diary of Sir Henry Channon* (Phoenix, 1996, first published 1967).
4 MoL A14000376, Letter book No. 4.
5 Morton, *In Search of London*, p. 18.

A PAWNBROKER'S SON

1 Dickens, Charles, *Sketches by Boz, Illustrative of Everyday Life and Everyday People*, Chapter 23, 'The Pawnbroker's Shop' (John Macrone, 1836).

INSIDER TRADING AND THE EGYPTIAN BOOK OF THE DEAD

1 In his memoir, *In Search of London*, H.V. Morton corroborates this, writing of Lawrence's 'daughter, who, I seem to remember, was a medium'.
2 Lord Esher quoted in Lees-Milne, James, *The Enigmatic Edwardian* (Sidgwick & Jackson, 1986).
3 James, Edward, ed. George Melly, *Swans Reflecting Elephants: My Early Years* (Weidenfeld, 1982), Chapter III, 'Shades of the Prison House'. Edward James became a poet and well-known patron of the Surrealist movement, painted twice by Magritte. He recalled in his memoir that 'something really awful happened' when he went with his mother as an Eton schoolboy of 'twelve or thirteen' to a weekend house party at the Harcourt country estate, Nuneham Courtenay, around 1919. He claimed to have been cornered on multiple occasions and subjected to indecent exposure and groping. When he confessed to his mother she was naturally appalled, and told everyone she knew when they got home – and she knew everyone. Evelyn Forbes James was a Scottish socialite and enthusiastic thrower

of house parties at her estate in West Dean, West Sussex. She had been a friend of King Edward VII, when he was Prince of Wales, and he was James's godfather (rumours were that the king was James's real father, but James believed that Edward had actually fathered his mother, rather than being her lover, and that the king was therefore his grandfather). James's cousin, the Bloomsbury-set painter, Esher's daughter, also accused Harcourt of attempting a sexual assault on her when she was fifteen.

4 Hynes, Samuel, *The Edwardian Turn of Mind* (Princeton University Press, 1968), p. 4.
5 See Petrie, Sir William Flinders, *Seventy Years in Archaeology* (Cambridge University Press, 2013; first published 1931), p. 192.
6 Wilkinson, Toby and Julian Platt, *Aristocrats and Archaeologists: An Edwardian Journey on the Nile* (AUC Press, 2017).
7 Platt's letters to his daughter May.
8 See Oates's personal 1917 catalogue and handwritten addendum noting the later acquisition of a Roman silver ring featuring the gods Isis and Serapis, given to him by Lawrence in 1919.

THE HOARD ON SHOW IN THE GLITTERING GOLD ROOM

1 See Sheppard, *The Treasury of London's Past*, Chapter IV, 'The London Museum'. Laking writing to Esher, 3 March 1914, MoL DC3/7, 349; Laking to Harcourt, 13 March 1914, MoL DC3/7, 488; Laking to Esher, DC3/7, 292.
2 Sheppard, p. 86
3 Royal Archives, Windsor QM/PRIV/CC26/93, Queen Mary to Augusta, Grand Duchess of Mecklenburg Strelitz, 15 July 1914. See Ridley, Jane, *George V: Never a Dull Moment* (Chatto & Windus, 2021).
4 Queen Mary organised a private view of the Museum in its new premises in Kensington Palace the night before its official opening in 1951.

5 Harcourt paid Seymour Lucas £1,000 for his costumes, around £140,000 today.
6 'Daily Graphic' featured in the *Sutton Coldfield News*, 16 September 1911.
7 Bell, Walter G., 'City Hoard', article to mark publication Mortimer Wheeler's catalogue of the Hoard, March 1928 (source: Lawrence family cuttings, publication title obscure).
8 Ibid.
9 Mortimer Wheeler in his preface to the 1928 catalogue.
10 Bell, Walter G., 'City Hoard' article, March 1928.
11 Mortimer Wheeler in a letter to W.T. Gordon, Kings College, London, 23 March 1928 (MoL, A14).
12 Mortimer Wheeler quotes J.S. Brewer *The Reign of Henry VIII from his Accession to the Death of Wolsey*, I, 10, ed. James Gairdner (John Murray, 1884); See H. Clifford Smith, *Jewellery* (Methuen & Co., 1908), pp. 206–7.
13 King and Queen and old London – Visit to Stafford House, his Majesty's Message, *Daily Telegraph*, Saturday 21 March 1914.
14 'London Museum at Stafford House – Elizabethan Jewels', *Daily Telegraph*, Thursday, 19 March 1914.
15 *Westminster Gazette*, 19 March 1914.
16 Bell, Walter G., 'City Hoard' article, March 1928.
17 *Manchester Courier*, 19 March 1914.

THE QUEEN'S PRIVATE VIEWS

1 See Princess Olga Romanoff's interview for an article in the *Daily Mail*, 11 May 2021. As a descendant of George V's cousin Tsar Nicholas II, her version of Mary must be seen in the context of her family's grievance against the British royal family for selling off the Romanov jewels after the Revolution of 1917 in murky circumstances. See Perry, John Curtis, *The Flight of the Romanovs* (Basic Books, 1999).
2 See Edwards, Anne, *Matriarch: Queen Mary and the House of Windsor* (Rowman & Littlefield, 2014; first published 1984), p. 234.

3 Royal Archives, Mary, then Princess of Wales, letter to close friend and wealthy collector Lady Mount Stephen, 10 February 1910. See Pope-Hennessy, James, *Queen Mary, 1867–1953* (George Allen & Unwin Ltd, 1959) p. 410.
4 Queen Mary in a letter to Lady Mount Stephen, 12 March 1914. See Pope-Hennessy *Queen Mary, 1867–1953*, p. 411.
5 Copy of a letter from Queen Mary to Sir Cecil Harcourt Smith regarding the return of historic royal loans from the V&A to Buckingham Palace in 1919 (V&A Archive, MA/1/R1949/8. © Victoria and Albert Museum, London). See Matthew Abel, 'The Curator Queen: Queen Mary and the V&A' (online), 2 March 2020, accessed 9 December 2024.
6 The king and queen read *The Mail* most assiduously, according to Lord Crewe, the secretary of state for India.
7 Dickie, John, *The Craft: How the Freemasons Made the Modern World* (Hodder & Stoughton, 2020). Dickie gathered some first-hand intelligence of the initiation ceremonies.
8 *Westminster Gazette*, 19 March 1914.
9 James Pope-Hennessy published Queen Mary's official biography in 1959, but took additional notes of confidential conversations with her friends, family and courtiers, stipulating that they were not to be published for fifty years. These notes appear unexpurgated in Hugo Vickers's edit of Pope-Hennessy's work, *The Quest for Queen Mary* (Hodder & Stoughton, 2019), reporting the gossip.
10 *Where the Rainbow Ends*, by 'Clifford Mills' (Emilie Clifford) and 'John Ramsey' (Reginald Owen), with music by Roger Quilter. According to Anne Edwards, the American newspaper columnist with the byline 'Cholly Knickerbocker' nicknamed the King and Queen 'George and the Dragon' and a cartoon was published after the war in America depicting a vast Mary wearing an apron and holding a miniature King George on a string. Lady Airlie reported that someone sent a clipping of the cartoon to the Queen and the pair 'laughed together over its absurdity.' See Edwards, *Matriarch, Queen Mary and the House of Windsor*, p. 324.

11 Ascengreen Piacenti, Kirsten; Boardman, John, *Ancient and Modern Gems and Jewels in the Collection of Her Majesty The Queen* (The Royal Collection, 2008).
12 Shakespeare, William, *Twelfth Night*, Act II, Scene IV.

WHO WILL PROTECT A MAN THESE DAYS?

1 Morton, *In Search of London*, p. 18.
2 Morton, *Daily Express*, 24 July 1928.
3 Sheppard, *Treasury of London's Past*, pp. 50–51.
4 MoL, Port of London Authority Library File, 13.
5 MoL, DC3/04,1912.
6 Morton, H.V., *In Search of London*, p. 16.
7 See 'British Religion in Numbers', a comprehensive database of religious data sources, hosted by Manchester University, including government data, opinion polls and historical faith community sources.
8 MoL, Annual report (1984), 9.
9 Dickie, John, *The Craft: How the Freemasons Made the Modern World* (Hodder & Stoughton, 2020).
10 See Dickie, *The Craft...*, who gathered some first-hand intelligence of the initiation ceremonies.
11 Gould, Robert Freke, *Gould's History of Freemasonry* (Thomas C. Jack, 1882), Volume 1, pl. facing 163, nos 55, 77, pl. facing 166; 3, nos 84, 86, pl. facing 106, no. 3.
12 See Jean Macdonald's essay, 'Stony Jack's Roman London', in *Interpreting Roman London: Papers in Memory of Hugh Chapman*, Monograph No. 58, Eds. J. Bird, M. Hassall and Harvey Sheldon (Oxbow Books, 1996).

THE TREASURES GO BACK UNDERGROUND

1 Brewer, Reverend E. Cobham, *Brewer's Dictionary of Phrase and Fable* (Cassell & Co., 1898), p. 518.

2 Museum of London archive: Lambert 1915, 240, no. 1; accession no.: A11876.
3 Museum of London archive: Lambert 1915, 240, no. 1; MoL A11876 / A11406; Lambert 1915, 235–62. See also Merrifield, Ralph, *The Roman City of London* (Ernest Benn, 1965), pp. 8, 199 no. 35.
4 Sheppard, *Treasury of London's Past*.
5 MoL A14000376.
6 According to his Service Attestation, a document created at enlistment.
7 We know of Read's fate thanks to a few documents that survived him: his Active Service Casualty Form; next of kin records, and the record of a bronze commemorative plaque issued on the death of a serving soldier, known as the 'Dead Man's Penny', along with a scroll showing the name, rank and regiment of the deceased, accompanied by a 'King's Message'.
8 See letter from Queen Mary to Augusta, Dowager Duchess of Mecklenburg-Strelitz, 24 March 1916 (Royal Archives, Windsor).
9 See Lenman, Bruce P., 'Jacobean Goldsmith-Jewellers as Credit-Creators: The Cases of James Mossman, James Cockie and George Heriot', *Scottish Historical Review* (1995) LXXIV, no. 2, 198, pp. 171, 173. See also Auble, Cassandra, 'The Cultural Significance of Precious Stones in Early Modern England' (University of Nebraska, 2011).
10 First recorded evidence of the diamond is a dowry entry for Valentina Visconti, daughter of the Duke of Milan.
11 Nichols, John, *The Progresses, Processions and Magnificent Festivities of King James the First, Vol II* (John Nichols, 1828), pp. 46–7.
12 See Humphrey, David, 'To Sell England's Jewels: Queen Henrietta Maria's Visits to the Continent, 1642 and 1644', *E-rea: Revue électronique d'études sur le monde anglophone*, 11.2 (2014).
13 Harleian MS 7379:2, cited in Humphrey (2014).
14 Sowerby, E. Millicent, *Rare People and Rare Books* (Constable, 1967).
15 Lawrence himself later corrected 'errors' in provenance. In one instance Tessa Verney, the archaeologist and Mrs Mortimer Wheeler wrote in the *Antiquaries Journal*, 'Mr Lawrence informs me that the

find spot given in the 1917 catalogue [found at Windsor 1900] is incorrect, and that the ring was found in Worship Street, E.C.2.' *The Antiquaries Journal*, Volume 14, issue 4, October 1934, pp. 430–1.
16 Morton, *Daily Express*, 27 June 1928.

THE SHOW MUST GO ON

1 Pliny the Elder, *Natural History*, Volume IX, Book XXXIII, LCL 394 18–19, trans. H. Rackham, Loeb Classical Library 394 (Harvard University Press, 1952). See Jones, William, *Finger-Ring Lore: Historical, Legendary, Anecdotal* (Chatto & Windus, 1877). See also Kunz, George Frederick, *The Curious Lore of Precious Stone* (J.B. Lippincott, 1913).
2 Harman Oates's annotated personal copy of his 1917 ring catalogue, shared by kind permission of his great grandson, Martyn Oates.
3 Gardiner, Muriel (ed.), *The Wolf Man by The Wolf Man* (Noon Day, 1991), p. 139.
4 *Evening Mail*, 26 June 1922.
5 As told in the (London) *Daily News*, January 1921. Lady Glenconner's eldest son, Andrew Wyndham Tennant, known as 'Bim', served in the Fourth Grenadier Guards and fell, like Walter Read, in the Battle of the Somme. She wrote a memoir, *The Earthen Vessel* (Bodley Head, 1921), about her experiences with a 'professional' medium, Mrs Gladys Osborne Leonard, who conducted so-called 'book tests', channelling a spirit at a séance who then led Mrs Leonard to passages in books in their family library conveying such personal meanings to the bereaved they were filled with joy.
6 *Sheffield Evening Telegraph*, 28 April 1919.
7 *St Helen's Examiner*, October 1920.
8 See Rose Steveley Wadham, 'Understanding the 1920s Spiritualism Revival', British Newspaper Archive (online), 14 October 2021, accessed 19 December 2024.
9 Morton, H.V., 'England's King of Collectors', *Daily Express*, 27 June 1928.

10 'London's Buried Treasures', *Weekly Dispatch* (London), 5 August 1928.
11 Article entitled 'Ghostly Museum Treasures', *Evening Telegraph*, Monday, 1 December 1919.
12 *Evening Telegraph*, Monday, 1 December 1919.
13 Walter Henderson, writing in personal correspondence, suggested that the legend of the ghostly jeweller originated with Ethel May. See Macdonald, Jean, 'Stony Jack's Roman London', *Interpreting Roman London* (1996), p. 251, note 2.
14 *Evening Telegraph*, Monday, 1 December 1919.
15 Government figures on the cost of food and fuel for 1905, 1912 and 1920. Based on government sources, the *Board of Trade/Ministry of Labour Gazette* and the Ministry of Food 1920. Figures on the contemporary cost of living collected by the Dock, Wharf, Riverside and General Workers' Union of Great Britain and Ireland as part of their evidence for the 1920 Court of Inquiry into Wages, Rates and Conditions of Men Engaged in Dock and Waterside Labour (also known as the Shaw Inquiry).
16 *Evening Telegraph*, Monday, 1 December 1919.

THE QUESTION OF IDENTITY AND THE ORIGINAL OWNER

1 See Honoré de Balzac's miser in his novel *Eugénie Grandet* (1833) set in a vast chateau on the Loire. Felix Grandet is a wine merchant and acquirer of vast wealth after the Revolution; his parsimony has turned to pathological hoarding and meanness to his Eugénie, who is to inherit, letting the house fall down, rationing slices of bread and keeping the gold locked away – Balzac gives a coruscating portrait of a bourgeois who has made money his god: 'there was no one not persuaded that Monsieur Grandet had a private treasure, some hiding place full of Louis, where he nightly took ineffable delight in gazing upon great masses of gold. Avaricious people gathered proof of this when they looked into the eyes of the good

man, to which the yellow metal seemed to have conveyed its tints.' English trans. Katherine Prescott Wormeley (Roberts Brothers, 1886).

2 The swan on the Stafford badge came from the family's connections to the Bohun family of Buckinghamshire who first used the swan in their insignia. This is the same swan that appears on a stone plaque on the front of the building sited on the opposite corner to Wakefield House, where Friday Street meets Cheapside, often mistaken for the site of the discovery of the Hoard. It's apparently no more than a coincidence.

3 See Lane, Kris, *Colour of Paradise: The Emerald in the Age of Gunpowder Empires* (Yale University Press, 2010). See also Forsyth, Hazel, *London's Lost Jewels: The Cheapside Hoard* (Philip Wilson Publishers, 2013) for her comprehensive account.

4 Dep. 1, Elizabeth Addams, Christopher Addams's wife.

5 Dep. 44, Christopher Addams.

6 Dep. 58, Jeremy Sambrook, Gent, reference to entry in the purser's book 'for the shippe called Discoverye belonging to the Company that one Gerrard Pulman died… On 30 June 1631'. See also Dep. 41, Edward Castleton: 'four months after ship set sale, upon the southern coast of Africa, Polman died.' Dep. 46, Thomas Parker, 'lapidary', describes how the accomplices split the treasure.

7 *Treasure Island*, Chapter XXXIII 'The Fall of a Chieftain'.

8 The trade card of 'William Smith, Jeweller and Working Goldsmith', in a directory compiled by Ambrose Heal, 1643, gives Smith's address as 'The Black Moor's Head, opposite Gutter Lane, Cheapside'. Records show a William Smith living on the site of Wakefield House, suggesting the sites are one and the same.

9 *The Treatises of Benvenuto Cellini on Goldsmithing and Sculpture*, 1568. See John Webster's *The Duchess of Malfi* (1612–13), 'Whether we fall by ambition. Blood or lust / Like diamonds we are cut with our own dust.' (*Ferdinand*, Act V, Scene V.)

10 William Taylor's lease, 6 August 1654 (GC MS 1915, fol. 130): 'All which demised premises were sometime in the holding of Francis Sympson and John Sympson…' See Weinstein, Rosemary,

'A Goldsmith's Row Mystery', *London Topographical Society Record*, XXXII, 2021, pp. 179–81. Also, *Who Hid the Cheapside Hoard?* Weinstein's lecture for the Society of Antiquaries, April 2023. Weinstein's groundbreaking archival research and the evidence she pieced together builds a strong case for Francis Simpson as the original owner of the Cheapside Hoard.

11 Thomas Simpson, Francis and his brothers' father, was also a notorious counterfeit jewel-maker who found himself in trouble many times for faking jewels by carving quartz crystals and then dying them to pass them off as the real thing: two counterfeit 'rubies' of a similar style appear in the Hoard.

12 Weinstein, *London Topographical Record*, XXXII, p. 183. The National Archives LC3/1, fol. 4v (1642); LC 3/2; LC5-135 Warrant 5 October 1643, PCO 5/7 Grant, May 1644. The previous royal jeweller was presumably otherwise engaged. Another royal jeweller, William Herrick, apprenticed to his brother Nicholas Herrick on Cheapside, later based himself just behind Cheapside, on Wood Street, becoming rich enough to purchase Beau Manor Park from the Queen's favourite, the Earl of Essex. Herrick caught Queen Elizabeth's eye and became MP for Leicester, and later a principal jeweller to King James and Anne of Denmark. He lived to a very old age, dying in 1653.

13 *Calendar of State Papers Domestic: Charles II: 1660–1*, ed. Mary Anne Everett Green (Her Majesty's Stationery Office, 1860), Vol. 1, p. 77. See Diana Scarisbrick, *Jewellery in Britain, 1066–1837: A Documentary, Social, Literary and Artistic Survey* (Michael Russelll, 1994), p. 171.

14 The National Archive, Inventory of Francis Simpson, PROB 32/9/47, 4 June 1667.

15 Parliamentary Archives HL/PO/JO/10/1/199 and 71. Francus Simpson deposition 66, 21 October 1641, emerald seen 1632. See Weinstein, 'A Goldsmith's Row Mystery', *London Topographical Society Record*, XXXII, 2021.

16 The Howards did indeed have to leave the country for the safety of the continent, and like Simpson, Viscount Stafford, survived the

war. In the end, however, the viscount was framed by none other than Titus Oates in his 'Popish Plot' of 1678, which saw him tried and executed in 1680 for Treason before Oates's dastardly scheme could be discredited. Simpson had managed to duck and dive more successfully.

THE CHANCE OF ESCAPE

1 After some audacious stalling for time by the London Museum, in March 1921 the City solicitor gracefully declined the Museum's reluctant offer to present the puller to the Library Committee (MoL A25501. See Merrifield, 1965, pp. 233, np. 146.
2 In his 1951 memoir *In Search of London*, H.V. Morton remembers how 'The authorities of Guildhall Museum, on whose territory he was poaching, looked upon him as a dangerous pirate, and many were the bitter complaints lodged against him...in any case Lawrence was unmoved.'
3 Hope was created 1st Marquess of Linlithgow on his return to England. Hope and his wife had four children, one of whom, Victor, 2nd Lord Linlithgow, became the longest-serving Viceroy of India.
4 Howard Carter's excavation journals and diaries, as transcribed and published online by the Griffith Institute, University of Oxford.
5 Morton, *Daily Express*, 17 February 1923.
6 Reid, Donald Malcolm, *Contesting Antiquity in Egypt: Archaeologies, Museums and the Struggle for Identities From World War I to Nasser* (American University in Cairo Press, 2015).
7 Howard Carter Excavation Diaries as transcribed by the Griffith Institute, University of Oxford. Howard Carter's journal for the 4th excavation season of the tomb of Tutankhamun which took place between autumn 1925 and spring 1926.
8 Hewlett, Geoffrey, *A History of Wembley* (Brent Library Service, 1979), pp. 176–8.
9 *The Aberdeen Press and Journal*, 17 August 1933.

10 The morning paper announced the death of Lord Harcourt on 22 February 1922 at his house on Berkeley Square, near to the cupboard he was reputed to have used to store Hoard in the early days. 'LouLou' was found dead next to a draft of the biography he was editing about his father and political partner Sir William. The rumour was that he had committed suicide and, wittingly or unwittingly, he had overdosed on the sleeping draft, Bromidia. An Inquest returned a verdict of misadventure. The coroner found heart failure and sudden oedema of the lungs brought on by the draft and threw out the suggestion that Harcourt had taken his own life after speaking to his physician, who confirmed the underlying weaknesses. The ongoing work on his book was apparent evidence that he had every intention of living to finish the job. Nevertheless, rumours of suicide persisted in society circles, following allegations of sexual impropriety with, among others, Edward James. See James, *Swans Reflecting Elephants: My Early Years*, ed. George Melly (Weidenfeld, 1982). Whether or not fear of a public disgrace drove him to suicide, society was finding his behaviour harder to ignore or to cover.

11 See Jean Macdonald, 'Stony Jack's Roman London', *Interpreting Roman London*, p. 247/MoL DC3/13.

A RECKONING

1 Mallowan, Max, 'Sir Mortimer Wheeler', *Iran, Journal of the British Institute of Persian Studies*, Vol. 15 (Taylor & Francis, 1977) pp. v–vi.
2 Sheppard, *Treasury of London's Past*.
3 Carr, Lydia C., *Tessa Verney Wheeler, Women and Archaeology Before World War Two* (Oxford University Press, 2012).
4 Mills, Jane A., 'Writings and Sources VII, Cromwell's Watch: Somewhere in Time', *Cromwelliana, the Journal of the Cromwell Association*, Series II, Number I, 2004, p. 100.
5 *The Register*, Adelaide, South Australia, 24 October 1928.

6 Thompson, Laura, *Agatha Christie: An English Mystery* (Headline Review, 2007).
7 'L'Amethyste, ou les Amours de Bacchus et d'Amethyste', from Belleau's collection: Remy Belleau, *Les Amours et Nouveaux Eschanges des Pierres Precieuses...* (Mamert Patisson, 1576), pp. 4–6.
8 Rosicrucians were a brotherhood supposedly founded in medieval Europe, who believed they were possessed of ancient wisdom passed down from ancient times, mixing religious beliefs and practices, including occultism and Jewish mysticism. As with Freemasonry, the origin story was an elaborate work of fiction.
9 A member of staff at the Natural History Museum took the box from the vault in 1972 and opened it, finding the jewel and the note. According to the Natural History Museum there are links in the tale of the Delhi Sapphire to some real-life stories of misfortune of several families in East Sussex where Heron Allen lived. One theory goes that he met these people in the gentlemen's clubs of London or Lewes, where he was also mingling with Indian army men, hearing tales of army life in India, and may have felt the urge to mix the two in fiction. Then again, he may have fabricated the legend to give credence to a supernatural short story he wrote in 1921 under the pseudonym Christopher Blayre called 'The Purple Sapphire', one of a series of supernatural tales supposedly written by the former 'Registrar' at the mythical 'University of Cosmopoli', this one, you guessed it, about a jewel that brought bad luck to whoever owned it.

MAKING THE CATALOGUE

1 *Westminster Gazette*, 19 March 1914.
2 See Perry, John Curtis, *The Flight of the Romanovs* (Basic Books, 2001). See also Clarke, William, *The Lost Fortune of the Tsars* (St Martin's Press, 1995).

THE AUCTION OF RINGS

1 Oates had this Christ head ring in his 1917 collection and described it as having been 'given to the writer by G.F. Lawrence Esq.'.
2 Tessa Verney Wheeler, the archaeologist and professional partner of her husband Mortimer Wheeler writing in an article for the *Antiquaries Journal* about gold rings from London in 1934 states that, 'It was bought at that sale [1929] by Mr. G. F. Lawrence, from whom it passed to the London Museum, where it now is.' The buyers' list for the 1929 Sotheby's sale shows, however, that it was in fact 'Brett' who bought the ring in 1929 [Colonel Brett].
3 Oates had this gold ring, the 'head of a knight in armour', in his 1917 collection. It's described there as having originally belonged to Laking who had given it to Oates at some unknown point before 1917. There's no record of where Laking got it from.

THE BANK OF ENGLAND

1 According to the archaeologist Joanne Bird. See Bird, J., Chapman, H., and Clarke, J. (eds.), *Collectanea Londiniensia: Studies in London Archaeology and History*, London Middlesex Archaeological Society Special Paper 2, 1978.
2 Masson, Rosaline, 'The Opal Ring', a short story serialised weekly in the *Derby Advertiser and Journal* in 1929.
3 *Observer*, 22 June 1930.
4 MoL archive, Lawrence letter to Wheeler, 24 June 1930.
5 MoL archive, Lawrence letter to Wheeler, 6 July 1931.
6 Bradley, Simon and Pevsner, Nikolaus, *The Buildings of England: 1: The City of London* (Yale University Press, 2002), p. 276.
7 Abramson, Daniel, *Building the Bank of England: Money Architecture Society 1694–1942* (Yale University Press, 2005).
8 Bank of England Museum & Historical Research Section, file ADM 30/143, 7 February–5 March 1934. See Macdonald, Jean, 'Stony Jack's Roman London', in *Interpreting Roman London* (Oxbow Books,

1996) for Macdonald's research into the Bank of England excavations and G.F. Lawrence's near-prosecution.
9 Bank of England Museum & Historical Research Section, file ADM 30/143, 27 February 1934.
10 BM Accession number 1934.12-10.1-100/12.10.100.
11 BM Accession number 1910.10-7.1/ 1911.7-17.2.

STAGE AND SCREEN

1 The topographical writer and historian of London, Francis Sheppard.
2 Shakespeare is the first to mention Herne the Hunter in *The Merry Wives of Windsor*, Act IV Scene IV; he is said to haunt a particular oak tree in Windsor Great Park.
3 For reference, see Frank Winnold Prentice, merchant seaman, born in 1889, from a similar class background to Lawrence, interviewed on BBC television show *Great Liners* in 1979 about his experience surviving the sinking of the *Titanic*. Prentice pronounces 'Forward' as 'Forred'.

WHAT WE LEAVE BEHIND

1 *Manchester Evening News*, 'Navvies Mourn King of Collectors', 3 March 1939.
2 Most famously, in 1910 De Vere Cole was egged on by a naval officer friend to pull the leg of an officer on a rival ship, the HMS *Dreadnought*, the Royal Navy's flagship. He organised the group, which included Virginia Woolf, to pose as the Abyssinian royal family who wished to visit the ship, and they put on regal eastern robes and stage make-up blackface. It worked, the commander-in-chief welcomed them on board, complete with an honour guard and a national anthem, and caused scandal and embarrassment for the navy.
3 Hawkes, Jacquetta, *Mortimer Wheeler: Adventurer in Archaeology* (Weidenfeld & Nicolson, 1982) pp. 200–2. Mortimer Wheeler rose

to brigadier in the North African campaign and bravely led his men in action, and with a ruthless discipline. He was known as 'Flash Alf' by the men who served under him. After a diversion to serve as one of the 'Monuments Men' in Libya, saving ancient Roman sites from destruction, he had then been pulled out to run the British Archaeological Survey in India from 1944, witnessing the horrors of Partition, and had returned to the Indus Valley, now Pakistan, to excavate the ancient site of Mohenjo-Daro, one of the world's earliest cities, contemporaneous with those of ancient Egypt. He had also somehow squeezed in drama in his love life, filing for divorce from his wife, Mavis de Vere Cole, after finding her in bed with a rival who referred to him as 'that whiskered baboon' and marrying his third wife, the archaeologist Margaret Collingwood. This did not slow his compulsive womanising.

4 *Daily Herald*, 4 February 1937, 8.
5 Morton's later career and legacy were more problematic. In 1942, he penned a future history novel, commissioned for Churchill by the Ministry of Education as propaganda, *I, James Blunt*, imagining Britain under German occupation in 1944. Morton was one of two reporters invited to a meeting between Churchill and Roosevelt on a British warship off Newfoundland. He made millions with his *In Search of...* series, which included Ireland, and is probably the most famous journalist you've never heard of. Harry's alter ego turned out to be an antisemite and anti-socialist Nazi sympathiser who was serially unfaithful to his wife and went to South Africa after in 1948, the same year apartheid was brought in. In 1942 William Flinders Petrie died in Jerusalem – he was a eugenicist, the views of both men were not palatable in a new era.
6 Herrmann, Frank, *Sotheby's: Portrait of an Auction House* (Chatto & Windus, 1980).
7 Perhaps the people at the sale today had been at the even more discreet auction of Lawrence's property three weeks previously, on Tuesday, 9 May, at Stevens's Auctions in Covent Garden. The catalogue for that sale of *Coins, Flint Implements, Roman and Egyptian Curios, Showcases, Furniture etc. (The property of the late G. F. Lawrence,*

Esq.) had included a lot described sketchily as '*Egyptian 2 carved painted wood heads*'; another with a '*17th cent, Spanish wine flagon blue glass bowl*'; a '*miniature of lady on ivory gilt chatelain*' and '*A small jade pendant…small quantity of cut and polished stones, etc.*' 'There will also be a sale at Sotheby's on Monday 17 July at 1'O'Clock by executors of his estate Fine Greek and Roman Coins.'

8 See Brier, Bob, *Tutankhamun and the Tomb that Changed the World* (Oxford University Press, 2022).

9 See research tracing Tutankhamun's collar to museums and collections around the world, by Marc Gabold, professor of Egyptology at Paul Valéry University Montpellier.

THE POSTWAR GHOST

1 Carr, Lydia C., *Tessa Verney Wheeler, Women and Archaeology Before World War Two* (Oxford University Press, 2012).

2 The Italian-born designer and dressmaker Elsa Schiaparelli also had connections to Holmes via Handley-Seymour – to whom she had given special permission to copy her designs. Schiaparelli ran a couture house in Paris but had always been fascinated with psychic phenomenon. She had been in London in 1912, escaping an unwanted marriage proposal, when the exhibition of the Hoard, and the ghost haunting it, were all over the papers, and married her choice, Wilhelm Frederick Wendt de Kerlor in the capital in 1914. De Kerlor was a Vaudeville stage actor who styled himself as a psychic practitioner and turned out to be a charismatic fraud. In 1915 he was deported for fortune telling, which was an offence under the Vagrancy Act of 1824, and opened a bureau offering paranormal consultations in Paris with his wife, but he abandoned Elsa with their young daughter Gogo (who then contracted polio and spent years rehabilitating and looked after by her mother) and when Gogo asked Elsa about her father, she told her he was dead. Princess Alice, the Duchess of Gloucester, wife of the Dowager Queen Mary's third son Prince Henry, had dresses made by 'Schiap'.

LOOKING FOR THE ST GEORGE OPAL RING

1. In the Lawrence family, there is talk of other kinds of inheritance. Gweneth, Frederick and Rose's daughter, married Cyril Smith in 1940, and remembered talking to her grandmother, Florence's half-sister Ellen Wallis, after supper in Muswell Hill as the bombs rained down on London. Ellen talked about her clairvoyant experiences and said to her daughter Rose: 'Well you will know about that'. Stories were passed down via Rose's grandson about the women in the family all having a second sight. Ethel May was related to the Wallis women through her mother. Gweneth was related to the Wallis women both through her mother, Elsie, and her father, Frederick, who were first cousins.

 A fear of a heritable mental illness likewise passed down the family. The belief that 'mad blood' was heritable persisted in aristocratic circles too, and in the early 1950s Lady Glenconner's engagement to Earl Spencer was called off when his father objected to the match on the grounds that her grandmother was a Trefusis. Queen Mary's daughter-in-law, Elizabeth Bowes-Lyon had two nieces via her brother, John Bowes-Lyon and Fenella Hepburn Stewart Forbes Trefusis, Nerissa and Katherine Bowes-Lyon. In 1941 they were placed in Earlswood hospital for disabled people in Redhill, Surrey, and classified as 'imbeciles'. They died several decades after their deaths were announced in the *Burke's Peerage*.

2. In his 1951 memoir, H.V. Morton informs us that Lawrence's shop is 'now a laundry, or something like that.'

POSTSCRIPT

1. Sheppard, *Treasury of London's Past*, refers to a 'Sèvres chestnut blanket' but given Sèvres is famous for porcelain, and made fine chestnut baskets, it's safe to assume this is an error.

Index

Page numbers with prefix 'n.' refer to the notes section.

Aberdeen Evening Express 299
Aberdeen Press & Journal 238
Addams, Christopher 212–15
Albert, Prince, Duke of Clarence
 and Avondale 133, 287
Alexandra of Denmark, Queen 73
Amenhotep III, Pharaoh 260
amethysts 58–9, 60–2, 247–52, 258
amulets 55, 56, 99, 307–8, 334
Anglo-Saxon artefacts 15, 183–4,
 309–10
Anne of Denmark, Queen 176–7
Antique Collector, The 271
Archaeological Journal, The 270
Ashmole, Elias 71–2
Ashmolean Museum, Oxford 71
Asquith, Herbert 164–5
Asquith, H.H. 60–1, 63, 68–9, 109,
 164
Astor, Nancy Astor, Viscountess 179
Attlee, Clement 311
Augusta of Cambridge, Princess
 125–6

Baker, Herbert 274
Bank of England 273–7
Barlow, Montague 262

Bartlett, John Allen 154
Battersea Power Station 270
Baudrillard, Jean 3
Beauchamp, Lady Evelyn née
 Herbert 227–8, 245
Beech Street, Cripplegate 88, 91,
 150, 344
Bell, James 168
Belleau, Rémy 247
Belzoni, Giovanni 260
Berkeley Square, Mayfair 74, 76,
 110, n. 368
 see also Savile Club, Mayfair
Bethlem Hospital 52, 92, 149
Black Moor's Head, Cheapside 8,
 11, 217
Bligh Bond, Frederick 153–5, 160
Boer War 51, 74
Book of the Dead 104, 230, 233
Bradaye, Susan 213
Brett, Dorothy 96–7
Brett, Maurice (Colonel) 'Bois'
 264–5, 267, n. 370
Brett, Reginald Baliol, *see* Esher,
 Reginald Baliol Brett, Viscount
British Empire Exhibition (1924–
 1925) 140, 236–8

British Museum 72
 collections of 99, 104, 310, 343
 acquisition of part of hoard
 76, 172, 290
 thefts from 344–6
 'Unlucky Mummy' 105, 157,
 227
 Lawrence's work at 270, 278,
 295, 297, 298
 staff at 46, 64–5, 81, 103, 309
Brown, Basil 309–10
Budge, Ernest Alfred Wallis 103–4,
 155
Burton, Harry 228, 229–30, 231,
 234, 308
Butler, Gordon 342–3

Cairo Museum, Egypt 231, 234,
 308
Cambridge, Augusta, Duchess of
 125–6
Cambridge, Margaret Cambridge,
 Marchioness of 134
'Cambridge Emeralds' 22, 125–6,
 259
Cambridge University 'Ghost Club'
 104, 155, 157
cameos 32, 55
 see also St George and Dragon
 opal ring ('X5')
Campbell-Bannerman, Henry 34
carcanets 142–3
Carnarvon, George Herbert, Earl
 of 101, 163, 207, 226–31,
 235–6
Carpenter, L.W. 274, 275
Carter, Howard 100–102, 103,
 183, 243–5
 death 307–8, 337–8
 discovery of Tutankhamun's
 tomb 163, 226–36, 245, 307–8
 friendship with Lawrence
 99–100, 226, 337

Carter's, Great Portland Street 64,
 203
Castrol Lubricants 9, 160
Cavendish, Margaret 3–4
Cecil, Edmund 192
Central School of Arts and Crafts
 61
Chalmers, Robert 76
Channon, Henry 'Chips' 73
Charles I, King 111, 219, 221, 223
 jewellery collection of 137, 177,
 178
Charles II, King 80, 111, 221
Cheapside 5–6, 166, 215–17
 Black Moor's Head 8, 11, 217
 Cheapside Cross 215–16
 Goldsmith's Row 8, 75, 117,
 216, 217–21
 Nos 30–34 7, 9, 42, 75, 117
 see also Wakefield House,
 Cheapside
Cheapside Hoard ('Elizabethan
 Jewels'):
 on cigarette cards 279–80
 discovery of 14–19
 exhibitions:
 pre-WWI 106–7, 108–20, 121,
 145, 168
 post-WWI 186–90, 280, 332,
 344
 inquest 166–7
 items 15, 55–6, 114–15
 amethysts 58–9, 62, 245–7,
 250–2
 cataloguing of 94–5, 239,
 253–9, 285, 289–90
 'X' accession numbers 66,
 257–8, 290, 329–30
 chains 31, 55, 114, 141–4, 285
 rings 79, 260–1, 267
 seals 210
 Lawrence's acquisition of 26–37,
 38–63, 81–2, 118–19, 196–203

origins of 117–18, 208–24,
 312–30
 estimation of date 75, 210
 payment to Lawrence for 83, 85
 payment to navvies for 34–5
 'permanent loans' to Queen
 Mary 143–4, 285
 in storage during wars 168–9,
 172, 186, 308–9
 see also Guildhall Museum;
 London Museum; V&A
 (Victoria & Albert) Museum
Child & Co. 35, 77, 93
Christie, Agatha 103, 240, 244
Christie's 70, 79, 262
Churchill, Winston 68, 103, 159,
 235, 343
Church of England 152–3, 154,
 157–8, 192
cigarette cards 98, 279–80
cinemas 21–2
City of London Corporation 9,
 128, 276
 claims over hoard 77, 78, 93,
 166–72
 dispute with London Museum
 63, 145, 146, n. 367
 and Tresure Trove law 41–2, 75
Civil War, English 111, 179, 216,
 219–20, 222
Clarence and Avondale, Prince
 Albert, Duke of 133, 287
Cletcher, Thomas 223–4
Cole, Horace de Vere 296, 343,
 n. 371
Cole, Mavis de Vere (later Wheeler)
 295–6, 315
Colley, Archdeacon 157–8, 162
Collingwood, Margaret 315
Collins, Wilkie 206
Colville, Cynthia 133–4, 287
Conan Doyle, Arthur, *see* Doyle,
 Arthur Conan

conscription 173
Corelli, Marie 235–6
Cripplegate 90–1, 150–1, 342
Cromwell, Oliver 241–2
'Cullinan Diamond' 126–7
curses:
 Egyptian artefacts 106, 231–2,
 234–6
 'Unlucky Mummy' 105, 157,
 227
 'Ghost of the Cheapside Hoard,
 the' 44, 58, 193–206, 209
 letter 1–2, 314–30, 331–2
 jewellery 140, 143, 177, 248
Custom House, Westminster 214

Daily Express 47, 183, 194, 229,
 230, 270
Daily Herald 200–1, 202
Daily Mail 47, 309
Daily Telegraph 116, 118, 119
Davison, Emily 110
Dawson, Charles 83, 343
De Beers 139–40
Delhi Durbar 21–2, 73, 126, 259
'Delphi Sapphire' 248–9, n. 369
Derry, Dr 234
Devereux, Robert, Earl of Essex
 80, 281–2, 322–3
Devonshire, Spencer Compton
 Cavendish, Duke of 102
diamonds 56, 139–40
 'Cullinan Diamond' 126–7
 'Hope Diamond' 57
 'Koh-i-Noor' 127, 206, 238
 'Sancy Diamond' 177–8, 179
Dickens, Charles 26, 89, 104
Dickie, John 160, 161
Discovery (ship) 211–13, 214–15,
 222
Dissolution of the Monasteries
 209–10
Dolman of Hendon 304

Douthwaite, J.L. 256, 274, 275–7
Doyle, Arthur Alleyne Kingsley 192
Doyle, Arthur Conan 294, 343
　interest in Spiritualism 104, 157, 192–3, 234–5
　Sherlock Holmes series 57–8
Dugdale, George 317
Dundee Evening Telegraph 195, 199
Dundee People's Journal 196, 202, 203–4, 209
Dunning, G.C. 274

East India Company 127, 211, 213–14, 222, 291
Eates, Margot 317
eBay 345
Edward III, King 130, 132, 136
Edward VII, King 70, 73, 126, 159, 160
Edward VIII, King 124, 160, 281, 341
Edwards, Anne 142
Egypt, ancient 104, 161, 244, 248
　artefacts 304
　　Lawrence's Ka shop sign 23–4, 99, 226, 301, 302
　　Sotheby's Sekhmet bust 180, 260–1
　Book of the Dead 104, 230, 233
　curses 106, 231–2, 234–6
　　'Unlucky Mummy' 105, 157, 227
　'Egyptomania' 98–9, 103, 106, 162
　Tutankhamun, Pharaoh 163, 183, 207, 226–36, 260, 337
　　artefacts from tomb 244–5, 307–8
Egyptian government 227, 234, 308
　dispute with Britain over Tutankhamun's tomb 228, 231–2, 236, 243, 307

Elizabeth I, Queen 115, 177–8
　depicted in plays 33, 135, 281–2, 285, 323
　hoard cameos depicting 31, 79–80, 129, 282
Elizabeth II, Queen 22, 288, 332, 341
Elizabeth (Bowes-Lyon), Queen 328, n. 374
Elizabethan Jewels, *see* Cheapside Hoard ('Elizabethan Jewels')
emeralds 56
　'Cambridge Emeralds' 22, 125–6, 259
employment benefits 51
Engelbach, Rex 307–8
English Civil War 111, 179, 216, 219–20, 222
Esher, Reginald Baliol Brett, Viscount 69, 78, 80, 143, 285
　as London Museum keeper 63, 69–70, 72–4, 77, 112, 113
　personal life 96, 276
Essex, Robert Devereux, Earl of 80, 281–2, 322–3
'Essex Ring' 79
Evening Telegraph and Post 157, 205

Fabian, Mary, *see* Lawrence, Mary née Fabian (mother)
Fawcett, Hugh 304
Festival of Britain (1951) 331, 332
First World War 6, 163–84, 202–3
Folk Park, New Barnet 156
Ford, Avis 328
Foreign Office 311–12, 319
Forster, E.M., 12
　Howards End 11–12, 51
Forsyth, Hazel 211
Fortnum & Mason 232
Fountain Court 11
'Francis Towneley's Ghost' (ballad) 198

Franks, Augustus Wollaston 45–6
freemasonry 159–62, 278
Freud, Sigmund 2, 189
Friday Street, Cheapside 7, 9, 160
 in 17th century 215, 216, 217, 220
 see also Wakefield House, Cheapside
Frith, Mr 218

Gardiner, Alan 307
Garrick Club, Covent Garden 70–1, 105, 159
Garrick, David 71
Gedney Beatty, William 304, 334
gemstones 53–5, 56–7
 amethysts 58–9, 60–2, 247–52, 258
 emeralds 22, 56, 125–6, 259
 opals 34, 138–41, 238, 256
 see also St George and Dragon ring
 pearls 141, 142
 sapphires 56, 248–9, n. 369
 see also diamonds
Geological Society 84
George IV, King 57, 137
George V, King 21–2, 70, 258, 287–8
 association with St George 134, 141
 death and burial 281, 341
 during WWI 174–5, 176
 patronage of London Museum 73
 private viewing of hoard 109–12, 116
George VI, King 160, 290, 298, 319, 324, 332
'Ghost Club' 104, 155, 157
'Ghost of the Cheapside Hoard, the' 44, 58, 193–206, 209
 letter 1–2, 314–30, 331–2

Gibbon, Mr 218
Gielgud, John 283–4
Gillray, James 273
Glastonbury Abbey, Somerset 153–5
Glenconner, Pamela Tennant, Baroness 192, n. 363, n. 374
Globe 192
Goldsmith's Company, The 9, 42, 75, 216–20
Goldsmith's Row, Cheapside 8, 75, 117, 216, 217–21
Gordon, W.T. 256
Gould, R.F. 159, 161, 162
Great Fire of London 5, 7, 217, 221
 as theory for hoard burial 29, 118, 209, 210
'Great George' (badges) 137
Great Portland Street 19–20, 42, 64, 203, 267
Greece, ancient 49, 141, 161, 271
 artefacts 301, 344
Greenwell, William 45
Gresham, Thomas 72
Grimes, William Frances 'Peter' 317
Guildhall Museum 10, 70, 254, 274, 297
 acquisition of part of hoard 171–2, 256
 dispute with London Museum 63, 93, 145, 146, 168, n. 367
 amalgamation with London Museum 344
 see also Museum of London
 staff 25, 225, 256
 see also City of London Corporation

Haggard, H. Rider, *King Solomon's Mines* 16, 17–18

Handley-Seymour, Elizabeth 122, 328, n. 373
Hanson (electrical business) 92, 149
Harcourt, Lewis Harcourt, Viscount 68–9, 74, 80, 104
 death 238, n. 368
 as London Museum keeper 71–6, 110, 143, 166, 188
 accusations of wrongdoing against 78, 82, 120, 169–72
 acquisition of hoard 63, 68–9, 76–7, 81, 108–9
 personal life 96–7, n. 357–8
Hardy, Charles 293, 294–5
Hardy, Ethel 'May' née Lawrence (daughter):
 assists with hoard 30, 45, 46, 47, 60, 62
 health 42–3
Hardy, Ethel 'May' née Lawrence (daughter) *(cont.)*
 interest in Spiritualism 61, 95, 152–3, 197, 199, 331–2
 marriage and later life 208, 293, 294–5, 300
Harlay de Sancy, Nicholas 178
Harman Oates, *see* Oates, Frederick Harman
Hartnell, Norman 328
Hatton Garden 333
Hazlitt, W. Carew, *English Proverbs and Proverbial Phrases* 164
Henderson, Walter 95, 199, 203, 242, 318, n. 364
Henrietta Maria, Queen 177, 179, 223
Henry VIII, King 31, 115
Herbert, Evelyn, Lady Beauchamp 227–8, 245
Heriot, George 177, 178
Heron-Allen, Edward 248–50, n. 369
Hildyard, Edward 304

hoaxes 83–4, 343
Holmes, Martin Rivington 1, 259–70, 289–90, 309
 friendship with Queen Mary 280–3, 324–5, 332, 341
 'Ghost of the Cheapside Hoard' letter 1–2, 314–30, 331–2
 theatre career 269, 281–2, 284, 286, 324–5
'Hope Diamond' 57
Hopetoun, Alice 'Hersey' Hope, Countess of 287–8, n. 367
Hopetoun, John Hope, Earl of 287–8, n. 367
Hynes, Samuel 97

Illustrated London News 128, 141, 231
Illustrated Sporting and Dramatic News, The 271
Inspector Calls, An (play) 325
intaglios 31, 55

James, Edward 96, n. 357–8, n. 368
James I, King 176–7, 178, 217
James, T. 193
John, Prince 148, 192
Joicey, Mr 109
Josephine, Empress 138, 140
Jung, Carl 2

Ka shop sign 23–4, 99, 226, 301, 302
Keiller, Alexander 304
Kensington 243–4
Kensington Palace 27, 73, 74, 94, 332
 see also London Museum
Kilmorey, Ellen Constance, Countess, 'Nellie' 126
King James Bible 216–17
Kingston, W.H.G. 165
King William Street 19, 272

INDEX

Koh-i-Noor diamond 127, 206, 238
Koop, A.J. 263–4, 266–7

Lacau, Pierre 229, 233
Laking, Guy 70–1, 105, 173
 as London Museum keeper 63, 78–9, 130, 143, 199
 initial inspection of hoard 63, 68–70, 75–6, 108–9, 112
 reaction to Lawrence's methods 113, 118–19, 146–7, 166, 169
 death 187
 personal ring collection 182, 264–5
Lambert, Frank 166
Lancaster House 108, 121, 168, 189–90, 309, 328
 see also London Museum
Lane, Kris 211
lapidaries 53–4
Lawrence, Alfred (brother) 48–9, 62, 91–2, 148–9, 226, 247
Lawrence, Alfred (nephew) 149
Lawrence, Anne Mary (sister) 91
Lawrence, Arthur (brother) 91
Lawrence, Charles (uncle) 49
Lawrence, Christopher (father) 46–7, 52, 88, 90–1, 92–3
Lawrence, Edgar (grandson) 148, 295
Lawrence, Edith (sister-in-law) 149
Lawrence, Emily (sister) 91
Lawrence, Emily née Hall (stepmother) 92
Lawrence, Ethel May, *see* Hardy, Ethel 'May' née Lawrence (daughter)
Lawrence, Faye (niece) 149
Lawrence, Florence Emily 'Flo' (wife):
 assists with hoard 30, 44, 53, 63
 death 297
 husband's death and funeral 294–5, 300, 333
 marriage and family life 43, 53, 55, 91, 149, 283
 disapproves of son's marriage 47–8
 dissuades husband from Egypt trip 226–7, 229, 238
Lawrence, Frederick (son):
 acquisition of amethysts 58–9, 62, 246–7, 250–2
 death 296–7, 333
 health 43, 51, 92–3, 147–8, 164–5, 295
 marriage and career 47, 48, 50–1, 59–60
Lawrence, Geoffrey (grandson) 48, 148, 295, 333
Lawrence, George Fabian 'Stony Jack':
 'Antiquities from the Middle Thames' (article) 270
 antiquities shop, *see* West Hill, Wandsworth, No 7 (antiquities shop)
 see also Cheapside Hoard ('Elizabethan Jewels')
 character 26–7, 29, 36, 47, 86–7, 150
 interest in spiritualism 104, 194–5
 childhood and early life 46–7, 88–93, 150–1
 death and funeral 294–7
 employment:
 accusations of illegal methods 145–6, 166, 225, 270–2
 Bank of England site 274–8
 Cheapside Hoard 78, 81–2, 188
 at Guildhall Museum 254

Lawrence, George Fabian 'Stony Jack': employment (*cont.*)
 at London Museum 27–8, 45, 53, 67–8, 191, 207–8
 collection methods 84, 146–7, 188
 retired from 238–9
 post-retirement 270–2, 290–1, 302
 cataloguing hoard 94–5, 239, 253–9, 285, 289–90
 friendship with Howard Carter 99–100, 226–7, 238, 337
 friendship with H.V. Morton 29–30, 193, 195, 270, 297
 friendship with Queen Mary 73–4, 143–4, 270, 277–8, 294
 private viewing of hoard with 121, 122. 127, 137–8
 joins Freemasons 159–61
 legacy and reputation 297–8, 318–19, 331, 335, 337–9
 personal antiquity collection 182, 187, 242, 265, 268
 see also St George and Dragon opal ring ('X5')
Lawrence, Gweneth, *see* Smith, Gweneth née Lawrence (granddaughter)
Lawrence, Hester 'Hettie' (sister) 62, 91, 92
Lawrence, Mary née Fabian (mother) 90, 92
Lawrence, Michael (great-grandson) 333
Lawrence, Rose Elsie née Smith (daughter-in-law) 47, 48, 62, 148, 295, 333
Lawrence, Ruth (sister) 62, 91, 92
Lawrence, William (grandfather) 90
Lawrence family pawnbroker shops, Wandsworth
 55 Wandsworth High Street 62, 91, 335
 Beech Street, Cripplegate 88, 91, 150, 344
Law Society 48, 50
'Lesser George' (badges) 137
Leverhulme, William Lever, Viscount 94, 108, 190, 311
Liberal Party 20, 34, 60, 63, 68–9
Liberty & Co. 21
Lindsey, Robert Bertie, Earl of 213–14, 222
Lloyd George, David 69
Lombard Street 10
London Bridge 72, 147, 198
London Magazine 61
London Museum:
 acquisition of hoard 67–87, 94–5, 106–7
 dispute with Guildhall over 63, 93, 145, 146, 168, n. 367
 during and post-WWI 309, 311–12, 332
 establishment of 72–4
 see also Kensington Palace; Lancaster House
 exhibitions 121, 189–90, 199, 225, 281
 pre-WWI 106–7, 108–20, 121, 145, 168
 post-WWI 186–90, 280, 332, 344
 keepers 63
 Esher 69–70, 72–4, 77, 112, 113
 Wheeler 241–2, 250–2, 269, 271–2, 297
 see also Harcourt, Lewis Harcourt, Viscount; Laking, Guy; Oates, Frederick Harman
 'slush fund' 35
 staff 264

see also Lawrence, George
 Fabian 'Stony Jack',
 employment, at London
 Museum
London Stock Exchange 333
London Wall 225
Lord Mayor of London 215
 see also Wakefield, Charles Cheers
Lowther Gardens, South
 Kensington 243
Lutyens, Edward 237, 274

Macdonald, Jean 317
Mace, Arthur 236
Mallowan, Max 240, 244
Manchester Courier 120
Manchester Guardian 118
Maria Feodorovna, Empress 176,
 258–9
Maria Pavlovna, Grand Duchess
 176
Marie Antoinette, Queen of France
 57, 73
Marie Louise of Schleswig-Holstein
 237
Marlborough House 124, 144, 299,
 341
Marshall, Herman 214
Martin, Mrs 31
Marylebone 12
Mary of Teck, Queen, 'May':
 childhood and marriage 73,
 133–4, 148, 192, 287–8, n. 360
 collections of 65, 123–5, 127,
 258–9, n. 359
 'permanent loans' to 128,
 143–4, 242, 258–9, 285,
 332, 341
 death 341
 friendship with Holmes 280–1,
 284–5, 324–5, 332, 341
 friendship with Lawrence 73–4,
 143–4, 270, 277–8, 294

 private viewing of hoard with
 121, 122. 127, 137–8
 as Queen consort 134, 138, 142,
 328
 during WWI 174–6, 179–80
 patronage of London Museum
 73, 74, 109–12
 private viewing of hoard 116,
 121–44
 royal visits 21–2, 181, 236–8
 Wandsworth car accident
 298–9
Matthews, Charles W. 256
Mayor of London 215
 see also Wakefield, Charles Cheers
'mediums' (psychic beliefs)
 153–4, 236, 314, 321–2, 337,
 n. 363
May Lawrence 61, 95, 191,
 331
Mellor, John 76
Merrie England (opera) 134–5,
 285–7, 289, 342
Metropolitan Museum of Art, New
 York 271, 308, 334
Mildenhall, Suffolk 14, 207, 342–3
'Mirror of Great Britain, The',
 brooch 177, 178–9, 224
Mitchell's Hill, Suffolk 207
Moore, Ada Small 304, 334
mortgages 60
Morton, H.V. (Henry Vollam):
 in Egypt with Howard Carter
 229–30
 In Search of... series 33, 36, 246
 on Lawrence 146, 150, 183–4,
 297–8, n. 367
 on hoard discovery 26–9,
 35–7, 85
 interviews with 193–5
 on West Hill shop 23, 24–5,
 151–2
 personal life and legacy 30, n. 372

Museum of London 66, 70, 210, 298, 344
 see also Guildhall Museum; London Museum

Napoleon I, Emperor 98, 138
Napsbury Hospital, Hertfordshire 52, 295, 297
National Insurance Act (1911) 34, 51–2, 276
Natural History Museum 83, n. 369
navvies 8, 27, 184
 at Bank of England site 274–6
 at Cheapside site 7, 12–19, 28–9, 64, 81–2
 Lawrence's payment to 34–5
New Bond Street 180
 see also Sotheby's
Newcastle-upon-Tyne, Margaret Cavendish, Duchess of 3–4
Nicholas II, Tsar 175–6, 258

Oates, Frederick Harman 80, 130, 238, 239
 death and ring auction 181–3, 187, 260–8, n. 370
 as secretary to Laking 78–9, 80, 83, 85
Observer 271–2
O'Connor (museum guard) 239, 242, 318
'Old Sixpenny' 25
Olga Alexandrovna, Grand Duchess 258–9, n. 359
onyx 55
opals 34, 138–41, 238, 256
 see also St George and Dragon opal ring ('X5')
Ottoman Empire 98
Oxford Street 60

Pankejeff, Sergei 189
Pankhurst, Emmeline 136
Pankhurst, Sylvia 61
pawnbrokers 34, 46–7, 52, 88–90
 55 Wandsworth High Street 62, 91, 335
 Beech Street, Cripplegate 88, 91, 150, 344
pearls 141, 142
People's Journal, Dundee 196, 202, 203–4, 209
Pepys, Samuel 29
Pethick-Lawrence, Emmeline 60
Petrie, Hilda 101
Petrie, William Flinders 101, n. 372
phenobarbital 148
Phillips, Robert 262
Phoenix Insurance Company 272
Pillar, Mr 275–6
'Piltdown man' forgery 83–4, 343–4
Pitt-Rivers, Augustus 45
plague 118, 209
Plato 49
Platt, Ferdy 102–3
Pliny the Elder 138, 186
Plough Inn, Suffolk 207
Polman, Gerald 211–12, 214–15, 222, 224
Pope, Nicholas 213
Pope-Hennessy, James 124, n. 360
Porter, Abraham 212
Pretty, Edith 309–10
protheses 203
psychic beliefs 153–4, 236, 314, 321–2, 337, n. 363
 of May Lawrence 61, 95, 191, 331
Putney Vale Cemetery 295, 297, 337–8

quartz 54–5

radio programmes 291
Raleigh, Walter 286–7

Read, John George 173–4
Read, Maurice Edgar 81, 173–4, n. 362
Regent Street 60
Richard I 'the Lionheart', King 32, 132
Richard II, King 283–4
Rider Haggard, H., *King Solomon's Mines* 16, 17–18
RMS *Titanic* 6, 105, 116–17, 157
Romanov, House of 175–6, 258, n. 359
Rome, ancient 41, 106, 131, 141
 artefacts 28, 151, 166, 298, 301
 British archaeological sites 90, 240, 309–10, 342–3
Rose Marie (film) 292
Rosenthal, Leopold 9
Rosicrucianism 249, n. 369
Rothschild, Alice von 309, 317
rubies 56

'Sancy Diamond' 177–8, 179
sapphires 56
 'Delphi Sapphire' 248–9, n. 369
Savile Club, Mayfair 76, 104, 159
Saxe-Coburg-Gotha, House of 132, 175
Scott, Robert Falcon 6
Scott, Walter 55, 56, 139–40
Second World War 308–10, 317
Seymour Lucas, John 111
Shaftesbury, Constance Ashley Cooper, Countess of 134
Shakespeare, William 31–2, 134, 269
 productions 20, 71, 93, 138–9, 274, 283–4
Sheppard, Francis 241, 269
'Sign of the Golden Time and Dial', Great Portland Street 64, 99, 267
 see also Webster, Percy

Simpson, Francis 219–24, 331, n. 366
Simpson, James 222, n. 366
Simpson, John 219, 221, 222, n. 366
Simpson, Wallis 281
Smith, Gweneth née Lawrence (granddaughter) 48, 51, 148, 295, 331, n. 374
 memories of Lawrence 39, 254, 283, 292, 333
Smith, Rose Elsie, *see* Lawrence, Rose Elsie née Smith (daughter-in-law)
Smith, T.H. 8
Smith, Tony (great-grandson) 331, 333
Smithfield Market 344
Soane, John 273
Society of Antiquaries 181
Sotheby's 180, 181, 271, 295, n. 372–3
 auction of Lawrence's stock-in-trade 300–6, 334
 auction of Oates' rings 260–8
Sowerby, Githa, *Rutherford and Son* 52
Sphere 298
Spiritualism 143, 153–8, 191–4, 200, 321
 of May Lawrence 61, 95, 191, 331
 psychic beliefs 153–4, 236, 314, 321–2, 337, n. 363
 see also 'Ghost of the Cheapside Hoard, the'
Stafford, William Howard, Viscount 210, 222, n. 365, n. 366–7
Stafford House 108, 190
 see also Lancaster House
Stead, William Thomas 105, 157
Stevenson, Robert Louis, *Treasure Island* 15–16, 18
St George (legend) 32–3, 130–2, 134–7, 152, 289

St George and Dragon opal ring
 ('X5') 32
 appears in catalogue 255–8, 329
 assigned number 'X5' 66, 257,
 290, 338
 appears in exhibition 129–30,
 138, 158, 168
 missing from hoard 76, 168, 258,
 289–90, 331–9
 theories of whereabouts 85–6,
 168, 215, 271, 333–7
St James's Palace 63, 124
Stopford, Albert 175–6
Stow, John 216
strikes 22, 175, 246
Suffragette movement 21, 60–1,
 74, 109–10, 121–2, 136
Sumptuary Laws 248
Sutherland, Duke and Duchess of
 108, 190
Sutton Hoo treasures 309–10

Tatler 69
Taylor, William 219
Teck, Francis, Duke of 126, 133–4,
 287
Teck, Mary of, *see* Mary of Teck,
 Queen, 'May'
television programmes 290–1
theatre 20, 71, 97–8, 172–3,
 281–91, 324–5
 Lawrence's love of 52, 280
 Merrie England (opera) 134–5,
 285–7, 289, 342
 Where the Rainbow Ends (play) 33,
 135–6, 288–9, 342, n. 360
Threadneedle Street 273
'Three Brothers' pendant 177, 178,
 179, 223
Throckmorton, Bessie 286–7
Times, The 29, 109, 127, 190,
 227–8, 230
Titanic 6, 105, 116–17, 157

toadstones 31, 55, 334
Towneley, Francis 198
Townley, Francis H. (Lawrence's
 pseudonym) 196–7
Treasure Trove law 39–42, 76, 128,
 145–6, 167–8, 310
 inquest into hoard 166–7
 see also City of London
 Corporation
Treasure Trove Reviewing
 Committee 41
Treasury Department 76, 77
Tree, Herbert Beerbohm 71
Trollope & Colls 10
Trotman, Arthur 309, 317
Tutankhamun, Pharaoh 163, 183,
 207, 226–36, 260, 337
 artefacts from tomb 244–5,
 307–8
Twysdale or Twysedale, William
 320

unemployment 51–2, 246, 276
'Unlucky Mummy' 105, 157, 227

V&A (Victoria & Albert) Museum
 124, 125
 hoard collection at 172, 242,
 281, 285, 290
 purchase of Oates rings 262,
 263–4, 266–7
Verulamium, Saint Albans 240
Victoria, Queen 70, 74, 133, 148,
 190, 287
 collections of 34, 73, 127, 137,
 139, 140
'Vladimir Tiara' 176, 259

Waddesdon Manor,
 Buckinghamshire 309, 317
Waetcher, Harry 72
Wakefield, Charles Cheers 9–10,
 42, 75, 78, 160, 171

Wakefield House, Cheapside 78, 171, 180, 217–21, 255
　building plans 8–9, 10
Waldo, Dr (coroner) 42, 63, 76, 128, 167
Walkley, A.B. 189–91
Walters, Stephen 202–3
Wandsworth 19, 21, 22–3, 90–1, 195, 335–6
　55 Wandsworth High Street (pawnbrokers) 62, 91, 335
　see also West Hill, Wandsworth
Ward, John Sebastien Marlow 155–8, 159, 160, 192
Ward, Reginald 'Rex' 192
Warre, Felix 262
Watertown, Edmund 262
Webster, Malcolm 267
Webster, Percy 64–5, 81–2, 84, 99, 267
Weekly Dispatch 194
Weinstein, Rosemary 217
Wembley Park 236
West Hill, Wandsworth 21, 23, 298–9, 335–7
　Lawrence family flat 23, 43–5, 92, 191
　No 7 (antiquities shop) 23–5, 45, 50, 99, 242–3, 336–7
　　Ka shop sign 23–4, 99, 226, 301, 302
　　stock-in-trade auction 300–6, 334
　see also Lowther Gardens, South Kensington
Westminster Gazette 112, 129–30
wheelchairs 42–3
Wheeler, Mavis 295–6, 315
Wheeler, Michael 241

Wheeler, Robert Eric Mortimer 240–2, 243, 295, 296, 315, 343, n. 371–2
　as London Museum keeper 241–2, 250–2, 269, 271–2, 297
　cataloguing of hoard 253–7, 289–90, 329
Wheeler, Tessa Verney 241, 295, 317
Where the Rainbow Ends (play) 33, 135–6, 288–9, 342, n. 360
Whitechapel 20, 187
Whitney, Constance 151
Wicquefort, Joachim de 223
Windsor, House of 140, 175
Wolsey Lodge, Hampton Wick 159, 162
women's suffrage movement 21, 60–1, 74, 109–10, 121–2, 136
Wood, Thomas 216
workmen (navvies) 8, 27, 184
　at Bank of England site 274–6
　at Cheapside site 7, 12–19, 28–9, 64, 81–2
　Lawrence's payment to 34–5
World War I 6, 163–84, 202–3
World War II 308–10, 317
Worshipful Company of Goldsmiths 9, 42, 75, 216–20

X (letter) 338
'X5' see St George and Dragon opal ring ('X5')
Xenia Alexandrovna, Grand Duchess 258–9

Yeats, W.B. 104, 155

Zweig, Stefan 158